# MASTERWORKS
## of European Painting

39403

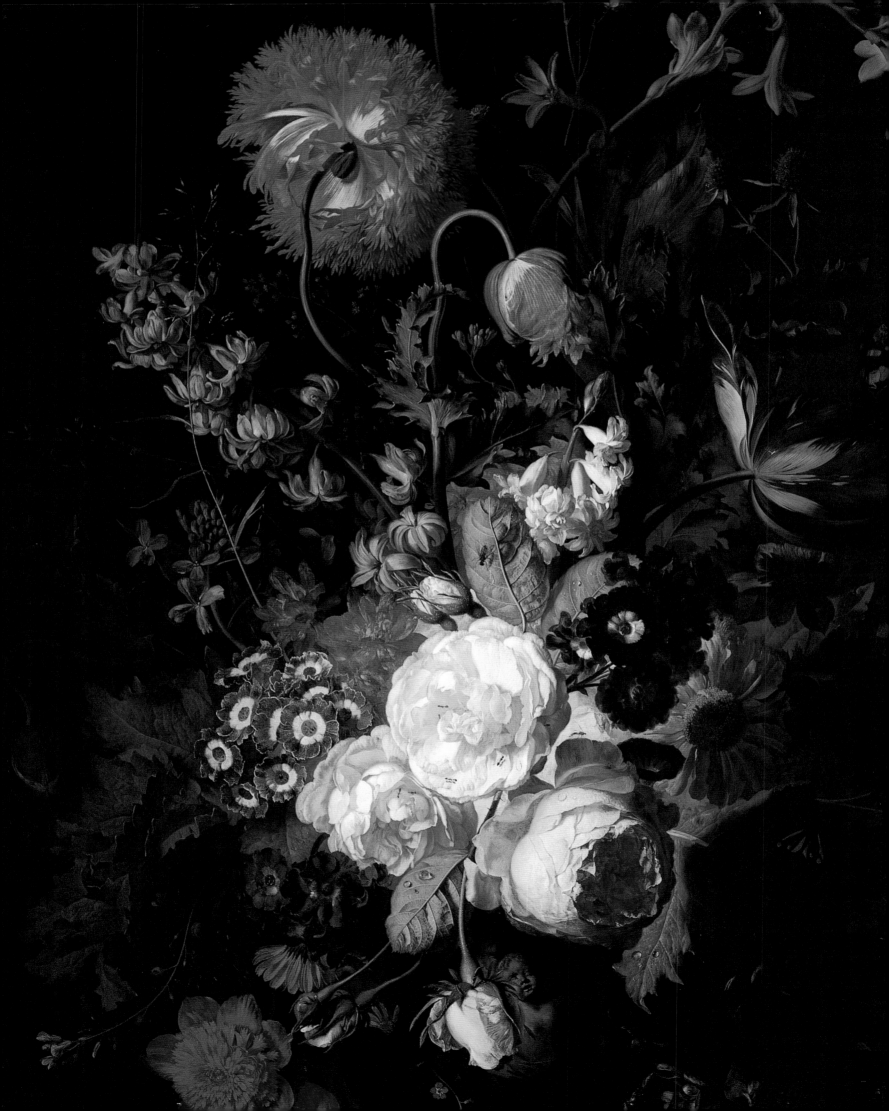

# MASTERWORKS
## of European Painting

IN THE MUSEUM OF FINE ARTS, HOUSTON

EDGAR PETERS BOWRON

AND MARY G. MORTON

PRINCETON UNIVERSITY PRESS

IN ASSOCIATION WITH

THE MUSEUM OF FINE ARTS, HOUSTON

Jacket/cover illustrations: *(front)* Gustave Caillebotte, *The Orange Trees* (detail), 1878; *(back)* Attributed to Bernardino Zaganelli, *Virgin and Child Enthroned with Saints Michael, Catherine of Alexandria, Cecilia, and Jerome*, c. 1506–12

Frontispiece: Jan van Huysum, *Still Life of Flowers and Fruit* (detail), c. 1715

Pages xviii–1: Canaletto, *The Entrance to the Grand Canal, Venice* (detail), c. 1730

Published by Princeton University Press
41 William Street, Princeton
New Jersey 08540

In the United Kingdom: Princeton University Press,
Chichester, West Sussex
The Museum of Fine Arts, Houston, P.O. Box 6826,
Houston, Texas 77265-6826

© 2000 Princeton University Press and The Museum of
Fine Arts, Houston
Works by Pierre Bonnard, Georges Braque, André Derain,
Armand Guillaumin, Vassily Kandinsky, Paul Signac, and
Edouard Vuillard © 2000 Artists Rights Society (ARS),
New York
Works by Pablo Picasso © 2000 Estate of Pablo Picasso /
Artists Rights Society (ARS), New York
Works by Alexei Jawlensky © 2000 Artists Rights Society
(ARS), New York / VG Bild-Kunst, Bonn
Works by Henri Matisse © 2000 Succession H. Matisse,
Paris / Artists Rights Society (ARS), New York

All rights reserved. No part of this book may be reproduced in any form or by any electronic or mechanical means, including information storage and retrieval systems, without permission in writing from the publishers, except by a reviewer who may quote brief passages in a review.
Photography by Thomas R. DuBrock with Jud Haggard, Department of Photographic Services, The Museum of Fine Arts, Houston

Unless noted, all photographs © The Museum of Fine Arts, Houston

Printed in Hong Kong
10  9  8  7  6  5  4  3  2  1

Library of Congress Cataloging-in-Publication Data

Museum of Fine Arts, Houston.
    Masterworks of European painting in the Museum of Fine Arts, Houston / Edgar Peters Bowron and Mary G. Morton.
        p.   cm.
    Includes bibliographical references and index.
    ISBN 0-691-00460-9 (cloth : acid-free paper). —
    ISBN 0-89090-093-0 (pbk. : acid-free paper)
    1. Painting, European Catalogs.   2. Painting —
Texas—Houston Catalogs.   3. Museum of Fine Arts,
Houston Catalogs.   I. Bowron, Edgar Peters.   II.
Morton, Mary G.   III. Title.
ND450.M793  2000
759.94'074'7641411—dc21                           99-39064
                                                          CIP

# CONTENTS

# AN INTRODUCTION TO THE EUROPEAN PAINTINGS COLLECTION

Edgar Peters Bowron

The origins of the Museum of Fine Arts, Houston, the oldest art museum in Texas, can be traced to the educational reform movements that flourished in the United States in the late nineteenth and early twentieth centuries. Since the 1840s education reformers like Horace Mann in Massachusetts and Henry Barnard in Washington, D.C., had promoted the fine arts as an essential element in the basic curricula of elementary-school education. They advocated instruction in drawing and the use of lithographic copies of original works of art to introduce students to the Old Masters. The founding of the Houston Public School Art League in 1900 was a local response to these progressive ideas, and its installation of fine-art reproductions in classrooms marked the first step toward the establishment of an art museum for the city.[1]

In 1913 the organization changed its name to the Houston Art League and broadened its purpose to serve the entire city, offering art classes, lectures on art appreciation, and exhibitions in the Scanlan Building downtown. During this period the league began acquiring art objects and determined to establish a public museum. In 1917 the land that now serves as the site of the museum was acquired by the league from the estate of George Hermann, a wealthy Houston rancher and oilman. The funds to purchase the land and initiate the construction of a new building were gathered from Houston's civic and business leaders, who constituted a "who's who" of local society and whose families have in great measure continued to support the museum to the present day. Their numbers included Joseph S. Cullinan, one of the founders of the Texas Company (now Texaco); William C. Hogg, businessman and real-estate developer; Robert Lee Blaffer, a founder of Humble Oil; and William L. Clayton, who had created one of the largest cotton brokerages in the world.

The first major gift to the Houston Art League was a bequest in 1919 of twenty-five paintings and a few works in other media from George M. Dickson (1864–1918) and his sister Belle. While living in Mexico City,

Dickson assembled a small art collection consisting of copies after Raphael, Correggio, Guido Reni, and other Old Masters and a few French nineteenth-century Salon paintings, notably Anton Mauve's *Landscape with Cattle* (p. viii) and Jean-Léon Gérôme's *Tiger on the Watch*. In the absence of a building to house Dickson's pictures, the works were initially placed on public view at the University Club of Houston. There they served as focal points for an ambitious program of art exhibitions, lectures, and discussions throughout the city and laid the foundation for the collections of the future Museum of Fine Arts, Houston.

When the museum opened to the public on 12 April 1924, in a beaux-arts building designed by William Ward Watkin (1886–1952), head of the architecture department at Rice Institute (which became Rice University in 1960), there were fewer than fifty objects on view. Initially, Watkin's designs for the new museum were only partially completed, but during the 1920s additional sections were added on to the original block as funds were raised.[2] Acquisition funds were negligible, however, and there were few local collectors available to support the new museum with appreciable gifts of art. There was little tradition of interest in art and little social prestige connected with its ownership in Houston in the 1930s. With the arrival of the Great Depression, operating funds for the Museum of Fine Arts, with its staff of six part-time employees, withered. The museum's director, James H. Chillman, Jr. (1891–1972), appointed in 1924 to a part-time position at a salary of three thousand dollars, often took no salary so that the museum's operating expenses, such as the janitor's salary, could be paid. Although trained as an architect and serving on the faculty of Rice as a professor of architecture, Chillman presided over the critical initial years of the Museum of Fine Arts and was responsible for bringing to it three of its founding collections of European paintings. His devotion to the museum was legendary; it was during his tenure that the museum began to build a collection of Old

1. For the history of the Museum of Fine Arts, see Peter C. Marzio, "A History of the Museum of Fine Arts, Houston," in *A Permanent Legacy: 150 Works from the Collection of the Museum of Fine Arts, Houston* (New York: Hudson Hills Press, 1989), and Kendall Curlee, "Museum of Fine Arts, Houston," in *The New Handbook of Texas,* ed. Ron Tyler (Austin: Texas State Historical Association, 1996), 4:900–903, with further bibliography.

2. With the formal reorganization of the Art League in 1925, the name was changed to the Museum of Fine Arts, operating under a state charter, supported by private donations and annual appropriations from the city. For a brief, illustrated architectural history of the Museum of Fine Arts, see Donnelley Erdman, "The Museum of Fine Arts, Houston: Fifty Years of Growth, 1922–1972," in *Architecture at Rice* 28 (1972): 1–40.

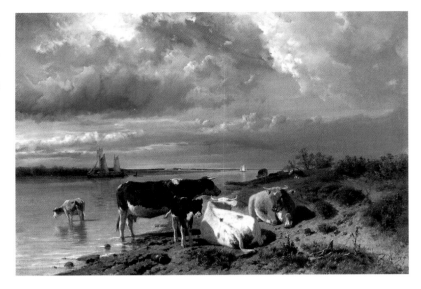

Anton Mauve (Dutch, 1838–1888), *Landscape with Cattle.* Oil on canvas, 29 7/8 x 43 1/2 in. (75.9 x 110.5 cm). Gift of the Houston Art League, the George M. Dickson Bequest. This unpretentious pastoral scene by one of the leading artists of the Hague School was among the first European paintings to enter the museum's collections.

Master and nineteenth-century European paintings.

Although the acquisitions and exhibitions programs of the new museum were dominated by the work of local artists and photographers, American art, and arts and crafts, there was a sliver of interest in European art at the time. In 1930 the merchant Samuel H. Kress gave the museum a *Holy Family with a Donor as Saint Catherine of Alexandria,* thought to have been the work of the sixteenth-century Venetian painter Lorenzo Lotto.[3] Kress was a friend of one of the most important civic leaders in Houston history, Jesse H. Jones (1874–1956), publisher of the *Houston Chronicle,* founder of the National Bank of Commerce, real-estate entrepreneur, and builder of many of Houston's tallest office buildings in the 1940s. In 1935 Kress continued his support of the museum with the gift of a pair of sides of a Lombard polyptych panel, and in 1939 he gave the museum a *Virgin and Child* attributed to Bartolomeo Veneto.[4] These paintings were the first Old Masters to enter the collection after the Dickson bequest, and Kress's generosity at this early date is often cited as an important inducement to others to support the Museum of Fine Arts with gifts of art.

In its early days the museum occasionally held exhibitions of European paintings to stimulate interest in the area among its visitors. Most of these were trade exhibitions such as *Paintings by Old Masters,* a group of twenty-one seventeenth- and eighteenth-century paintings attributed to Rubens, Hals, Cuyp, Canaletto, Reynolds, Gainsborough, and Corot, brought to Houston by Reinhardt Galleries, New York, and shown at the museum in January 1931. In 1940 Knoedler & Co. Gallery, New York, lent the museum a group of European paintings dating from the fifteenth to the nineteenth century, which Chillman justified "due to the great interest in the works of the older masters, as well as the difficulty in assembling a representative group of their works."[5]

## THE EDITH A. AND PERCY S. STRAUS COLLECTION

The bequest of the Edith A. Straus and Percy S. Straus Collection to the Museum of Fine Arts, Houston, immediately and generously enhanced the permanent collection of European art that had been developing since the museum's inception. Percy Selden Straus (1876–1944) was one of six children of Isidor Straus, who together with his brothers had acquired R. H. Macy & Co., New York, in 1888. The success of the store was meteoric. In 1902, when the store moved to Herald Square, it became what is generally recognized as the world's largest department store, and in 1919, the year the company changed from a partnership to a corporation, it earned $35 million. Percy Straus was largely responsible for the development of the store after his father and mother perished in the *Titanic* disaster in 1912, and he eventually served as vice-president, president, and chairman of the board of Macy's.

His father had collected medieval and Renaissance paintings, sculpture, and works of

3. Wilson 1996, 349–56, no. 35; the painting was examined in Washington in 1997 on the occasion of the Lorenzo Lotto exhibition and was determined conclusively to be a copy with variations after the artist's painting in the Accademia Carrara di Belle Arti, Bergamo.
4. Ibid., 230–41, no. 20; the *Virgin and Child* was returned to the Kress Foundation in 1953.
5. James Chillman, Jr., "Extracts from the Annual Report of the Director," *Bulletin of the Museum of Fine Arts of Houston, Texas* 3 (June 1940): n.p. Exhibitions of Old Master painting were held periodically at the museum; for example, *Masters of Painting of the Sixteenth and Seventeenth Centuries,* 1950, organized by Duveen Brothers, French & Co., M. Knoedler & Co., and Wildenstein and Co.; see *Bulletin of the Museum of Fine Arts of Houston, Texas* 12 (Summer/Fall 1950): n.p.
6. See Wilson 1996, appendix II: "Letters to Percy S. Straus, 1922–36," 385–408.
7. Rice University did not establish an art department until 1965.
8. *Catalogue of the Edith A. and Percy S. Straus Collection,* exh. cat. (Houston: Museum of Fine Arts, 1945).
9. Wilson 1996, 101–17, no. 8.

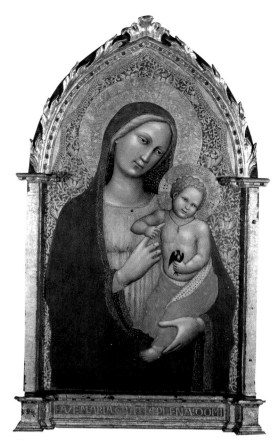

Master of the Straus Madonna (Italian [Florentine], active at the end of the 14th century), *Virgin and Child*, c. 1395–1400. Tempera and gold leaf on wood, 35 1/2 x 19 in. (90.1 x 48.2 cm). The Edith and Percy S. Straus Collection. Often, the author of an anonymous work is named for convenience after the collection to which the work belongs, as was this unknown Florentine painter who flourished around 1400.

Bernardino Fungai (Italian [Sienese], 1460–1516), *A Scene from Ancient Mythology*, c. 1510. Tempera, oil, and gold leaf on wood, 20 3/8 x 79 1/2 in. (51.7 x 201.9 cm). The Edith A. and Percy S. Straus Collection. This complicated narrative panel has been thought to have decorated the wall of a bedchamber of a newly married couple.

art early in the century, and Percy Straus continued to build the collection, which he kept in his apartment at 875 Park Avenue, New York. Straus belonged to the small group of American collectors in the 1920s who were keen to acquire Old Masters, and each year he traveled to Europe with his family. He maintained active contact with scholars, dealers, and connoisseurs and was guided in his selection of Italian paintings by the English art historian, dealer, and museum director Robert Langton Douglas; the art historian and collector F. Mason Perkins; and the great authority on early Italian painting Richard Offner, who frequently counseled Straus about his purchases and whose monumental *Critical and Historical Corpus of Florentine Painting* (1930–34) Straus supported with funds for publication. Straus also corresponded frequently with the art historian, collector, and connoisseur Bernard Berenson, who answered his requests for attributions.[6]

Percy Straus married Edith Abraham, daughter of the founder of the Brooklyn department store of Abraham & Straus. Percy and Edith Straus were generous philanthropists whose interests included New York University (to which he gave one million dollars in unrestricted endowment in 1929), Harvard, the New York Public Library, and several Jewish charitable organizations. The Strauses had three sons, one of whom, Percy Selden Straus, Jr., an attorney and vice-president of the Museum of Fine Arts, had moved to Houston in 1939. When he and Edith pledged their collection to the Museum of Fine Arts in 1941, Percy Straus both expressed a desire to help establish his son in the Houston community and promised his support of the future economic prosperity of the Southwest. (Straus, like Samuel Kress, was also a friend of Jesse Jones, who in 1937 established his own foundation, The Houston Endowment, Inc., which, supported by

Straus, would become a major benefactor to the museum.) Straus believed strongly in stimulating the growth of art centers in regions of the United States outside New York, citing the importance of museums in Kansas City, Detroit, Cleveland, and Worcester, for example, in making original works of art available to the people of those communities. He also hoped that the presence of his collection in Houston would encourage Rice Institute to establish a fine arts department along the lines of the Institute of Fine Arts, which had been recently developed at New York University.[7]

The Straus gift was announced in the newspapers on 7 December, 1941, the day Pearl Harbor was bombed. Amid front-page reports of Hitler's troops preparing to invade Moscow and President Roosevelt's warning to the Japanese to quiet their saber rattling, the *Houston Chronicle* trumpeted "Magnificent Straus Collection of Art Given to Houston Museum—Works of Masters of Many Ages to Make City Great Art Center." The arrival of the Straus collection of fifty-four paintings and twenty-eight sculptures, placed on view in Houston for the first time in April 1945, signaled the start of a new era for the Museum of Fine Arts and established a foundation for its collections of European art.[8]

The best-known works in the Straus collection are the Italian paintings of the fourteenth and fifteenth centuries, several of which are included in this handbook to the museum's European paintings. Since Straus had generously shared his collection with scholars and connoisseurs such as Offner, several of his paintings have become quite famous in the literature on Italian art. For example, two anonymous Italian artists are known by paintings in the Straus collection, notably a *Virgin and Child* by the Master of the Straus Madonna (left), an important Florentine painter in the early Renaissance.[9]

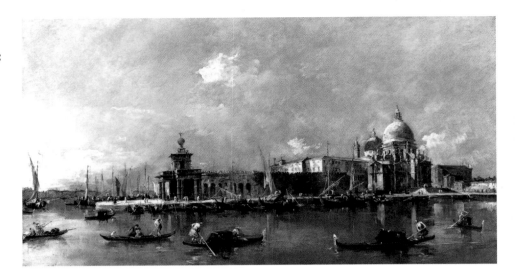

Francesco Guardi (Italian [Venetian], 1712–1793), *Santa Maria della Salute and the Dogana, Venice,* c. 1780. Oil on canvas, 19 5/8 x 35 3/8 in. (49.8 x 89.8 cm). The Edith A. and Percy S. Straus Collection. This is one of the few later Italian paintings in the Straus Collection.

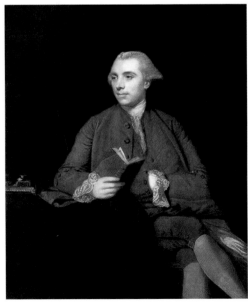

Sir Joshua Reynolds (English, 1723–1792), *Anthony Chamier, M.P.,* 1767. Oil on canvas, 50 1/2 x 40 1/4 in. (128.4 x 102.2 cm). The Edith A. and Percy S. Straus Collection. This portrait of an intimate friend of both Samuel Johnson and the artist epitomizes the Strauses' interest in eighteenth-century English and French art.

Among the early Italian paintings in the Straus collection is a beautiful example of contemporary interior decoration, a panel by the Sienese painter Bernardino Fungai (p. ix) illustrating an obscure Greek myth of the sort beloved by art historians of the Italian Renaissance for the opportunity it offers to display their erudition. F. Mason Perkins, who admired "the perfect concept, the perfect technique, the freshness of the landscape, the grace of the various figures, and the refinement of details" of the work, published the panel early in this century. Once thought to have adorned a *cassone,* the Italian term for a large chest, which contained a bride's dowry or was given as a wedding present, the picture is now believed to have decorated the wall of a bedchamber or study of a newly married couple.[10] Like most collectors of their generation, Edith and Percy Straus had nothing to do with Baroque art, but the Venetian settecento was very much in vogue in the early twentieth century among New York collectors, and so the collection contains a fine view by Francesco Guardi of *Santa Maria della Salute and the Dogana, Venice* (above).

The Strauses' predisposition toward Italian art was not exclusive, however, and the collection also included Northern Renaissance paintings by Rogier van der Weyden, Hans Memling, and other early Netherlandish masters. Three small portraits by Corneille de Lyon, a male portrait by Anthony van Dyck, and a portrait by Reynolds (left) further attest to the range of their interests. Renaissance bronzes held a special fascination for the Strauses, who also collected French eighteenth-century terra-cotta sculptures, notably a pair of *Infant Satyrs* by the sculptor Clodion.

## SARAH CAMPBELL BLAFFER AND THE ROBERT LEE BLAFFER MEMORIAL COLLECTION

The next milestone in the development of the European paintings collection was the Robert Lee Blaffer Memorial Collection, established in 1947 in memory of one of the founders of the Museum of Fine Arts. Blaffer was among the Texas entrepreneurs associated with the birth of the modern petroleum industry and Spindletop oilfield, the 1901 strike that formed the basis of wealth for many Texans who would later support the museum. In 1917 Blaffer, with several partners, founded the Humble Oil and Refining Company, which later became an affiliate of Standard Oil. The wealth of Blaffer's wife, Sarah Jane Campbell (1885–1975), also came from oil. Her father, William T. Campbell, signed the original charter for the Texas Company, which would later become Texaco, and her marriage to Robert Lee Blaffer in 1909 was locally declared "the conglomerate of the century."

Raised in Lampasas, Texas, "Sadie" Blaffer's first exposure to original works of art occurred at Isabella Stewart Gardner's mansion at Fenway Court, when she was a student at Boston Conservatory. The social, artistic, and philanthropic achievements of "Mrs. Jack" greatly impressed Sarah Blaffer, and she may have sought consciously to emulate the Boston patron and collector.[11] Her devotion to the visual arts deepened during her honeymoon in 1909, when she spent three months with her husband in Europe visiting museums and cathedrals. When she returned

10. Ibid., 256–65, no. 23.

11. Jane Blaffer Owen, quoted by Shelby Hodge, "Fine Eye, Strong Spirit Live on in Art Collector's Legacy," *Houston Chronicle,* 18 October 1992, 45.

12. Quoted in Peter W. Guenther, *Edvard Munch,* exh. cat. (Houston: Sarah Campbell Blaffer Foundation, University of Houston; New Orleans: New Orleans Museum of Art; San Antonio: Witte Memorial Museum, 1976), 6.

13. Friction between the museum's director, James Johnson Sweeney, and the Blaffer family had been increasing for a host of reasons. According to numerous printed and oral sources, the culminating event was Sweeney's refusal to accept from the Blaffers a gift to the museum of a painting by Fragonard. A panel by the sixteenth-century Italian painter Giovanni Battista Bertucci, *Saint Thomas Aquinas* (Wilson 1996, 290–98, no. 28), was accepted by the museum as a compromise, but no further donations were made to the Robert Lee Blaffer Memorial.

14. The foundation sold its collection of twenty-eight Abstract Expressionist works in 1987. For an overview of the Blaffer Foundation's holdings of European paintings, see Shackelford 1992. Individual catalogues of the individual schools have been published, the most recent of which is by Temperini 1996.

to Texas, she devoted her life to filling her house in Shadyside, across from Rice University, with works of art. Some sense of her aesthetic sensibility is found in the reminiscences of a daughter, Jane Blaffer Owen: "Long before Mother brought this eye to the serious collecting of art, she designed and furnished the rooms of her house as though she were painting on canvas. She created her uncluttered rooms in subtle planes of color and with the sure touch of a master who does not make an unnecessary brush stroke."[12] Blaffer reacted strongly against the tastes of her generation and uncurtained her windows, stripped her floors, exiled embroidered centerpieces from her dining table, and flooded her house with candlelight.

Sarah Campbell Blaffer brought a similar independence of taste to the buying of art, and the excellent pictures she acquired raised immeasurably the standard of the European paintings in the Museum of Fine Arts. She initiated the collection in memory of her husband with the gift of Cézanne's exceptional portrait of his wife, *Madame Cézanne in Blue.* Her original intention was to limit the collection to a few outstanding examples of French painting of the nineteenth and

early twentieth centuries, but in the end, the Robert Lee Blaffer Memorial comprised splendid pictures by Giovanni di Paolo, Frans Hals, van Dyck, and Canaletto as well as by Renoir, Degas, and Vuillard. The collection eventually grew to include some two dozen paintings, and with a gift of funds from the Blaffer family, the Robert Lee Blaffer Memorial wing was added to the museum in 1953, completing William Ward Watkin's original 1924 design for the museum.

Sarah Campbell Blaffer made her last gift to the Blaffer Memorial in 1964.[13] In the same year she established the Sarah Campbell Blaffer Foundation, the primary goal of which is to bring the visual arts to people throughout the state of Texas. In the early 1970s the foundation embarked on an ambitious program of collecting European paintings and lending them to small communities throughout the state. Depending largely on the advice of the late New York art dealer Spencer Samuels, the foundation collected artworks in two categories, Old Masters and Abstract Expressionism.[14] The Blaffer Foundation's collections have been exhibited throughout the state of Texas and elsewhere in the United States, fulfilling Mrs. Blaffer's intention of

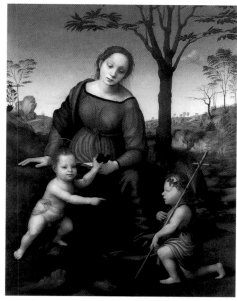

Giuliano Bugiardini (Italian [Florentine], 1475–1554), *The Virgin and Child with the Infant Saint John the Baptist,* c. 1515. Oil on wood, 44 x 34 in. (111.7 x 86.3 cm). Collection of the Sarah Campbell Blaffer Foundation. One of the finest early Italian paintings in the Blaffer Foundation, the work displays the artist's attention to the Renaissance masters Raphael and Fra Bartolomeo.

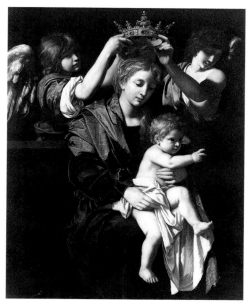

Bartolomeo Cavarozzi (Italian [Roman], c. 1590–1625), *The Virgin and Child with Angels,* c. 1620. Oil on canvas, 61 1/8 x 49 1/4 in. (155.3 x 125.1 cm). Collection of the Sarah Campbell Blaffer Foundation. This is a smaller version of Cavarozzi's altarpiece of the *Mystical Marriage of Saint Catherine* in the Prado, Madrid.

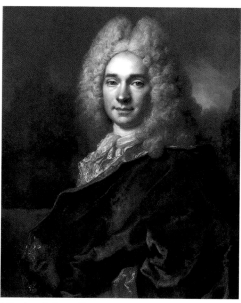

Nicolas de Largillière (French, 1656–1746), *Pierre Cadeau de Mongazon,* c. 1715. Oil on canvas, 32 x 25 5/8 in. (81.5 x 65 cm). Collection of the Sarah Campbell Blaffer Foundation. This fine portrait of a French nobleman of the legal profession typifies the quality of the Blaffer Foundation's later French paintings.

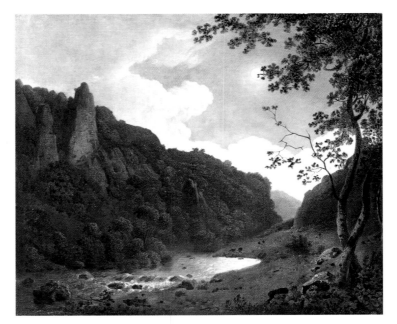

Joseph Wright of Derby (English, 1734–1797), *Dovedale by Moonlight,* c. 1785. Oil on canvas, 24 3/8 x 29 3/8 in. (62 x 74.5 cm). Collection of the Sarah Campbell Blaffer Foundation. A night scene in England by one of the most original, versatile, and accomplished British artists of the eighteenth century, the painting complements an evening Italian landscape in the Blaffer Foundation of a few years later.

bringing fine works of art to regional and local institutions without charge. In the past twenty years the foundation has presented more than two hundred exhibitions of British, French, Italian, and Netherlandish paintings and lent generously to major exhibitions organized by museums in the United States and Europe.

Beginning with the opening of the museum's Audrey Jones Beck Building in 2000, the Blaffer Foundation's finest European paintings will be shown in their own individual galleries adjacent to the permanent collections of the Museum of Fine Arts. Among the works on view will be fine Italian, Dutch, French, and English pictures by Botticelli, Giuliano Bugiardini (p. xi), Bartolomeo Veneto, Scarsellino, Bartolomeo Cavarozzi (p. xi), Jan van Goyen, Jacob van Ruisdael, Johannes Lingelbach, Jan Steen, Aert de Gelder, Nicolas Lancret, Nicolas de Largillière (p. xi), François Boucher, Jean-Siméon Chardin, Jean-Baptiste Greuze, Jean-Baptist Le Prince, George Morland, Thomas Gainsborough, Sir Joshua Reynolds, Richard Wilson, and Joseph Wright of Derby (above).

THE SAMUEL H. KRESS
COLLECTION

The third great addition to the museum's European paintings was part of what *Life* magazine in 1953 called "The Great Kress Giveaway": the gift by Samuel H. Kress of nearly

3,000 European works of art to museums and academic institutions across America.[15] When Kress died in 1955, he had assembled the nation's premier collection of European art from the thirteenth century to the nineteenth century—in round numbers, almost 3,000 objects, including more than 1,400 Old Master paintings, 150 works of Italian and French sculpture, 1,300 Italian bronzes, and a wealth of frames, furniture, tapestries, and decorative arts. From his origins, however, one would scarcely have predicted that he would become one of the greatest art collectors of this century.

Kress was born in Pennsylvania in 1863 in the middle of the Civil War—he was named for an uncle recently slain at Gettysburg—and from the age of seventeen he taught in a one-room schoolhouse for $25 a month. At twenty-four he bought a small stationery and notions shop with his savings; three years later he acquired a wholesaler. In 1896 he opened the first S. H. Kress & Co. Five-and-Ten-Cent store in Memphis, and it became an instant success, selling quality merchandise at low prices by eliminating the middleman and by largely concentrating in the South. By 1900 there were Kress stores in a dozen cities, and by 1907, when Kress opened in New York, sales totaled over $3 million. Eventually the chain expanded to 264 stores throughout the South and West, and by early in the century Kress had become one of the nation's wealthiest men.

In the 1920s Kress lived in an apartment done up as an Italian palazzo on Fifth Ave-

nue, across from the Metropolitan Museum of Art, and began to fill it with oil paintings, sculpture, and furniture. According to *Life* magazine, Kress began collecting at the suggestion of his friend Delora Kilvert, the cultured and beautiful ex-wife of an American illustrator. Then in his mid-sixties, Kress visited European spas and specialists for health reasons and was exposed for the first time to European architecture, paintings, and sculpture. With the help of a Florentine art dealer, Alessandro Contini-Bonacossi, Kress in 1928 began buying Italian Renaissance works from the thirteenth to sixteenth centuries. Contini conceived the ambitious, improbable project of acquiring a fine work by every known Italian master, and Kress bought almost exclusively from Contini from 1927 to 1936, paying incredible sums of money for his pictures, from tens of thousands to hundreds of thousands of dollars—at a time when a lunch cost 25 cents, a good hotel room $5, and a round-trip voyage to Europe $200. By 1935 he had already invested the rough equivalent of $60 million in today's money in his collection; in the next two years he more than doubled that outlay.

In 1929 Kress formed the Samuel H. Kress Foundation "to promote the moral, physical and mental well-being and progress of the human race." He began to distribute works from his collection to civic museums, art associations, and educational institutions in cities with Kress stores, especially in the South and West. One must remember that the appreciation of Italian art was remote for most Americans in the 1930s and that outside of cities like Boston, New York, Philadelphia, and Chicago, art museums hardly existed. In 1932 Samuel H. Kress organized a traveling exhibition of more than fifty Old Masters from his collection, from fourteenth-century Sienese painting to eighteenth-century Venetian, which became a major cultural event in the history of the twenty-four cities it visited, from Atlanta to Portland, Oregon. Shown in Houston for three weeks in 1933 during the height of the Depression, the exhibition provided a remarkable opportunity to see five centuries of Italian painting, and the population of the city responded with unprecedented enthusiasm.

One of the distinguishing features of the Kress collection as a whole is the variety, number, and quality of its Italian Baroque paintings. It is easy to forget in what low regard such works once were held in the United States. Virtually none of the great American collectors—Bache, Frick, Huntington, Mellon, Morgan, Rockefeller, Widener—thought Italian seventeenth- and eighteenth-century pictures to be of any significance, and what few they did purchase were restricted to the occasional sketch by Tiepolo or view by Canaletto or Guardi. Thus, when Samuel H. Kress bought the museum's *Rest on the Flight into Egypt* by Tanzio da Varallo he was truly swimming against the tides of taste. The prejudice in America against the art of the Catholic Counter Reformation, deeply rooted in aesthetic, social, and religious traditions, was not overturned until relatively recently, in the 1950s and 1960s. Many of the museum's best Italian paintings from the sixteenth through the eighteenth centuries came from the Kress collection.

In 1949 the Kress Foundation made a decision to place the main emphasis on the Kress Collection in the National Gallery of Art, which would become "the most comprehensive and complete demonstration of Italian art, from 1200 to 1800, existing in the world." But for some time it had become evident that the National Gallery in Washington could not or would not remain the repository for the entire collection, and sites in other cities were considered, often in the South and the West where Kress stores provided an appropriate affiliation. The significance of this program—and its effect upon the recipient museums and cities like the Museum of Fine Arts and Houston—has never been sufficiently appreciated. The promise of a donation to the local institutions galvanized them in every respect: it altered local thinking about space, staff, climate control, educational programs, fund-raising, and long-term community support.

In October 1953 the Kress Foundation placed thirty-six paintings on long-term loan at the Museum of Fine Arts, a large portion of which were donated to the museum in 1961.[16] Today there are twenty-six Kress paintings in the permanent collection, several of which are among the museum's finest works: Sebastiano del Piombo's portrait of *Anton Francesco degli Albizzi*, Vincenzo Catena's *Virgin and Child with Saints John the Baptist*

15. For the Samuel H. Kress Collection, see Ishikawa 1994, notably the introductory essays by Marilyn Perry and Edgar Peters Bowron, from which this account is derived.

16. William E. Suida, *The Samuel H. Kress Collection at the Museum of Fine Arts, Houston* (Houston: Museum of Fine Arts, 1953).

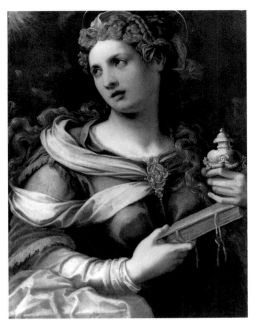

Michele Tosini (Italian [Florentine], 1503–1577), *Saint Mary Magdalene,* 1560s. Oil on wood, 34 1/4 x 25 13/16 in. (87 x 65.7 cm). The Samuel H. Kress Collection. This is one of the few Italian Mannerist paintings in the museum's European paintings collection.

THE ERA OF ENDOWMENT FUNDS
AND THE ACQUISITION OF
INDIVIDUAL PICTURES

The addition of the Straus, Blaffer, and Kress collections created an urgent need for expansion of the museum's exhibition space. In 1958 a seven-thousand-square-foot gallery, known as Cullinan Hall, was opened. Designed by the German architect Ludwig Mies van der Rohe (1886–1969), once director of the Bauhaus and a leading figure in the development of modern architecture, the addition (followed by another expansion designed by Mies in 1974) symbolized the emergence of the Museum of Fine Arts in Houston's cultural life and its increasing importance as a home for works of art from all periods and in all media. During the first thirty years of the museum's existence, for example, the collections numbered about four thousand works of art, including the European paintings in the Straus, Kress, and Blaffer collections. Thirty-five years later, around 1990, the number of objects in the collection totaled more than twenty thousand. The era of gifts of entire collections was almost over, but with increased funds for acquisitions, the museum began to focus on individual works of great quality to enhance its collection of European paintings.

*and Joseph,* Bernardino Luini's *Lamentation over the Dead Christ,* Orazio Gentileschi's *Portrait of a Young Woman as a Sibyl,* Juan van der Hamen's *Still Life with Fruit and Glassware,* Cristoforo Munari's *Still Life with Musical Instruments,* Giovanni Paolo Panini's *Fantasy View with the Pantheon and Other Monuments of Ancient Rome,* and Pompeo Batoni's portrait of *William Fermor.* The Kress Collection also brought to Houston one of the museum's few Mannerist paintings: a half-length devotional image of the Magdalen by Michele Tosini (left) derived from Michelangelo's drawings known as the "divine heads." The Florentine painter's beautiful drawing, soft shading, and sharp palette led art historians to believe for a long time that the painting was the work of his contemporary, the Italian writer and painter Giorgio Vasari.[17]

During his short tenure as director of the museum from 1969 to 1974, Philippe de Montebello invigorated the European paintings collection with a number of significant acquisitions, notably French seventeenth-century paintings and Baroque oil sketches, and rehung the permanent collection of European art in a logical art-historical flow and sequence. Montebello also stirred interest in the European paintings with expanded educational programs, exhibitions, and the initiation of a publications program that included articles on recent acquisitions. In 1970 the museum used a bequest from the estate of Laurence H. Favrot to strengthen its collections of classical, medieval, and Baroque art. The lack of endowment funds had plagued the museum since its inception and prohibited a methodical development of the museum's permanent collection of European art. Few serious acquisitions had been made in those areas since 1957, when Raymond and

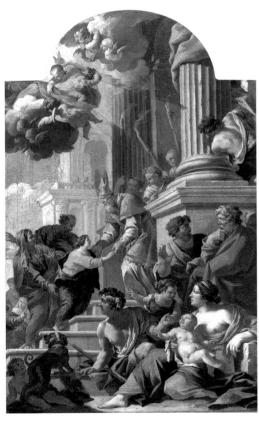

Nicolas Chaperon (French, 1612–1656), *The Presentation of the Virgin in the Temple,* 1639. Oil on canvas, 23 1/4 x 17 5/16 in. (59.1 and 44.1 cm). Museum purchase with funds provided by the Laurence H. Favrot Bequest. A preliminary oil sketch for an altarpiece in the church of Saint Nicolas, Compiègne, this is one of several French seventeenth-century paintings acquired in the early 1970s.

17. Wilson 1996, 266–74, no. 25.

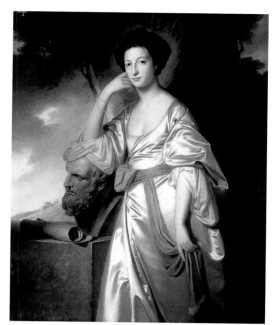

George Romney (English, 1734–1802), *Portrait of a Lady,* 1760s. Oil on canvas, 49 1/2 x 40 1/2 in. (125.7 x 102.9 cm). The Rienzi Collection, gift of Mr. and Mrs. Harris Masterson III. This is an early portrait by the most successful English portraitist of the day, apart from Reynolds and Gainsborough.

Esther Goodrich contributed William Claesz. Heda's splendid large still life, *Banquet Piece with Ham,* to the museum. Among the European paintings acquired from the Favrot funds were Mattia Preti's *Martyrdom of Saint Paul,* a masterpiece of Neapolitan Baroque painting from the late 1650s, and several French paintings from the seventeenth through the nineteenth centuries by Nicolas Chaperon (p. xiv), Nicolas Bertin, Jean-Simon Berthélemy, and Gustave Doré.[18]

In 1970 the museum's first endowment fund for the purchase of works of art was established in honor of Agnes Cullen Arnold, and a series of major works of European painting were acquired for the permanent collection. The first purchase supported by the Arnold fund was Philippe de Champaigne's *Penitent Magdalen* in 1970. During the past thirty years a number of important European paintings have been acquired from the Arnold fund, including Scarsellino's *Virgin and Child with Saints,* Claude's *Landscape with a Rock Arch and River,* Luca Giordano's *Allegory of Prudence,* Théodore Chassériau's *Woman and Little Girl of Constantine with a Gazelle,* Théodore Rousseau's *Great Oaks of Old Bas-Bréau,* Corot's *Orpheus Leading Eurydice from the Underworld,* and Matisse's *Olga Merson.*

Another important source of acquisition funds for European paintings has been the families of Herman (1892–1962) and George (1898–1983) Brown, who owned and operated Brown & Root, a heavy-construction company founded early in this century. The two brothers and their wives were active in the museum as trustees and donors, and the creation of the Brown Foundation in 1951 has made important acquisitions possible in a number of fields. When George Brown died in 1983, his wife, Alice, and her children purchased for the collection in his memory Chardin's *The Good Education.* The Brown family also established the Alice Pratt Brown Museum Fund, an endowment for accessions intended to bring important works of art to the museum. The notable Goya *Still Life with Golden Bream* was a museum purchase made possible by this endowment, and recently it made possible the acquisition of a memorable *Still Life of Flowers and Fruit* by the Dutch painter Jan van Huysum.

Beginning around 1970, the European

paintings collection was enriched with several gifts from the Houston collectors Harris Masterson III and his wife, Carroll Sterling Masterson, such as Angelica Kauffman's *Ariadne Abandoned by Theseus.* The Mastersons began collecting English paintings and ceramics in the 1940s, and as early as 1956 Mr. Masterson told the *Houston Post* that he was "hoping someday to have a really fine collection" to leave to the Museum of Fine Arts. Upon Harris Masterson's death in 1997, the museum received the couple's home, Rienzi, designed in the early 1950s by John F. Staub, the prominent local architect responsible for a number of important Houston houses. In 1999 Rienzi opened as the European decorative arts center of the Museum of Fine Arts, featuring the Mastersons' collection of Worcester porcelain and English eighteenth-century furniture.[19] Although intended primarily as a house museum focusing on the decorative arts, Rienzi contains a collection of some fifty European paintings, mostly English pictures of the eighteenth and early nineteenth centuries, that includes a few Italian and Spanish works of distinction such as Guido Reni's *Saint Joseph and the Christ Child,* 1638–40.

## THE JOHN A. AND AUDREY JONES BECK COLLECTION

In January 1974 the Museum of Fine Arts greatly strengthened its European paintings collections—and vastly increased its attractiveness for the average museum visitor— when the John A. and Audrey Jones Beck Collection of nineteenth- and early-twentieth-century paintings was placed on view. Audrey Beck, a granddaughter of Jesse Jones, had conceived the Beck collection many years before to demonstrate the artistic vitality that centered in Paris from about 1870. Like Sarah Campbell Blaffer before her, Audrey Beck became enthralled with art when she visited France, Italy, Switzerland, and England as a schoolgirl.

In 1942 Audrey Jones married John A. Beck (1916–1973), and the couple began buying art in Paris. John Beck was active in Houston in the heavy industrial equipment business and served on the museum's board

18. The finest of the museum's paintings acquired through 1980 were published in Museum of Fine Arts 1981.

19. "Rienzi," *MFAH Today,* March/April 1999, 4–11.

of trustees for a number of years. Although the Becks began visiting the art market in Paris in the 1940s, it was not until the 1960s that their buying intensified and the collection began to assume its definitive shape. On the advice of dealers and experts like Philippe Brame, Alex Maguy, Paul Pétridès, and Philip Reichenbach in Paris; David Bathhurst, Martin Summers, and Dudley Tooth in London; William Acquavella and Howard Young in New York; and Marianne Feilchenfeldt in Zurich, the Becks acquired most of their finest pictures between 1960 and 1970. With an eye toward painters in the vanguard of the movements of Impressionism, Pointillism, Fauvism, and early modernism, the result is a splendid assemblage that abounds in such extraordinary individual paintings as Honoré Daumier's *A Meeting of Lawyers,* Jean-Baptiste-Armand Guillaumin's *Seine in Paris,* Gustave Caillebotte's *Orange Trees,* Mary Cassatt's *Susan Comforting the Baby,* Vincent van Gogh's *Rocks,* Paul Signac's *Bonaventure Pine,* André Derain's *Turning Road, L'Estaque,* Georges Braque's *Fishing Boats,* Vassily Kandinsky's *Sketch 160A,* Pierre Bonnard's *Dressing Table and Mirror.*[20]

The Beck Collection was never intended to remain a fly in amber, however, and Audrey Beck has in recent years enhanced the collection with such paintings as Edouard Manet's *Toilers of the Sea,* Claude-Emile Schuffenecker's *Portrait of Emile Bernard* and František Kupka's *Yellow Scale.* The collection has remained on view in the museum as a long-term loan since 1974, and for many visitors it has provided their first experience of seeing an original Impressionist painting. Audrey Beck has given various paintings to the Museum of Fine Arts from time to time, and in 1998 she generously donated the remaining forty-seven paintings in the collection. Recognizing Mrs. Beck's extraordinary generosity and lifelong participation as patron and trustee of the museum, the board of trustees named the new museum building in her honor.

Like many American museums in recent years, the Museum of Fine Arts has embarked upon a major effort to expand and refurbish its physical facilities. At the center of this expansion program is a 200,000-square-foot building that will provide for new installations of the museum's collections of American and European art and a variety of expanded education services for its visitors. Designed by the Spanish architect Rafael Moneo, winner of the 1996 Pritzker Prize, the Audrey Jones Beck Building was built adjacent to the museum's original buildings. Noteworthy features of the new limestone and glass building include a vast sweep of exhibition galleries, a lighting system incorporating the dramatic use of natural light, expanded education facilities, a full-service restaurant, updated visitor information services, and a covered driveway entrance.

The Beck Building will become the central repository for the museum's collections of art from antiquity to the early twentieth century. The new construction will add more than 100,000 square feet of exhibition space, more than doubling present capacity and elevating the rank of the Museum of Fine Arts to sixth among the nation's art museums in terms of footage available for the display of art. The entire top floor will be given over to European painting and sculpture, including the

Gustave Caillebotte (French, 1848–1894), *Mademoiselle Boissière Knitting,* 1877. Oil on canvas, 25 5/8 x 31 1/2 in. (65.1 x 80 cm). Gift of Audrey Jones Beck. This domestic scene of family life is one of forty-seven paintings added by Audrey Jones Beck in 1998 to the Beck Collection of nineteenth- and early-twentieth-century art.

20. *The Collection of John A. and Audrey Jones Beck,* compiled by Audrey Jones Beck (Houston: Museum of Fine Arts, 1998).

Beck Collection and the Sarah Campbell Blaffer Foundation Collection, and for the first time in many years the public will be able to see the museum's holdings in these areas in their entirety.

The opening of the Beck Building on 25 March 2000 will at last permit the museum's growing collections to be shown in their entirety. During the past seventy-five years these collections have grown to nearly forty thousand works—the largest "encyclopedic" art collection in the Southwest. In recent years very few of the museum's greatest possessions have been shown to its more than 1,000,000 annual visitors, and each time the museum hosts a major loan exhibition even more of the permanent collection must be removed temporarily to storage—a problem that will be alleviated in the new building with the creation of galleries designed specifically for loan exhibitions.

The inauguration of the Beck Building will be the capstone of a long-range program under the direction of Peter C. Marzio, director, and the board of trustees to bring the Museum of Fine Arts to the fore of American art museums. The museum's fortunes have mirrored the legendary boom-and-bust cycles of Houston itself during the past seventy-five years. But what has been constant is the extraordinary generosity of Houstonians on behalf of the museum, and its recent phenomenal growth underscores their belief in the importance of art and art museums for the local community.

The institution has been fortunate, too, to have benefited from strong professional leadership and directors with pronounced talents and personalities. Peter Marzio's eighteen-year tenure has brought about a marked increase in the museum's endowment, from $26 million to nearly $500 million, and the successful conclusion of a $120 million campaign that is believed to be the largest ever for a museum expansion outside of New York City.

In the end, what distinguishes a museum, of course, is neither its endowment nor its facilities nor the enthusiasm of its supporters, but the quality, beauty, and significance of its holdings. When the European paintings are at last unveiled in the Beck Building, the Museum of Fine Arts, Houston, will deliver more than a few surprises for those who believe they know its collections.

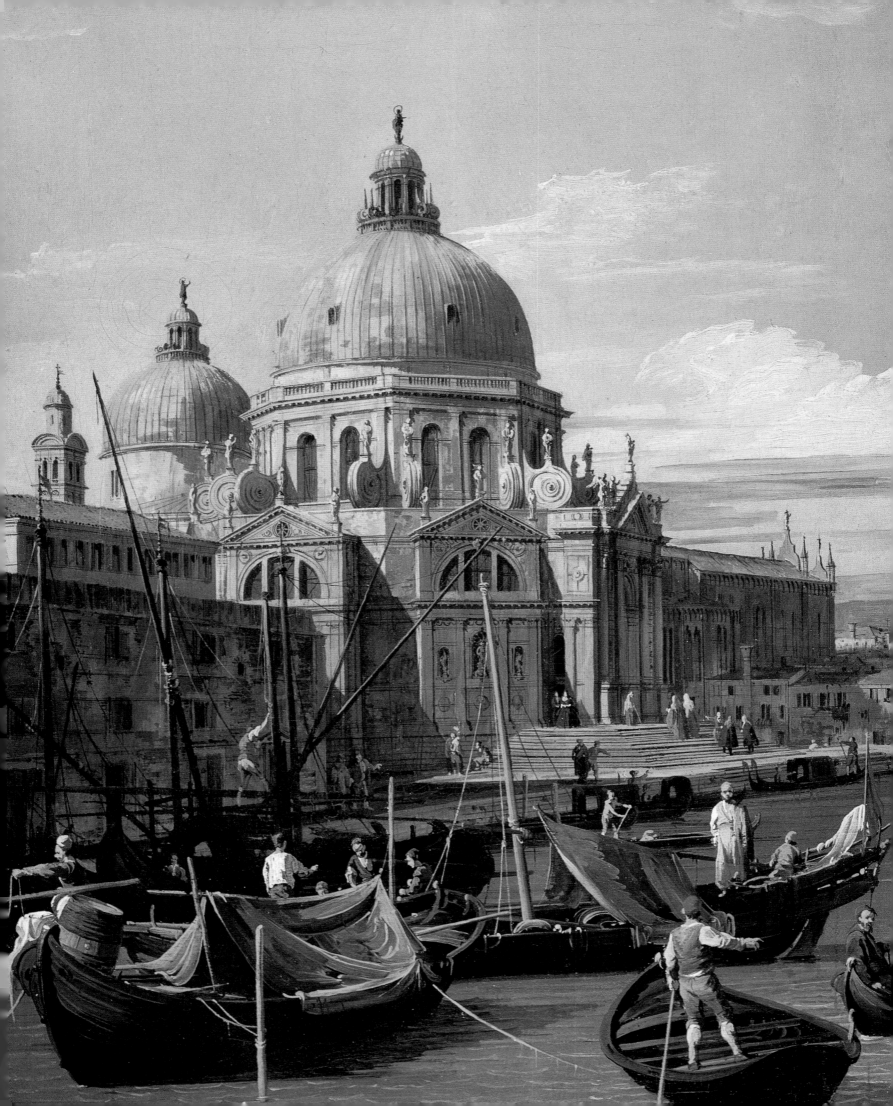

# MASTERWORKS
## of European Painting

## Master of the Sienese Straus Madonna

Italian (Sienese), active c. 1340–60

*Virgin and Child,* c. 1340–50

Tempera and gold leaf on wood, 32 x 17 3/4 in.
(81.3 x 45.1 cm)
The Edith A. and Percy S. Straus Collection
44.564

Master of the Sienese Straus Madonna is
the pseudonym given to an unknown
artist active in Siena toward the middle of the
fourteenth century. In spite of his anonymity,
the painter was recognized in the early 1930s
as a follower of the great Sienese painter
Simone Martini (c. 1285–1344). He shares the
main features of Simone's style, especially his
decorative use of outline, color, and pattern-
ing. In spite of his distinctive manner, how-
ever, there remains considerable controversy
among scholars about which altarpieces,
private devotional images, and other works
he painted. Numerous efforts to identify
his works with those of specific individual
painters known from documents have proved
inconclusive.[1]

The Sienese Straus Madonna is an excep-
tionally fine and unusually well preserved
example of late Gothic Italian painting. The
image of the Virgin and Child probably func-
tioned originally as the central component of
a large altarpiece. The panel is likely to have
been flanked on either side by two or three
images of saints, also shown to three-quarter
length but in separate compartments of
somewhat lesser height and width. On the
basis of style, proportions, and format, two
panels with images of saints are thought to
have belonged to the same altarpiece as the
museum's *Virgin and Child:* a *Saint Agnes* in
the Worcester Art Museum and a *Saint John
the Evangelist* in the Yale University Art
Gallery. The basic configuration of Sienese
altarpieces at the time often included an
upper tier of images, and thus a third panel
associated with this hypothetical ensemble is
a triangular half-length figure of a bishop
saint, now in the Museum of Fine Arts,
Boston. This would have served as a pinnacle
over such an upper register.[2]

The motif of the Christ Child holding a
goldfinch occurs frequently in central Italian
images of the Virgin from the fourteenth
through the sixteenth centuries and has long
been assumed to symbolize the suffering and
death of Christ on the Cross. According to
legend, the goldfinch acquired its red spot at

the moment when it flew down over the head
of Christ on the road to Calvary and drew a
thorn from his brow, splashing itself with a
drop of his blood.[3] Sometimes the Child is
seen recoiling from the goldfinch; in other
images the bird is shown pecking at the
Child's finger and thus shedding his blood.
The museum's painting presents a variation
of this iconography in which the Christ
Child offers his finger to the goldfinch, an
allusion to the Eucharistic sacrifice.[4]

The excellent state of preservation of the
painting provides an unusual opportunity to
examine the technique of tempera painting as
it was commonly practiced in the late Middle
Ages and early Renaissance. Our understand-
ing of the materials and methods used by the
artists is enhanced by consulting *Il Libro
dell'arte* (The Craftsman's Handbook), by the
Florentine painter and writer Cennino Cen-
nini (c. 1370–c. 1440).[5] Written around 1390,
this remarkable text is the most important
written source concerning artistic practice in
the late Middle Ages. Cennino's master was
Agnolo Gaddi (active c. 1369–96), who
learned from his father Taddeo Gaddi (active
mid-1320s–1366), who in turn was a pupil of
Giotto (1267/75–1337), so *The Craftsman's
Handbook* describes the technique of tempera
painting as it was practiced in Tuscany in the
fourteenth and early fifteenth centuries.[6]

The usual support for a tempera painting
is a panel composed of several pieces of
poplar wood prepared in accordance with
Cennino's description. A thin linen cloth
drenched in size, or glue, is pasted on the
front of the panel; its function is to prevent
cracking and to form a strong base for the
application of gesso, or plaster of Paris.
"Scraped smooth like ivory," the gesso layer
becomes the ground upon which the gold
and paint are applied.[7] The artist then draws
on the gesso surface with a piece of charcoal
and scratches with a needle the outlines of
the figures where they are to meet the gold
background. Incised contours between the
painted area and the gold background are
quite evident in the museum's painting, but

1. For a discussion and complete bibliography, see Wilson
   1996, 24–37. The anonymous painter is designated as
   Sienese to avoid confusion with a later, Florentine
   painter in the Museum of Fine Arts, Houston, known in
   the literature as the Master of the Straus Madonna.
2. Ibid., 29–32, figs. 1.10–12.
3. See Friedmann 1946, and Wilson 1996, 26, 29, 35, with
   additional references.
4. Wilson 1996, 26.
5. Cennini [c. 1390] 1954, 75–76.
6. For the technique of early Italian paintings, see Monte-
   bello 1966, Bomford 1990, and Dunkerton 1991.
7. Cennini [c. 1390] 1954.

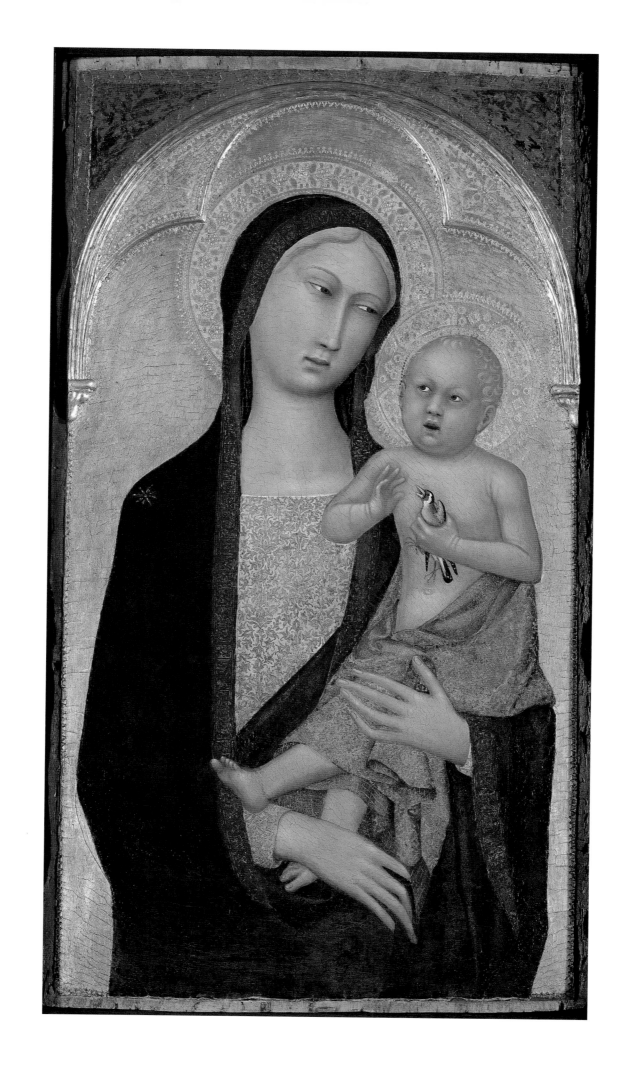

8. Ibid., 92.
9. Ibid., 93.
10. Ibid., 94.

the artist did not strictly adhere to them; for example, he altered the placement of the Virgin's proper right elbow, leaving a clear incised outline visible at the left of the sleeve.

The areas to be gilded are covered with Armenian bole (gilder's red clay) mixed with egg white and water. In various passages above the Virgin's head, where the gilding has worn thin, the red bole is seen quite clearly. Gilding, Cennino explains, should be finished before the application of color; the slight overlap of pigment defining the hair of the Christ Child onto the gold background shows that the artist did indeed paint after gilding. The decoration of the halos of the Virgin and Child was imprinted into the gilded gesso with a punch, a roughly cylindrical metal tool with a decorative motif cut into one end. Another technique shown to beautiful effect in the Virgin's gold-and-cream-colored robe and in the orange brocade cloth swaddling the Child is *sgraffito*, a method of decoration in which paint is applied over gold leaf and then scraped away to reveal the gold beneath, or in which a design is created by incising or cutting lines through one layer of plaster or stucco to reveal the contrasting color of an underlayer.

Tempera painting differs from oil painting in that egg yolk, rather than oil, is used as a medium. The pigments are mixed in water with the yolk, and the result is an extremely resistant and durable paint that lends itself to the use of pure and brilliant colors. Because of its fast-drying properties and poor blending qualities, smooth gradations are difficult to achieve; the paint must be laid on as thinly as possible, layer upon layer, in numerous small strokes applied side by side. Great care must be exercised in the practice of this technique, and its basic rules must be adhered to strictly.

The colors must be ground in advance, advises Cennino, each in a separate dish. Basically, three tones are required: a dark tone, usually the pure local color; a medium tone, consisting of the local color with white

added; and a light tone, with still more white. The quick-drying properties of tempera do not allow for the smooth blending of the colors, and Cennino provides precise instructions for applying the separate application of the dark, middle, and light tones, "laying them in afresh and blending them skillfully, softening delicately."[8] Cennino recommends painting the draperies and accessories before filling in the flesh areas, and in a few places, notably in the face of the Virgin, a bit of the flesh tone spills over onto the drapery.

The faces of the Virgin and Child were painted according to Cennino's instructions: "Take a little terre-verte [a green earth pigment commonly used as the underpaint for flesh in tempera painting on panel] and a little white lead, well tempered; and lay two coats all over the face, over the hands, over the feet, and over the nudes."[9] Then,

*make three values of flesh color [using vermilion and lead white], each lighter than the other; laying each flesh color in its place on the areas of the face; still do not work up so close to the verdaccio shadows as to cover them entirely; but work them out with the darkest flesh color, fusing and softening them like a puff of smoke . . . and have the green which lies under the flesh colors, always show through a little. When you have got your flesh colors down so that the face is about right, make a flesh color a little bit lighter, and pick out the forms of the face, making it gradually lighter, in a careful way, until you finally come to touch in with pure white lead any little relief more pronounced than the rest, such as there would be over the eyebrow, or on the tip of the nose. Then outline the upper edge of the eyes with an outline of black, with a few lashes as the eye requires, and the nostrils of the nose. Then take a little dark sinoper [a red ocher earth pigment] and a trace of black; and outline all the accents of the nose, eyes, brows, the hair, hands, feet, and everything in general, . . . always using that yolk-of-egg tempera.*[10]

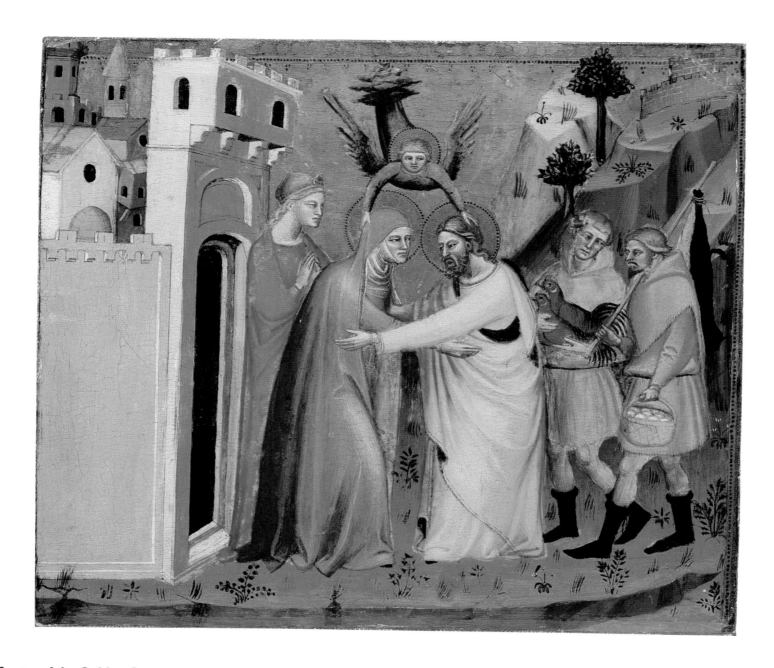

## Master of the Golden Gate

Italian (Florentine), active second half of the 14th century

*The Meeting of Joachim and Anna at the Golden Gate,* c. 1370–90

Tempera and gold leaf on wood, 11 7/8 x 13 11/16 in. (30.2 x 34.8 cm)
The Edith A. and Percy S. Straus Collection
44.561

1. For a discussion and complete bibliography, see Wilson 1996, 91–100.

The designation "Master of" is a term used by art historians to label the author of anonymous works for convenience in discussing them. The use of invented names began in Germany in the nineteenth century for the description of early Netherlandish paintings. The choice of names was often quite imaginative, although today anonymous masters are usually named after a particular picture or the collection to which it belongs. The name Master of the Golden Gate was applied to the author of the museum's painting by an authority on early

Italian paintings, Richard Offner, to distinguish the works of an unknown Florentine painter active during the middle of the second half of the fourteenth century.[1]

The style of the Master of the Golden Gate reveals close contact with the workshop of the leading master in Florence at the time, Orcagna (Andrea di Cione; died 1368/69), and his younger brother, Jacopo di Cione (active 1365–98). On the basis of shared formal elements, Offner designated several other small panels as the work of this unknown painter, notably a *Nativity with Shepherds,*

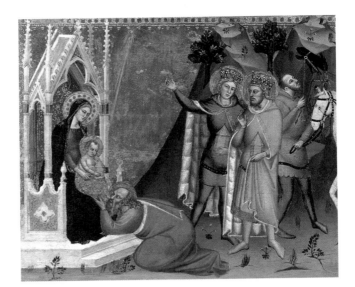

Master of the Golden Gate, *The Adoration of the Magi,* c. 1340–50. Tempera and gold leaf on wood, 12 x 14 in. (30.5 x 35.6 cm). Fogg Art Museum, Harvard University Art Museums, Cambridge, Massachusetts (© President and Fellows of Harvard College)

formerly in the Western European Museum in Kiev and now untraced, and an *Adoration of the Magi,* in the Fogg Art Museum (above).[2] The panels are stylistically compatible. They share the same punching motifs in the gilded surfaces along the border and in the halos and a similar distinct palette of bright colors. Thus they appear to have been executed by the same painter.

The three panels almost certainly made up a *predella* (a painting or series of small, narrative paintings running horizontally beneath the main panels of an altarpiece) devoted to the life of the Virgin. Mary's life was popularized during the Middle Ages through the *Golden Legend* (c. 1260),[3] a compilation of the lives of the saints, legends of the Virgin, and other narratives relating to the Church's feast days gathered by Jacobus de Voragine (c. 1230–1298), a Dominican friar who in 1292 became archbishop of Genoa. The influence of the book on Christian iconography and its representation in art in the late Middle Ages and Renaissance was enormous.

In the *Golden Legend,* the parents of the Virgin Mary, Joachim and Anne, although righteous and "without reproach in all the commandments of the Lord," remained without child after twenty years of marriage. When Joachim went to the Temple of Jerusalem on a feast day, his offering was refused and he was turned away by the high priest because he was without descendants. The absence of children was considered to be a sign of a divine curse. Rejected and ashamed, Joachim took refuge with his shepherds in the desert, where an angel appeared to him and announced that Anne would conceive, and that the child would be the mother of Jesus. As a sign, Joachim was to go to the Golden Gate at Jerusalem where he would join his wife. The elderly couple met at the appointed place and embraced joyfully, and from that moment Anne was with child.[4]

The episode was frequently represented in fourteenth-century painting, appearing in life cycles of the Virgin. The meeting at the Golden Gate was intended to reinforce the Franciscan doctrine that Anne, like Mary herself, conceived her child immaculately. Before the emergence of the theme of the Immaculate Conception in art, the embrace of Joachim and Anne was used to symbolize the moment of conception. Thus the angel Gabriel hovers above the couple and touches their heads to focus attention on the elderly pair and to underscore the miraculous and redemptive nature of the event.

In the scene depicted here, Anne appears just outside the gate of a walled city and is accompanied by a youthful attendant. Joachim is escorted by rustic figures who, although presumably shepherds, carry instead of sheep, a pair of fowls and a basket of eggs. These items have been interpreted as symbols of fertility on the basis of the account of Joachim and Anne in the apocryphal New Testament literature. According to these accounts, Anne was sitting in her garden under a laurel tree lamenting her barrenness, when she saw a nest of sparrows in the tree and cried, "Woe unto me, unto what am I likened? I am not likened unto the fowls of the heaven, for even the fowls of the heaven are fruitful before thee, O Lord."[5]

2. Ibid., 93, fig. 7.5.
3. Jacobus de Voragine [c. 1260] 1993, 2:152–53.
4. Hall 1979, 170–71.
5. Wilson 1996, 97, 100 n. 30.

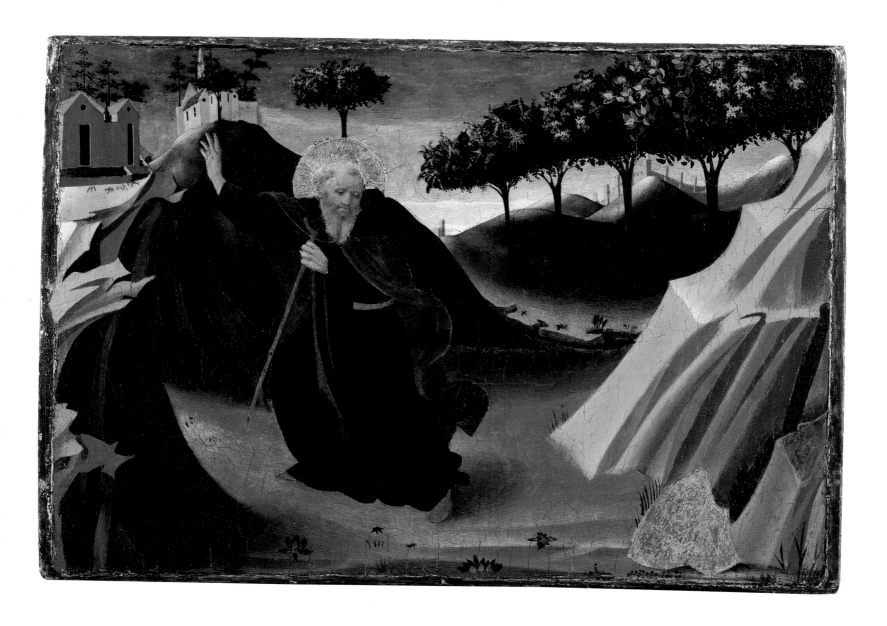

## Fra Angelico

Italian (Florentine), c. 1395–1455

### Saint Anthony Shunning the Mass of Gold, c. 1435–40

Tempera and gold leaf on wood, 7 3/4 x 11 1/16 in.
(19.7 x 28 cm)
The Edith A. and Percy S. Straus Collection
44.550

1. The literature on Fra Angelico is vast; for an excellent, brief introduction, see Hood 1996, and the references in Wilson 1996, 142 n. 1.

One of the dominant figures of the early Renaissance in Florence, Fra Angelico created paintings that are among the most loved of all time. He seems to have already been established as a painter and manuscript illuminator when, at some date between 1417 and 1425, he entered the reformed, or Observant, Dominican convent at Fiesole near Florence and began a course of training as a monk. Although his baptismal name was Guido di Pietro, he took the name Fra Giovanni. The name Angelico is first recorded in 1469, and later he was known as Beato Angelico, meaning the "Blessed Angelico."

Devoted largely to the creation of altarpieces and other works of art for Dominican churches, Fra Angelico's career was remarkably productive. By the early 1430s he was operating the largest and most prestigious workshop in Florence. His paintings are remarkable for their naturalism, color, luminosity, and control of perspective, and his great achievement was his ability to translate this style from manuscript illuminations and small panel paintings to a monumental scale.[1]

Fra Angelico's most famous works are the more than fifty frescoes that he and his assistants produced c. 1440–45 as aids to devotion

2. For a discussion and complete bibliography, see Wilson 1995b, and Wilson 1996, 128–45.

3. The *Life of Anthony* became a classic and was widely diffused throughout Christendom. For an English translation, see Gregg 1980.

4. Wilson 1996, 132, quoting Gregg 1980, 40.

5. Offner 1945, 22–23.

6. Wilson 1996, 136.

7. Ibid., 137.

8. Ibid., 138–41, figs. 10.5, 10.10; Wilson 1995b.

in the common rooms, corridors, and individual cells in the Dominican convent of San Marco, Florence. These comprise the largest group of related works to survive almost intact from the workshop of a single Renaissance painter. For the church of San Marco itself he painted a magnificent high altarpiece—a landmark of Medici patronage and of fifteenth-century art—showing the Virgin and Child enthroned and accompanied by angels and saints in a unified composition. This work is now in the Museo di San Marco, Florence, together with many of Fra Angelico's most important paintings, in what amounts to a museum devoted to his art. In 1446 he was called to Rome by Pope Eugenius IV, and his last major commissions were monumental fresco cycles in Saint Peter's basilica and the Vatican Palace.

The museum's panel illustrates an episode in the life of the Christian saint and hermit Anthony Abbot (also Anthony the Great, c. 251–356),[2] generally regarded as the founder of monasticism. On the death of his parents he distributed his property among the poor and withdrew into the Egyptian desert where he remained in solitude for many years. The cult of Saint Anthony, which in the Middle Ages was strongly associated with the healing of disease, was of widespread and enduring importance. The scene of the saint shunning a mass of gold is derived from the biography compiled by his friend Saint Athanasius (c. 296–373), patriarch of Alexandria.[3] Anthony, like other hermits, was subject to vivid hallucinations resulting from his ascetic life in the desert. He is described as enduring numerous trials of faith orchestrated by Satan, who could not abide his devout conduct. The devil tried to seduce the young man away from his monastic discipline with memories of family and luxury and then with erotic thoughts. Failing to tempt him by these means, Satan assumed the form of a voluptuous woman and later sent demons and savage beasts to torment and threaten the saint. Anthony attempted to escape, but on his journey the devil created in his path an apparition of a large silver dish. Anthony banished this temptation with the knowledge that it was only an illusion, but his tribulations were not over. In the words of Athanasius's *Life of Anthony:*

*And as he continued, he saw next no illusion, but actual gold thrown in his path. It is not clear whether the enemy pointed it out, or whether some more excellent power was training the athlete and demonstrated to the devil that he was not, in fact, concerned about money. This he did not relate, nor do we know the answer—only that what appeared was gold. So Anthony marveled at the amount, but as one stepping over fire he passed it without turning. Indeed he hurried at such a pace that soon the place was hidden to view and unseen. Intensifying more and more his purpose, he hurried toward the mountain. When he discovered beyond the river a deserted fortress, empty so long that reptiles filled it, he went there, and took up residence in it. Then at once the creeping things departed, as if someone were in pursuit.[4]*

In the museum's painting, the gold—often represented in other works as a heap of gold coins—is located near the lower right corner, and the saint is shown dramatically hastening away. Rushing toward the left with his right knee bent and left leg extended, he flings up his right hand in a gesture probably intended to convey alarm as he "turns his back" on worldly wealth. Fra Angelico's conception of the scene shares a number of features in common with other representations by Tuscan painters, though it is marked by a greater degree of spatial sophistication and an intricate interplay of light and shadow. As one scholar remarked, "The scene looks as if the very shadow of embodied evil were sweeping across the crowded space of earth and rock driving the light before it."[5] Fra Angelico, with characteristic narrative liveliness, has made a clear distinction between the foreground, the place of the devil with its jagged and precipitous rock formations, sinister shadows, and gold, and the background, a peaceful refuge of the Lord where the light is even and the slopes gently rounded and fertile.[6]

The buildings on the mountain behind Saint Anthony are intended to suggest the deserted fortress to which, according to Athanasius, he hurried, and the tiny lines scattered on the plateau before the buildings are the fleeing serpents described in the narrative. Thus he goes from the sordid gold and

a darkened, hostile territory in the foreground toward the spiritual retreat and brightly lit sanctuary in the distance. The actual road that Saint Anthony travels is obscured by menacing crags along the left edge of the composition that suggest both his metaphorical journey up the mountain and "the inherent and timeless difficulty of the path that he has chosen for himself."[7]

The scene of Saint Anthony shunning the mass of gold originally formed part of a larger devotional complex designed by Fra Angelico and produced in his studio with the aid of assistants. Precisely what form this work assumed has been the subject of extensive discussion by scholars. Some have linked the painting with a hypothetical *predella;* others have associated it with a standing devotional image of Saint Anthony bordered by narrative scenes from his life.[8] Sparse documentation has made it difficult for art historians to disentangle the contribution of Fra Angelico from that of the various assistants who worked as a team in his workshop. A vast amount of literature has arisen from the detailed analyses of the rock formations, architecture, lighting, and structure of the museum's painting as scholars have sought to determine the function of the work and its place within Fra Angelico's oeuvre.

## Attributed to Rogier van der Weyden
Netherlandish, c. 1399/1400–1464

## *Virgin and Child,* after 1454

Oil on wood, 12 9/16 x 9 in. (31.9 x 22.9 cm)
The Edith A. and Percy S. Straus Collection
44.535

Rogier van der Weyden is generally considered the greatest Netherlandish artist of the fifteenth century, along with Jan van Eyck (active by 1422, died 1441). In the artist's lifetime his paintings were sent all over Europe, and he attained considerable contemporary celebrity in Italy as well as north of the Alps. The dramatic power and emotional intensity of his paintings had an overwhelming influence in particular on Netherlandish and German art during the second half of the fifteenth century. Although art historians have constructed a large, relatively well defined body of work by van der Weyden, there is little documented knowledge about his career, and there are no signed or dated works by the artist. Van der Weyden's early life and career remain problematic, but it is known that by 1435 he was living in Brussels and the following year was appointed official painter for the city. His commissions from the city included secular works, but all his surviving paintings are either religious pictures or portraits. He seems to have had a large workshop with numerous assistants and pupils, and many of his compositions recur in several versions.[1]

Three surviving paintings may be considered securely authenticated works by Rogier van der Weyden: the Miraflores Triptych, representing scenes from the *Life of the Virgin,* c. 1435 (Gemäldegalerie, Berlin); the *Descent from the Cross,* c. 1442 (Museo del Prado, Madrid); and the culmination of the artist's achievement, *Christ on the Cross with the Virgin and Saint John,* c. 1455–56 (Monastery of the Escorial, Madrid). These paintings show van der Weyden to have been a superb draftsman and designer, much concerned with the emotional impact of his work. He possessed an extraordinary ability to create an illusion of spatial depth, and his painterly skill enabled him to achieve a miraculous impression of infinite detail. He conveyed the emotional reaction of his figures with startling realism and created memorable images of immense dramatic power. In his later years van der Weyden seems to have become so successful a portraitist that his religious commissions were largely delegated to assistants.[2]

The exquisitely tender representation of the embracing Virgin and Child in the museum's Straus Collection evokes van der Weyden's superlative drawing skills, his feel for design, and his unrivaled handling of oil paint. The motif of the Infant turning toward Mary and pressing his cheek to hers is loosely based on a fourteenth-century Italian por-

1. For a summary of the artist's life and career with extensive bibliography, see Campbell 1996.
2. Ibid., 122.

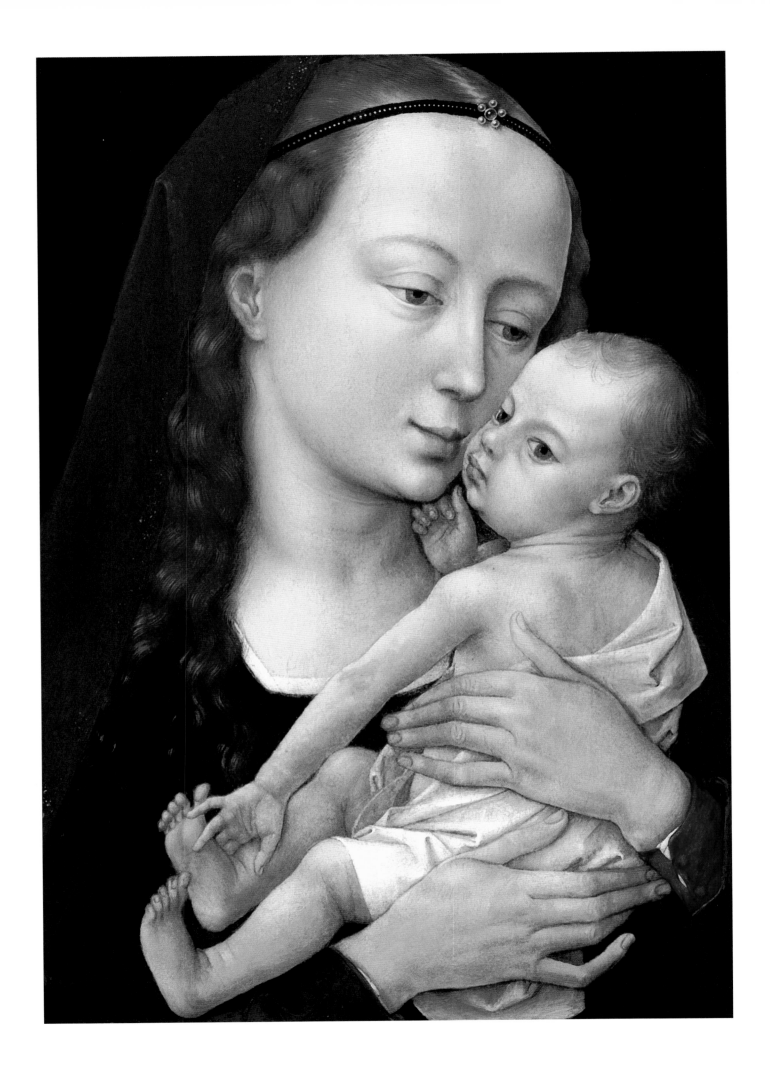

trayal of the Virgin and Child, itself a replica of an earlier Italo-Byzantine icon.[3] In 1440 a Cambrai canon named Fursy du Bruille brought back from Rome an Italo-Byzantine image of the Virgin, which he bequeathed to his chapter in 1450. This picture, installed in 1452 in the cathedral of Cambrai, became a highly popular model for private devotional works, as numerous miracles were attributed to it.

Like many icons of its kind, this panel was reputed to be a work of Saint Luke (who, according to popular legend, painted an authentic portrait of the Virgin Mary), and in 1454 it was decided, for religious and political reasons, that the picture should be popularized throughout the Netherlands. At least fifteen copies of the Cambrai Madonna were ordered for distribution, including three from Petrus Christus (c. 1410–1475/76) in 1454 and twelve from a painter known as Hayne de Bruxelles (active 15th century) in the following year. Almost half a century ago Erwin Panofsky noted that van der Weyden, being in contact with Cambrai from 1455 and having presumably delivered there in person an altarpiece of 1459, had seen the Cambrai Madonna and appropriated its design for a painting, the result reflected in the museum's *Virgin and Child*.[4] The position of the Virgin's hands, the motif of the Infant reaching for the Virgin's chin, the *contrapposto* (poses in which one part of a figure twists or turns away from another) of shoulder and face, and the Child's gaze out of the painting are derived from the medieval prototype.

The central question that has vexed scholars since the *Virgin and Child* was first published in 1924 by the great authority on early Netherlandish painting Max J. Friedländer, "with a sound claim to be original,"[5] is the degree to which van der Weyden participated in the actual painting of the image. The modern concept of an "original" work of art was unknown in medieval painters' workshops, which were craft undertakings employing journeymen and apprentices as in any other trade. Successful innovations on

the part of the master were repeated under his supervision, according to demand. These works were regarded by contemporaries as of no less value than the prototype and can scarcely be distinguished from them in many cases. Rogier van der Weyden's half-length Madonnas, conceived as independent devotional pictures or as parts of portrait diptychs, were frequently repeated by members of his workshop. The fact that he ran a large and busy workshop makes the attribution of a great many works to him and to his assistants extremely complicated.[6]

The divisions among art historians over the "authenticity" of the museum's *Virgin and Child* as a work by the hand of Rogier van der Weyden are therefore not surprising. For just as Friedländer in 1924 admired the painter's delicacy of handling and sensitivity of modeling, and thus for whom "doubts are stilled" regarding the painting's authorship, in 1953 Panofsky, no less an authority on the subject of early Netherlandish painting, described the Straus painting as "an excellent replica."[7] Scholars writing more recently on the painting have shown a similar lack of agreement. The English scholar Martin Davies, in his 1972 catalogue of van der Weyden's paintings, accepted the painting as an autograph work without qualification; on the other hand, in the scholarly catalogue of the Metropolitan Museum of Art exhibition *From Van Eyck to Bruegel,* 1998–99, this painting is further cited as "an excellent replica" from van der Weyden's workshop.[8]

And so it goes. The small number of indisputable works by van der Weyden, such as those in Berlin and Madrid mentioned above, are paintings against which any further attributions to the artist must be judged.[9] Whether or not scholars reach a consensus on the authorship of this little devotional picture—whether it is found to be by van der Weyden or to have been produced by a painter taught by him or working under his guidance—the painting remains a highlight of the museum's collection of European paintings.

3. First recognized by Panofsky 1953, 1:296–98; see also Mary Sprinson de Jesus in Ainsworth and Christiansen 1998, 103–4, fig. 49.
4. Panofsky 1953, 1:297.
5. Friedländer 1924–37, 2:36, 102, no. 35.
6. For discussions of Rogier's workshop and contemporary workshop practice, see Campbell 1994, and Maryan W. Ainsworth, "Workshop Practice in Early Netherlandish Painting: An Inside View," in Ainsworth and Christiansen 1998, 205–11.
7. Friedländer 1967–76, 2:23–24; Panofsky 1953, 1:296.
8. Davies 1972, 216–17, pl. 84; Mary Sprinson de Jesus in Ainsworth and Christiansen 1998, 104.
9. Campbell 1996, 118.

## Giovanni di Paolo

Italian (Sienese), c. 1399–1482

### *Saint Clare Saving a Child from a Wolf,* c. 1455–60

Tempera and gold leaf on wood, 8 1/4 x 11 1/4 in.
(20.6 x 28.1 cm)
The Edith A. and Percy S. Straus Collection
44.571

This charming little panel reminds us that very few early Italian paintings have survived in their original format. The collections of most American art museums are filled with fragments of this sort, bits of altarpieces that have broken apart or been willfully dismembered for one reason or another. The founding collection of the Museum of Fine Arts, Houston, given by the New York collector Percy Straus and his wife, contains a number of fragments of important early Italian paintings,[1] including a pair of standing saints also by Giovanni di Paolo that has not been included in this introduction to the museum's collection of European paintings.

The exact purpose for which this miracle of Saint Clare of Assisi (1194–1253) was painted remains unclear, but some sixty years ago the great scholar of Italian art John Pope-Hennessey recognized that it matched three other panels of similar dimensions, originally forming part of a narrative series.[2] The other panels (below) depict *Saint Francis Investing Saint Clare with Her Habit, Saint Clare Blessing the Loaves before Pope Innocent IV,* and *Saint Clare Rescuing the Shipwrecked.* This series probably formed part of a devotional ensemble dedicated to Saint Clare in Siena, the Tuscan city in which Giovanni, one of the

greatest painters of the fifteenth century, practiced. Keith Christiansen has proposed that the four narrative panels, along with a centrally placed Crucifixion, originally formed the *predella* of an altarpiece (see p. 6) depicting the Virgin and Child flanked by Saints Peter, Damian, Thomas, Clare, and Ursula (Pinacoteca Nazionale, Siena).[3] The provenance of this altarpiece is not known, but it was almost certainly commissioned for a church of the Poor Clares, the order founded by the saint. In the fifteenth century there were four communities of Poor Clares in Siena, for which Giovanni had worked previously.

All four *predella* scenes are taken from episodes in Saint Clare's official biography, written by Tommaso da Celano shortly after her canonization in 1255 at the request of Pope Alexander IV, and circulated widely throughout Italy. In the museum's panel, the figure of a child dressed in pink is shown in the center of the composition being attacked by a wolf, who clutches the child's severed and bloody forearm in its teeth. The child looks back toward the lower left at his mother, who pleadingly raises her hands toward an apparition of Saint Clare in the heavens above. Clare, in her gray Franciscan

Giovanni di Paolo, *Saint Francis Investing Saint Clare with Her Habit,* c. 1455–60. Tempera and gold leaf on wood, 8 1/16 x 11 9/16 in. (20.4 x 29.4 cm). Gemäldegalerie, Staatliche Museen zu Berlin, Preussischer Kulturbesitz (photograph courtesy Jörg P. Anders, Berlin)

1. For the Italian paintings in the Straus collection, see Wilson 1996.
2. Pope-Hennessy 1937, 78. For a full discussion and bibliography, see Wilson 1996, 166–71.
3. Christiansen 1988, 204–5, fig. 3.

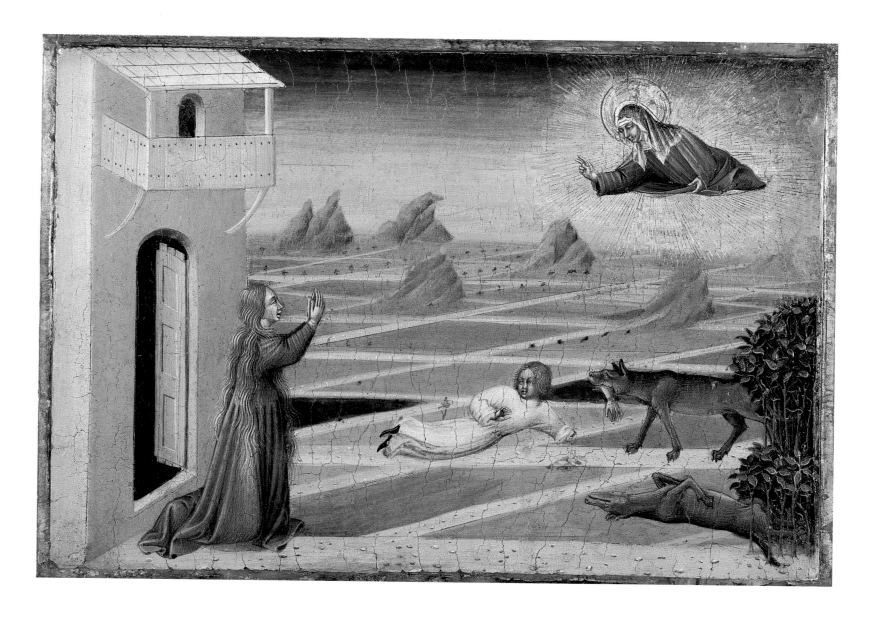

Giovanni di Paolo, *Saint Clare Blessing the Loaves before Pope Innocent IV*, c. 1455–60. Tempera and gold leaf on wood, 8 1/2 x 11 7/8 in. (21.6 x 30.1 cm). Yale University Art Gallery, New Haven, Connecticut

Giovanni di Paolo, *Saint Clare Rescuing the Shipwrecked*, c. 1455–60. Tempera and gold leaf on wood, 7 5/8 x 11 5/8 in. (19.4 x 29.6 cm). Gemäldegalerie, Staatliche Museen zu Berlin, Preussischer Kulturbesitz (photograph courtesy Jörg P. Anders, Berlin)

4. Ibid., 207. Strehlke observes that because of the real threat that wolves posed, stories related to their taming or to being rescued from them were a common topos in hagiographical literature.

5. Rowlands 1996, 100.

6. See Wilson 1996, 168, 169 n. 3.

habit, emerges from a burst of gilt rays and makes a gesture of benediction over the scene below.

In the written version of the miracle, a rapacious wolf mauls a child and carries him into the woods. Alerted by vineyard workers of the child's cries, his mother, Buona of Monte Galliano (near Assisi), who already has lost one son to a wolf, prays to Saint Clare, threatening to drown herself if this son also perishes. Meanwhile, the workers rush into the forest and find the wolf gone and a dog licking the child's wounds. Here the narrative has been reduced to its essential elements, ignoring details that might confuse the dramatic impact of the picture. The head wound described in the written account has become a severed arm, and the workers and the dog have been eliminated altogether. The wolf is also shown a second time, dead and supine, a device employed by medieval painters known as "simultaneous narration."[4]

*Saint Clare Saving a Child from a Wolf* shows why Giovanni was one of the most original masters in fifteenth-century Italy. His expressive style retains a late Gothic quality that testifies to his earliest documented activity as a miniaturist. And perhaps more than any other Sienese painter of the time, his art embodied the mysticism and impassioned devotion that defined religious life in that city.[5] The dreamy, visionary quality of his aesthetic is exemplified here in the eerie panoramic backdrop (which one writer described as a "volcanic landscape")[6] that suggests the helpless isolation of the mother and child. The treatment of pictorial space could be considered antinaturalistic or even anti-Renaissance, but in fact the artist is interested in using the principles of linear perspective for his own expressive ends. Like the best Renaissance painters, Giovanni observed the natural world closely and mastered the means to create realistic three-dimensional space. His inventive powers were such, however, that he often chose to ignore those principles when it suited him.

## Sano di Pietro

Italian (Sienese), 1405–1481

### The Virgin and Child with Saints Jerome and Bernardino of Siena and Six Angels, c. 1460s

Tempera and gold leaf on wood, 23 1/2 x 16 in. (59.7 x 40.6 cm.)
The Edith A. and Percy S. Straus Collection
44.572

1. For a full discussion and bibliography, see Wilson 1996, 172–78.

2. J. Patrice Marandel in Museum of Fine Arts 1981, 25.

3. Wilson 1996, 174–75.

Although many early Italian paintings survive in a fragmentary state and often in poor condition, this image of the Virgin and Child with saints and angels is as well preserved today as it was in the fifteenth century.[1] This fine state of preservation provides a textbook example of the method used to make these "gold-ground" panels during the late Middle Ages through the sixteenth century (see also pp. 2–4).

Sano di Pietro was a successful painter and miniaturist who maintained a flourishing workshop in Siena, where he was listed in the guild of painters in 1428. Reportedly a pupil of the great Sienese master Sassetta (active by 1423–50), Sano produced numerous altarpieces for churches in Siena and its environs and many small devotional panels for private patrons from the 1440s onward. In spite of the progressiveness of nearby Florence, Sano remained faithful to the Sienese tradition. Well into the fifteenth century, his works attest to the vitality of the Sienese taste for graphic refinement and pure compositions prevalent since the thirteenth century.[2]

The museum's panel is a typical and fine example of a composition produced by Sano and his workshop that exists in several similar formats and evidently enjoyed considerable popularity. The particular combination of saints Jerome at the left and Bernardino at the right and angels was repeated quite closely by the artist in a number of works. The analogies among the pose of the Child; the dress, pose, and halo of the Virgin; and the relation between the other figures have led to the suggestion that Sano used one cartoon for the general layout of these different versions[3]—and also to the unfair dismissal in modern criticism that the artist, in the nineteenth century compared to Fra Angelico,

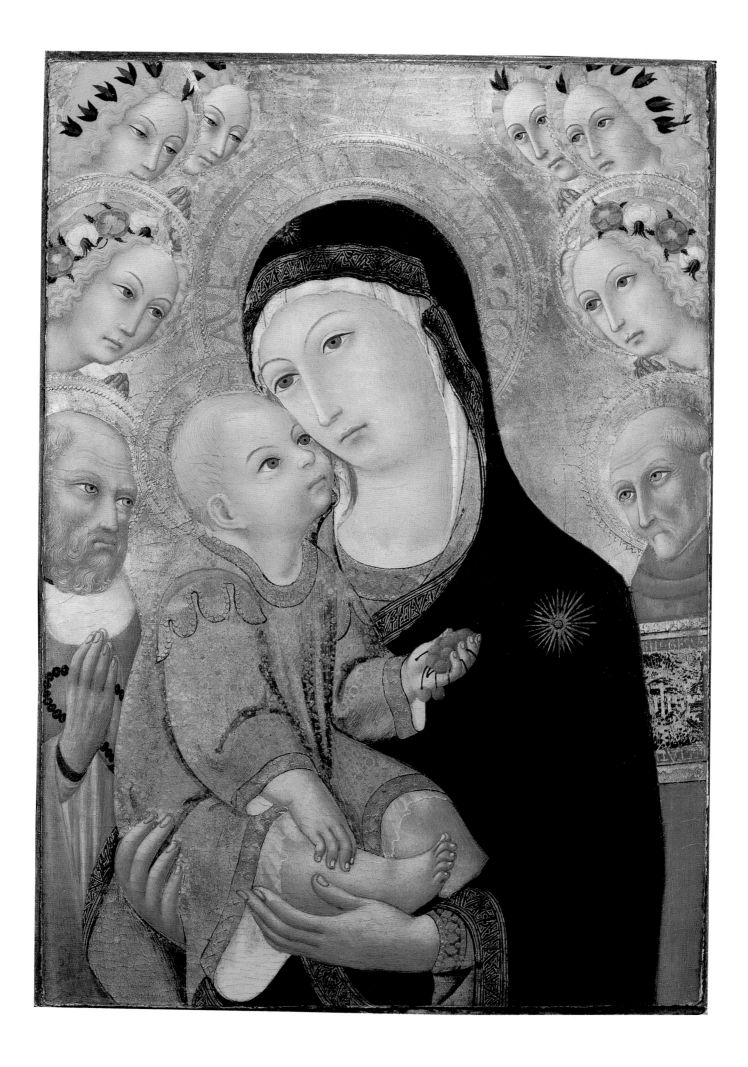

4. For Sano's career, see Christiansen 1988, 138–41; Wilson 1996, 177 n. 1.

5. Farmer 1997, 56.

6. Wilson 1996, 176, 177 n. 17.

was little more than a gifted craftsman who repeated endlessly the same tired formulas.[4]

Sano enjoyed extensive patronage by convents and confraternities of the Franciscan order to decorate the walls of their monastic cells. Saint Jerome (c. 341–420), a monk and one of the four Latin Fathers of the Church, is shown wearing cardinal's robes and holding a rosary. He never was a cardinal (the office did not exist in his time and he refused all rank), but he was retrospectively honored as one of the Doctors of the Church. He was favored by the Gesuati, who frequently employed Sano.

Saint Bernardino of Siena (1380–1444), a vicar-general of the Observant branch of the Franciscan friars, was a renowned preacher. He traveled over most of Italy, always on foot, as he preached the need for penance and voluntary poverty. Sometimes preaching for three or four hours and offering several sermons on the same day, he drew crowds so large that he used a pulpit in the open air. Best remembered for his fostering devotion

to the Holy Name of Jesus, Saint Bernardino would hold up for veneration a tablet inscribed with the letters IHS (the abbreviation of the name Jesus in Greek) at the end of his sermons. Examples of them can be seen to this day in churches and museums of Tuscany and elsewhere.[5] The saint, portrayed at the right edge of the composition as an old man with emaciated features, dressed in Franciscan habit, holds such a plaque.

Sano almost certainly had observed Saint Bernardino and heard his lively and emotional sermons, and he became the interpreter and major exponent of the Observant movement. His depictions of the saint preaching, and of various representations of his miracles, helped establish the popular image of the great Franciscan reformer and ascetic, who was canonized in 1450.

The motif of the Christ Child holding cherries is not common, but it is found in other Sienese paintings of the fifteenth century. A traditional fruit of paradise, the cherries may signify the delights of the blessed.[6]

## Italian (Ferrarese), third quarter of the 15th century

### The Meeting of Solomon and the Queen of Sheba, c. 1470–75

Tempera and gold leaf on wood, 36 3/8 in. (92.3 cm) diam.
The Edith A. and Percy S. Straus Collection
44.574

1. For a discussion and complete bibliography, see Wilson 1996, 214–29.

*T*he Meeting of Solomon and the Queen of Sheba has been known to modern scholars since it was in the Edmond Foulc collection, Paris, in the late nineteenth century, and it has attracted the attention of dozens of specialists on account of its aesthetic quality, meticulous technique, and intriguing iconography. Yet more than a century after it was first published, the painting's authorship continues to elude art historians. Italian painters from Florence to Siena to Ferrara, from Domenico Veneziano (active 1438, died 1461) to Francesco del Cossa (c. 1435–1476/77) to Gherardo d'Andrea Costa (recorded 1452–74), have been suggested as the painter of the circular painting, or *tondo* (literally, a circle, from *rotondo,* round).

The work derives from decorated circular or twelve-sided trays given as presents to new mothers or in anticipation of a birth. Known as *deschi da parto* (birth trays), these were often painted with subjects appropriate for

commemorating a birth, such as the Nativity. The museum's painting represents the encounter between Solomon and the queen of Sheba and is one of the finest examples of this type of ceremonial painting. Believed to have been painted in Ferrara in the early 1470s, the work epitomizes the artistic taste of the humanist courts of northern Italy during the fifteenth century.[1]

King Solomon of Israel appears frequently in Renaissance art because, like King David, he was considered an Old Testament prefigurer of Christ. People and events in the Old Testament were viewed by the early Fathers of the Church as prefigurations of sacred history. Thus Abraham's sacrifice of his son Isaac, for example, foreshadowed God's sacrifice of Christ, and David's fight with Goliath anticipated the struggle of Christ with Satan. "The Old Testament," Saint Augustine wrote in the *City of God,* "is nothing but the New covered with a veil, and the New is nothing

2. Hall 1979, xv.
3. Wilson 1996, 220, fig. 19.5.
4. Ibid., 217.
5. The painting was cleaned and restored by Andrea di Guidi Bagno and Maite Leal at the Museum of Fine Arts, Houston, in 1998 and 1999.

but the Old unveiled."[2] Numerous episodes from the life of Solomon—the construction of the Temple of Jerusalem, the magnificence and luxury of his court, his many wives, his idolatrous forms of worship, and his proverbial wisdom (see pp. 66–69)—were depicted in the art of the late Middle Ages and the Renaissance.

The meeting between Solomon and the queen of Sheba (1 Kings 10:1–13) was considered a prefiguration of the Adoration of the Magi. The renowned wisdom of Solomon having reached the queen of Sheba, she came to test him with difficult questions. She brought immense riches to Jerusalem with her, camels laden with spices, great quantities of gold, and precious stones. On coming to Solomon, she opened her mind freely to him and, in the words of the biblical text, "Solomon had an answer for all her questions, not one of them was too obscure for the king to expound." When the queen of Sheba saw all the wisdom of Solomon, the palace he had built, the prosperity of his court, and the beneficence of his rule, she concluded that because of God's love for Israel he had granted Solomon his favor and made him king. In return the king bestowed on her "all she desired, whatever she asked, in addition to all he gave her of his royal bounty."

The subject of Solomon receiving the queen of Sheba was popular in fifteenth-century Florence, and the scene was often used to decorate marriage chests (cassoni). Perhaps the most famous Renaissance depiction of the subject is the Florentine sculptor Lorenzo Ghiberti's (1378–1455) relief on the gilded bronze doors for the Baptistery, Florence, c. 1436. Here the posture and gestures of Solomon and the queen of Sheba, and also the arrangement of their attendants on either side of the rulers, were first established and greatly influenced subsequent representations of the subject.[3]

In the painting, the two rulers stand within the forecourt of a temple facing one another and joining hands at the center of the composition before a shrine containing a golden altar and vessels of gold. The figures' prominence is enhanced by the complex architectural setting, the system of perspective, and the skillful disposition of the numerous figures that make up their respective retinues.

The anonymous creator of the museum's *tondo* obviously took great delight in the depiction of these secondary figures and the servants and animals accompanying them. The queen's entourage is represented as a party of young female attendants whose rich attire is embellished by the use of delicately tooled gold leaf. Their garments and headdresses are decorated by *sgraffito.* The costumes of Solomon and of the throng of men to his right are also richly adorned with tooled gold.

Apart from the extraordinary technical quality of the craftsmanship and the breathtaking beauty of the museum's *tondo,* much of the delight of the painting resides in its details of daily life. The heavily robed and bearded elders to the right of Solomon engage in debate; to their right stands a party of fashionably dressed youths conversing with one another. At the extreme left of the composition, a mother and child are seen from behind, crossing the distant square; at the right, a falconer is seen from behind. On the pavement in front of the central scene is a pair of gray mastiffs, one sniffing the hind quarters of the other, who snarls in confrontation with a black racing hound and a monkey perched on the railing to which it is tied. And before the railing on the left, closest to the viewer's space and isolated from the scene behind him, is the pointing figure of a hunchback, holding a jester's bauble and bearing a second monkey on his shoulder. The hunchback has often been understood by scholars as our interpreter of the courtly rituals from which he is excluded.[4]

The precise outlines, gilded and punched surfaces, bright colors, and naturalistic details of the painting were vividly revealed after recent cleaning and restoration.[5] The architectural space of Solomon's temple, with its central vanishing point located on the altar chalice, is now more rational, and individual details such as the pillars and ceiling of the portico can be more readily appreciated. The painter's mastery of the marbling technique to describe the floors and columns is now also more evident. Further insight into his technique is gained by the disclosure of subtle highlights brushed on as strokes of white or yellow throughout the picture, notably on the faces of the figures.

# Hans Memling

Netherlandish, 1430/40–1494

## Portrait of an Old Woman, 1480–90

Oil on wood, 10 1/8 x 6 15/16 in. (25.6 x 17.7 cm)
The Edith A. and Percy S. Straus Collection
44.530

Northern European artists of the early 1400s were the first to perfect the technical means to create lifelike portraits in oil paint. The oil-based medium, first exploited to the fullest by Hubert (c. 1385/90–1426) and Jan van Eyck (active by 1422, died 1441)—giving rise to the legend of their invention of it—allowed painters to simulate the appearance of the real world with unprecedented naturalness. For early Netherlandish painters, portrait painting was part of a greater endeavor. Portraits were often minor components of works that fulfilled a larger purpose beyond that of recording individual likeness. The contributor of an altarpiece might have himself portrayed as a witness to a sacred event, or a patron might order a portrait of himself depicted in an attitude of perpetual prayer, to be paired with an image of the Virgin and Child. Independent portraits at the time were primarily a prerogative of ruling noble families and served as demonstrations of position and power, as records of family history, and even as a form of propaganda. Later in the fifteenth century it became increasingly common for members of the lesser nobility and the wealthy bourgeoisie to commission portraits in imitation of aristocratic practice.[1]

Hans Memling's *Portrait of an Old Woman* and its companion, *Portrait of an Old Man,* in the Metropolitan Museum of Art, may have been commissioned to document a long and presumably successful marriage.[2] The natural desire to foster a sense of family history existed in the fifteenth century, and couples often commissioned double portraits that celebrated their conjugal unions and included a coat of arms on the frames or on the reverse of the panels. The standard format employed by fifteenth-century Flemish painters was the three-quarter profile view, and often the illusionism was enhanced by various devices—a stone parapet, a window, a landscape behind the sitter.

Memling, the dominant painter in Bruges at the end of the fifteenth century and one of the most popular early Netherlandish

painters,[3] made numerous portraits and is often credited with more originality in this field than in religious painting. Among his patrons were members of Bruges's large Italian mercantile community during the second half of the fifteenth century. These businessmen had Memling paint their portraits, bust or full length, in devotional paintings or on altarpieces for their chapel in Bruges or back home. The most famous pair of these works—*Tommaso Portinari* and *Maria Portinari,* probably 1470 (The Metropolitan Museum of Art, New York)—has been justly hailed as among the masterpieces of northern Renaissance art.[4] Memling is the first known south Netherlandish artist to set a portrait against a landscape background. He was probably inspired by such Italian painters as Piero della Francesca (c. 1415–1492) and Filippo Lippi (c. 1406–1469), but in turn Memling's portraits and Virgins were imitated in Florence, often because of their landscape backgrounds.[5]

Memling painted Houston's fine portrait in the traditional manner of fifteenth-century oil technique. An oak panel was prepared with a thin white ground on which Memling laid out the main elements of the composition in an underdrawing in black paint. The portrait was then painted with successive thin layers of oil paint. Regrettably, the painting has suffered from harsh cleaning in the past that has damaged much of the surface. Fortunately, enough of the original paint has survived to allow a recent conservation treatment to reconstruct the main elements of the painting.[6]

The portraits in Houston and New York were regarded as isolated works until 1970 when the art historian Jack Schrader suggested, on the basis of their similar dimensions, style, and general appearance, that they might be companion pieces.[7] X-ray radiography revealed that the museum's picture had originally included hands (now overpainted) in the lower left corner in a pose similar to that of the man's hands. The two portraits likely formed a diptych consisting of two

1. For early Netherlandish portraiture, see Bauman 1986, from whom this introduction is derived, and Maryan W. Ainsworth, "Portraiture: A Meeting of the Sacred and Secular Worlds," in Ainsworth and Christiansen 1998, 139–45.
2. Bauman 1986, 34. For discussions of the portraits and earlier literature, see De Vos 1994b, 230–32, and Mary Sprinson de Jesus in Ainsworth and Christiansen 1998, 168–69, no. 29.
3. For Memling's life and career, see De Vos 1994a, De Vos 1994b, and De Vos 1996.
4. Mary Sprinson de Jesus in Ainsworth and Christiansen 1998, 162.
5. De Vos 1996, 105.
6. The painting was cleaned and restored by David Bull in Washington, D.C., in 1998.
7. Notes and correspondence in the archives of the two museums.

8. Peter Klein, "Dendrochronological Analysis of Panels of Hans Memling," in De Vos 1994a, 2:103.

9. Mary Sprinson de Jesus in Ainsworth and Christiansen 1998, 169.

panels hinged and facing one another like the pages of a book. It has been thought that the two paintings once formed a continuous double portrait, but there is no evidence that any of the elements—such as the man's left shoulder or the woman's white headdress— overlapped, an aspect one would expect to find if the panels had been cut down to create two independent works.

Scholars have argued about the authorship of the two panels for many years, although the museum's portrait was published as a Memling as early as 1912. In the case of the male portrait, scholars have objected to the strong realism with which the aged sitter has been portrayed and also to the cropping of the composition, which creates an image that is unusually compressed for Memling's work. Both portraits are related to similar portraits by Rogier van der Weyden (see pp. 9–11), with whom Memling is thought to have worked in Brussels until the master's death in

1465. For a long time the paintings were thought to be among Memling's earliest works and to date from the mid- to late 1460s. However, dendrochronological analysis (dating by comparative study of growth rings in trees and aged wood) of the museum's panel has revealed that it can hardly have been produced before 1480 and was probably executed a good many years later.[8]

As secular works created to preserve the appearance of a couple for posterity, the Houston and New York portraits belong to a long tradition of paired portraits of bourgeois sitters, a field that would flourish in seventeenth-century Flanders and Holland. The intimate portrayal of this old couple is unusual, however, in early Netherlandish painting, and their instilled sense of humanity and expressions of gentle forbearance have been seen as anticipating certain portraits by Rembrandt.[9]

Hans Memling, *Portrait of an Old Man,* 1480–90. Oil on wood, 10 3/8 x 7 5/8 in. (26.4 x 19.4 cm). The Metropolitan Museum of Art, New York, Bequest of Benjamin Altman, 1913

# Antoniazzo Romano

Italian (Roman), c. 1430–1512

## Virgin and Child with a Donor, c. 1480

Tempera and gold leaf on wood, 18 9/16 x 14 7/8 in. (47.2 x 37.9 cm)
The Edith A. and Percy S. Straus Collection
44.551

Antoniazzo Romano was the leading local painter in Rome during the later fifteenth century. He supervised the most prolific workshop in the city at the time and enjoyed considerable prosperity. He was frequently employed by the Vatican for fresco and panel paintings as well as for banners, shields, and coronation and funeral decorations. His professional practice was unusual in that he appears to have placed himself and his workshop at the disposal of painters summoned from other regions of Italy to the papal court, including Domenico Ghirlandaio (1448/49–1494), Melozzo da Forlì (1438–1494), and Pietro Perugino (c. 1450–1523). Antoniazzo played a significant role in the refurbishing of Roman church interiors during his time, and he is known to have restored and made copies of revered Roman religious icons.[1]

The museum's *Virgin and Child with a Donor* was first recognized as the work of Antoniazzo by Frederick Mason Perkins in 1922 and was exhibited with this designation the following year at the Metropolitan Museum of Art, New York.[2] The painting had always been regarded as by Antoniazzo and of the highest quality, but its importance in the literature on the artist was established by the attention given to it in a 1927 article in *Vita artistica* by Roberto Longhi, the most important Italian art historian and critic of his time. Longhi extolled the excellence of the portrait, the authority of the draftsmanship, the power of the contour of the figures against the abstract background, and the elegance of the rhythmically repeated curves in the Virgin's drapery.[3]

The composition of this Virgin and Child, depicted in the medieval tradition in sharp relief against a plain gold background, evidently was a great success because it served as the prototype for nearly a dozen variations produced in Antoniazzo's workshop.[4] A feature of the composition is the Child's crossed legs, which Carolyn Wilson, the author of the museum's catalogue of early Italian paintings, has suggested may derive from an un-

usually animated Christ Child in the medieval apse mosaic of Santa Maria Nova, Rome. Alternatively, the Child's stance may reflect Antoniazzo's attention to a recently completed work by the Lombard sculptor Andrea Bregno (1418–1503), a pair of winged, nude putti on the balustrade at the entrance to the Della Rovere chapel in Santa Maria del Popolo, Rome.[5] Whatever the origin of the pose, the Holy Infant's complex stance both animates and humanizes him and enlivens the interplay between mother and child.

Wilson has called attention to Antoniazzo's depiction of the standing Christ Child as unclothed except for a swag of transparent drapery across his hips. The convention was widely used by contemporary Italian artists, and the significance of the cloth and the emphatic manner with which the Virgin holds it has been recognized as an allusion to a passage in a fourteenth-century devotional work, *Meditations on the Life of Christ.*[6] In this text, Mary is said to have wrapped the Child at the time of his birth in the kerchief from her head. Later in the text she is said to have placed the same cloth about his loins at the Crucifixion. In a famous study by the scholar Leo Steinberg, the motif of the cloth was placed within the context of a contemporary theological debate on the dogma of the Incarnation.[7] This led to a new pictorial emphasis in Renaissance art not only on the nudity, but specifically on the genitals of Christ. Steinberg cited sermons preached in Rome during the second half of the fifteenth century that were directed against the heresy of disbelief in Christ's human nature while on earth. According to this interpretation, the small-scale kneeling figure at the left of the Virgin and Child is not only petitioning admission to heaven, but is also specifically witnessing the Incarnation—the Word Made Flesh—that is his salvation.

The inclusion of the patron or donor in the painting suggests that it was commissioned for a private chapel within a church or dwelling. Moreover, it has been speculated that the composition and its individual

1. For a summary of the literature on Antoniazzo, see Wilson 1996, 242.
2. For a discussion of the painting and its history, see ibid., 242–54, 388; the exhibition at the Metropolitan Museum of Art was titled *Loan Exhibition of the Arts of the Italian Renaissance.*
3. Longhi 1927, 232–33, pl. 2; Wilson 1996, 245.
4. Wilson 1996, 247, figs. 22.6–10. The prevalence of workshop productions has meant that Antoniazzo's name is often associated with paintings of inferior quality.
5. Ibid., 246–47, figs. 22.4–5.
6. Green and Ragusa 1961, 33, 333; Wilson 1996, 248, 253 n. 23.
7. Steinberg 1983, 61–65; Wilson 1996, 253 n. 24.

8. Wilson 1996, 250.

iconographic elements may reflect specific devotional and theological concerns on the part of both the patron and the painter. Wilson, for example, notes the location of the goldfinch, isolated against Mary's red robe at almost the exact center of the panel.[8] The goldfinch has been associated with Christ's Passion (see p. 2) and may have been included to emphasize the symbolism of the veil as Christ's loincloth at the Crucifixion. These references to the Passion are in turn underscored by the presence of the stone parapet on which the Christ Child stands, a common element in fifteenth-century painting, intended to foreshadow the Entombment.

## Follower of Sandro Botticelli

Italian (Florentine), 1444/45–1510

*Portrait of a Young Woman,* c. 1485–90

Tempera on wood, 15 1/4 x 9 3/4 in. (38.7 x 24.8 cm)
The Edith A. and Percy S. Straus Collection
44.554

Sandro Botticelli is today one of the most famous and best-loved Florentine painters of the quattrocento (literally, "four hundred" in Italian and a term applied to the fifteenth century in Italian art). The delicate sentiment, feminine grace, and seductive linearity of Botticelli's pictures found favor in the second half of the nineteenth century among English art critics such as John Ruskin and Walter Pater, who dedicated one of his most eloquent essays to Botticelli's art. Botticelli's mythologies and poetic allegories in the Galleria degli Uffizi, Florence—*Birth of Venus,* c. 1486, and *Pallas Athena and the Centaur* and *Primavera,* both c. 1478—and his Madonnas are certainly among the most famous Italian paintings in the world.

Botticelli's modern fame is such that an enormous number of late-fifteenth-century Florentine paintings have been attributed to him, with the result that scholars have argued for more than a century over which works are actually his. The museum's *Portrait of a Young Woman,* one of these much-debated works, represents a type of female Florentine portrait highly admired and even romanticized by art critics and collectors in the nineteenth century. The painting was acquired early in the nineteenth century by Baron Karl Friedrich von Rumohr for the royal collections in Berlin as a work by Botticelli. However, by 1878 the painting was designated as in the "manner of Botticelli" by the German art historian Wilhelm von Bode, and it was in fact sold by the Kaiser Friedrich Museum, Berlin, in the early 1920s. Since that time the painting has been assigned variously to an assortment of Florentine contemporaries of Botticelli, notably Raffellino del Garbo (1466–1524) and Sebastiano Mainardi (1466–1513), and occasionally to the master himself.[1]

The bust-length format, profile pose, and distinctive style of the young woman's blond hair were quite popular in Florence at the end of the fifteenth century. The source of these female portraits appears to be the fresco cycles painted in the Sassetti chapel in Santa Trinità, about 1480–85, and in the Tornabuoni chapel in Santa Maria Novella, Florence, about 1486–90, by Domenico Ghirlandaio.[2] Ghirlandaio's talent for including vivid contemporary portraits in his religious works led to his popularity and spurred the production by other painters of reprises and imitations of these celebrated images.

The Italian painter and writer Giorgio Vasari (1511–1574) mentions two portraits by Botticelli in the *guardaroba* (or wardrobe) of Cosimo I de' Medici (1519–1574), grand duke of Tuscany, thereby encouraging scholars to identify female portraits of this type with the artist. One is a portrait of the wife of Lorenzo de' Medici (whom Vasari misidentified as Lucrezia Tornabuoni, Lorenzo's mother); the other is Simonetta Vespucci, the mistress of Lorenzo's brother Giuliano. Thus, many portraits of this type have been identified as either Lucrezia or Simonetta, who is mentioned in the *Stanze per la giostra* by the Italian poet Angelo Poliziano. Accordingly, the museum's portrait was attributed by the art critic Gustave Waagen to Botticelli and identified by him as Lucrezia.[3]

Carolyn Wilson, in her recent catalogue of the museum's early Italian paintings, has ob-

1. For a discussion and complete bibliography, see Wilson 1996, 150–53.
2. See Borsook and Offerhaus 1981, pl. 33; Kecks 1995, 119–44; and other examples cited by Wilson 1996, 153 n. 2.
3. Wilson 1996, 150.

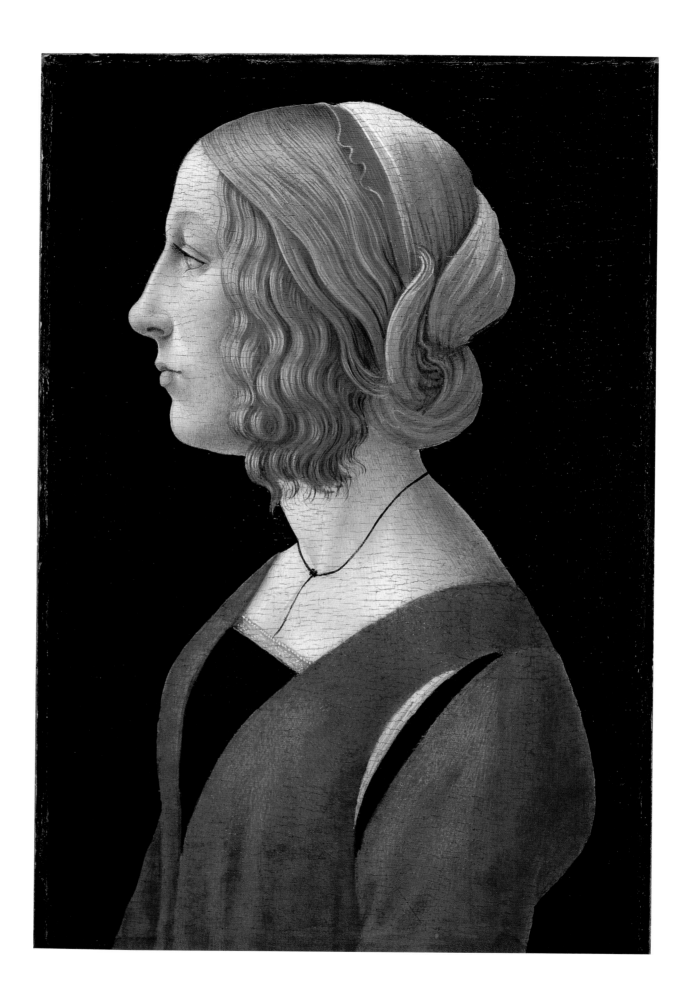

4. Ibid., 152–53.
5. Erich Schleier in Asmus and Grosshans 1998, 328–29, repr.
6. Wilson 1996, 150.

served a distinguishing characteristic of the sitter, her upturned nose, a feature relatively rare in Florentine quattrocento portraits. The simplicity of the garments—that is, the lack of any identifying jewelry or fabric design—might also be used as an argument against an identification of the sitter as a prominent member of one of the more important Florentine families.[4] There is nothing unusual, however, in the fact that the sitter of the museum's portrait lacks identity and that its author is unknown. One of the most famous female portraits of the early Italian Renaissance, for example, a Florentine portrait in profile in the Gemäldegalerie, Berlin, remains equally elusive. Nothing was known about it

and its history before 1800, and nothing definite about the artist. After more than a century of art-historical research conducted since the portrait's appearance in 1894, its authorship is still the subject of controversy.[5]

Although the museum's painting is generally in good condition, the background, now black, was described in 1845 as dark blue. The panel may have undergone other changes from its original appearance, an experience not unusual in the case of a work of art five hundred years old. Analysis of the dark pigment on the woman's bodice indicates that it also was not black originally, and there has been a change made in the pendant of the black cord necklace.[6]

## Attributed to Bernardino Zaganelli

Italian (Romagnese), documented 1499–1509

### Virgin and Child Enthroned with Saints Michael, Catherine of Alexandria, Cecilia, and Jerome, c. 1506–12

Oil on wood, 9 7/8 x 8 in. (25.1 x 20.3 cm)
Museum purchase with funds provided by
Alice N. Hanszen
78.1

1. For a discussion and complete bibliography, see Wilson 1996, 282–89.
2. Pouncey 1977, 376.
3. Wilson 1996, 287, fig. 27.5.
4. Hall 1979, 208.

This exquisite work is one of a few Renaissance paintings whose authorship, debated by art historians without resolution,[1] is of relatively little importance. The subject is so tender, the handling of paint so exquisite, the color so pleasing, and the condition so fine that one simply admires the painting for its quality and charm. The work was unknown prior to its appearance in the sale room in London in 1977. The late Philip Pouncey, an English scholar with an extraordinary knowledge of fifteenth- and sixteenth-century Italian paintings and drawings, published the painting shortly thereafter as a work by Bernardino Zaganelli or his brother, Francesco (1470/80–1532).[2] Bernardino Zaganelli exists as an artistic personality principally on the basis of a signed *Saint Sebastian* (National Gallery, London), which has been identified as the central panel of an altarpiece commissioned by the students of the University of Pavia for their chapel in the Carmine, Pavia, painted about 1505–6.[3] Cotignola, the painter's birthplace, is in the province of Umbria, and his work is generally seen as strongly influenced by contemporary Umbrian painters, particularly Perugino, whose

paintings had great influence on the young Raphael (1483–1520), as well.

The painting, which might at first glance seem to be an altarpiece rather than a wooden panel smaller than a sheet of typing paper, was probably a private devotional commission. The Virgin and Child are enthroned beneath a green canopy within a stone aedicula, or niche, beautifully ornamented with colored marble. The winged archangel Michael stands in armor at the left, bearing a sword and holding a balance with one pan heavier than the other. Saint Michael is often depicted in representations of the Last Judgment as a weigher of souls, and the implication of the imbalance in the scale he holds is that the righteous and the sinner are of unequal weight. He stands upon a demon that represents Satan and alludes to the battle between the forces of light and darkness described in the book of Revelation (12:7–9): "Then war broke out in heaven. Michael and his angels waged war upon the dragon. . . . So the great dragon was thrown down, that serpent of old."[4]

The female saints kneel at the base of the throne, their faces turned toward the Child.

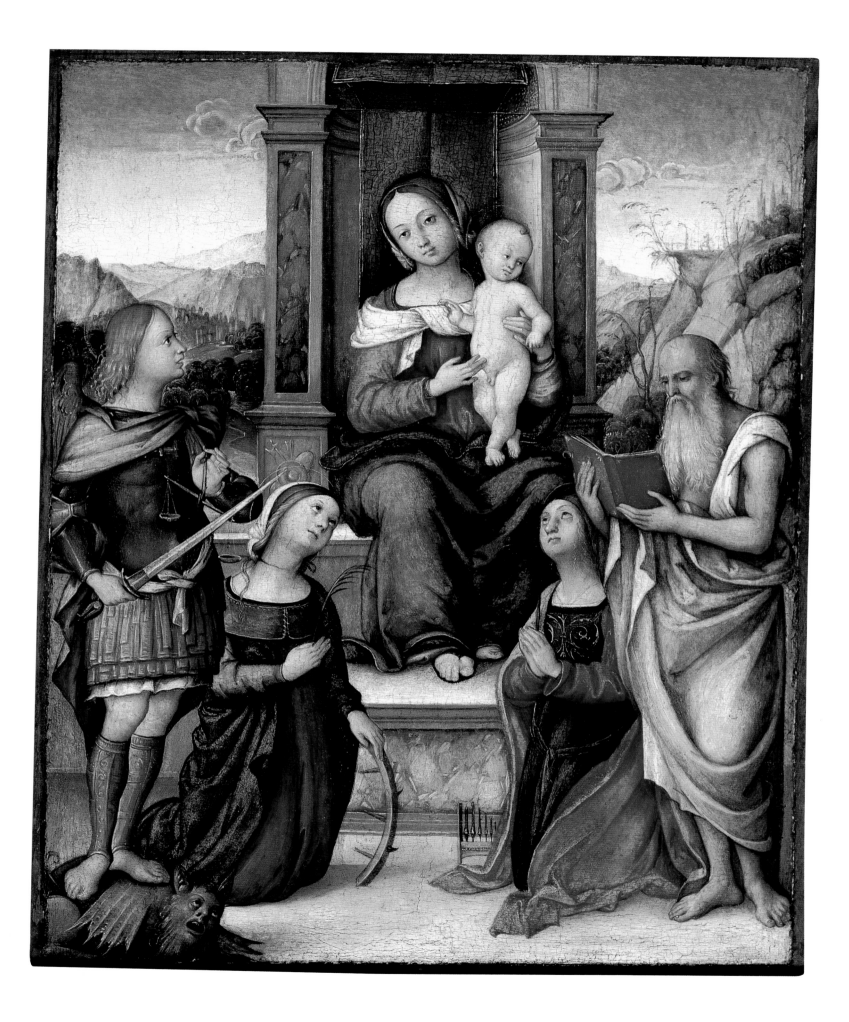

5. Farmer 1997, 91–92.

6. Ibid., 258.

7. Wilson 1996, 285, 289 n. 4, noting comparative examples dating from the late fifteenth century in the Venetian state armory.

8. Wilson 1983, 69, repr.

9. Wilson 1996, 284, figs. 27.2–4, 27.6.

10. Ibid.

11. Wilson 1983, 285.

Saint Catherine of Alexandria is said to have been executed by the Roman emperor Maxentius in the fourth century for her protests against the persecution of Christians. She holds the martyr's palm frond in her right hand and supports a broken wheel with spikes, the instrument of her torture, with her left. The cult of the saint flourished throughout Europe in the Middle Ages under the influence of the Crusaders and later of the *Golden Legend,* and her life strongly appealed to the imagination of artists. Because of her very uncertain historicity she was removed from the Catholic Church calendar in 1969.[5] The third-century virgin martyr Cecilia, identified by the miniature pipe organ—an allusion both to the events of martyrdom and her traditional status as patroness of music—holds her hands in an attitude of prayer. Beside her, Saint Jerome (c. 341–420) is dressed as a hermit in reference to his withdrawal to the desert of Chalcis in Syria for five years. During this period he gave up the classics he knew and loved so well and learned Hebrew instead to study Scripture in its original language.[6] The book he holds indicates his role as one of the four Latin Fathers of the Church.

Carolyn Wilson has noted the meticulous attention of the painter to the world around him. For example, Saint Michael's jambeaux are a type characteristic of the late fifteenth century in Italy, and his short sword *(stocco)* conforms to contemporary north Italian types.[7] The grotesque demon on which he stands, with its weblike wings and expressive human face, is reminiscent of sculptures such as *Neptune on a Sea Monster* (National Gallery of Art, Washington, D.C.) by the famous contemporary bronze caster Severo da Ravenna (documented 1496–1525).[8] The panoramic mountain landscape behind the figures is especially closely observed. It is filled with minute detail, like the river valley and distant city on the left, and the tiny depiction of Saint Jerome kneeling in penance before a cross on the rock formation directly above the head of the full-length saint in the foreground.

The painter's seemingly effortless compositional harmony and balance have in fact been attained with great care, as analysis of the painting by x-ray radiography and examination by infrared reflectography have revealed.[9] The head of Saint Cecilia was altered slightly during the course of painting, from a profile view toward a more frontal orientation, and the artist made subtle changes throughout the layout of the preliminary design in the positions of the feet of the two male saints, the bodice of Saint Catherine, and in the position of the Virgin's right hand.[10] These careful calculations and minor but significant modulations, along with the palette of rich colors and atmospheric light, go a long way toward establishing the painting's "pervasive mood of quiet communion."[11]

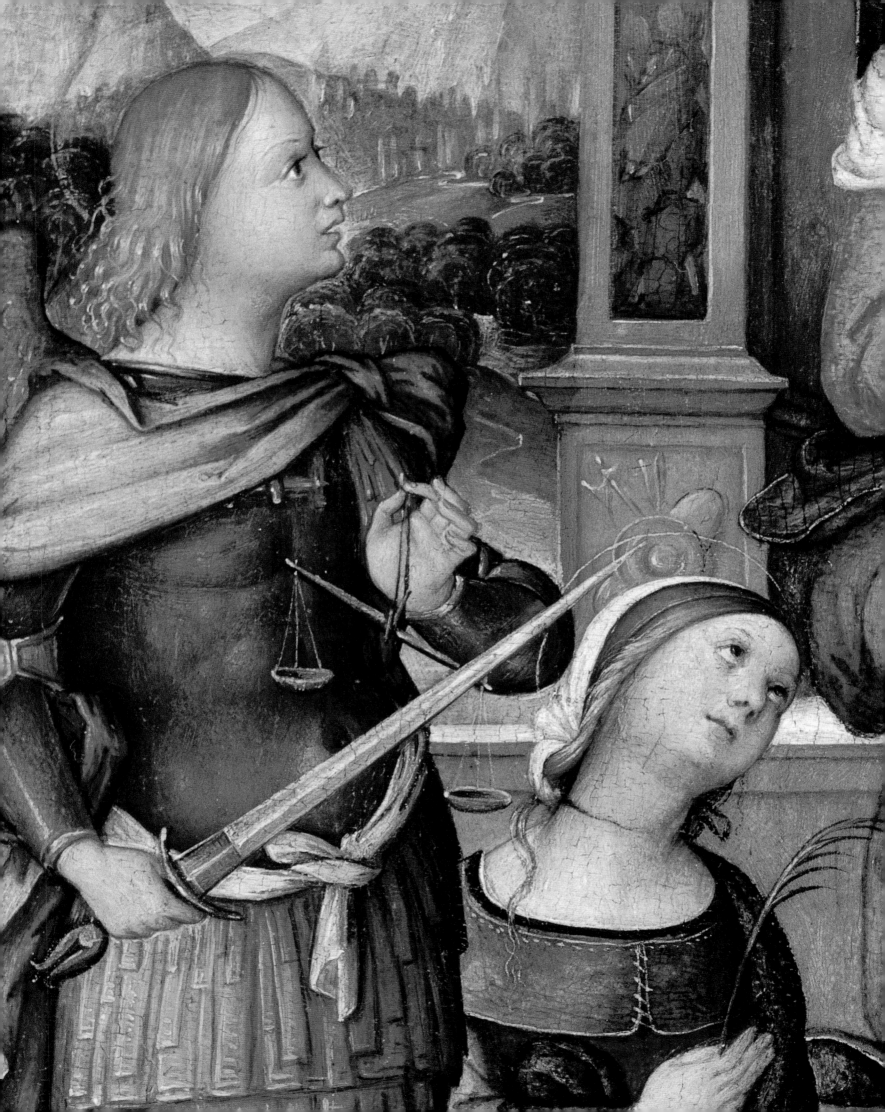

## Bernardino Luini

Italian (Lombard), c. 1480/85–1532

### Lamentation over the Dead Christ, c. 1515–20

Oil on wood, 34 3/8 x 23 11/16 in. (87.2 x 60.2 cm)
The Samuel H. Kress Collection
61.68

Bernardino Luini was one of the most prominent contemporary followers of Leonardo da Vinci (1452–1519) in Lombardy. Quotations from Leonardo can be recognized in many of Luini's works, and Luini made frequent use of the master's compositional devices. He was also highly attentive to the Roman paintings of Raphael, and from these two sources he created a Lombard Renaissance style. In spite of Luini's profound reverence for two of the greatest and most sophisticated Italian painters of the day, his own work is unique, a striking and curious mixture of the innovative and the *retardataire*. But he had a successful and prolific career in and around Milan and in the region of Lakes Como and Lugano, and he was particularly distinguished as a fresco painter. The formal elegance of Luini's style and the sentimentality of his paintings ensured him great popularity with the Victorians.[1]

The term *Lamentation* is used to describe the scene immediately following the Descent from the Cross in which the body of Christ, stretched out on the ground or on an altarlike block of stone, is surrounded by mourners. The subject, absent from the gospels, appeared in the mystical literature of the thirteenth and fourteenth centuries, such as the *Revelations* of Saint Bridget of Sweden (1303–1373), in which she described her visions of the sufferings of Christ with much vivid and circumstantial detail. The Lamentation scene with its cast of various sorrowful figures is often distinguished from the Pietà, which usually shows the mourning Virgin Mary alone with the body of the dead Christ.[2]

In Luini's treatment of the theme,[3] several mourners grieve over the seated body of Christ before a dark background. The Virgin looks tenderly on his face while holding his lifeless left hand; Saint John the Evangelist helps support Christ's head and body as he turns his tear-filled eyes away. Seated at the lower right, Saint Mary Magdalene embraces the Savior's feet, with which she was particularly associated in accordance with the theme of her penitence.[4] At the upper right, one of the "Three Marys" wails and looks to heaven, tears running down her face. At the lower left a winged putto holds a pair of nails in one hand and stares in grief at a bent nail from the cross. Other visible reminders of Christ's Passion include the wound in his side, the result of his being pierced with a lance while on the cross, and the puncture marks on his forehead from the crown of thorns, which sits on the white winding sheet covering the stone ledge.

The *Lamentation* demonstrates Luini's sensitivity to sacred subjects and his ability as a painter of devotional images. Scholars have called attention to the iconic nature of the painting, with Christ's mortally wounded body presented for the pious contemplation of the beholder.[5] The sacramental associations of the image are intentional; Christ sits, Hostlike, on the stone ledge covered with a white cloth that suggests an altar. Although the three nails symbolizing Christ's Passion are often held by angels or Nicodemus or Joseph of Arimathea in scenes following Christ's death, the unusual emphasis in the painting on the nail—and the punctures on Christ's hands and feet—has led Carolyn Wilson to suggest that the painting is connected to contemporary devotion to one of Milan's most revered relics, one of the nails purportedly from Christ's cross that had been housed in the cathedral since 1461.[6] The *Lamentation* therefore might originally have been intended for a chapel or altar dedicated to the Sacrament and perhaps commissioned by a confraternity or religious society devoted to the promotion of the *Corpus Domini*.

The *Lamentation* is like any other picture by Luini, only more so. Even at this relatively late stage in his career, there remains a certain archaism about his work—for example, in the use of rigid gestures that emphasize the symbolic significance of each figure but fail to individualize them or unite the composition. The facial expressions owe much to Leonardo (as does the use of a delicate chiaroscuro), but the stylized gestures and poses, and the suppression of extraneous de-

1. For an introduction to Luini's life and work, see Binaghi Olivari 1996.
2. Hall 1979, 246.
3. For the most recent discussions of the painting, see Wilson 1996, 299–303, and Clifton 1997, 86–87.
4. In the feast in the house of Simon the Pharisee (Luke 7:36–50), Mary Magdalene wept tears over the feet of Christ, which she wiped with her hair and then kissed and anointed with oil of myrrh.
5. Wilson 1995a, 39; Clifton 1997, 86.
6. Wilson 1995a, 40, 41, fig. 4.

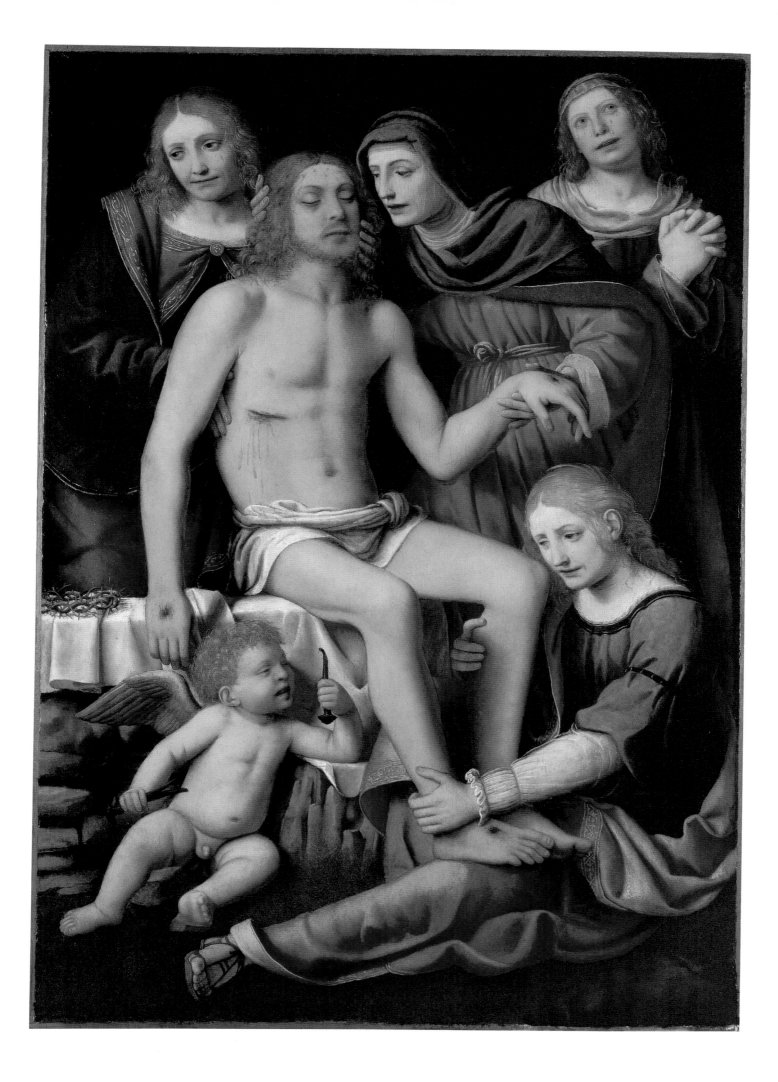

7. Binaghi Olivari 1996, 785, repr.

8. Clifton 1997, 86.

9. Vasari [1568] 1996, 1:808.

10. The painting was cleaned and restored in 1998 by Mario and Dianne Modestini at the Conservation Center of the Institute of Fine Arts, New York University.

tail are very much Luini's own. Luini made frequent use of his figures and motifs from one composition to another; the figures and expressions in the museum's painting, for example, are identifiable in a large altarpiece of the *Deposition,* 1516, painted for the chapel of the Sacrament in San Giorgio al Palazzo, Milan.[7]

None of these observations are intended as pejorative, however, or to diminish Luini's remarkable ability as a painter of powerful and affecting religious images. Luini's sacred paintings have always found admirers, in his day and in ours. His work was highly regarded particularly in the early seventeenth century by the archbishop of Milan, Cardinal Federico Borromeo (1564–1631), an important patron and collector who owned nearly a dozen of Luini's paintings. His praise for "the exceptional beauty, sweetness, and the tender and pious movements and faces" in a work by

Luini applies equally to the museum's remarkable and deeply felt *Lamentation.*[8]

Giorgio Vasari characterized Luini as "a very delicate and pleasing painter" and noted in particular that he "worked with a very high finish in oils."[9] Luini's technical finesse is shown to perfection in the *Lamentation,* in which the paint has been handled with consummate skill to produce an enamel-like surface. In composing the body of Christ, for example, Luini applied thin scumbles and glazes over an underlayer to give the appearance of marble or alabaster. He handles oil paint like a Flemish master, resembling the technique of Rogier van der Weyden (see pp. 9–11) or Hans Memling (see pp. 19–21). The recent cleaning and restoration of the painting reveals once more Luini's soft and luminous rendering of the flesh and draperies, his rich palette of glowing colors, and his meticulous technique.[10]

## Bartolomeo Veneto

Italian (Venetian), active 1502–died 1531

### *Portrait of a Gentleman,* 1520

Oil on wood, 27 7/8 x 21 1/2 in. (70.8 x 54.6 cm)
The Edith A. and Percy S. Straus Collection
44.573

1. For discussion and complete biography, see Wilson 1996, 306–14; Pagnotta 1997, 90, 91, 232–35, no. 31.

2. Pagnotta 1997, 213–15, no. 27.

3. Ibid., 156–57, no. 2.

Bartolomeo Veneto's *Portrait of a Gentleman* is a memorable creation,[1] characteristic of the half-length portraits of young men dressed à la mode in the Armani and Versace of their day. The American art historian, critic, and connoisseur Bernard Berenson recognized Bartolomeo's authorship of the painting in 1895, and since then the work has been appreciated as one of his finest portraits of fashionable young men. Bartolomeo was also an accomplished portraitist of women (for example, *Portrait of a Young Woman,* Sarah Campbell Blaffer Foundation, Houston),[2] so it is surprising that much of our knowledge of the artist is based largely on the signatures, dates, and inscriptions on his works. He worked in Venice, the Veneto, and Lombardy in the early decades of the sixteenth century, and his earliest surviving works are mediocre devotional paintings that reveal the influence of the Venetian master Giovanni Bellini (1431/36–1516) and his

workshop. His earliest dated painting, a *Virgin and Child,* 1502 (location unknown), is signed "Bartolomeo half-Venetian and half-Cremonese."[3] The inscription, thought to refer to his origins, has also been taken as an indication of the eclectic nature of his training.

A host of influences has been evoked to explain the style and character of Bartolomeo's portraits, including the work of such contemporaries as Leonardo da Vinci, Albrecht Dürer (1471–1528), and Titian (c. 1487–1576). Bartolomeo's experience as a painter at the Este court in Ferrara from 1505 to 1508 and contact with the leading Ferrarese painters of the day have also been cited as factors in his artistic development. By the second decade of the sixteenth century, he had developed a grand manner that focused on the fancy dress and rich adornments of his patrician patrons, marked by opulent costumes, dramatic lighting, and formal backdrops. He developed an

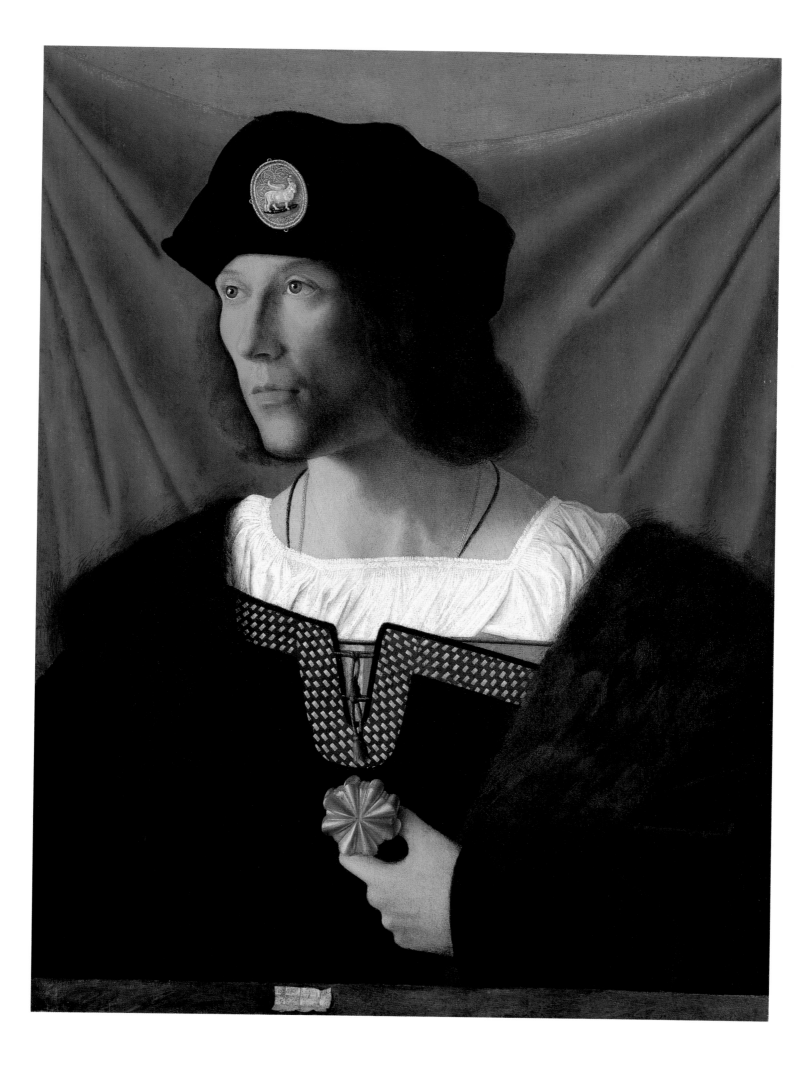

4. Wilson 1996, 309.
5. Pagnotta 1997, 90.
6. Ibid., 210–12, 238–41, nos. 26, 33.

extraordinary ability to endow his paintings with a sense of material richness, and he always paid meticulous attention to costume detail.

The museum's portrait characterizes Bartolomeo's ability to convey an impression of vitality and alertness through the sitter's rapt gaze and thoughtful expression. The bold contrast of the vibrant red cloth hanging against a sky-blue background, which enhances the sitter's blue eyes and ruddy complexion, seizes our attention as forcibly as the elegant interplay of white, black, and gold in the costume. Bartolomeo's technical skills are amply revealed in the meticulous drawing and the careful rendering of the various textural surfaces. His Venetian training and the heritage of Bellini are indicated in the atmospheric play of light over the sitter's features (especially the shading of the near side of his face) and costume. The inclusion of the *cartellino,* or rectangle of white paper, resting against the red-and-gray marble ledge is another feature of Bellini's portraiture.

The young man is depicted in accordance with a convention favored by the artist for his male portraits, slightly more than bust length, the face in three-quarter view to the viewer's left and the shoulders turned slightly in the same direction. With his left hand the sitter grasps the hilt of a sword or rapier, which terminates in a gilt knob. He wears a black cord and gold chain around his neck and a black hat embellished with a gold filigree brooch decorated with the image of a winged ox in mother-of-pearl. The sword pommel and brooch belong to the tradition of bust-length portraiture of fashionably dressed young men in northern Italy and in Germany in the second decade of the sixteenth century. The cap brooch is a personal emblem, and the winged ox, identified as a symbol of Saint Luke, probably refers to the sitter's name or indicates his membership in a particular society.[4]

The identity of the subject of this exceptional Renaissance portrait remains unknown. Unfortunately, the date once visible on the *cartellino,* variously read as 1512 and 1520, has been obliterated in previous cleanings of the panel, although the later date has been reaffirmed in the most recent discussion of the painting.[5] Bartolomeo was probably in Padua in 1512, and this had led to the suggestion that the sitter was possibly a student at the University of Padua. From 1520, the painter was in Milan, and this has led to other possible identifications, none of them conclusive. The museum's portrait has been convincingly linked with two other male portraits by Bartolomeo, one in Rome (Galleria Nazionale d'Arte Antica) and one in Washington, D.C. (National Gallery of Art), of fashionably dressed young men in similar poses wearing similarly striking, voguish costumes and sporting cap badges.[6]

## Vincenzo Catena

Italian (Venetian), c. 1480–1531

### *Virgin and Child with Saints John the Baptist and Joseph,* c. 1525

Oil on canvas, 30 1/4 x 41 in. (76.8 x 104 cm)
The Samuel H. Kress Collection
61.61

This late work by the Venetian painter Vincenzo Catena is one of the most tender and serene Renaissance paintings in the museum's collections. Catena was far from being either the most original or innovative painter of his time, but his paintings are almost always handsome and pleasing, with their distinctive, diffused light and warm colors. He seems to have been active as a painter in Venice around 1500, and the earliest written record of his existence is an inscription dated 1 June 1506 on the reverse of the Venetian painter Giorgione's (1475–1510) *Laura* (Kunsthistorisches Museum, Vienna), which indicates that the two artists had entered into some kind of partnership at the time. Catena was relatively prosperous, thanks to some commercial activity, possibly trading in spices, and as a painter he may have been a dilettante. He moved in intellec-

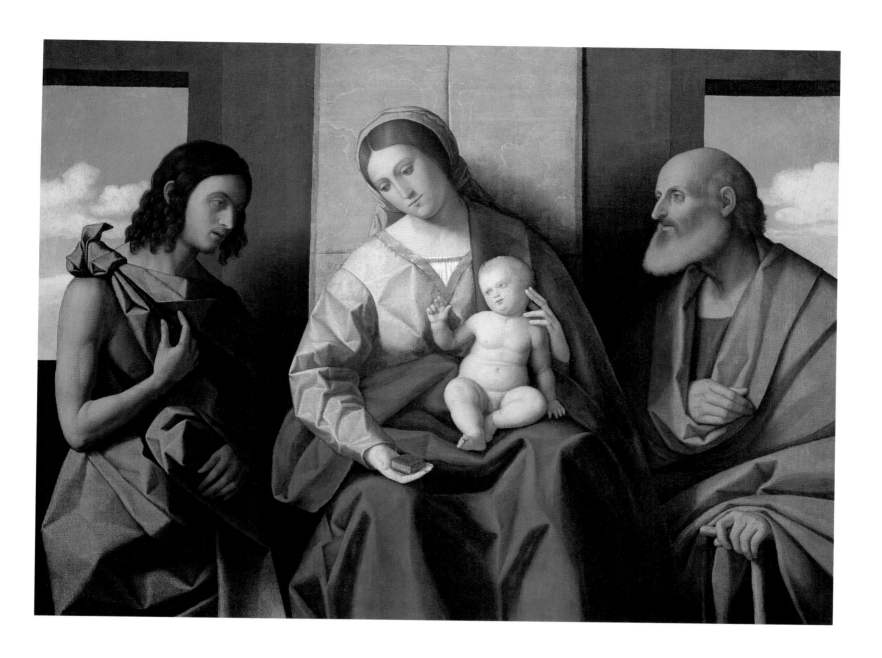

tual and aristocratic circles, and his friends included the Venetian humanist and scholar Pietro Bembo. Despite this suggestion of learning and worldly sophistication, he appears to have painted only religious subjects, mostly Madonnas, and male portraits, which Vasari thought were among his finest works.[1]

Catena was deeply influenced by the paintings of Giovanni Bellini and his workshop, whose motifs and compositions he borrowed and perpetuated into the second quarter of the sixteenth century. Art historians have minutely analyzed Catena's paintings and have shown that he was attentive to the leading Venetian painters of his time, including Titian, Sebastiano del Piombo (see pp. 36–39), Palma Vecchio (1479/80–1528), Cima da Conegliano (1459/60–1517 or 1518), and Marco Basaiti (active 1496–1530). His masterpiece is *Christ Saving Saint Christina*

*from Drowning,* painted at the beginning of the 1520s for the church of Santa Maria Mater Domini, which is said to be the earliest example in Venice of a narrative altarpiece that does not represent a New Testament subject.[2]

Informal groupings of saints around the central figure of the Virgin Mary holding the Child are traditional features of Venetian Renaissance art. These representations, which

1. The standard monograph on Catena is Robertson 1954; for a brief introduction, see Rylands 1996.
2. Rylands 1996, 85.
3. J. Patrice Marandel in Houston 1981, 38. Wilson 1996, 334–40, has summarized meticulously the particulars of the Bellinesque compositional type.
4. The painting was cleaned and restored in 1998 by David Bull, Washington, D.C.
5. Wilson 1996, 336.

bear no relation to a specific story from the gospels or to the particular legends of the represented saints, are called *sacre conversazioni*. Their invention is usually credited to Venetian painters of the late fifteenth or early sixteenth century, such as Bellini, who devised a horizontal format for his representations of the Madonna and Child with saints that enjoyed widespread popularity in Renaissance Venice.[3] Here, the Virgin and Child are shown seated in a stone interior before a pale gray hanging of watered silk. Large windows at either side open to a blue sky with white clouds, suggesting that the setting is an upper room. As in many of Catena's paintings, the Christ Child is shown nude and raises his hand in blessing. The three-quarter-length saints flanking the Virgin and Child are also familiar and appear in other works of the same compositional format.

Catena developed his painting technique from his fellow Venetian painters just at the time that oil paint was coming into common usage. Vasari offers the anecdote that Antonello da Messina (c. 1430–1479) learned the technique of oil painting under Jan van Eyck in Bruges. He reported that Antonello visited Venice and passed on the knowledge of his new technique to Bellini. Although it seems highly unlikely that Antonello did actually study under van Eyck, it is known that he visited Venice in 1475 and probably brought the new technique of oil painting to the Venetian painters. The first known use of oil paint has been found in passages of the *Coronation of the Virgin* altarpiece painted by Bellini

(Museo Civico, Pesaro), which is generally dated at this time. While Bellini continued to use both tempera and oil for a number of years, his younger students, assistants, and followers readily adopted the new medium of oil.

The *Virgin and Child with Saints John the Baptist and Joseph* was painted entirely with oil paint on top of a traditional white gesso ground on a canvas support. Unfortunately, the painting has suffered considerable paint loss in a number of areas. The largest of these losses occur in the Virgin's blue robe, in passages of Joseph's orange robe, in some areas in the sky, and at the edges of the composition. Abrasion of the uppermost paint layer covers a majority of the painting's surface, although the figure of Saint John the Baptist exists in a fine state of preservation.[4]

In spite of its condition, the *Virgin and Child with Saints John the Baptist and Joseph* readily reveals Catena's strengths as a painter. His style is close to Bellini's, but his extensive use of geometric shapes to set off the figures of the saints is original. He establishes an aura of reverence by the simplicity of the symmetrical setting; the quiet poses, gentle demeanor, and trancelike expressions of his figures; and the atmospheric quality of the chiaroscuro.[5] Rich, harmonious color is one of the best features of Catena's paintings— the Virgin's violet headcloth, rose-colored robe, white shirt, and blue mantle; Saint John's richly saturated green cloak (worn instead of his traditional hair coat and cloak); and Joseph's blue robe and vivid orange mantle.

## Sebastiano del Piombo

Italian (Venetian), c. 1485/86–1547

## *Anton Francesco degli Albizzi,* 1525

Oil on canvas, 53 x 38 7/8 in. (134.6 x 98.7 cm)
The Samuel H. Kress Collection
61.79

Sebastiano del Piombo's biographer, Giorgio Vasari, enthusiastically described this portrayal of the thirty-eight-year-old Florentine patrician:

*He also painted a portrait of the Florentine Anton Francesco degli Albizzi, who happened to be then in Rome on some busi-*

*ness, and he made it such that it appeared to be not painted but really alive; wherefore Anton Francesco sent it to Florence as a pearl of great price. The head and hands of this portrait were things truly marvelous, to say nothing of the beautiful execution of the velvets, the linings, the satins, and all the other parts of the pic-*

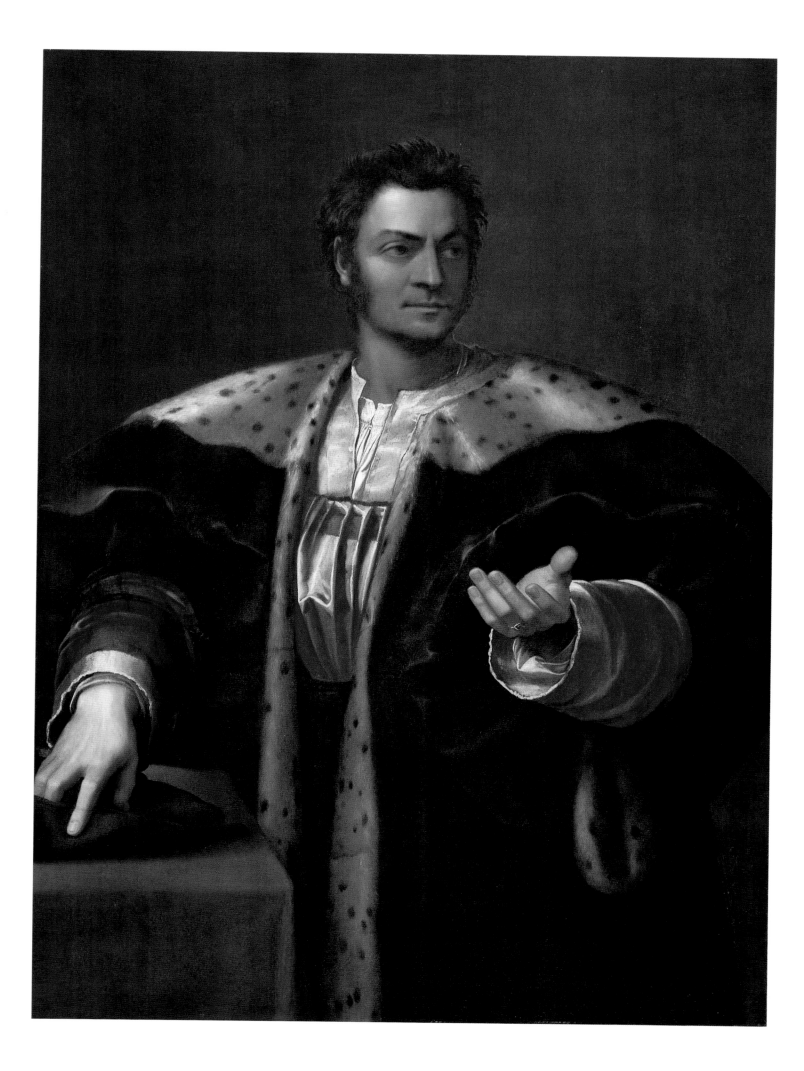

1. Vasari [1568] 1996, 2:146.
2. For Sebastiano's life and career, see Hirst 1981.
3. Ibid., 69–70.
4. Wilson 1996, 344. For discussion and bibliography, see J. Patrice Marandel in Museum of Fine Arts 1981, 40; Wilson 1996, 341–48; Hirst 1981, 102–8, figs. 121, 123.
5. Hirst 1981, 103 n. 55; Wilson 1996, 345–46.
6. Hirst 1981, 103 n. 55, citing Varchi 1888, 3:71.

*ture; and since Sebastiano was indeed superior to all other men in the perfect delicacy and excellence of his portrait-painting, all Florence was amazed at this portrait of Anton Francesco.*[1]

The rhetorical grandeur with which Sebastiano has imbued this portrait, which represents the *ne plus ultra* of arrogant assurance, demonstrates why he is considered one of the major exponents of High Renaissance painting.[2] According to Vasari, Sebastiano trained in Venice with Giovanni Bellini, but his early work was most strongly influenced by Giorgione. In 1511 Sebastiano moved to Rome on the invitation of the wealthy Sienese financier Agostino Chigi and remained there for the rest of his life, excepting a visit to Venice in 1528–29 after the Sack of Rome. Sebastiano formed a friendship and professional relationship with Michelangelo (1475–1564), who recommended him to people of influence and supplied him with inventive ideas in the form of drawings, as with *The Raising of Lazarus,* 1517–19 (National Gallery, London).[3] Under Michelangelo's guidance, Sebastiano's work achieved a distinctive somber eloquence, which together with the illusionistic colorism of his Venetian heritage, resulted in a powerful and original personal style.

Following the death of Raphael in 1520, Sebastiano had no rival in Rome in the field of portraiture. His early Roman portraits combined elements from the portrait traditions of both Venice and Rome, and the monumental style he created came to fruition in a series of portraits in the mid-1520s, of which the museum's portrait is one of the most memorable. After Giulio de' Medici, who reigned as Pope Clement VII from 1523 to 1534, appointed Sebastiano keeper of the papal seals in 1531, he became less active as a painter. The seals were made of lead, *piombo* in Italian, which explains the name (properly Sebastiano Luciani) by which he is known in the literature on art.

The museum's extraordinary portrait, in its scale, breadth, and monumentality of form, has long been admired as the epitome of Renaissance portraiture for its conveyance of "magnificence, power, and irreproachable rank."[4] Sebastiano chose a life-size, three-quarter-length format for his subject and posed him in a powerful frontal stance. The subject turns his head toward the viewer's right and looks in that direction, without engaging the viewer. The face is calm except for the slight contraction of the brows, which with bristling hair convey a hint of ferocity. The rhetorical attitude of the left hand, dramatically lit and foreshortened, implies authority and purpose and commands attention. (The bold projection of the arm has been described as almost violent.) The weight and opulence of the costume, the three-dimensional solidity of the fabrics, and the almost terrifying sense of physical presence represent the height of Sebastiano's career as a portrait painter.

Anton Francesco degli Albizzi (1486–1537) was a political figure who participated in the establishment and maintenance of the Florentine republic of 1527 to 1530. In 1537, following the assassination of Alessandro de' Medici, he met with the anti-Medicean cardinals in Rome and participated in the alliance against Tuscany. Along with other Florentine notables, he was taken prisoner by troops of Cosimo I de' Medici, grand duke of Tuscany, and was beheaded for treason in the courtyard of the Bargello.[5] Albizzi was described by the Italian historian Benedetto Varchi as overbearing, haughty, and restless, qualities of temperament Sebastiano captured vividly.[6]

The portrait is recorded in an exchange of letters between Sebastiano and Michelangelo and thus is known to have been completed in 1525 in Rome, where Anton Francesco had apparently made a recent visit. Toward the middle of April 1525, Michelangelo wrote to Sebastiano from Florence: "Sebastiano, colleague and dearest friend—A Picture by your hand, painted for Anton Francesco degli Albizzi, is here awaited, not only by me, but by others who are attached to you or who know you through the excellence of your reputation. We imagine that it is finished and are longing to see it." On 22 April Sebastiano replied from Rome. He begged forgiveness for being five or six days behind, requested Michelangelo to tell Anton Francesco and his former patron, Pierfrancesco Borgherini, that the work would be finished in two days, and confessed, "It is more difficult for me to paint a hand or a simple fold of drapery than to make all the saddles in the world." On 29 April Sebastiano wrote that the picture was

7. Wilson 1996, 345, with full bibliographical citations in nn. 14–18.

8. J. Paul Getty Museum 1997, 30, repr.

finished and that he would varnish it the following day. In May Michelangelo wrote again to Sebastiano to reassure him of the high esteem in which his art was held in Florence as well as in Rome: "Seeing then, that my opinion is justified, don't say, henceforth, that you are not unique, when I write and tell you that you are, because there are too many witnesses and there is a picture here, thank god, which proves, to anyone who has eyes to see, that I'm right."[7]

The painting was originally executed on a panel consisting of three vertical planks, but sometime before 1930 it was mounted on canvas. This process, known as a "transfer," was traditionally undertaken to separate the paint film and its ground from an unsound support and remount the picture on a new support, in this instance, canvas. The technique had been practiced since the eighteenth century, often with disastrous results. The museum's painting inevitably suffered, too, in the procedure, and upon close examination losses can be seen in the background, along the join lines of the original panel, and

in the sitter's proper right sleeve. Its present condition notwithstanding, the qualities of the portrait that Vasari so enthusiastically praised—its lifelike quality and the admirable rendering of the materials in the costume—may nonetheless be admired nearly 475 years after the work was created.

Sebastiano seems to have anticipated the destructive effects of time on his art and often experimented with various painting supports to extend the longevity of his works. He began painting on stone about 1530, for example, and a portrait of Pope Clement VII painted on slate about 1531, now in the J. Paul Getty Museum, Los Angeles, epitomizes these efforts.[8] Slate had not often been used as a support for painting, but Sebastiano came to favor it for especially important commissions. The pope seems to have shared Sebastiano's concern with longevity, as he specified the stone support for his own portrait. They both knew that wood and canvas would eventually deteriorate and surmised correctly that slate might prove to be an extremely durable support.

## Domenico Tintoretto

Italian (Venetian), 1560–1635

*Tancred Baptizing Clorinda,*
c. 1586–1600

Oil on canvas, 66 5/16 x 45 1/16 in. (168.4 x 114.7 cm)
The Samuel H. Kress Collection
61.77

1. Lee 1981, 329.

2. Buzzoni 1985.

One of the most popular sources for artistic themes in seventeenth- and eighteenth-century Italy and France was the romantic epic poem *Gerusalemme Liberata* by the Italian poet Torquato Tasso (1544–1595). Appearing in pirated editions against the author's wishes in 1575–76, *Jerusalem Delivered* is an idealized account of the first crusade against the Saracens, which ended with the capture of the holy city in 1099 by Godfrey of Bouillon and the establishment of a Christian kingdom. The poem reflects the Church's historical concern with the Muslim threat against Europe, renewed after the fall of Constantinople in 1453. The progress of Islam had occupied continuously the minds of popes and princes, and plans for a new crusade to

regain the Holy Land became a recurrent proposition. Tasso's poem was not only appropriate to the religious piety of the Counter Reformation, it was vividly topical in light of the perceived danger Islam posed to Italy in the late sixteenth century.[1]

Tasso modeled his poem on the two great epics of antiquity, the *Iliad* and the *Aeneid*. Like those classics, the appeal of *Gerusalemme Liberata* owes much to its rich human and romantic content, particularly its many amorous adventures between Christian and pagan men and women. Tasso's epic created excitement among artists, writers, musicians, and playwrights almost immediately upon its publication in 1581 and continued to inspire them for the next two hundred years.[2] For

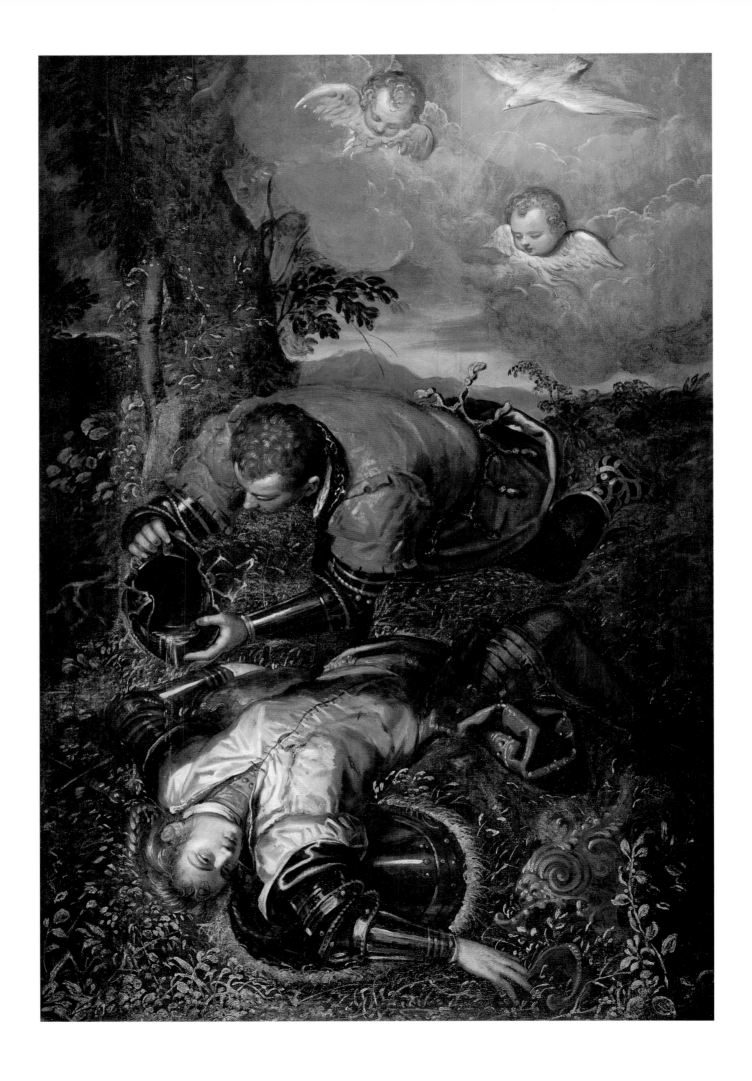

3. For discussion and bibliography, see David H. Steel, Jr., in Ishikawa 1994, 80–84, no. 5; Wilson 1996, 369–77.

4. Lee 1970, 20. For exhaustive summaries of the literature on the painting, see Wilson 1993, and Wilson 1996, 370–77.

5. Wilson 1993, 121–22; Wilson 1996, 374–76.

6. Wilson 1996, 369.

7. Ridolfi 1648, 2:262.

painters in particular, the accounts of the lovers Rinaldo and Armida, Tancred and Erminia, and Tancred and Clorinda became a marvelous source for pictorial representation.

*Tancred Baptizing Clorinda* was first published in 1924 as a work by Jacopo Tintoretto (1518–1594),[3] one of the most successful Venetian painters in the generation after Titian's death. The painting is one of the earliest pictorial representations of Tasso's poem. It depicts the aftermath of the battle in the twelfth canto (stanzas 64–70) between one of the heroes of the poem, Tancred, a Christian knight, and Clorinda, a Saracen princess with whom he has fallen in love. Not recognizing Clorinda in armor, Tancred engages her in combat. Following a nightlong battle, he wounds her mortally as dawn breaks. Before she dies, Clorinda requests Christian baptism, and Tancred carries water from a nearby brook in his helmet, only recognizing her identity as he unlaces her helmet. As he kneels in full armor, pouring water from his helmet, Clorinda appeals to Tancred with her dying breath:

> *This thine—my friend!—I pardon thee the stroke—*
> *O! let me pardon, too, from thee invoke!—*
> *Not for this mortal frame I make my prayer,*
> *For this I know no fear, and ask no care:*
> *No! For my soul alone I pity crave;*
> *O! cleanse my follies in the sacred wave!*

It is then that he recognizes his beloved; the heavens open and in radiant glory the dove of the Holy Spirit descends. Numerous commentators on the museum's painting—over which an astonishing amount of ink has been spilled in discussions of its authorship, meaning, and date—have agreed with Rennselaer Lee that the work is "one of the most striking, the most poignantly felt of all illustrations of Tasso."[4] The painter's sensitive reading of the text is revealed in such pictorial details as Clorinda's pale face "overspread with a lovely pallor," her hand "ungloved and cold," her eyes already veiled by death, "as if she sleeps." Scholars have made numerous analogies to the poses and gestures of figures in the paintings of Jacopo Tintoretto, and the source of the specific disposition of Clorinda's limbs and torso has been traced to an antique marble sculpture of a dead Gaul now in the Museo Archeologico, Venice.[5]

For many years *Tancred Baptizing Clorinda* was thought to be the work of Jacopo Tintoretto, but, beginning around sixty years ago, the painting was increasingly thought to be attributable to his son and collaborator, Domenico. Trained by his father, Domenico continued the stylistic language of the Tintoretto workshop into the seventeenth century in numerous altarpieces and devotional pictures he painted for Venetian churches and confraternities. He helped his father on numerous commissions, including the decoration of the Scuola Grande di San Marco, where he painted additional scenes in the life of Saint Mark in the remarkable series begun by Jacopo in 1548. Domenico's work has been characterized as more realistic than Jacopo's, and his sharp eye for the details of physiognomy and costume contributed in great part to his success as a portraitist.[6]

Domenico Tintoretto's biographer singled out for comment Domenico's literary education, his delight in composing verses, and his enthusiasm for painting subjects based on the literary works of ancient and modern poets.[7] He indeed produced several paintings that confirm his grasp of classical literature, such as Ovid's *Metamorphoses*, notably a *Venus and Adonis with the Three Graces* (The Art Institute of Chicago) and a *Death of Adonis* (University of Arizona, Tucson).

# Pieter Isaacsz.

Dutch (active in Denmark), 1569–1625

## The Baptism of Christ, c. 1590

Oil on copper, 17 1/4 x 14 1/4 in. (43.5 x 36 cm)
Museum purchase
73.185

Although the usual support for oil paintings is stretched linen or wood, beginning in the third quarter of the sixteenth century, artists in both the north and south of Europe began to paint on copper.[1] The primary reason painters chose to work on small copper plates was because their hard, smooth, nonabsorbent surfaces were perfect for achieving astonishing and meticulous pictorial effects. Around 1600, artists in droves used copper plates when they wanted to express themselves on a miniature scale and to demonstrate their virtuoso handling of the brush. Paintings on copper proliferated in collectors' cabinets across Europe in the late sixteenth century and were often featured in *Kunstkammern,* or cabinets of art, a fixture of many princely collections, intended to house small bronzes, works in cut stone, medallions and ivories, coins, scientific instruments, books, prints and drawings, and paintings.

The practice of painting in oils on copper seems to have originated in Bologna, Florence, and Rome in the late sixteenth century, but northern painters in Italy swiftly adopted the practice. The Antwerp painter Bartholomeus Spranger (1546–1611), active in Italy from 1557 to 1575, was painting on copper by around 1570. He played a significant role in the transmission of the technique from Italy to other parts of Europe when he left Rome in 1575 to work for the Holy Roman emperor Maximilian II in Vienna and in 1580 traveled to Prague, where he entered the service of the emperor Rudolf II.[2] Karel van Mander (1548–1606) in his *Schilderboeck,* or *Lives of the Illustrious Netherlandish and German Painters* (1603–4), cited a number of northerners in Italy in the late sixteenth century noted for their small pictures on copper.[3]

Among these is the Dutch painter Pieter Isaacsz., who was brought up in Denmark, where his parents had fled following disturbances in the Netherlands. According to van Mander, Isaacsz. began his artistic training in Amsterdam and later became a pupil of one of the foremost Prague school painters, Hans

von Aachen (c. 1552–1615), traveling with him through Italy and Germany. Isaacsz. acquired a reputation as a portrait painter, resulting in commissions to paint large militia group portraits, but van Mander also recorded his success as a history painter, citing his small oils on copper: a *Saint John the Baptist Preaching,* "which is a well composed, lively and subtle little piece," and the *Uprising of the Women of Rome,* c. 1600 (Rijksmuseum, Amsterdam), "a very subtle piece by him on copper."[4] Isaacsz. left Amsterdam in 1607–8 to return to Denmark, where he entered the service of Christian IV (1577–1648), king of Denmark, for whom he worked intermittently as a court painter, agent, and artistic adviser.[5]

*The Baptism of Christ* was acquired by the museum in 1973 with an attribution to von Aachen. Isaacsz.'s authorship was identified a few years later on the basis of a pen-and-wash drawing in the Ecole Nationale Supérieure des Beaux-Arts, Paris, inscribed with his name, that served either as a preparatory model for the painting or as an exact record of its composition.[6] Isaacsz.'s glowing colors, sinuous forms, and sophisticated composition are typical of Mannerist paintings in the Netherlands in the last decade of the sixteenth century.[7] In this early work his debt to his teacher, von Aachen, is evident in the drawing, astringent coloring, and combination of the most improbable figures in convincing arrangements. Compressed onto the confines of a small copper plate, Isaacsz.'s pictorial artifice—in van Mander's phrase, "full of details and very subtly and carefully executed"[8]—appears all the more extraordinary. Works like *The Baptism of Christ* were intended for private enjoyment; the typically small scale of the copper plate meant that its possessor could easily inspect the work closely and intimately, holding the painting in his or her hands.

Often the subjects of Mannerist paintings were approached in an unconventional way. Isaacsz. composed his paintings according to the rules explained by van Mander—the principal theme is set in the background, and

1. For a history and discussion of paintings on copper, see Bowron 1999.
2. For the work of Spranger and the Prague school, see Fucíková 1997.
3. Van Mander [1603–4] 1994 mentions Johann Rottenhammer (1564–1625), Jan Brueghel I (1568–1625), Paul Bril (c. 1554–1626), Adam Elsheimer (1578–1610), Aert Mitjens (1541–1602), Hans Soens (1553–1611), and Joseph Heinze (1564–1609) among painters noted for their works on copper.
4. Ibid., 1:422. The first painting is lost; for the second, see Luijten 1993, 541–43, no. 214, colorpl. 224.
5. See Roding and Stompé 1997 for a basic account of Isaacsz.'s life.
6. Geissler 1979, 1:70; Ecole Nationale Supérieure des Beaux-Arts 1985, 222, no. 115. Thomas Da Costa Kauffman initially made the connection between the drawing and the museum's painting, and the painting was first published by Fucíková 1985, 172, fig. 16. See also Tylicki 1996, 136–37, fig. 2, and Roding and Stompé 1997, 13, 14, fig. 3.
7. For a brief introduction, see Lowenthal 1990.
8. Van Mander [1603–4] 1994, 1:422.

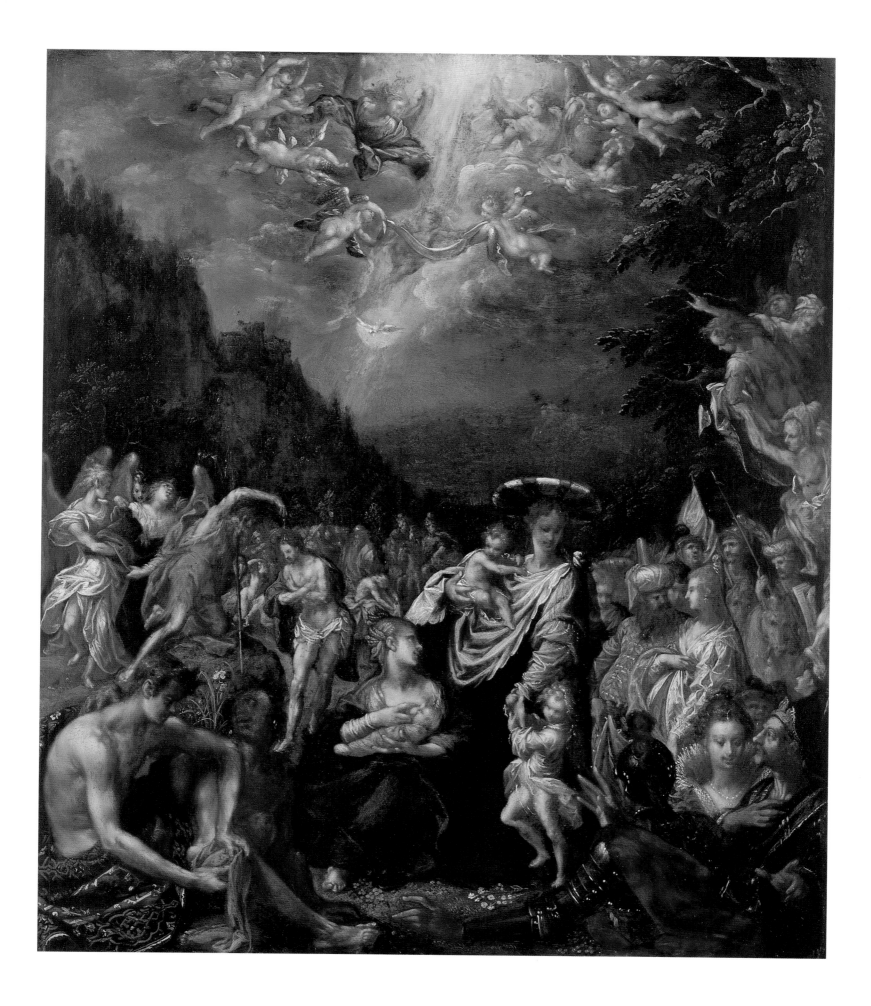

9. Tylicki 1996, 136, 141 n. 19.
10. Ibid., 136–47, 141 n. 23.

the composition is filled with an audience consisting of figures in a variety of attitudes, movements, and dress, enabling the artist to show off his skills.[9] The actual baptism of Christ, for example, takes place in the midst of a throng of onlookers so dense that the central figures of Christ and John the Baptist at the left of center are almost overlooked. Another Mannerist compositional device, inherited perhaps from von Aachen, is the placement in the foreground of only partly visible figures that are depicted from an unexpected angle. The painting is filled with unusual details, including strange coiffures, exotic headdresses such as the peaked turbans or the platelike hats of gypsy women (in those days regarded as Egyptian), and costly Oriental rugs worn as garments. These oddities have been explained as representations of the different nations of the East attending the event; Mark (1:5–6) tells how the people "flocked from the whole Judaean countryside and the city of Jerusalem."[10] There is always an element of wonder in seeing a virtuoso performance, and one of the delights of paintings on copper of this period is the sight of dozens of figures painted in a composition on such a small scale. Isaacsz. has painted no fewer than fifty figures, but it is not uncommon to find similar compositions by his Dutch contemporaries with more than a hundred figures.

## Scarsellino

Italian (Ferrarese), 1550–1620

### The Virgin and Child with Saints Mary Magdalene, Peter, Clare, and Francis and an Abbess, c. 1600

Oil on canvas, 110 7/8 x 63 5/8 in. (281.5 x 161.7 cm)
Museum purchase with funds provided by the Agnes Cullen Arnold Endowment Fund
97.118

Working in the atmosphere of the Counter Reformation, Scarsellino spent most of his long career painting religious subjects in north Italy.[1] How ironic that modern taste instead recognizes the artist's representation of landscape and his excursions into classical mythology as his most congenial and sympathetic works. But it is works like this *Virgin and Child with Saints,*[2] painted for the high altar of the church of the convent of Santa Maria Maddalena delle Convertite, Ferrara, that established the painter's contemporary reputation.

Ippolito Scarsella (the diminutive "lo Scarsellino" was derived from his father, also a painter and an architect) appeared at a moment when the great age of Ferrarese painting, established by such artists of distinction as Dosso Dossi (c. 1490–1541/42), Battista Dossi (1490/95–1548), Girolamo da Carpi (c. 1501–1556), and Garofalo (1481–1559), began to decline with the death of the latter. Scarsellino remained not only the last of the important painters active in Ferrara in the sixteenth century, but also perhaps the only artist of major talent to paint there in the following century.

This altarpiece represents a type of composition known as a *sacra conversazione* (holy conversation) in which saints from different historical periods gather around the Virgin and Child. An inscription added early in its history to the bottom of the canvas explains the point: "Oh you who see and worship these saints here united in a single picture, whose earthly lives were led at different times, pause and read these sacred words and see the truth as if in heaven, face to face, for holier and more lovely than paradise is this image."

The principal saint, Mary Magdalene (1st century), kneels before the infant Jesus and holds her attribute, an ointment jar. The Magdalen is patron both of repentant sinners and of the contemplative life; this, together with her close association with Christ, explains her immense popularity through the ages. She was highly prominent in devotional images at the time of the Counter Reformation as a result of the Church's efforts to foster devotion to the Sacraments, particularly that of penance. Peter (died c. 64), whose deep reverence before his Savior is evident, is identifiable by his attribute of the keys of the Kingdom of Heaven (Matthew 16:19).

1. The basic study of the artist and his work, now out of date, is Novelli 1964.
2. The fundamental information about the painting is contained in the entry of the sale catalogue, *Important Old Master Pictures* (London: Christie's, 10 December 1996), 192, lot 114.

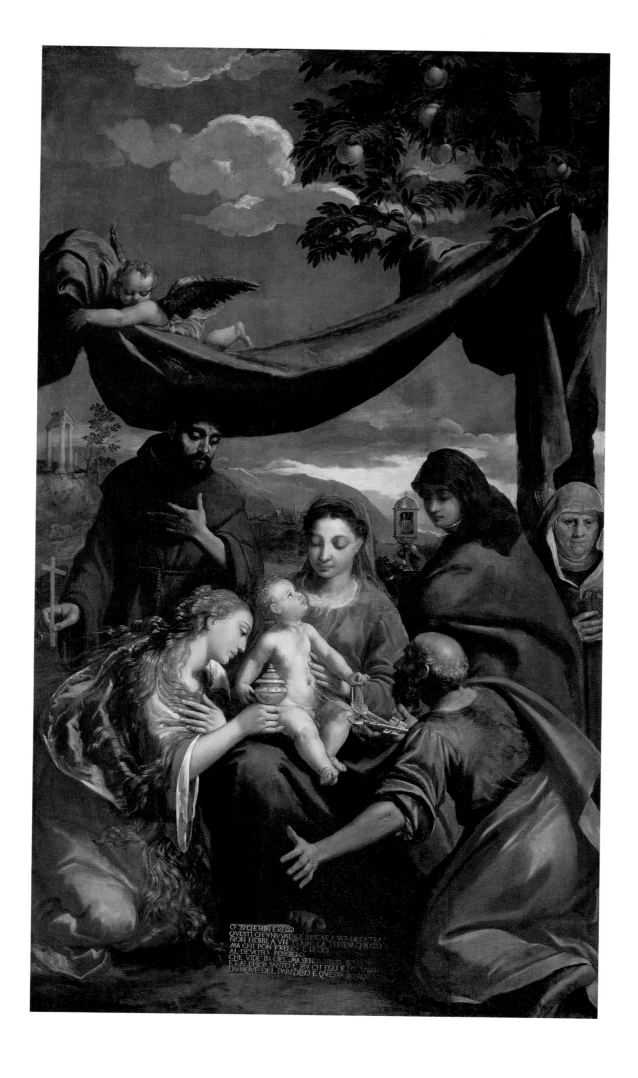

O LVCHE MIRI E REGGI
QVESTI CH'VNIVVADE E INSIEME A VOI DILONTRA
NON HEBBE A VN TEMPO LA TERRENA CHIOSTRA
MA CHI PON FRENO E LEGGI
AL DEVOTO PENSIERO
CHE VIDE IN CIEL MA SENZA FRENO E VERO
ET ALL'HOR SANTO E PIV CH'EGLI E PIV VAGO
DVNQVE DEL PARADISO E QVESTA IMAGO

3. Lanzi [1792] 1847, 2:208.
4. Laderchi 1838–41, 1:29–30, no. 245.
5. Giordani 1871, 11, no. 126: "Scarselli Ippolito, ferrarese, detto Scarsellino: La Madonna ed il Bambino sedenti, la Maddalena e S. Pietro ginocchioni, S. Francesco d' Assisi e santa Chiara, con un ritratto di monaco in piedi, figure al naturale, quadro su tela per altare."

Because of his denial of Christ and subsequent repentance (Mark 14:66–72), Peter also figured in devotional images intended to strengthen the Catholic reaction to Protestantism, which did not accept penance as a valid sacrament.

The presence of Francis of Assisi (1181–1226), founder of the Franciscan order, and Clare, virgin and founder of the Minoresses, or Poor Clares, confirms the order of the church. (The austere woman at the right edge of the composition is presumably the abbess of the nuns of the convent and the painter's patron for the commission.) The ease and simplicity with which these powerful, easily recognizable saints are arranged around the Virgin and Child reflect the dictates of Cardinal Gabriele Paleotti (1522–1597) on sacred art and his advice to painters of religious art. His *Discourse on Sacred and Profane Images* (1594) had a wide circulation in Italy and in other Roman Catholic countries. It expressed Paleotti's belief in sacred art as "the bible of the illiterate" and his efforts to stimulate a new art that would be openly propagandistic in the service of the Church.

Certainly not the least of the difficulties, and delights, encountered in the experience of Scarsellino's painting is his extraordinary ability and willingness to absorb the manner of other artists. Writing in the eighteenth century, Luigi Lanzi described his visits to Roman palaces in the company of others to examine the artist's paintings and how those present commented on Scarsellino's attention to the sixteenth-century painters Veronese (1528–1588), Parmigianino (1503–1540),

Titian, Dosso, and Girolamo da Carpi.[3] Here, for example, the figure of Saint Peter reveals the influence of the great Venetian painter down to the spirited brushwork and rich colors of his green and orange robes. The Magdalen, on the other hand, shows Scarsellino's admiration for Emilian painting of the sixteenth century, in particular the work of Correggio (c. 1489–1534) and Parmigianino, from whom her pose and shimmering hair are taken. A nineteenth-century writer, Carlo Laderchi, noted the inspiration of Correggio for the Magdalen, most probably from the same saint in Correggio's *Giorno,* now in the Pinacoteca Nazionale, Parma.[4]

When the church of Santa Maria Maddalena delle Convertite was suppressed in 1796 during the Napoleonic invasion of Italy, Scarsellino's painting entered the collection of Marchese Giovanni Battista Costabili Containi (1756–1841) in Ferrara. The marchese Costabili used the prominent position he gained from collaboration with the French during the Naploeonic regime and the patronage of the viceroy Eugène de Beauharnais to enrich greatly the family collection, concentrating on pictures from his native Ferrara. He amassed no fewer than 624 paintings, of which 385 were Ferrarese. The dispersal of the collection began after the middle of the nineteenth century; the majority of the Ferrarese pictures in the National Gallery, London, for example, were acquired in the 1860s from Costabili's heirs. Costabili owned no fewer than 20 pictures by Scarsellino, of which the museum's work is by far the most important.[5]

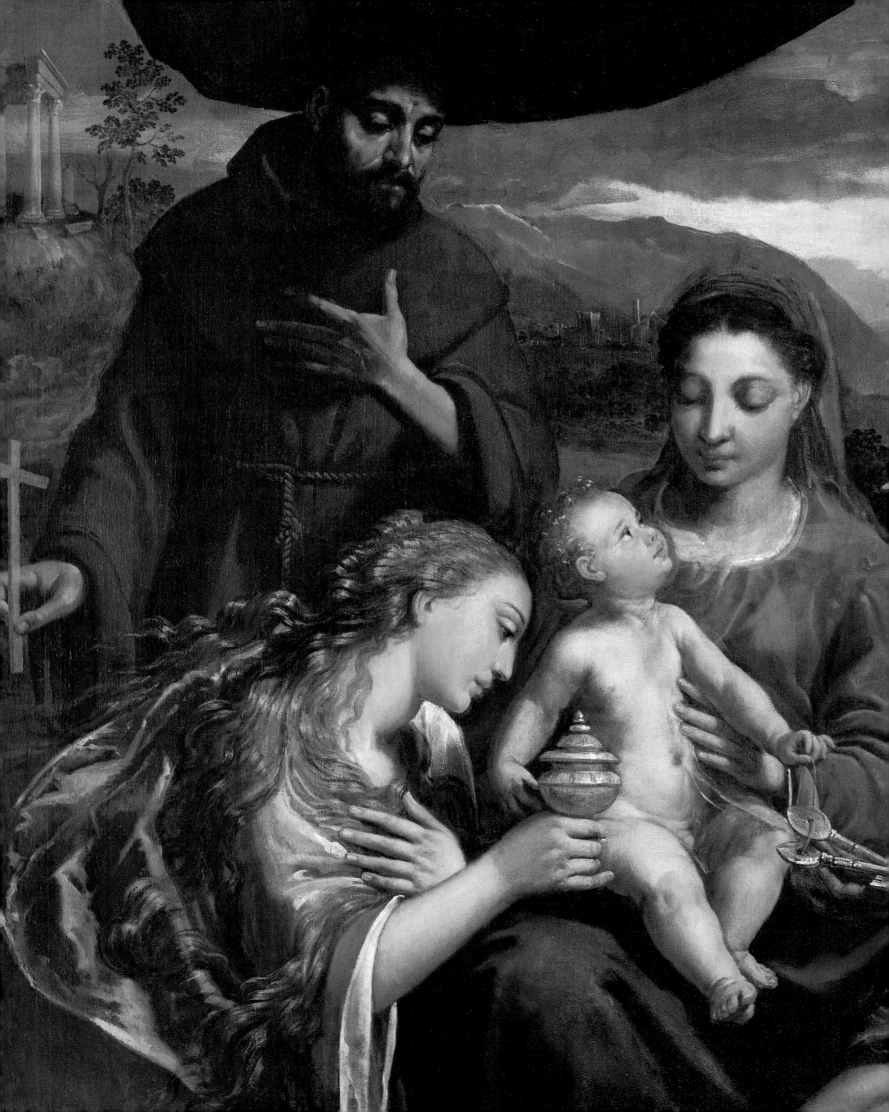

# Orazio Gentileschi

Italian (Florentine), 1563–1639

## Portrait of a Young Woman as a Sibyl, c. 1620

Oil on canvas, 32 1/8 x 28 3/4 in. (81.6 x 73 cm.)
The Samuel H. Kress Collection
61.74

The young woman holding a scroll and leaning against a slab bearing hieroglyphics has been identified as a sibyl, defined in ancient Greek literature and legend as a woman with the gift of prophecy, in particular a priestess of Apollo.[1] Initially mentioned in the writings of the Greek philosopher Heraclitus, Sibylla was given as the name of a specific woman from Asia Minor. By the first century B.C., the Roman writer Varro records ten sibyls, each linked to a famous oracular shrine of the ancient world, such as the one at Delphi. By the end of the Middle Ages the western Church, through its interpretation of the sibyls' foretelling of the Christian story, had accepted twelve of the women as prophets of the coming of Christ; they were designated as pagan counterparts of the Old Testament prophets.[2]

Sibyls were often depicted in Baroque painting, most memorably by Domenichino (1581–1641) (Galleria Borghese, Rome) and Guido Reni (collection of Sir Denis Mahon, London). The young woman depicted here—wearing a kind of turban to identify her as a sibyl and holding the scroll on which her prophecies are recorded—is thought to represent specifically the Libyan sibyl.[3] The solid young woman is typical of the physical types of Orazio Gentileschi, one of the most important of the followers of Michelangelo Merisi da Caravaggio (1571/72–1610) in Rome, whose lyrical style was a refined and elegant amalgam of the Lombard master's powerful realism. Like Caravaggio before him, Gentileschi chose subjects that required few figures and placed them close to the picture plane. The view of the sibyl and her upturned head are typical features of his heroines, and the rendering of her sumptuous orange brocade drapery anticipates the increased elegance of his later painting. Gentileschi delighted in intense attention to such details as hands, feet, and faces, and the ex-quisite refinement and meticulous handling of the sibyl's drapery, skin, hair, and turban are practically a signature of the artist.

This portrait of a young woman has generated a great deal of speculation about whether the model is or is not the artist's daughter, Artemisia (1593–1652).[4] A heroine to feminist art historians, Artemisia Gentileschi was one of the greatest of Caravaggesque painters and possessed a formidable personality. She was precociously gifted, established a European reputation, and lived a life of independence rare for women of that time. Much of her modern notoriety, however, derives less from her powerful style and predilection for blood-thirsty subject matter—such as paintings of Judith and Holofernes—than from her alleged rape at the age of nineteen by Agostino Tassi (c. 1580–1644).[5]

On the basis of a contemporary engraved portrait (believed to be after a self-portrait drawing by Artemisia) and a seventeenth-century portrait medal of the artist, scholars have identified the museum's *Sibyl* as a likeness of Artemisia. The facial features of the young woman—her high forehead, fleshy face, small mouth, and prominent chin with a cleft—are comparable to the established likenesses of Artemisia, and for some the similarities cannot be ignored. Orazio's posing of his daughter as the model for the sibyl would explain the tender mood of the picture and the sense of familiarity between the figure and viewer that exists for some observers. If Orazio did portray Artemisia as a sibyl, there would have been another important association for both father and daughter. In the rape trial of 1612, in order to determine the truth of her testimony, Artemisia voluntarily submitted to a type of torture in which metal rings were tightened about her fingers by a set of cords. This particular device for establishing the truth was called "the sibyls" (*sibille*).[6]

1. Hall 1979, 282.
2. Lynn Federle Orr in Ishikawa 1994, 126.
3. Bissell 1981, 187.
4. For the painting, see Spear 1971, 102–3, no. 31; Shapley 1973, 83–84; Bissell 1981, 187, no. 60; J. Patrice Marandel in Museum of Fine Arts 1981, 48, no. 88; and Orr in Ishikawa 1994, 124–27, no. 14.
5. Garrard 1989, 403–87, for testimony of the rape trial of 1612. The records preserved in the Archivio di Stato, Rome, contain no notice of the trial's resolution. Tassi was presumably found guilty, but there is no record of a sentence.
6. Garrard 1989, 21.

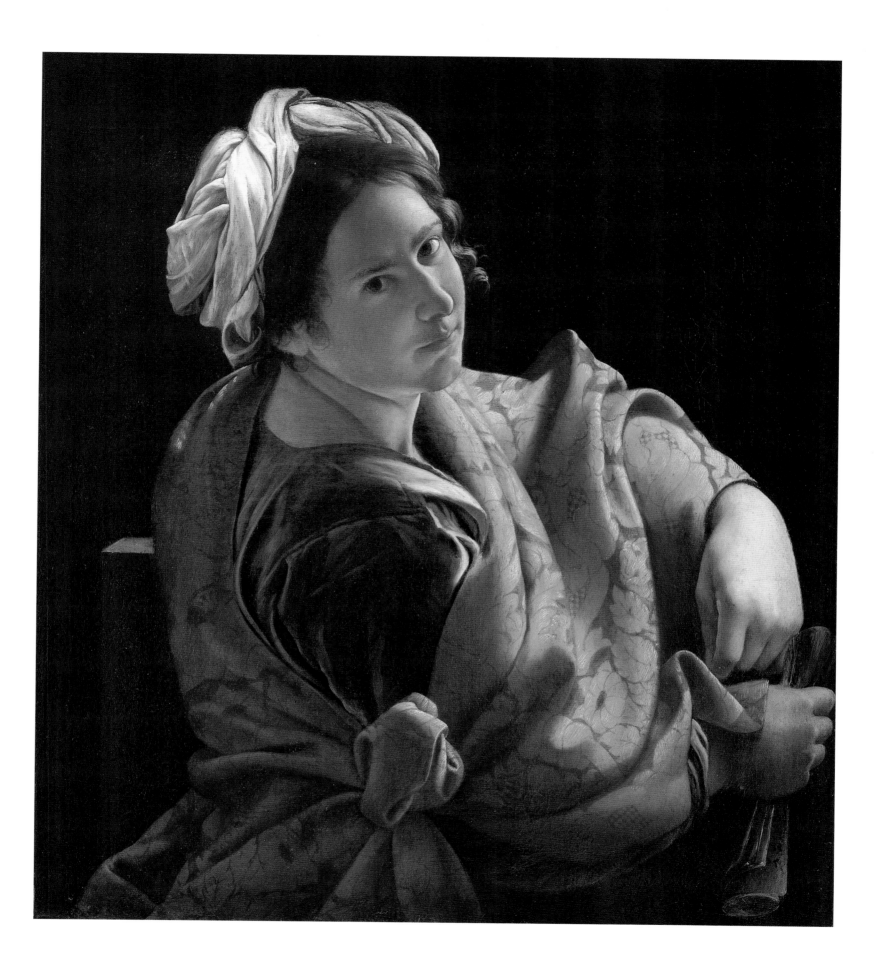

# Pieter de Grebber

Dutch, c. 1600–1652/53

## *Charity,* 1622

Oil on canvas, 29 3/4 x 23 11/16 in. (75.6 x 60.2 cm)
Gift of the children of Herbert Godwin
71.27

During the first quarter of the seventeenth century, Haarlem was the leading center of painting and the graphic arts in Holland. This period was marked by great prosperity and a strong sense of community that fostered artistic growth and change. Haarlem artists were linked by their membership in the Guild of Saint Luke, by teacher-pupil and family relationships (which were often due to extensive intermarriage), and by living in close proximity to one another. The city itself became an important patron, commissioning the building and decoration of the new Stadhuis, or town hall (1620–30), portraits of the trustees of its charitable institutions, and large group portraits of its militia companies, most notably by Frans Hals (see pp. 76–79), since the nineteenth century the painter most closely associated with Haarlem.[1]

Haarlem began to relinquish its position as the center of Dutch art to Amsterdam by the end of the first quarter of the seventeenth century, although the city nevertheless maintained its high rank in certain fields: portraiture, landscape painting, still lifes, architectural painting, and history painting. Its practitioners included some of the greatest names in Dutch painting, including Hals, Judith Leyster (1609–1660), Salomon van Ruysdael (1600/3–1670), Pieter Claesz. (c. 1597–1660), Willem Claesz. Heda (see pp. 79–81), Pieter Saenredam (1597–1665), and Salomon de Bray (1597–1664).[2] The origins of Haarlem's vital artistic development are often traced to the 1580s to the so-called Haarlem Academy, a loosely bound artistic community established by three prominent members of the Haarlem Mannerist circle: Hendrick Goltzius (1558–1616/17), Cornelisz. van Haarlem (1562–1638), and Karel van Mander (1548–1606). Their promotion of drawing from life fostered the development of naturalism in Haarlem at the end of the sixteenth century, a trend that eventually collided with the artificial, contrived images of late Dutch Mannerism, which is best exemplified by Goltzius's engravings and Cornelisz.'s paintings of athletic nudes in wrenched and sharply foreshortened positions.

Pieter de Grebber received a thorough training in painting and drawing under his father, Frans Pietersz. de Grebber (1573–1649), a well-known history painter and portraitist, and was then apprenticed briefly to Goltzius. In 1621 Pieter was recorded in a list of Haarlem painters compiled by a local historian, Samuel Ampzing (1590–1632), and in the second (1628) edition of this chronicle of the city, Ampzing praises him as a history painter, together with his father and sister, Maria (c. 1602–1680). Pieter de Grebber enjoyed increasing success as a history painter (mostly biblical subjects) and received a number of commissions from the Haarlem city authorities. Between 1638 and 1650, de Grebber assisted in the decoration of various palaces belonging to Stadtholder Frederik Hendrik, under the supervision of the painter Jacob van Campen (1575–1657). The de Grebbers were practicing Catholics and maintained close ties with members of the clergy in Haarlem and elsewhere. (During the late sixteenth and early seventeenth centuries, when the Dutch gained political independence from Catholic Spain, Calvinism was recognized as the official religion. Although Catholicism still commanded a strong minority of believers, they were required to worship in secret.)[3] Painting portraits of priests and religious scenes for clandestine chapels in Holland and in Flanders, Pieter occupies a special position among the Catholic artists of his day because of his open proclamation of faith through his art.

One of a series of half-length paintings of women with children that de Grebber painted early in his career, this work and a related painting recently purchased by the Frans Halsmuseum, Haarlem, are both monogrammed and dated 1622.[4] The compression of boldly drawn figures in a small space close to the picture plane is typical of de Grebber's first works, such as a *Musical Trio* painted the following year (private collection, United States). The museum's

1. Hofrichter 1996, 894–95.
2. Haak 1996, 229–54.
3. Thiel-Stroman 1993, 220–21.
4. Peter C. Sutton has kindly shared the entry on the painting for his forthcoming catalogue raisonné of the artist's works in which he notes two related paintings, *Nursing Mother with Child Eating Fruit* (Michaelis Collection, Cape Town) and *Nursing Mother with Two Children* (private collection, The Netherlands).

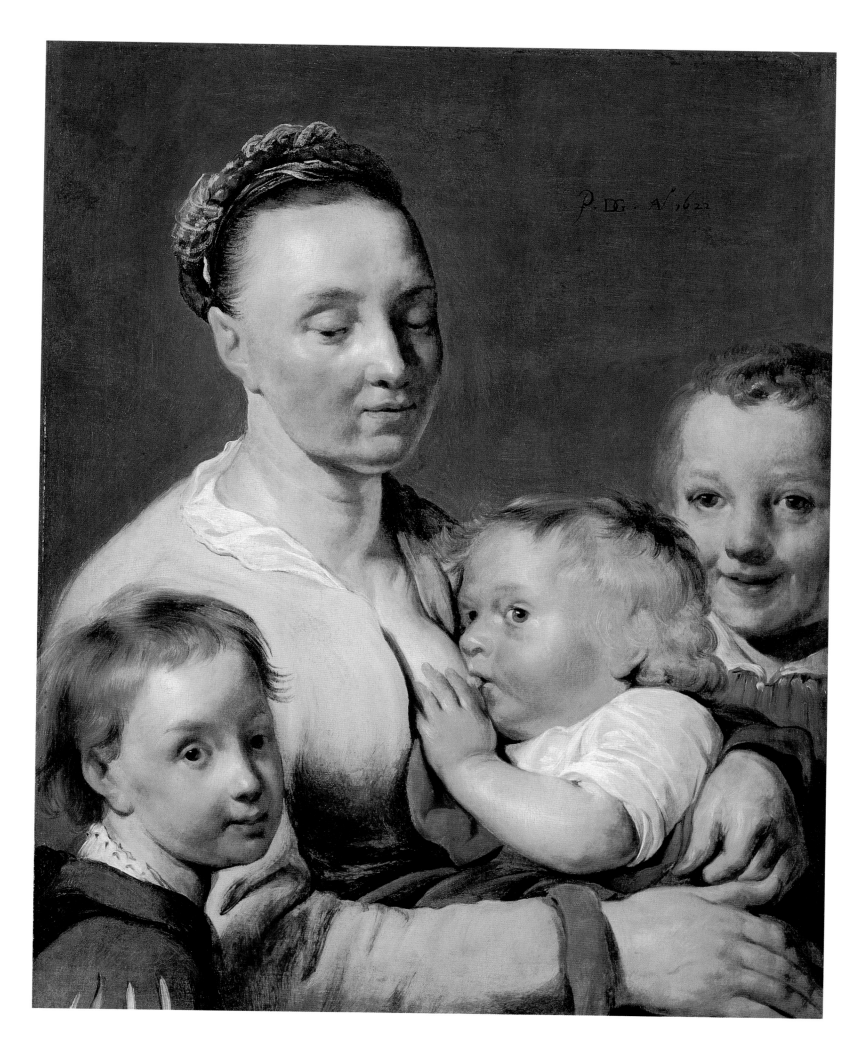

5. Quoted by Thiel-Stroman 1993, 221 n. 32.
6. Sutton 1986, 115–16, seems to have first pointed out the subject of the painting.
7. Ripa [1603] 1971, 64, specifies the number of nursing children surrounding their mother as three.
8. Cited by Sutton, n. 4, above.

*Charity* reveals de Grebber's strong debt to Cornelisz., considered at the turn of the seventeenth century to be the greatest living Dutch painter. De Grebber's teacher Goltzius also depicted similar half-length figures in the second decade of the century and asserts his influence in the boldly portrayed figures and in the color scheme of clear grays and lilac tints. Not surprisingly, in 1642 Philips Angel expressed his admiration in his *Lof der schilderkonst* (Praise of Painting) for De Grebber's "manifold analyses and wondrously close observation" of the human anatomy, and urged other painters "to follow him in this virtue."[5]

De Grebber's early paintings often appear to be straightforward genre scenes, but as in Ferdinand Bol's *Woman at Her Dressing Table* (pp. 72–74), everyday appearances may disguise a deeper meaning. Long thought to be a simple representation of a mother and her children, the subject of the museum's painting is probably an allegorical depiction of the Christian virtue of Charity *(Caritas)*.[6] The costumes of the figures (for example, the slashed jacket worn by the small boy at the lower left) are not everyday Dutch attire but fanciful dress, thus supporting the presumption of an allegorical subject. Moreover, De Grebber's mother and children, one of whom is nursing at her breast, conform to an iconographical model of *Caritas* that appeared in Italy in the first half of the fourteenth century and that by the sixteenth century had become the standard type of representation throughout European art.[7] The most striking earlier representation of the theme by a northern artist is a print by Aegidius Sadeler (c. 1570–1629), which depicts a nursing mother and three children in a close-up view and exhibits an informal, genrelike character similar to de Grebber's painting.[8]

## Bernardo Strozzi

Italian (Genoese), 1581/82–1644

### *The Guardian Angel*, c. 1620–25

Oil on canvas, 83 7/8 x 50 3/4 in. (213 x 129 cm)
Anonymous gift in honor of Mrs. William Stamps Farish (née Libbie Randon Rice), Benefactress and Lifetime Trustee of The Museum of Fine Arts, Houston
76.256

1. The fundamental study of the painter is Mortari 1995.
2. J. Patrice Marandel in Museum of Fine Arts 1981, 50–51, no. 92; Newcome Schleier 1992, 92, no. 29; Mortari 1995, 153, no. 332.

Trained in Genoa and active there for more than thirty years, Bernardo Strozzi was one of the leading artists in the city's golden age of painting in the first half of the seventeenth century. During Strozzi's lifetime, Genoa occupied for many years a privileged position among the major artistic centers of the Italian peninsula. Because of its location, the city served not only as an important port but also as a vital link between the southern and northern states of Italy and to the northern European countries. The city was open to foreign artistic influences, and as a result Strozzi drew inspiration from a variety of diverse sources such as Mannerist paintings and prints, the paintings of Caravaggio, contemporary Milanese painting, and the presence of Flemish painters and pictures in Genoa. As a young man Strozzi entered the Capuchin monastery of San Barnaba in Genoa, earning him the nickname "Il Cappuccino" (as well as another, "Il Prete Genovese," the Genoese priest). He eventually left the Capuchin order and in 1633 traveled to Venice, where he won widespread recognition as a painter.[1]

In the 1620s Strozzi received important commissions for frescoes to be painted in palaces of the Genoese nobility and for altarpieces and frescoes in churches, but primarily he painted easel paintings, mostly of religious subjects, for private clients. *The Guardian Angel* was one of these private commissions and may have been painted for Giovanni Carlo Doria (1576/77–1625),[2] a member of the powerful Genoese noble family in whose collection the work was recorded. Giovanni Carlo was an enthusiastic patron of the arts. He and his brother Marc'antonio (1572–1651) owned numerous paintings by contemporary artists as varied as Caravaggio, Simon Vouet

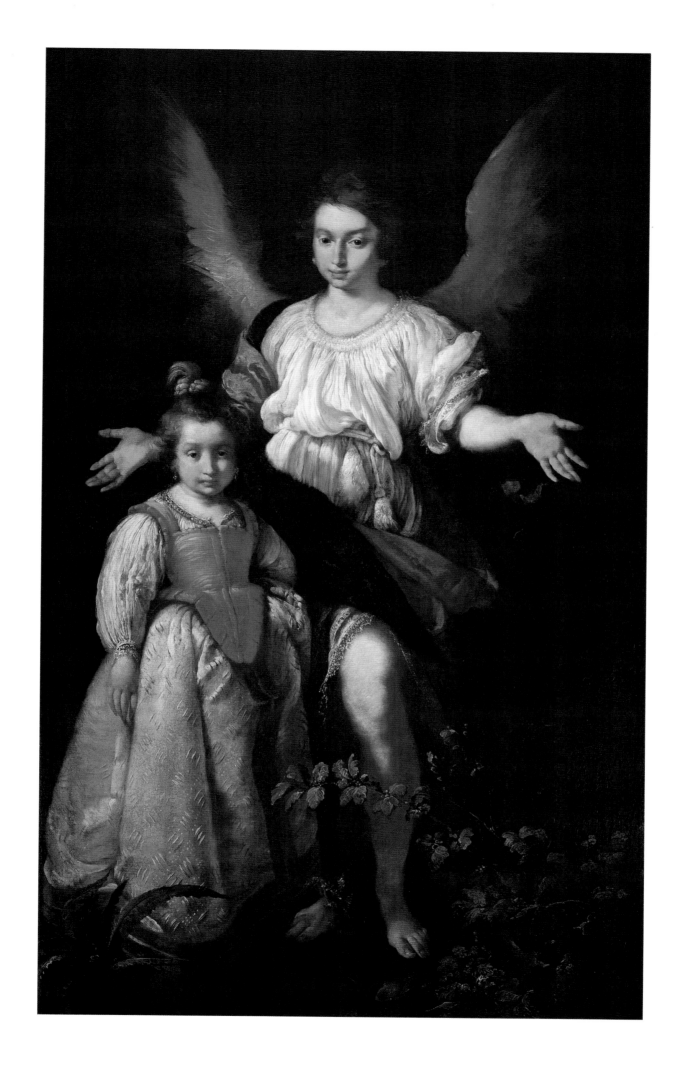

3. Rowlands 1996, 266–68, colorpl. 30, fig. 30c.
4. Rowlands 1996, 266, citing a suggestion of Patricia J. Fidler that Strozzi appears to have studied such Northern prints as Hendrick Goltzius's *Standard Bearer* of 1587 (Bartsch 125).
5. Mortari 1966, 27–28.
6. J. Patrice Marandel in Museum of Fine Arts 1981, 50.
7. Newcome Schleier 1992, 92.

(1590–1649), Sir Peter Paul Rubens (1577–1640), and Giulio Cesare Procaccini (1574–1625)—and by Strozzi in particular. He owned, for example, two of the painter's most memorable works now in American collections, *Saint Cecilia* (Nelson-Atkins Museum of Art, Kansas City) and *Saint Catherine of Alexandria* (Wadsworth Atheneum, Hartford).[3]

*The Guardian Angel* is one of the highlights of Strozzi's Genoese career, and the work reflects his robust manner of painting in the 1620s. The simple composition—culminating in the widespread wings of the angel, which balance the gesture of his outstretched arms; the crowding of the figures in a confined space; and the direct gazes of the figures toward the viewer—is typical of his style at this point in his career. The highly spiritual atmosphere of this serene and balanced picture certainly owes a debt to Caravaggio, but Strozzi's dazzling painterly technique reveals his admiration for the work of the Milanese painters Procaccini, who arrived in Genoa in 1618, and Cerano (c. 1575–1632). Yet Strozzi's brushwork is neither so bold nor his impasto so thick that it impedes the naturalistic description of the details of the plant life in the foreground or an exact rendering of the tactile quality of individual materials, such as the dress of the two figures. (Strozzi painted the costume of the Kansas City *Saint Cecilia,* similar to that worn by the child in the museum's painting, with a linear precision so totally at odds with his usual, painterly style that the influence of Northern prints has been advanced as an explanation.)[4] Glowing color is one of the hallmarks of Strozzi's paintings, and in this work the angel's luminous red wings and the child's red stomacher suggest the artist's intense study of the paintings of Rubens, who visited Genoa in 1606–7.[5]

The precise meaning of the painting is difficult to determine. The concept of the guardian angel, who watches over every mortal at birth and exercises care and protection of every human soul throughout life on earth, has its roots in the ancient world. A *genius* was a good and beneficent spirit that anticipates the appearance in the Old Testament of the Archangels Michael, the protector of the Israelites (Daniel 10:13), and Raphael, the guardian of the young Tobias (Book of Tobit). The Christian belief that each human being has his or her own protecting angel is drawn in large measure from Jesus' words in Matthew 18:10: "See that you despise not one of these little ones; for I say to you that their angels in heaven always see the face of my Father who is in heaven." The concept never became part of official Church dogma, but widespread popular belief in angelic guardians led to the establishment of a liturgical observance on 2 October in the Roman calendar of feasts.

The cult of guardian angels was well established in Italy in the seventeenth century following the Counter Reformation and became a popular subject in painting. The little girl in contemporary costume is presumably a daughter of Doria, but whether she is represented as a soul departing this world or as a living child, cured after illness and protected by her guardian angel, is uncertain.[6] Although no demon appears in the composition, the care with which Strozzi has depicted thistles and weeds in the right and left foreground—ancient symbols of man's fall from Grace—suggests that the angel is assisting the child in her attainment of eternal salvation.[7]

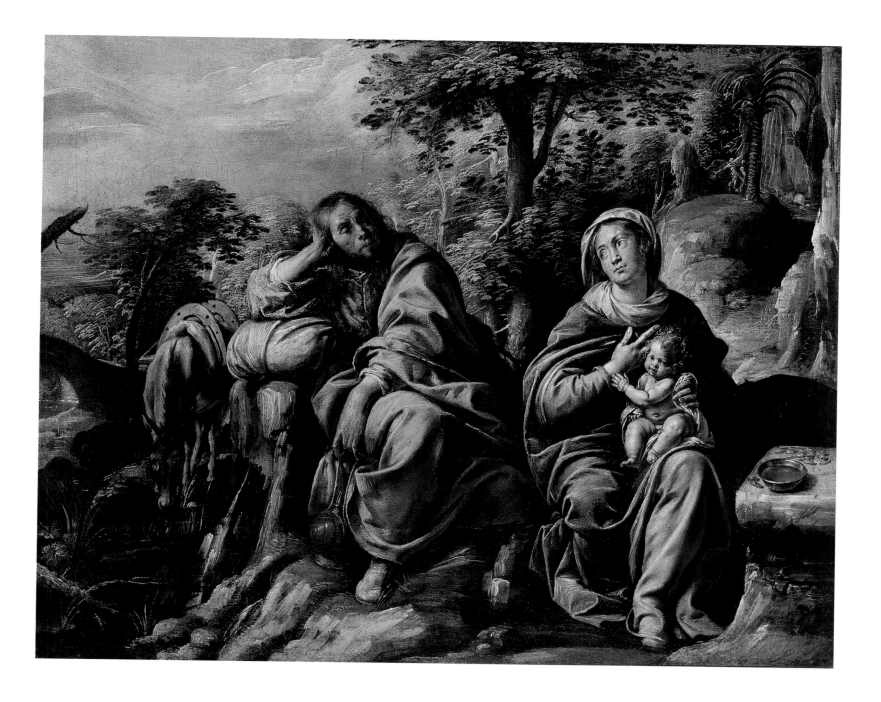

## Tanzio da Varallo

Italian (Lombard), 1575/80–1635

### *The Rest on the Flight into Egypt,* c. 1625–30

Oil on canvas, 22 1/4 x 27 7/8 in. (56.5 x 70.8 cm)
The Samuel H. Kress Collection
61.69

1. On Kress's collecting of Baroque paintings, see Bowron 1994b.

Many of the museum's finest Italian Baroque paintings came from the paintings and sculptures assembled by the merchant and collector Samuel H. Kress (1863–1955). Kress was remarkable for ignoring the American prejudice in the first half of the century against the art of the Catholic Counter Reformation, and he displayed considerable independence in his purchases of later Italian art.[1] One measure of his temerity

and originality as a collector is the fact that he acquired three paintings by Tanzio da Varallo at a time when most scholars had never heard of the artist: *Saint Sebastian* (National Gallery of Art, Washington, D.C.), purchased in 1935; *Saint John the Baptist in the Wilderness* (Philbrook Museum of Art, Tulsa), before 1939; and the museum's painting, acquired before 1950.

Antonio d'Enrico, called Tanzio da Va-

2. Longhi's (1961, 1:511) identification of several paintings by Tanzio was noted in his marginal annotations to the catalogue of the important exhibition of Italian Baroque paintings, *Pittura Italiana del Seicento e del Settecento* (Florence: Palazzo Pitti, 1922).

3. Palazzo Madama 1959, figs. 7, 17, 30–35; for a concise discussion of Tanzio's participation in this local artistic tradition, see Conisbee 1991, 79–82 (entry by Philip Conisbee).

4. Testori 1995, 119–20.

5. Orr in Ishikawa 1994, 132, 134, fig. 1, dates the museum's painting to about 1630; Frangi 1996, 305, also dates the painting around 1630, citing the influence of northern landscapes deriving from the works of Adam Elsheimer and Rubens. Comparison with one of the artist's masterpieces, the altarpiece of the *Visitation* in the church of San Brizio, Vagna (Testori 1995, fig. 8), in place by 28 July 1627, suggests a slightly earlier date, perhaps 1625–30.

6. For a brief summary of the iconography, see Steel 1984, 76, 78.

rallo, was not even registered in the literature on art as a distinct personality before 1923, when the Italian scholar Roberto Longhi gathered together several paintings by the same hand and assigned them to Tanzio.[2] The artist's origins in a German-speaking alpine area of northeastern Piedmont have often been cited in explanation of his pietistic, deeply felt religious images. This region of Piedmont and Lombardy is notable for its mountain sanctuaries adorned with illusionistic sculptural tableaux vivants depicting religious events. Life-sized terra-cotta figures, naturalistically carved and painted, fitted with glass eyes and real hair, and posed before frescoed backgrounds, presented the events of the life of Christ to the pious with terrifying realism. Tanzio, with his brothers Melchiorre (c. 1570/75–after 1640), a fresco painter, and Giovanni (c. 1560–1646), a sculptor and architect, contributed to the decoration of several chapels in the Sacro Monte above Varallo, the most ancient and significant sanctuary of this type.[3]

The small number of paintings attributed to Tanzio are principally religious in subject, although he is known to have painted a few portraits. His paintings are conventional in both subject matter and composition, for although he traveled widely enough (Rome, Abruzzi, and Naples) to have seen the stylistic innovations of the emergent Baroque, he maintained the symmetry and hieratic formality typical of the art of his native region. *The Rest on the Flight into Egypt* is a work that conveys the restlessness and brooding pathos of Tanzio's artistic maturity and fully reveals his idiosyncratic manner of painting. His hard, sculptural sense of form, his use of bright color, his vivid realism, and his intensity of feeling all derive from the depiction of religious imagery in the Sacro Monte. Tanzio's almost obsessive interest in creating volume through the use of drapery reminds us that as a young artist he had worked in his father's sculpture workshop and that his brother Giovanni was a sculptor.[4] His principal interest is the expression of extreme religious sentiment, which he conveys through the intense (if peculiar) expressions and poses of the Virgin and Child and Joseph and their psychological interaction with one another. The relative informality of the figures and

small scale of the painting suggest that it was intended for private devotional purposes.[5]

The Holy Family's flight into Egypt is described briefly in the Gospel of Matthew (2:13–15). The angel of the Lord warns Joseph in a dream that King Herod, hoping to destroy the child called the King of the Jews, has ordered the murder of all the infants in Bethlehem. Joseph departs that night with the infant Jesus and Mary for Egypt, where they stay until Herod is dead. No further mention of the journey appears in the Bible, but the tale was elaborated in the rejected biblical writings that form what is called the New Testament Apocrypha and appeared again later, in the Middle Ages, in the *Golden Legend*.

The scene depicted here derives from the apocryphal stories of the infancy and childhood of Christ, attributed to the Pseudo-Matthew and probably written in the twelfth century.[6] While on their journey, the Holy Family stops and rests in the shadow of a palm tree. Jesus instructs the palm tree to bend down so that his mother can pick the dates. Often in sixteenth- and seventeenth-century paintings, angels are shown pulling the branches down and giving the fruit to the Holy Family. (Jesus tells the tree that it will grow in Paradise and succor Christian saints and martyrs as it has nurtured him. This is why martyred saints are often depicted holding a palm frond or receiving one from an angel at the moment of their martyrdom.) Then the infant asks the tree to uncover the spring concealed beneath its roots, so that the travelers can quench their thirst. The palm grants this request, and a limpid pool of fresh water appears.

In the museum's painting, Tanzio has condensed the apocryphal narrative into a straightforward devotional representation of the Holy Family resting in a landscape. Allusions to the miraculous literary accounts of their journey are confined to the dates beside a dish on a stone plinth and the stream at the left from which their donkey drinks. Angels frequently accompany the Holy Family in representations of the Rest on the Flight, but the tiny figures depicted in the background beneath the palm tree in the museum's painting do not have wings and thus cannot be identified with certainty.

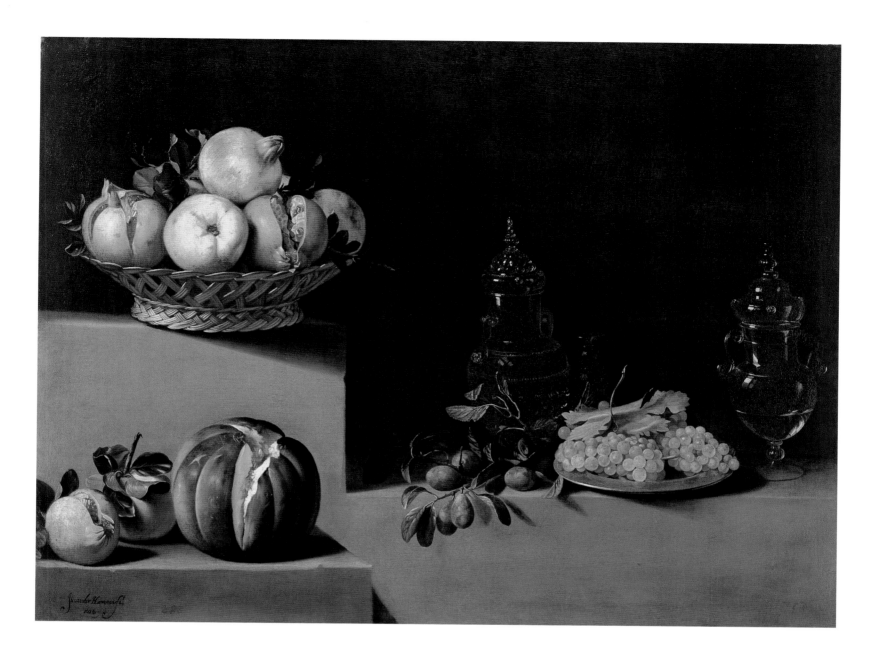

## Juan van der Hamen y León

Spanish, 1596–1631

### Still Life with Fruit and Glassware, 1626

Oil on canvas, 33 x 44 5/8 in. (83.8 x 113.4 cm)
The Samuel H. Kress Collection
61.78

Juan van der Hamen y León was one of the most original and sophisticated still-life painters of his age. The brief span of his creative activity fell mostly within the decade of the 1620s, and it was during this period, one of great turmoil in the visual arts in Madrid, that the artist created his greatest works. Van der Hamen's artistic origins and training are complex and, as William B. Jordan, the scholar who has done the most to advance our understanding and appreciation of the painter, has noted, have a great deal to do

with the cosmopolitan tastes of the Spanish capital at the time. Van der Hamen was inspired by both the austere still lifes of his Spanish predecessor Juan Sánchez Cotán (1560–1627) and the opulent abundance of Dutch and Flemish still lifes, such as those painted by Frans Snyders (1579–1657). Yet in the end he relied on no particular artist's work and created a manner of painting that was wholly his own. Without van der Hamen, the accomplishments of such later seventeenth- and eighteenth-century Spanish

1. This biographical account is derived from Jordan 1985, 103–24. See also Jordan and Cherry 1995, 44–56, and Jordan 1997, 50–63.
2. For the painting, see J. Patrice Marandel in Museum of Fine Arts 1981, 48–49; Jordan 1985, 132–34; and Ishikawa 1994, 141–44 (entry by Chiyo Ishikawa).
3. Jordan 1985, 132–34.
4. For the National Gallery painting, see Brown and Mann 1990, 84–86 (entry by Jonathan Brown), and Jordan 1985, 135. Discovered together with the Houston painting in 1950, this painting was considered its pendant for many years by those who had written about it. Eisler 1977, 206–7, no. K2109, however, pointed out that the compositions are not complementary, unless they were originally part of a series of four referring to the seasons, with the museum's still life representing fall and the Washington painting winter, a practice not at all uncommon in Spain at the time.
5. Jordan 1985, 132.
6. Ibid., pls. 17, 20, 21.
7. Ibid., 132, 134.

still-life painters as Francisco de Zurbarán (1598–1664) and Luis Meléndez (1716–1780) are unthinkable.[1]

The museum's splendid still life belongs to a group of works that marks a new stage in van der Hamen's development.[2] In his earlier works, the artist arranged his still lifes symmetrically upon a single horizontal surface, often on gray stone shelves or in niches. In this painting of 1626, he abandoned his customary format in favor of a more complex arrangement, with foodstuffs and glassware displayed on several levels formed by stepped stone plinths. The result is a composition of unprecedented breadth and grandeur. Possible sources for this decisive change in van der Hamen's ideas about composition have been much discussed in the literature on the artist.[3] But whether the innovation was derived from the still-life paintings of classical antiquity, contemporary Italian or Spanish still lifes, or even the architectural arrangement of pantries in seventeenth-century Spanish houses, the expansive format employed in the museum's painting, and in a closely related *Still Life with Sweets and Pottery* of the following year (National Gallery of Art, Washington, D.C.), permitted van der Hamen a profound new cultivation of three-dimensional space in his still-life paintings.[4]

Jordan has remarked upon the significance of the construction of the *Still Life with Fruit and Glassware* along a series of subtly interlocking diagonals that recede into the picture's depth:

*This represents for the artist a completely new way of structuring a still life. The dominant diagonal begins with the melon and pomegranates on the front ledge at the left and recedes, parallel to the branch of iridescent plums, through the large crystal jar and the small beaker with bubble shapes behind it. The secondary diagonal is formed by the same large jar and the silver plate of white grapes at the edge of the ledge. The large, plaited basket of pomegranates and quinces that overhangs the edge of the upper ledge establishes a diagonal with the plate of grapes that is parallel to the picture plane; it also creates a recession into space just above and behind the melon. A subtle shaft of light enters the composition from above and shines down toward the right, creating an atmospheric effect that had not been present in the artist's work previously, nor, for that matter, in the work of any Spanish still-life painter.*[5]

In addition to its spatial innovations, the technical mastery of this painting reaches a new level of sophistication for the artist. Van der Hamen has shown increased skill in his painting technique—his coloring is subtle, his light delicately varied, and his rendering of texture highly sensitive. With consummate control of his brush, he contrasts the brilliantly lit and warmly colored fruits at the left with the cool hues and delicate forms of the purple plums, white grapes, and three glass vessels that emerge from the deep shadows on the middle ledge. The pomegranates and quinces in the basket on the upper shelf and the melon and pomegranates below are firmly modeled so that their weight and volume are forcefully suggested. The fruit appears especially solid in contrast to the delicate Venetian glassware in the right half of the composition. Van der Hamen, like most contemporary still-life painters, maintained a repertory of motifs that he used over and over again in varying combinations throughout his career. Thus the basket with quinces and pomegranates at the left reappears in several still lifes between 1625 and 1630; the branch of iridescent plums appears with variations in a still life of 1629 (Williams College Museum of Art, Williamstown, Massachusetts); and the silver plate is a frequent accessory in his late still lifes.[6]

This still life is one of the few known today that can be traced with certainty to the great collection formed in Madid by the Marquis de Leganés (c. 1585–1655), who, at his death, owned nine still lifes (among eighteen paintings in all) by van der Hamen. Visible at the lower right of the canvas is a partially erased inventory number "353." Number 353 in the appraisal of Leganés's paintings reads: "Another by Vanderhamen, of the same size (*vara* and a quarter wide, and three quarters high), with fruits and pomegranates, quinces, melons and grapes and some glass vessels."[7]

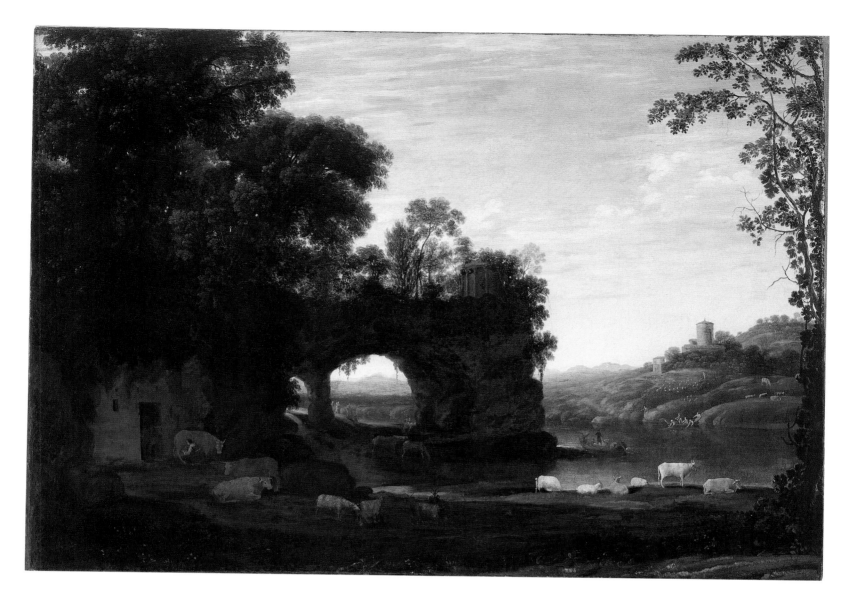

## Claude Lorrain

French, c. 1604/5–1682

### Landscape with a Rock Arch and River, c. 1628–30

Oil on canvas, 37 5/8 x 52 7/8 in. (95.5 x 134.3 cm)
Museum purchase with funds provided by the
Agnes Cullen Arnold Endowment Fund
73.172

1. Lagerlöf 1990.
2. The literature on Claude is vast; for an excellent introduction, see Kitson 1996.

The French painter Claude Gellée is often called le Lorrain in France or Claude Lorrain in the English-speaking world, but he is usually referred to simply as Claude, a tribute to his fame as the most celebrated of all ideal landscape painters. An "ideal" landscape is one in which the elements are simplified and arranged into a setting suitable for small figures to enact religious or mythological subjects.[1] Most ideal landscapes are pastoral and, as in the museum's painting, often feature shepherds and goatherds and other bucolic figures. Claude did not invent this art form, which first emerged in Venetian painting early in the sixteenth century and was

brought to the peak of its development by the Italian painter Annibale Carracci (1560–1609) in the first decade of the seventeenth, but he made it distinctly his own creation.[2]

Claude's profound sensitivity to the tonal values of light and atmosphere imbued his poetic landscapes with a magic attained by few other painters in the history of art. He used light as the principal means both of unifying his compositions and of lending beauty to the landscape. He spent most of his career in Rome, where he developed a deep feeling for the beauty of the Roman countryside with its rich associations of ancient grandeur. Like many artists from northern Europe,

3. Kitson 1969, 13, no. 1; J. Patrice Marandel in Museum of Fine Arts 1981, 51–52, no. 93; Russell 1982, 102–3, no. 2.

4. Russell 1982, 102, no. 2, reproduced an infrared photograph of the painting revealing the original modeling.

5. Röthlisberger 1961, 1:203, 208, 209.

6. For example, see a drawing by Carlo Labruzzi in the Vatican Library, in Keaveney 1988, 246–48, no. 68, repr.

7. Kitson 1969, 7.

Claude fell under the spell of the mild climate and warm light of the Mediterranean landscape. He often sketched antique ruins in the countryside, or *campagna,* surrounding Rome and evoked its pastoral serenity in his landscapes. The ostensible subjects of his pictures are scenes from the Bible, Virgil's *Aeneid,* Ovid's *Metamorphoses,* or medieval epics, but in many instances his real interest seems to be the depiction of light in all its fluctuations and moods.

The museum's landscape is one of the artist's earliest known paintings,[3] created shortly after his arrival in Rome. It is a work very much in the tradition of the river scenes of the Flemish landscape painter Paul Bril, from whom the strong tonal contrasts, the layout of the composition, the handling of the trees at the left, and the motif of the peasants living in a brick dwelling built into a cave are thought to have been derived. Another powerful influence on the young Claude at this moment are the landscapes of his teacher, Agostino Tassi, from whom the motif of the rock arch and the tall tree at the right may have been derived.

The *Landscape with a Rock Arch and River* has considerably darkened over the centuries, and as is the case with many of Claude's canvases, the surface has suffered. Some of the forms have lost their original definition, and the tonal contrasts between the foreground, middle ground, and distant view to the hills on the horizon were certainly once more pronounced in some places and more delicate in others. The massive rock formation and the bushes that grow out of it were carefully modeled, and these forms would have been distinguished more strongly from one another at the time the canvas left the painter's studio.[4] Claude's handling of paint gained in assurance very rapidly, and within a few years his works show more nuances of color, a more articulated modeling of the landscape, and a more atmospheric use of light. But even at this early date his characteristic delicacy of touch and his love of glowing, transparent light is evident. From the start, Claude was a conscientious painter, and such apparently minor details as the animals on the riverbank, the careful composing of the buildings in the middle distance, and the hills on the horizon would have been significant to him.

The little temple on the rock is adapted from the so-called Temple of Vesta at Tivoli, built in the first century B.C. One of the most famous of all Roman ruins, the remains of this beautiful marble building have fascinated artists, archaeologists, and tourists down through the centuries. The building was a feature in the landscapes of nearly every artist who visited the Roman countryside and appeared frequently in a number of Claude's early works.[5] The circular building in the distance may be a reference to the mausoleum of M. Plautius Silvanus, who served as consul with Augustus in the year 2 B.C. The tomb was adjacent to the Ponte Lucano, a celebrated bridge over the Tiber near Tivoli and itself a famous tourist site. In the Middle Ages the tomb was adapted as a stronghold and fortified to control access to the bridge, and it has suffered much damage through its history and has been repaired and restored many times, altering its original appearance.[6]

The reverence for nature revealed in Claude's paintings had its origins far back in European culture, although for a long time that feeling was expressed more in literature than art. Claude's achievement as a painter was to make visible the mood as well as the iconography of pastoral poetry. In his paintings, at last, in the words of one writer,

*was all that the mind desired and had previously been compelled to use words to evoke: cool shady trees, melting distances, winding streams, banks and flowers, a sunlit landscape in which a solitary shepherd sat piping to his herd or strange figures from no known country acted out a story from the Bible or classical myth. . . . Here was a world both ordered and varied, at once simplified, as the elements of a pastoral poem are simplified, and full of incident for the eye to dwell upon; a world designed for the imagination to enter and wander about in. This was achieved by means of an open foreground, like a stage, by framing trees on one side balanced by an answering motive on the other, and a circuitous path taking the eye by easy and varied stages to a luminous distance. This distance is the goal of the imaginary traveler in Claude's landscapes and is the point on which the whole composition depends.[7]*

## Carlo Dolci

Italian (Florentine), 1616–1687

### *The Virgin and Child with Saint John the Baptist*, c. 1635

Oil on wood, 31 1/8 in. (79.1 cm) diam.
Gift of Herbert Godwin
46.28

Few painters before the twentieth century have inspired more invective than Carlo Dolci. Beginning with the Victorian art critic John Ruskin, Dolci's religious paintings were derided as cloying and pietistic, and until relatively recently his art remained totally out of favor. Even today few visitors to the Palazzo Pitti in Florence take any interest in his devotional paintings, which easily outnumber those of any other artist represented there, and he is praised more for his few portraits than for the many religious compositions that made him famous. Yet Dolci was the only Florentine painter of the seventeenth century with a European reputation, and in the seventeenth and eighteenth centuries enthusiasm for his paintings was considerable.[1]

Dolci was deeply devout even as a child, and intense religious feeling was the guiding force behind his art. Many of his paintings were votive in nature, inscribed with prayers and intended to inspire spiritual fervor in those who beheld them. According to the artist's lifelong friend and biographer, Filippo Baldinucci (1624–1696), Dolci vowed at an early age to paint only sacred images "so that they might bear fruit of Christian piety in whomever looked at them. So I do not wonder that in this his brushes had a special gift, that is evident in all of his paintings, quite different from those of other, even famous artists."[2] The extent of his piety is illustrated by the fact that during Holy Week he would paint only scenes relating to Christ's Passion. His painstaking technique and the meticulous care with which he rendered every detail of his compositions brought him great patronage. The intense spirituality of his work was exceptionally suited to the prevailing religious sentiment in Florence in the age of Cosimo III de' Medici (1642–1743), and he painted many of his finest works for the grand duke and his mother, Dowager Grand Duchess Vittoria della Rovere, including paintings for their private devotion. Some of these works attained the status of venerated images and remain among the most popular devotional pictures within Catholicism.

Baldinucci says that *The Virgin and Child with Saint John the Baptist* was painted for Giovanni Francesco di Michele Grazzini (1596–1641), a wealthy Florentine, when the artist was still a young man in the workshop of the painter Jacopo Vignali (1592–1664): "He made for Gio. Francesco Grazzini, a rich gentleman and great lover of painting, a Madonna with Jesus and Saint John, on wood, of circular shape, which was renown in that time, and he received much credit and requests from others for similar works, although he lacked the time to satisfy even a few of these. I also wish to say, regarding his practice, that in my house he gave the first precepts of design of the painting, and used the face of Maria Maddalena, my sister, twelve years old at the time, for the face of the Virgin."[3] Well over a century after it was painted, the work was described in an eighteenth-century account of Dolci's life and art as of "incomparable beauty."[4]

The poses of the Virgin and of the Child, which derive from fifteenth-century Florentine painting and sculpture, were utilized frequently by Dolci in a series of devotional paintings in the early 1630s. The most famous of these was a painting known as the *Madonna delle Pietre Dure* (Palazzo Pitti, Florence) on account of its exceptional and precious silver and *pietre dure* (hard stones) frame made in the grand ducal workshops from the design of the sculptor Giovanni Battista Foggini (1652–1725).[5] The inclusion of the infant John the Baptist in the composition is conventional and reflects his role as patron of Florence and as precursor of Jesus Christ. Attached to his cross is a banderole with the words "Ecce Agnus Dei qui tollit peccatum mundi" (Behold the Lamb of God who takes away the sins of the world), words spoken of Christ by the adult John the Baptist as he was baptizing at the River Jordan (John 1:29).[6]

The delicate gestures and sweet facial expressions and exquisite attention to detail of every aspect of *The Virgin and Child with Saint John the Baptist* are evident in all of Dolci's finest paintings. He typically worked

slowly and carefully, and as a result autograph paintings by the artist are relatively rare. One problem in appreciating Dolci's work is the large number of weak copies of his paintings that began to emanate from Florence during the artist's lifetime and have diverted modern viewers from the high quality of his original paintings. Dolci is the embodiment of the

Counter Reformation ideal of the Christian painter, and his obsession with meticulous finish and illusionistic clarity may reflect the influence of Saint Ignatius Loyola's (1491–1556) *Spiritual Exercises,* which emphasized a contemplative awareness of the material world as an aid to achieving spiritual union with God.[7]

1. The standard study of the artist is Baldassari 1995.
2. Baldinucci 1845–47, 5:341–42.
3. Ibid., 342; for the painting, see Baldassari 1995, 46–49, no. 18, pl. 18.
4. Cited by Baldassari 1995, 48.
5. Ibid., 46, pl. 17, colorpl. 7.
6. Clifton 1997, 58, no. 10, with further discussion of the iconography and composition.
7. Heinz 1960, 212.

# Guido Reni

Italian (Bolognese), 1575–1642

*Saint Joseph and the Christ Child,*
1638–40

Oil on canvas, 35 x 28 1/2 in. (88.9 x 72.4 cm)
The Rienzi Collection, gift of Mr. and Mrs. Harris
Masterston III
96.1565

Guido Reni was the most famous Italian painter of his time, and in the eighteenth century his renown was second only to that of the Renaissance painter Raphael. The idealized figures as well as the harmony, color, and sentiment of his paintings, made his name synonymous with grace and beauty. Reni was called "divine," an epithet shared only with Raphael and Michelangelo, although it is difficult for many modern observers of his work to understand the rapture earlier critics felt when invoking his name. The eighteenth-century German art historian and archaeologist Johann Joachim Winckelmann (1717–1768), for example, compared him to the classical Greek sculptor, Praxiteles, and for Sir Joshua Reynolds (see pp. 124–27), Reni's idea of beauty was superior to that of any other painter. Reni's work fell from favor, however, in the second half of the nineteenth century under the scornful attacks of the influential English art critic John Ruskin, and the prejudice against his art was not overturned until relatively recently, in the 1950s and 1960s.

Despite Ruskin's aversion, Reni's gift as a creator of religious images is undeniable, and *Saint Joseph and the Christ Child* affirms his role as one of the great religious painters of the Catholic Counter Reformation. As part of the Church's new stance to combat Protestantism and propagate the Catholic faith, as articulated at the Council of Trent (1545–63), images of saints and holy figures were humanized and made more psychologically and emotionally accessible to the faithful. In order to heighten the empathy between viewer and image, for example, saints were commonly depicted in a half-length format, and the more complex and arcane attributes of their iconography were eliminated to make them more natural and convincing.

The qualities of grace and naturalness that mark Reni's painting served the Church splendidly. The earliest mention of the museum's painting in a seventeenth-century guide to Florence, when it belonged to the collection of Pierantonio Gerini (1650–1707),

a counselor and diplomat at the court of Cosimo III de' Medici, grand duke of Tuscany, suggests the reverence that Reni's work inspired: "Great is the Infant's tenderness, and the Saint Joseph who very well expresses the devotion and affection he had for the Redeemer of the world."[1]

Reni's intimate characterization of Joseph is very much a product of Counter Reformation devotion to the saint. Traditionally represented as an old man with a white beard on the basis of certain apocryphal texts of his life, Joseph was largely marginal to images of the Virgin Mary and the Child in the Middle Ages and Renaissance. By the later sixteenth century images of the saint alone and with the Christ Child had become increasingly popular, and a more vital depiction of Joseph as the foster father of Christ and husband of the Blessed Virgin Mary had developed. The appearance of Joseph as a younger, more vigorous man was fostered by the writings of the Spanish Carmelite nun Saint Teresa of Avila (1515–1582), who had taken Joseph as her patron and intercessor and recommended devotion to him in her writings. The founder of the Jesuits, Ignatius of Loyola (1491–1556), also promoted Joseph's veneration, and by the seventeenth century Saint Joseph had become a cult figure in Italy and Spain and a popular subject for artists. The feast of Saint Joseph, initiated in Rome by Sixtus II and celebrated on 19 March, was decreed a day of obligation by Gregory XV in 1621.[2]

The subject of the father's tender gaze upon the infant Jesus appealed to Reni, and between 1637 and 1640 he represented the theme numerous times.[3] His sensitive attention to Joseph's head, especially the treatment of the hair and beard, demonstrates why Reni's rendering of the heads of old men was praised by his seventeenth-century biographer, the art historian and antiquarian Count Carlo Malvasia:

*Those old men Guido painted were not left smooth and unified like those of other artists, but with masterful strokes, full of a thousand*

1. Pepper 1984, 285, no. 185, pl. 215, colorpl. XIV, citing Bocchi and Cinelli 1677, 499. For the painting, see also Pepper 1979, 423 n. 26, fig. 25; Cristina Casali Pedrielli in Pinacoteca Nazionale 1988, 306, no. 58.
2. For a brief history of the cult of Saint Joseph, see Baticle 1987, 149–52.
3. Pepper 1984, 285.

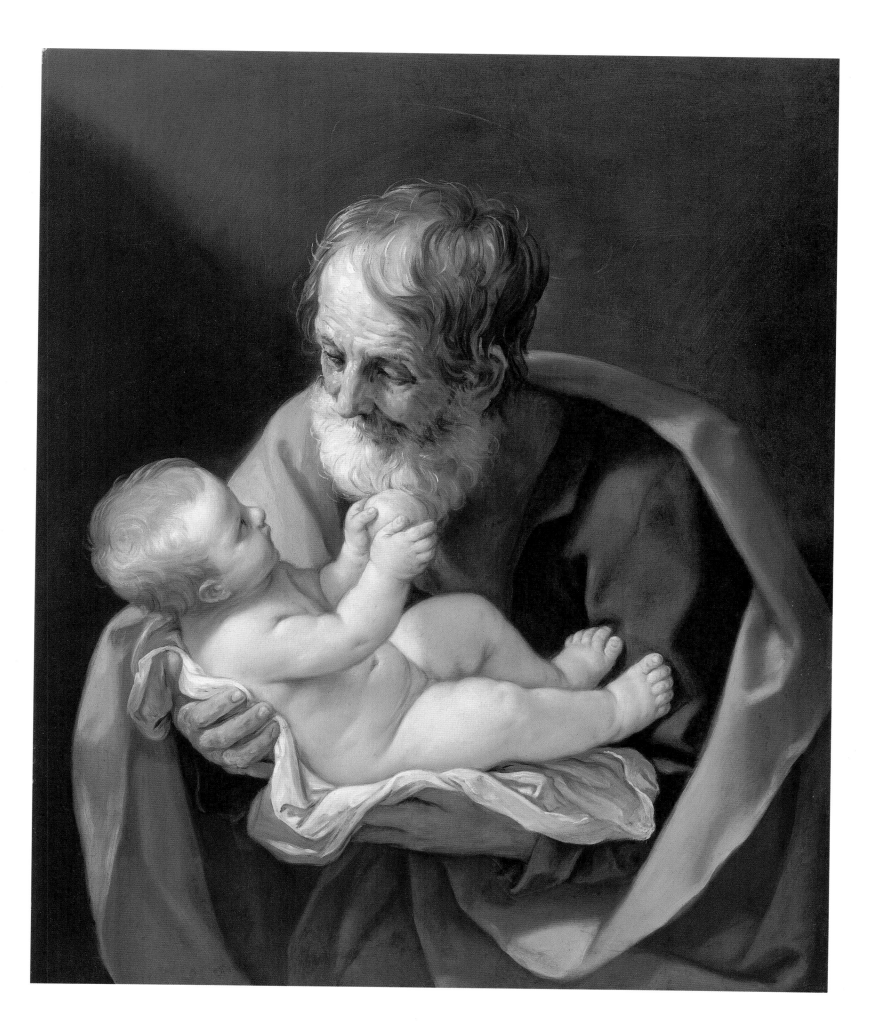

4. Malvasia, *Felsina Pittrice: Vite de' pittori bolognesi*, quoted in Malvasia [1678], 1980, 134.

5. For example, *Saint Francis Adoring a Crucifix*, 1631–32 (Nelson-Atkins Museum of Art, Kansas City); see Rowlands 1996, 272–80, cat. 31, colorpl. 31.

6. Cristina Casali Pedrielli in Pinacoteca Nazionale 1988, 306.

*subtleties, he depicted their sagging skin, which he derived from his famous relief of Seneca, generally called Guido's Seneca. Nor did he use a sketchy technique in the manner of Cavedoni to indicate their beards with quick loose strokes and their hair like softest feathers. On the contrary, he made use of the ground paint almost as if it were a space to play on, rapidly sketching in with great brio and equal skill in a manner never before practiced by anyone else (if not perhaps by Titian at times, although not with so much daring) the locks turned in various directions, toned down and highlighted in relation to the relative position, giving then the finishing touches at the top with the principal highlights.*[4]

The painting represents a late phase of what Malvasia called the artist's *seconda maniera* (second manner). Beginning around 1630, Reni painted with a softer touch, lightened his palette to banish dark shadows, and simplified the outlines and components of his compositions. These characteristics are

very evident in *Saint Joseph and the Christ Child,* which displays the distinctive features of Reni's late period: loose brushwork, luminous tonality, subtle interplay of pale colors, studied elegance of pose and drapery, and a sensitive balance between movement and stasis. Shadows are rendered with colors ranging from slate gray to dark gray-green. Flesh areas (for which Reni was especially famous) are modeled with delicate strokes of white, pink, and orange, recalling the technique of Reni's beautiful studies in red chalk. The system of illumination, whereby light enters from the upper left and tints the background from gradations of olive to pale green to brown, is another characteristic of Reni's *seconda maniera* paintings.[5]

The fruit that Jesus holds in his hands appears to be an apple, a symbol of the Fall and of Christian salvation. In the hands of the Infant Christ, an apple is traditionally the fruit of the tree of knowledge and therefore alludes to his future mission as Redeemer of mankind from original sin.[6]

## Matthias Stomer

Dutch (active in Italy), c. 1600–after 1652

### *The Judgment of Solomon,* c. 1640

Oil on canvas, 60 1/16 x 80 11/16 in.
(152.5 x 204.9 cm)
Museum purchase with funds provided by the
Laurence H. Favrot Bequest
70.15

The most original and innovative Italian painter of the seventeenth century was Caravaggio, and he exerted a powerful influence upon contemporary artists of every nationality who experienced his paintings. Many Dutch painters who traveled to Italy fell under his spell, particularly those from Utrecht, including Hendrick ter Brugghen (c. 1588–1629), Gerrit van Honthorst (1592–1656), and Dirck van Baburen (c. 1595–1624). Matthias Stomer was first introduced to the Italian painter's work in the 1620s while still in the Netherlands through the paintings of these so-called Utrecht *Caravaggisti.* Their art was transformed by the Baroque master's radical interpretation of traditional subjects, bold naturalism, treatment of dramatic action, use of light and shade, and rejection of ideal beauty. Stomer

was one of the last Caravaggesque painters still active in Italy during the 1640s. Perhaps because of his peripatetic career, or the fact that his final years were spent in a remote corner of Europe, or that by midcentury Caravaggism had largely come to be regarded as *retardataire* and out of fashion, Stomer has been ignored from his death until fairly recently.[1]

As is the case with most Dutch artists who went to Italy, it is not known precisely when Stomer left his native country, but his presence is documented in Rome in 1630, when he would have seen Caravaggio's work at first hand. The paintings Stomer executed there are strongly marked by this experience and share the same artistic elements—intense effects of light and dark, tight compositions, and representations of rough peasant types—

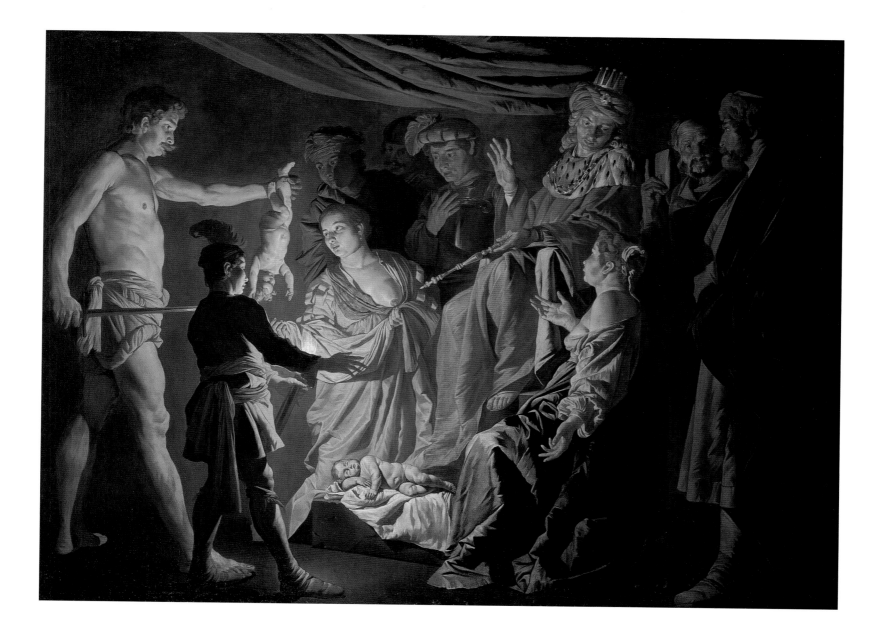

found in the works by other painters who had flocked to Rome and adopted a Caravaggesque style. Stomer probably went to Naples shortly after 1633 and remained there until about 1640, when he traveled to Sicily, where he painted pictures for churches in several major cities on the island. It is thought that Stomer may have gone to Malta, thus making him possibly one of the few contemporary painters to have known Caravaggio's work in Rome, Naples, Malta, and Sicily.

One of the specialties of the Dutch Caravaggesque painters, notably Honthorst, was the "nocturnal scene" in which the figures were illuminated by candle- or firelight. (As one writer has pointed out, in our time of almost universal electrification we can hardly imagine how sensitive Baroque artists were to the mystery of darkness or the

picturesque effects of light and shadow that candlelight produces in a darkened room.)[2] *The Judgment of Solomon,* newly cleaned, underscores Stomer's gifts as a painter and displays the characteristics of his final, Sicilian phase: the ruddy faces of his figures, their red and lemon-yellow complexions, frozen and stylized movement, strong modeling and contour, and theatrical artificial lighting.[3]

Although Stomer appears to have followed Caravaggio's practice and painted for the most part directly from life without using drawings, he planned his compositions with great care, often incorporating poses and gestures from the work of other painters into his designs. Quotations of gesture and pose in the museum's painting include the figure of the executioner holding the child, which is a direct adaptation from a painting by Pasquale

1. Even though this artist has been called Stom, the practice of writing his surname as Stomer has come to be widely adopted. For a brief account of his life and career with further bibliography, see Nicolson 1977, and Slatkes 1996.
2. Slive 1995, 19.
3. For discussions of the painting, see Nicolson 1977, 242, no. 106, fig. 18; J Patrice Marandel in Museum of Fine Arts 1981; and Nicolson 1989, 1:181, 3:pls. 1507–8.

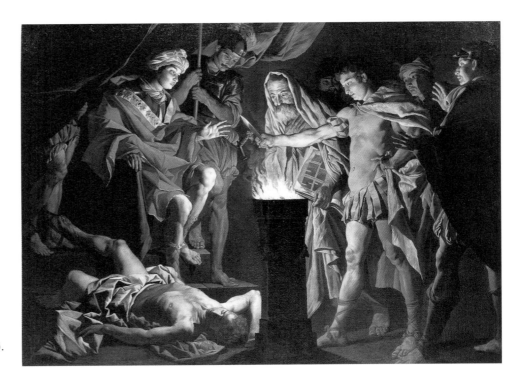

Matthias Stomer, *Mucius Scaevola before Porsena,*
c. 1640. Oil on canvas, 60 x 81 in. (152.4 x 205.7 cm).
The Art Gallery of New South Wales, Sydney

Ottino (1580–1630), a little-known Caravaggesque painter from Verona. A contemporary Flemish sculptor active in Rome, François Duquesnoy (1593–1643), provided the model for the dead child with one of his famous sculptures. The sleeping posture of the dead infant relates directly to a bronze of the Roman period and to a similar marble version in the Walters Art Gallery, Baltimore, both of which in turn rely on antique models.[4]

*The Judgment of Solomon* depicts an episode in the Old Testament (1 Kings 3:16–28) in which the Israelite king was called upon to judge between the claims of two prostitutes who dwelt in one house, each of whom had given birth to a child at the same time. One infant had died, and each woman then claimed that the living child belonged to her. To settle the dispute over the possession of the child, Solomon ordered a sword to be brought, saying, "Cut the living child in two, and give half to one, half to the other." At this, the mother of the living child, depicted by Stomer as dramatically lit, facing the spectator with bare breast, renounced her claim in order that his life be spared; the other said, "He shall belong to neither of us. Cut him up." The painting depicts the moment of Solomon's decision ("which all Israel came to hear") to restore the child to its rightful mother, earning him the awe of his subjects, who recognized his divine wisdom for dispensing justice.

The museum's painting was originally paired with another night scene by Stomer marked by dramatic lighting effects, *Mucius Scaevola before Porsena,* which is now in the Art Gallery of New South Wales, Sydney.[5] The subject of the painting is derived from classical history (Livy, *History of Rome,* 2:12–13), and like the Judgment of Solomon, it also carries moralizing undertones. When the Etruscan forces, led by Lars Porsena, king of Clusium, were besieging Rome, a young Roman nobleman, Gaius Mucius, succeeded in penetrating the enemy lines, intending to kill the king. Mucius slew Porsena's secretary by mistake, and when captured, in order to demonstrate the intensity of his devotion, thrust his right hand into the flames of an altar fire and let it burn. The king, deeply impressed and fearing a further attempt upon his life, ordered Mucius (thereafter called Scaevola, meaning "left-handed") to be set free and, withdrawing his forces, made peace with the Romans. From the Renaissance on, Mucius has stood for the virtues of patience and constancy. His sacrifice was held to be a prefiguration of Christ's sacrifice; Solomon, like King David, is also considered a sort of Old Testament Christ figure. Thus the two scenes, one from Roman history, the other from the Bible, may have offered a corresponding theological significance for the painter's contemporaries.[6]

4. Schrader 1970c, 55, was the first to note the borrowing for the figure of the executioner from Pasquale Ottino's *Massacre of the Innocents,* Capella degli Innocenti, San Stefano, Verona, and Stomer's derivation of the pose of a sprawling figure in the companion painting in Sydney from Alessandro Turchi's (1578–1649) *Martyrdom of the Forty* in the same chapel (Moir 1967, 2:figs. 382, 383).

5. Nicolson 1977, 242, no. 95; Nicolson 1989, 1:180, 3:pl. 1531.

6. Hall 1979, 217, 286. The conjunction of the two subjects derives from a long tradition of scenes depicting trials and the meting of justice; such scenes were especially popular in the fifteenth century for the decoration of halls of justice (for example, Rogier van der Weyden's lost paintings for the court of justice in Brussels; Dieric Bouts's (c. 1415–1475) paintings for the town hall of Louvain, and Gerard David's (c. 1460–1523) for the council hall in Bruges.

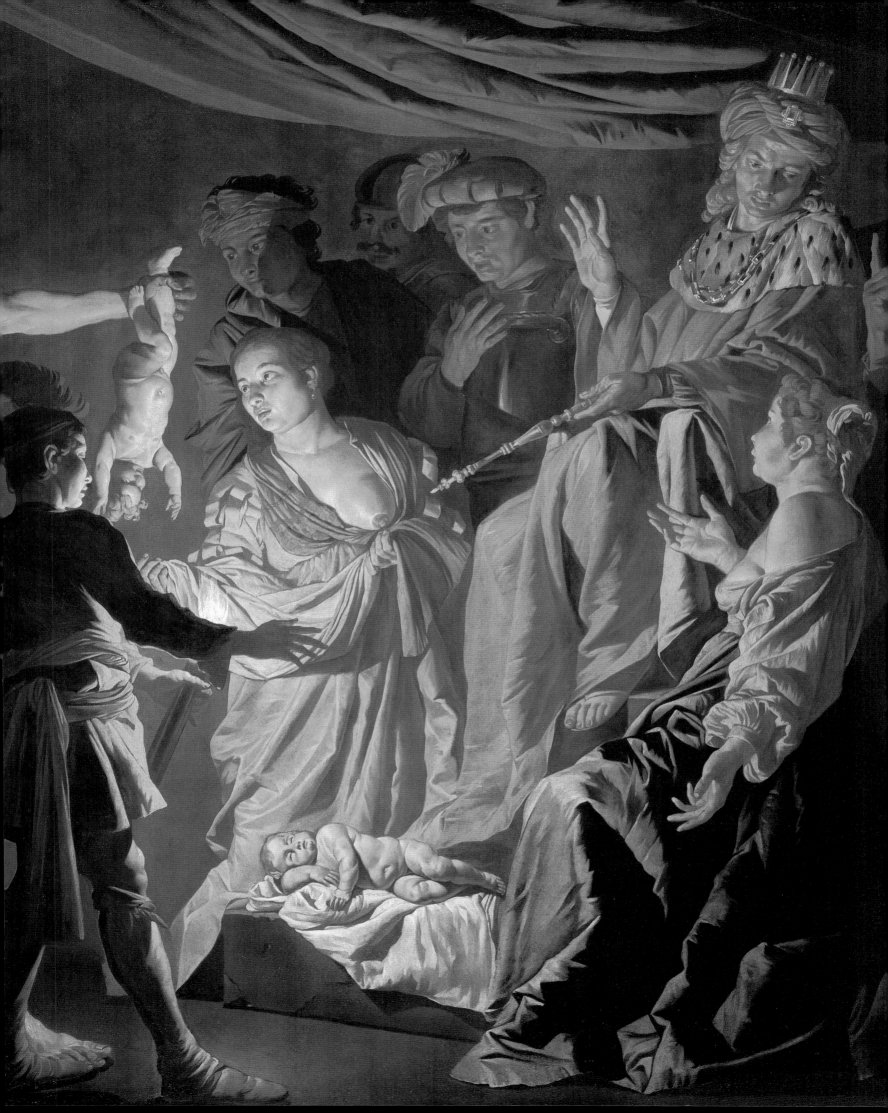

# Laurent de La Hyre

French, 1606–1656

## The Rape of Europa, 1644

Oil on canvas, 59 7/16 x 46 7/8 in. (150.9 x 119 cm)
Gift of Mr. and Mrs. Theodore N. Law
70.12

Laurent de La Hyre, a prominent Parisian painter in the first half of the seventeenth century, began his career with support from various religious orders, including the Capuchins and the Minims. Although his early style could be characterized as mannered, he soon developed the polished handling, luminous colors, and subtle effects of light that characterize *The Rape of Europa*. A cultivated, thoughtful artist, La Hyre was interested in both music and mathematics, and his graceful paintings attained an extraordinary degree of intellectual and aesthetic refinement that deepened over time. During the 1640s and 1650s La Hyre worked a great deal for private patrons, including financiers, members of the Paris parliament, and royal officials. He was one of the twelve original *Anciens,* or professors, at the founding of the Académie Royale de Peinture et de Sculpture in 1648, along with Philippe de Champaigne (see pp. 74–76).[1]

La Hyre's colorful, decorative classicism is shown to superb effect in *The Rape of Europa,* which bears a beautiful signature and the date 1644, inscribed prominently on a stone in the foreground beneath the reclining winged putto.[2] The figures are carefully and solidly modeled, and the draperies possess a faultless severity that are worthy of the French classical painter par excellence, Nicolas Poussin (1594–1665). The bust of the principal female figure, Europa, for example, simulates a classical Roman cameo portrait, the head viewed in profile. La Hyre has been called the most illustrious representative of "Parisian Atticism," which flourished between 1630 and 1650, parallel to the Baroque style of Simon Vouet and his followers.[3]

As a great huntsman and lover of the countryside of the Ile-de-France, La Hyre was interested in landscape from a very early stage in his career.[4] He achieved a number of successes in this field, his landscapes combining a lovely poetic feeling with a strict adherence to the rules of aerial perspective. In *The Rape of Europa,* La Hyre has endowed the objects in the foreground, shells, rocks, and other de-

tails with a kind of hyperrealism. But these details are easily integrated into the whole, for La Hyre was a master at manipulating the natural world in his paintings. He leads the viewer with consummate ease around his composition by means of his skillful ordering of the natural details—the rocks behind the figures, the falling water and foliage in the middle ground, and the marine landscape terminated by a barely glimpsed mountainous horizon.

The subject of the museum's painting was popularized by the Roman poet Ovid, whose *Metamorphoses* (2:836–75), written at the turn of the first century, is a retelling of the myths and legends of Greece and Rome. In Greek mythology Europa is a beautiful Phoenician princess, the daughter of Agenor, king of Tyre. Jupiter falls in love with her and, disguising himself as a white bull, comes to where she plays by the seashore with her attendants. Seduced by the animal's pleasant appearance, Europa bestows a garland of flowers upon him and climbs on his back. Suddenly, Jupiter plunges into the sea and abducts the princess to the island of Crete. Upon resuming his godlike form, Jupiter then seduces her. La Hyre's picture shows Europa and her attendants just prior to the actual abduction, as they naively decorate the bull with delicate garlands of flowers. The direct gaze of the bull toward the viewer is the equivalent of a wink, as if to remind us that we can guess the outcome of this ostensibly innocent scene.

The classical myth was especially popular with painters in the Renaissance and its aftermath, the most famous treatment of the theme being Titian's painting in the Isabella Stewart Gardner Museum in Boston. The loves of the gods described in Ovid's *Metamorphoses* were also popular subjects for tapestries in seventeenth-century France, and La Hyre's *Rape of Europa* provided the model for one of a series of tapestries woven for Louis XIV in the Faubourg Saint-Marcel manufactory in Paris, attesting to the fame of the composition.[5]

1. The basic study of La Hyre's life and career is Rosenberg and Thuillier 1989.
2. Schrader 1970b; J. Patrice Marandel in Museum of Fine Arts 1981, 55, no. 99; Rosenberg and Thuillier 1989, 244–46, no. 203.
3. Rosenberg 1982, 247.
4. Mérot 1996, 649.
5. Rosenberg and Thuillier 1989, 244, repr.

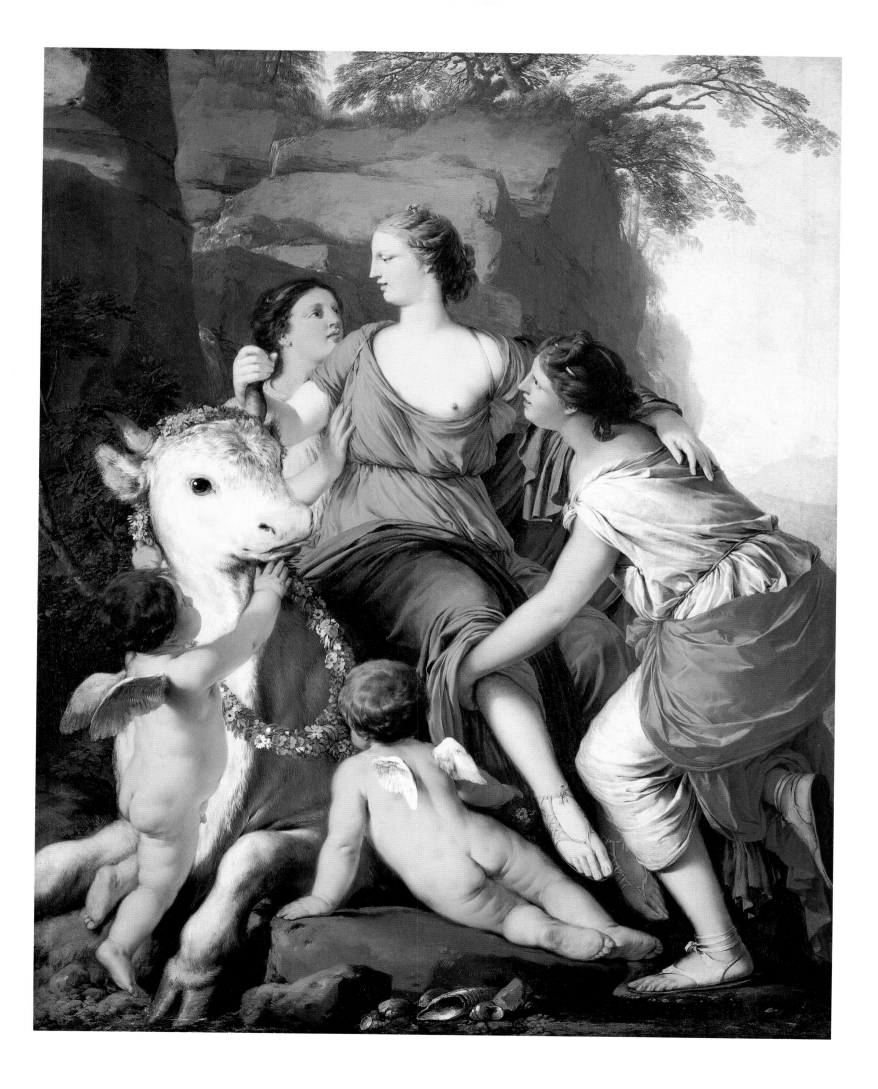

## Ferdinand Bol

Dutch, 1616–1680

### *Woman at Her Dressing Table,* c. 1645

Oil on canvas, 50 9/16 x 36 1/8 in. (128.4 x 91.7 cm)
Gift of Mrs. Harry C. Hanszen
69.4

One of Rembrandt van Rijn's (1606–1669) most gifted and successful pupils, Ferdinand Bol moved to Amsterdam shortly after 1635 to train with the older painter and work as his assistant. Bol enjoyed considerable success as an independent artist from around the beginning of the 1640s, but his pictures continued to reflect a strong debt in both style and subject to the work of his master. In *Woman at Her Dressing Table,* the viewer is immediately struck by Bol's Rembrandtesque manner and his shimmering yellow and warm brown palette, strong chiaroscuro, and heavy impasto.[1] Specifically, in this painting Bol reveals his attention to Rembrandt's manner of painting around 1640.

Like his master, Bol was interested in the effects of light as exemplified here, in the idealized face of the young woman bathed in a warm light against a dark background. The glistening details of her costume and jewelry glow with a vivid naturalness.[2] Bol also captures something of the mood and tender character of Rembrandt's art of this period with the manner in which the young woman gazes at herself in the mirror. It has been said that Bol lacked Rembrandt's ability to render the dramatic power of pose and facial expression,[3] but in *Woman at Her Dressing Table* Bol's command of the human figure is complete and convincing, and his technical skills are on a par with those of the great Dutch master.

Owing to the existence of a number of portraits of Rembrandt's wife, Saskia van Uylenburgh (1612–1642), in fanciful costume made by Rembrandt himself and his pupils,[4] the museum's portrait by Bol has been thought to represent a likeness of her as well. This identification has been questioned,[5] however, and it does not seem that Bol intended to paint a portrait of any specific person. *Woman at Her Dressing Table* appears to combine instead various elements of genre, allegory, and portraiture. At one level the painting can be understood as a genre painting, or a scene of everyday life. It is also plausible that the work is a so-called *portrait historié,* a fashionable form of portraiture in which the sitter plays a role in a historical or allegorical scene. Sitters often had themselves portrayed as shepherds or shepherdesses, for example, or as famous biblical or historical figures.[6] The most likely interpretation, however, is that the handsome woman admiring herself in the museum's painting represents a personification of the vice of Vanity.

The *vanitas* theme was a well-known subject in seventeenth-century Dutch art and was intended to symbolize the transitory nature of earthly life and the inevitability of death. Entire pictorial ensembles, such as arrangements of books, writing materials, rare and precious objects, terrestrial and celestial globes, scientific and musical instruments, pipes, snuffed candles, timepieces, and above all, skulls, were readily understood by contemporary beholders as symbols of the vanity of all earthly endeavor.[7] The term *vanitas* (Latin for "emptiness") derives from the admonition in Ecclesiasticus: "Vanity of vanities; all is vanity."

The motifs of a young woman and a mirror can be traced back to the Middle Ages and have been used to personify positive concepts, such as Veritas (Truth) or Sapientia (Wisdom), but also negative ones, such as Vanitas (Vanity), or Lascivia (Wantoness). In the museum's painting, the mirror on the dressing table may be meant as a *vanitas* symbol, because it implies the transience of beauty and the passage of time. The jewels adorning the young woman express the impermanence of earthly possessions, in contrast to the lasting virtues of the teachings of the Bible, and allude further to the vanity (that is, in the sense of futility) of outward beauty. One of the most explicit personifications of Vanity in Dutch art, for example, is a painting by the Utrecht painter Paulus Moreelse (1571–1638) of 1627 in the Fitzwilliam Museum, Cambridge, which he repeated in several versions.[8] The painting represents a young, attractive woman who points to her reflection in a mirror. The mirror is set before her on a table, strewn with

1. Blankert 1982, 139, no. 127, pl. 136, as c. 1645.
2. J. Patrice Marandel in Museum of Fine Arts 1981, 54, no. 97.
3. Haak 1996, 288.
4. Bredius 1969, pls. 83, 85, 87, 89, 92, 93.
5. Judson 1969, 703, was the first to query the traditional identification.
6. Huys Janssen and Sumowski 1992, 104, 106, discussing Bol's *String of Pearls,* 1649.
7. Slive 1995, 282.
8. Erica Doemla Nieuwehuis in Spicer 1997, 193–96, cat. 21.

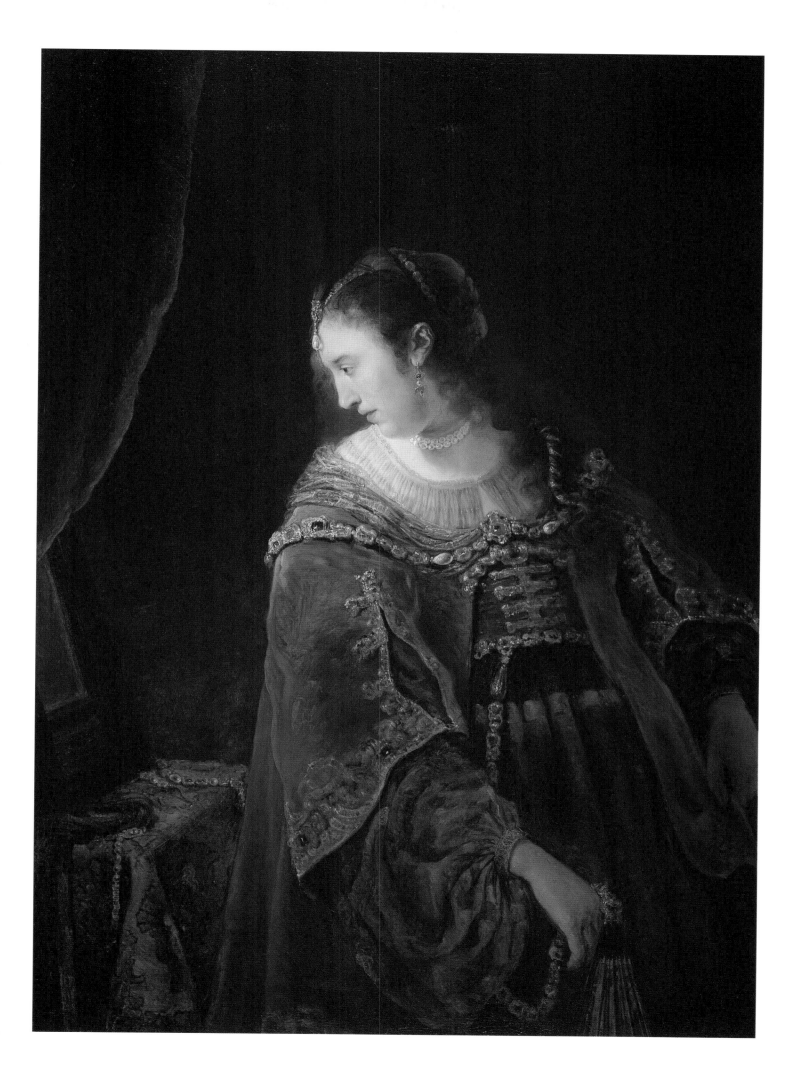

pieces of precious jewelry and a small book, which is opened to a page with an illustration of a kneeling woman offering a gift to Venus and Amor. The presence of a painting in the background depicting two nude lovers embracing reinforces further the identification of the female figure in Moreelse's painting as a personification of Vanity.

## Philippe de Champaigne

French, 1602–1674

### The Penitent Magdalen, 1648

Oil on canvas, 45 9/16 x 35 in. (115.9 x 88.9 cm)
Museum purchase with funds provided by the
Agnes Cullen Arnold Endowment Fund
70.26

Philippe de Champaigne was one of the leading painters in Paris in the middle years of the seventeenth century. After training in his native Brussels, Champaigne moved to Paris in 1621, becoming a naturalized French citizen in 1629. He was extensively patronized by King Louis XIII; the king's chief minister, the prelate and statesman Cardinal Richelieu, of whom Champaigne made a series of superb likenesses; the Church, for which he produced numerous religious pictures; and the magistrates of Paris, whose portraits he recorded. Champaigne remained much in demand throughout his life and enjoyed the patronage of Cardinal Mazarin, principal minister of the regent Anne of Austria. The origins of Champaigne's austere style have been traced by art historians to sources as diverse as fifteenth-century Netherlandish painting; contemporary Flemish painters like Sir Peter Paul Rubens and Frans Pourbus (1569–1622), court painter to Marie de' Medici; and his countrymen Nicolas Poussin and Simon Vouet. In 1648 Champaigne became one of the twelve original members of the Académie Royale de Peinture et de Sculpture.[1]

The most interesting and complex aspect of Champaigne's art developed after 1643, following his growing commitment to the severely ascetic religious sect known as Jansenism. Centered in the convent of Port-Royal-de-Paris, this was a Roman Catholic movement based on theories of moral determinism whose doctrine espoused a return of people to greater personal holiness. Profoundly religious, Champaigne was drawn toward the austerity, simplicity, and religiosity of the Jansenists, who engendered political and religious controversy and were opposed by the powerful Jesuits and other factions of the Church in Rome. He recorded the leaders of the movement in a series of simple, psychologically incisive images appropriate to the doctrine's radical, austere beliefs. One of the masterpieces of French seventeenth-century painting is *Mother Catherine-Agnes Arnauld and Sister Catherine of Sainte-Suzanne Champaigne,* 1662 (Musée du Louvre, Paris), painted by Champaigne as an ex-voto commemorating the miraculous recovery of his daughter from a serious illness through the intercession of Mother Agnes.[2]

*The Penitent Magdalen* is rooted in Champaigne's Jansenist experience, and it is a masterpiece by "this artist who combined a scrupulous perfectionism verging on coldness with an inner life of deep intensity," to use the words of Pierre Rosenberg.[3] The painting exhibits the qualities that define Champaigne's finest paintings: clarity of observation; meticulous drawing; rich, saturated color; and skillful execution. The finely rendered details—the cracks in the stone, reflections of light on the burnished skull, crystalline tears, and long copper tresses—have been likened to the precision of a Flemish primitive.[4] According to André Félibien, writing shortly after the death of Champaigne, *The Penitent Magdalen* was painted in 1648, and scholars have linked the painting with a canvas seized during the Revolution from the Couvent des Dames du Saint Sacrément in the fashionable Marais quarter of Paris.[5] The painting was engraved in reverse in 1651 by Nicolas de Plattemontaigne (1631–1706), one of the painter's students at the Académie des Beaux-Arts, where Champaigne was for a long time professor and rector. The engraving bears a Latin inscription, *Remit tuntur ei peccata multa, quoniam dilexet multum,* which refers to Jesus' words about

1. The standard study of the artist's life and work is Dorival 1976.
2. Musée National des Granges de Port-Royal 1995, 145–49, no. 33, repr.
3. Rosenberg 1982, 232–33, no. 14; see also Montebello 1970; Dorival 1976, 1:51, 140, 160, 2:73, no. 130, pl. 130; and J. Patrice Marandel in Museum of Fine Arts 1981, 55–56, no. 100.
4. Rosenberg 1982, 233.
5. This provenance has been called into question by Rosenberg 1982, 233; see also Musée National des Granges de Port-Royal 1995, 107–8, no. 21, and 110–12, no. 22, for a version of the Houston painting dated 1657 in Rennes.

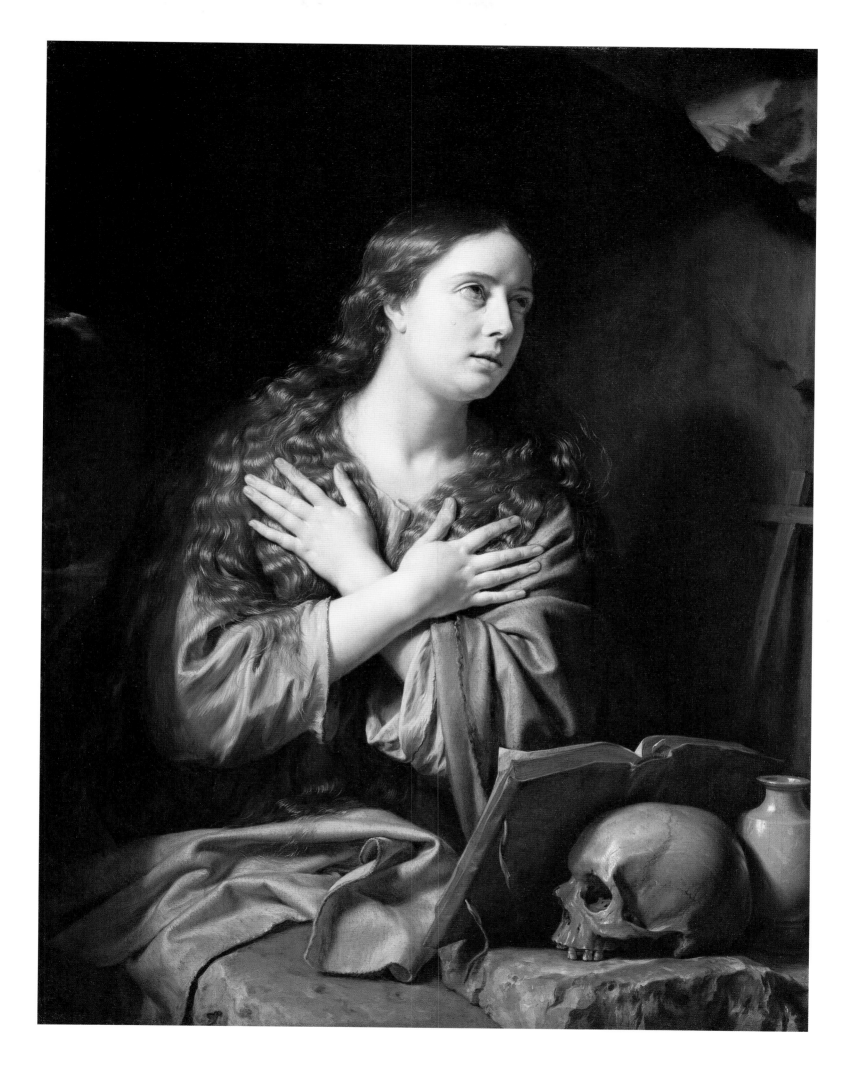

6. Farmer 1997, 339.

7. Alte Pinakothek 1985, 451, repr. On the popularity of penitential subjects in Counter Reformation art, see Steel 1984, 48–50.

8. Jacobus de Voragine [c. 1260] 1993, 1:374–83.

the Magdalen in Luke (7:47): "For this reason I tell you that her sins, her many sins, must have been forgiven her, or she would not have shown such great love."

Saint Mary Magdalene is patron both of repentant sinners and of the contemplative life; this, together with her close association with Christ in many episodes in the New Testament, explains her immense popularity through the ages.[6] Her portrayal in art flourished in the sixteenth and seventeenth centuries as the Catholic Church moved to foster devotion to the Sacraments, particularly penance (confession), which the Protestants of the Reformation had called into question. In response to this polemic, depictions of subjects illustrating the Sacrament flourished in Counter Reformation art. The motif of the weeping sinner is clear evidence of the influence of contemporary religious tracts, in which the significance of tears as an expression of penitence was stressed. The Counter Reformation depiction par excellence of the sinner whose sins had been forgiven as a result of penance is Rubens's *Christ and the Penitent Sinners*, c. 1618 (Alte Pinakothek, Munich), which includes the Magdalen, Saint Peter, King David, and Dismas, the penitent thief crucified alongside Christ.[7]

In the museum's painting, the Magdalen is shown with her attributes as a repentant sin-

ner. She reads and meditates and raises her tear-filled eyes toward heaven. Her long, flowing hair is a symbol of her penitence according to the biblical account (Luke 7:37–38), in which she expressed her love for Christ by washing his feet with her tears and wiping them with her hair. The skull is a special attribute of the Magdalen, and a reminder of the saint's penitential contemplation of eternal life after death following her conversion to Christianity. The container beside the skull is an ointment jar, which refers not only to the episode in which the Magdalen both washed and anointed the feet of Christ in the house of Simon the Pharisee, but also to the scene at the sepulcher, after the Crucifixion, when the Magdalen and two other women brought sweet spices to anoint the body of Christ (Mark 16:1).

Champaigne has reduced the background to a minimum. A large, dark area of brown and a few pieces of vine silhouetted against a small section of sky suggest the interior of a cave, adorned only with a simple wooden cross where according to legend, the Magdalen spent the last thirty years of her life as a hermit. The story of her pilgrimage to France, where she is said to have lived for many years as a hermit in a grotto at Sainte-Baume in Provence, originated in the eleventh century and is told in the *Golden Legend*.[8]

## Frans Hals

Dutch, 1582/83–1666

*Portrait of an Elderly Woman,*
1650

Oil on canvas, 33 5/16 x 27 3/16 in. (84.6 x 69.2 cm)
The Robert Lee Blaffer Memorial Collection, gift of
Sarah Campbell Blaffer
51.3

1. Slive 1995, 30–31, fig. 29.

Frans Hals is regarded today as one of the greatest Dutch artists of the seventeenth century and, after Rembrandt, the country's greatest portraitist. His *métier* was portrait painting; almost all his works are portraits, and even those that are not (a few genre scenes and a handful of religious pictures) maintain a portraitlike character. Although born in Antwerp, Hals settled in the prosperous town of Haarlem at an early age and spent his long life there. His activities prior to his late twenties remain largely a mystery, but in 1616 he painted the first monumental masterpiece of seventeenth-century Dutch paint-

ing, *The Banquet of the Officers of the Saint George Civic Guard Company* (Frans Halsmuseum, Haarlem).[1] There is no precedent in either his own work or that of his predecessors for the vivid characterization of his sitters in this painting, which has become a symbol of the healthy optimism and strength of the men who established the new Dutch republic. It demonstrates to the full Hals's remarkable ability and his greatest gift as a portraitist— to capture a momentary individual likeness and convey an impression of immediacy.

During the 1620s Hals perfected the rendering of vitality and spontaneity in works

Frans Hals, *Portrait of an Elderly Man,* c. 1650. Oil on canvas, 33 x 25 1/2 in. (83.7 x 64.7 cm). Formerly heirs of Sir Algar Stafford Howard, Penrith, Cumberland, England

like the *Laughing Cavalier,* 1624 (Wallace Collection, London), one of the most brilliant of all Baroque portraits, and the *Merry Drinker,* c. 1628–30 (Rijksmuseum, Amsterdam). Both show Hals's mastery of one of the principal preoccupations of Baroque artists: the rendering of instantaneous emotion and movement.[2] He attracted a distinguished clientele drawn almost exclusively from Haarlem's wealthy burghers, but also cultivated patrons from other strata of society. His most lasting achievements are probably his large group portraits of the civic guards, most of which are in the Frans Halsmuseum, Haarlem, the only place where a comprehensive view of the artist's range and power can be seen.

Over the course of a career that covered more than half a century, Hals shifted the direction of his painting style several times. In the 1630s his works acquired a greater unity and simplicity, and the bright colors of the 1620s gave way to more monochromatic effects. This tendency toward restraint marks the portrait of *The Regents of the Saint Elizabeth Hospital,* 1641 (Frans Halsmuseum, Haarlem), and sets the stage for the last decades, when his pictures became darker and his brushstrokes more economical. The culmination of this phase includes his group portraits of *The Regents* and *The Regentesses of the Old Men's Almshouse,* c. 1664 (Frans Halsmuseum, Haarlem), which rank among the most moving portraits ever painted. Despite his artistic success during his lifetime, Hals was almost totally forgotten after his death. It was not until the 1860s that the vigorous and free brushwork that brought his portraits of Dutch burghers vividly to life was once again appreciated by critics, collectors, and contemporary artists.[3]

Hals frequently received commissions for pendant portraits of husbands and wives during the course of his career, particularly in the 1640s and 1650s. At least thirty pairs are known today, and it is possible that a few of his single portraits almost certainly originally had mates that have disappeared. Traditionally in Dutch portraiture the male sitter took precedence over the female. This was acknowledged by Hals and other artists when they painted pendants, double, or family portraits according to the laws of heraldry. In companion paintings of a husband and wife,

the man's portrait was most often placed to the woman's right, or dexter side (to the viewer's left), while the woman's portrait was situated to the left, or sinister side (to the viewer's right), of her husband. The tradition can be traced to the late Middle Ages when artists painted donors in altarpieces, and Renaissance and Baroque portraitists continued to give husbands this priority over their wives.[4]

The museum's *Portrait of an Elderly Woman* conforms to this tradition and was originally paired with a corresponding half-length portrait of her husband facing to the right (left).[5] The woman has been identified as Elizabeth van der Meeren on the basis of what appears to have been an eighteenth-century inscription on the back of the painting. However, there seems no reason to regard it as conclusive, and the inscription disappeared in the course of a 1930s restoration. Our only clue to the sitter's identity is her age, sixty-two, and the date of the painting, 1650, which Hals has inscribed in the background on the left. Seymour Slive, the great scholar of Dutch art (and of Hals's paintings in particular), has written:

> There can be no question about Hals' sympathetic interpretation of the elderly couple. The dark color harmony is enlivened in the man's portrait by the freedom of the broad brushwork and the contrast of the blacks and deep browns of his heavy, fur-trimmed coat. In the companion piece the old woman's hands attract as much attention as her strong head. The intense light areas of the hands, cuffs, and gloves have been so thinly brushed that the warp and woof of the canvas are still visible. On this thin ground incredibly fine modulation of tones integrated with bold and delicate brush strokes model the forms without lingering over details. A few nervous strokes are enough to suggest the lace on her cuffs while crackling impasto touches of bright yellow indicate her glittering ring and the chains of her gold bracelets.[6]

Hals's most penetrating characterizations date from the last decades. The pictorial reserve of his last phase was particularly suitable for older sitters like the dignified woman depicted here who was only a few years younger than the artist himself. Hals established a basic scheme for his portraits of

2. Ibid., 41.

3. Jowell 1989.

4. Slive 1995, 46–47. The terms *dexter* and *sinister* refer respectively to the right and left of the person wearing the escutcheon.

5. Slive 1970–74, 1:182, 184, 2:pls. 282–83, 292, 3:94–95, nos. 180–81; J. Patrice Marandel in Museum of Fine Arts 1981, 57, no. 102. The close correspondence between the arrangement of the sitters, the dimensions, and the shapes of the letters and numbers of the inscription suggest the portraits were pendants. Grimm 1990, 245, 247, 292, fig. 139, assigns the portraits to the workshop of Hals, that of the woman in particular to one of the artist's sons who, in his opinion, are responsible for a group of works designated as group A.

6. Slive 1970, 1:184.

7. Ibid., 115, 2:pl. 124, 3:47, no. 78.

8. The painting was cleaned and restored by Nancy Krieg in New York in 1998.

seated women in a 1631 three-quarter length of *Cornelia Vooght Claesdr* (Frans Halsmuseum, Haarlem), and it became a favorite of his patrons thereafter.[7] Hals consistently lit his sitters from the left, causing a shadow to be cast on the right. The three-dimensionality of the figure in the museum's painting is enhanced by the powerful silhouette of the figure against the greenish gray background. The features are modeled with broad, bold strokes that have great strength and surety. The highlights and shadows of the white cap and collar are carefully depicted, as Hals sought to project not only their detail but also their translucence. Hals also articulated the design in the black jacket with great care,

but he indicated the lace cuffs, the fur-lined *vlieger* (long, sleeveless garment), and folded gloves held by the sitter with comparatively free brushstrokes that suggest the flickering of light off their surfaces.

The condition of the picture is much better than had been traditionally thought. Conservation treatment of the painting in 1998 revealed a vibrancy in the flesh tones and costume that had been obscured by discolored varnish and overpainting.[8] The face and hands, the headpiece, the white cuffs, portions of the brown-and-black fur trim, and the folded gloves can now be seen to have been originally vividly rendered with Hals's characteristic virtuosity.

## Willem Claesz. Heda

Dutch, 1594–1680

### *Banquet Piece with Ham*, 1656

Oil on canvas, 44 x 60 in. (111.7 x 152.3 cm)
Gift of Mr. and Mrs. Raymond H. Goodrich
57.56

Still-life painting is a typical expression of seventeenth-century Dutch culture, and no other country produced still lifes in such quantity or quality. The English *still life* derives from the Dutch word *stilleven,* which the Dutch themselves only began to use around 1650. Before that time they referred to "still-standing objects" *(stilstaende dingen)* or labeled their subjects "breakfast" *(ontbijit),* "banquet" *(bancquet),* "fruit piece" *(fruytagie),* "flower pot" *(blompot),* and so on.[1] Each type of still life had its own iconography, and individual painters often developed their own specialties among these categories, some representing flowers and others food, some fish and others dead birds. The Haarlem painters Pieter Claesz. and Willem Claesz. Heda popularized the small-scale monochrome still life ("monochrome" refers to the range of tones, rather than of colors). From these modest descriptions of a light breakfast or snack—some bread and cheese, a glass of beer or wine set near the corner of a table—Willem Claesz. Heda proceeded to create ambitious banquet scenes, like the museum's still life, that encompass an abundance of rare and expensive domestic objects

with a subtle brushwork that captures every nuance of texture, light, and atmosphere.

This so-called *banketje,* in which food and serving vessels are disposed on a table, demonstrates how rich and decorative Heda's compositions became in his mature phase.[2] Displayed in the painting are the remains of a sumptuously laden table. A suggestion remains of the care with which the vessels and utensils were once arranged, but Heda has presented them as if a real meal has been abruptly abandoned, the white linen tablecloth crumpled, ornate silver vessels overturned, glasses half emptied, plates negligently piled up, the lid of a silver pitcher left open, and slices of bread and oyster shells strewn across the table.

Beginning in the 1630s Heda executed a number of similar still lifes, which include many of the same objects in different arrangements and combinations. These items—the oval *roemer* (a glass used for drinking wine), a silver beaker fallen on its side, a flute glass *à la façon de Venise,* a tall and richly ornamented silver potbellied decanter with a spout in the form of a dragon, and a bell-shaped salt cellar—appear repeat-

1. Slive 1995, 277.

2. Vroom 1980, 1:52, fig. 64, 2:79, no. 382.

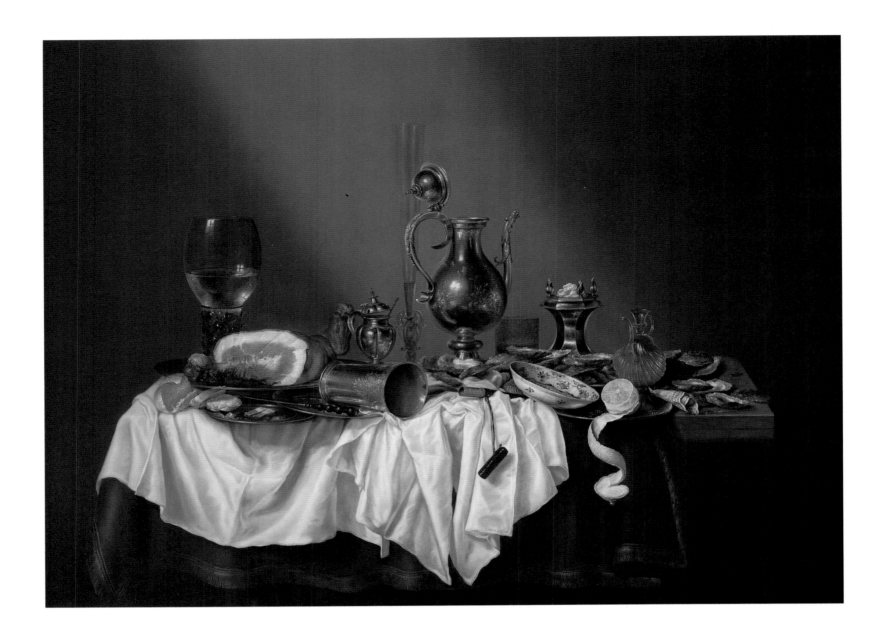

edly in Heda's still lifes.[5] Yet in spite of the harmonious and convincing manner of Heda's presentation of food and drink and the vessels in which they are served, there can be little doubt that the painting represents an imaginative arrangement of household objects and does not record the aftermath of an actual meal.

The composition is arranged in a broad triangular form, its apex defined by the tall Venetian glass in the center of the composition. Although the table is located in the frontal picture plane, Heda has introduced enormous variety into the composition by the profusion of precious vessels set at different depths. By placing several objects hanging over the nearest edge of the table (such as the porcelain dish and twisted lemon peel on a pewter plate), Heda created the illusion that they actually protrude into the viewer's space.

His superb control of light and tone throws the table and its contents into sharp relief and enhances the strong sense of spatial recession. The work demonstrates Heda's skill in accurately depicting reflections and textures: the glints from the glass, pewter, and silver vessels; the reflection of the latticed windows in the painter's studio captured on the surface of the olive-green *roemer;* the rough surface of the lemon peel. Although these compositional ideas had been current in Dutch and Flemish still-life painting from the first decades of the century, Heda utilized them with a fresh and unprecedented force and conviction.[4]

For some observers of Heda's work, the effort to discover "a message of the vanity of human existence which is supposed to reside in every fallen glass or partially eaten fruit pie" is better spent admiring Heda's master-

3. Ibid., 53–78.

4. Wheelock 1995, 102.

5. Vroom 1980, 1:56, 58–59.

6. For example, see the interpretation of Heda's *Banquet Piece with Mince Pie* in the National Gallery of Art, Washington, D.C., by Wheelock 1995, 99–102.

7. Slive 1995, 281.

ful and painterly control of his subject—the contrasts of a light color placed against a darker tone, perhaps, or the exquisite balance he achieves between horizontal and vertical accents in his compositions. [5] For others, Heda's selection of objects may well have been carefully chosen to convey a moralizing reminder frequently encountered in still-life paintings of the time, namely, that the sensual pleasures of the feast are momentary in comparison to the spiritual food provided by the Bible's teachings and threaten to distract man from the message of Christ's sacrifice and the significance of God's word. [6] In any case, as Seymour Slive has suggested, there can be no doubt about "the amazement and sheer delight seventeenth-century observers took in the skill of artists who could represent delicious food with such exactitude: our eyes have been numbed by countless color images of food illustrated in cookery books and advertisements designed to sell packaged edibles." [7]

## Mattia Preti
Italian (Neapolitan), 1613–1699

## The Martyrdom of Saint Paul, c. 1655–56

Oil on canvas, 73 3/4 x 70 11/16 in. (187.3 x 179.6 cm)
Museum purchase with funds provided by the Laurence H. Favrot Bequest
69.17

One of the most dynamic figures of Baroque painting in Naples, Mattia Preti came from Calabria (hence his nickname "Il Cavaliere Calabrese") but worked in several different parts of Italy. He formed an original style derived from a variety of sources ranging from Venetian High Renaissance painting to the Roman church ceilings of the Baroque painter Giovanni Lanfranco (1582–1647). His early works include dramatically lit groups of musicians and card players in the style of Caravaggio and his followers, but Preti's later paintings are predominantly religious subjects in fresco and oils. After the plague of 1656 carried off virtually a whole generation of artists in Naples, Preti worked with great success there, gaining many important commissions. These include a series of frescoes he painted on each of the seven city gates to commemorate the ending of the plague, of which only two oil sketches (Museo di Capodimonte, Naples) survive to offer some idea of how powerful the huge frescoes must have been. In 1661 Preti settled in Malta, where his association with the Knights of Malta resulted in an increase in commissions from all over Europe. [1]

Preti often executed large religious scenes for private patrons rather than for churches, and most of the important Neapolitan palaces had pictures by him. *The Martyrdom of Saint Paul*, together with a *Crucifixion of Saint Peter* and a *Martyrdom of Saint Bartholomew*, were recorded by Preti's biographer Bernardo De Dominici (1683–1759) as in the house of the marchese Ferdinand van den Einden, a rich Flemish merchant who lived in Naples in the second half of the seventeenth century. [2] His father, Jan, had from the 1630s on, been a business associate of Gaspar Roomer, another Flemish patron of the arts. Van den Einden was deeply impressed by Preti's *Marriage at Cana* painted for Roomer, and he later acquired numerous works from the artist. The three paintings obviously belong together by virtue of their stylistic similarity, almost equal size (the slight variations are due to the canvases being trimmed later), and compositional affinity. In 1688 the three canvases were valued at two hundred ducats each by Luca Giordano (see pp. 88–91) in a division of the inheritance among the marchese's three daughters, each receiving one of the pictures. [3]

The three scenes of martyrdom are each marked by a striking realism that reveals another powerful influence on Preti's art: the naturalistic treatment of the nude by the Spanish painter Jusepe de Ribera (1591–1652). The van den Eindend series pays homage to Ribera in every respect, notably in the attention paid to the crowded arrangements and cumbersome physicality of his compositions. The muscular figures of both saints and executioners with their wrinkled brows are a particular legacy of the Spanish painter. Ribera

1. For Preti's career, see Mariella Utili in Whitfield and Martineau 1983, 206–7; George Hersey, "Mattia Preti, 1613–1699," in Yale University Art Gallery 1987, 83–92; and Spike 1996.
2. The relationship between the three paintings and their ownership by van den Einden was discovered by Giovanni Carrandente and published in Heim Gallery 1971, no. 6. See also Whitfield and Martineau 1983, 211–13, nos. 103–5; Yale University Art Gallery 1987, 99–102, no. 3; and Spike 1999, 149–50, no. 53. The museum's painting was first published by Schrader 1970a.
3. Hersey in Yale University Art Gallery 1987, 100.

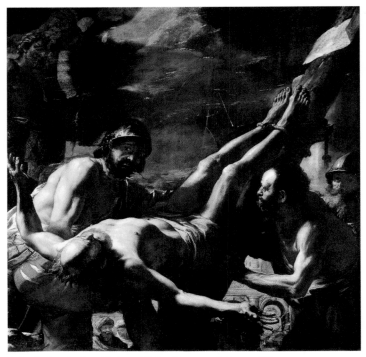

Mattia Preti, *Crucifixion of Saint Peter,* c. 1656–59. Oil on canvas,
76 7/16 x 76 1/2 in. (194.5 x 194.3 cm). Barber Institute of Fine Arts,
The University of Birmingham

Mattia Preti, *Martyrdom of Saint Bartholomew,* c. 1656–59. Oil on can-
vas, 75 x 75 3/4 in. (190.4 x 192.9 cm). The Currier Gallery of Art, Man-
chester, New Hampshire

was known for his depictions of violent
scenes of martyrdom, and Preti has also been
described as an "uninhibited interpreter of
Christian martyrdoms and Old Testament
mayhem." Indeed, it has been suggested that
he may have been encouraged to work in this
vein by Neapolitan collectors who champi-
oned Ribera, only recently deceased, as prior
to his arrival in Naples in 1653, Preti had not
shown a greater propensity to themes of vio-
lence than any other painter associated with
Caravaggesque naturalism.[4]

However, as in many of Preti's scenes of
martyrdom, Saint Paul is shown in the expec-
tation of salvation, and the depiction of the
violence and gore of the actual execution is
avoided.[5] According to tradition, Saint Paul
(died c. 65) was martyred at Rome during
Nero's persecutions (perhaps symbolized here
by the large gilt-bronze statue of Hercules
behind the foreground figures). As a Roman
citizen, Paul was entitled to the more honor-
able and swifter execution of beheading; in
the museum's painting, the aged yet vigorous
saint is shown naked to the waist at the
block, reading the word of God even in this

moment of extremity, awaiting the death
blow from a burly executioner.[6] The tradi-
tional place of Paul's martyrdom was known
as Tre Fontane, the three fountains, and he
was buried on the outskirts of Rome where
the basilica of Saint Paul "outside the walls"
now stands.

Even at this moment in Preti's career in the
late 1650s Caravaggio's influence remained
powerful: strong shafts of light sweep across
the canvas in luminous planes accentuating
the principal characters, notably Saint Paul
and the executioner. With the exception of
the red cloak around the saint's waist, the
powerful colorism of Preti's earlier work is
now subdued in favor of a prevailing silver-
gray tonality that dissolves some of the
massiveness of the forms. The bold fore-
shortening of the three main figures set
against the light is counterpoised by the
heads of the black page, young soldier, and
turbaned elder who peep through immedi-
ately behind. These pictorial qualities accord
with Preti's general development during the
1650s and suggest that the museum's painting
was the last completed of the series.[7]

4. Ibid., 99, 102.
5. Utili in Whitfield and Martineau 1983, 210.
6. The open book may also be a reference to Paul's own
   writings.
7. Hersey in Yale University Art Gallery 1987, 102.

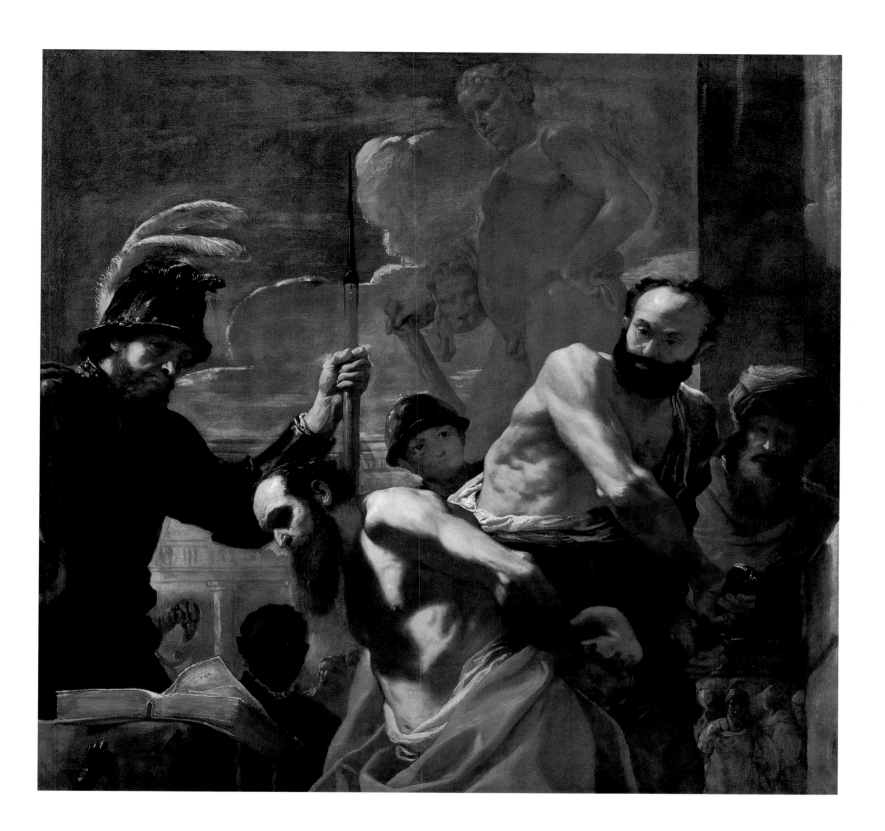

## Bartolomé Esteban Murillo

Spanish, c. 1618–1682

### *The Virgin of the Annunciation,* c. 1665–70

Oil on canvas, 28 1/2 x 22 1/2 in. (72.4 x 57.2 cm)
The Samuel H. Kress Collection
61.70

Bartolomé Esteban Murillo was one of the greatest seventeenth-century Spanish painters along with Diego Velázquez (1599–1660) and Zurbarán. His fame rests on his work as a devotional painter, especially on his paintings of themes such as the Virgin of the Immaculate Conception. Murillo's paintings of religious subjects appealed strongly to popular piety and exemplify the teachings of the Counter Reformation on the arts. He presented subjects clearly and simply, although the doctrines behind them were often complex and obscure. He began working in a dark, naturalistic manner, but his mature style is characterized by idealized figures; soft, melting forms; delicate coloring; and sweetness of expression and mood. Murillo was one of the greatest portrait painters of his time, but his fame abroad was established by his genre scenes of street urchins and beggar children that he painted for Dutch and Flemish merchants in Seville. These works were highly prized by eighteenth-century collectors for their sentimental appeal, and Murillo's paintings found an audience in other European countries, particularly England and France, where they served as an example to such artists as Gainsborough (see pp. 115–17), Reynolds (see pp. 124–27), and Jean-Baptiste Greuze (1725–1805).[1]

*The Virgin of the Annunciation* is a fine example of Murillo's mature technique and handling, admired since the nineteenth century for its "tender and delicate" means of expression.[2] In the 1650s he began to abandon the dark tonality of his early paintings and increasingly bathed his scenes in a luminous light. His coloring became richer following a visit to Madrid and the influence of Rubens and of the work of Genoese painters represented in Sevillian collections and churches. The museum's bust-length Virgin is thought to date from relatively late in Murillo's career and represents the refinement and purification of his final manner. The tonal range is reduced and his palette is restricted to a few colors, with blue, carmine, mauve, and gray predominating. His brushwork has become

much looser and gives the canvas an unfinished appearance. The term *estilo vaporoso* (vaporous style) is often used to describe the delicate coloring and light and open, free brushwork of paintings such as *The Virgin of the Annunciation.*

The pose and gesture of the Virgin derive from formulations for the depiction of the Annunciation (Luke 1:26–38) devised by the Jesuits in Seville in the first half of the seventeenth century. A highly detailed iconographical prescription was published in 1649 by the Spanish painter and writer Francisco Pacheco in *El Arte de la Pintura* (The Art of Painting). According to this scheme, the Virgin was to be shown kneeling at a writing table on which an open book lies. She is young (fourteen years and four months old, as Pacheco notes) and has long hair covered with a veil. Either her hands are clasped or her arms are crossed. Other details relating to the appearance of the angel Gabriel, God the Father, and the Holy Dove are provided, and the formula acquired great authority among the painters of Seville.[3]

Murillo followed the Jesuit formulation described by Pacheco in an *Annunciation* today in the Wallace Collection, London,[4] that suggests how the museum's half-length Virgin Mary would appear in a large-format depiction of the subject and explains the angle of her head and the position of her hands. The model for the lovely figure of the Virgin in the museum's painting appears in a half-length representation of *Santa Justa,* c. 1660 (Meadows Museum, Southern Methodist University, Dallas), and again as the Virgin in Murillo's *Two Trinities,* c. 1675–80 (National Gallery, London).[5] The museum's painting has been thought to represent a study for an Annunciation and, alternatively, a remnant cut from a much larger work in which Mary was shown kneeling at the right with Gabriel at the upper left. Examination of the canvas by x-ray radiography confirms, however, that the dimensions of the original support are close to the original size of the painting and that it is not a frag-

1. For introductions to Murillo's life and career, see Prado 1982, and esp. Mena 1996.
2. Eisler 1977, 219, no. Ki866, fig. 210, with earlier bibliography; Angulo 1981, 2:139–40, no. 134.
3. Brown 1978, 66–68.
4. Ingamells 1985–89, 1:397, no. P68, repr.
5. Prado 1982, 171, no. 29, repr. 102; Helston 1983, 42–43, repr.

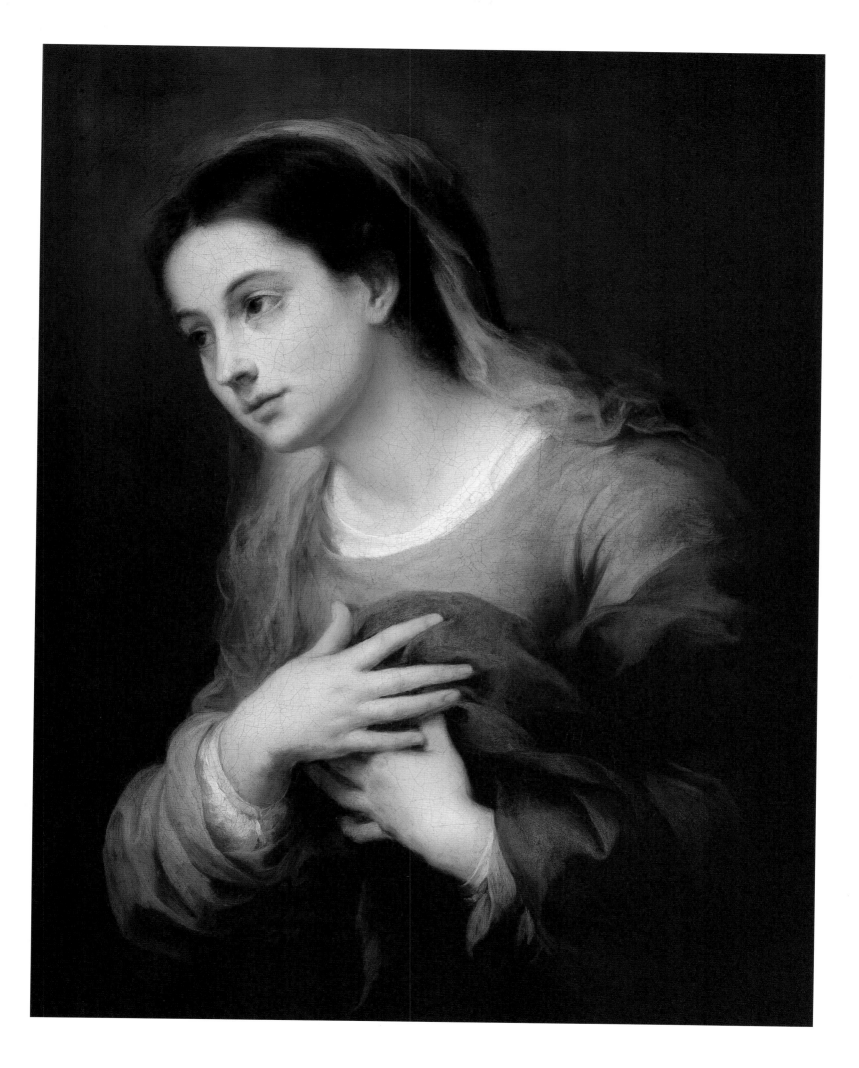

6. The painting was examined, cleaned, and restored by Friederike Steckling in 1998 at the Conservation Center of the Institute of Fine Arts, New York University.

ment of a larger piece of canvas. Given the size and scale of *The Virgin of the Annunciation,* it can be assumed that it was once paired with a companion piece representing the archangel Gabriel in a corresponding attitude, and that both paintings were intended for private devotion.

Cleaning and restoration of the painting in 1998 also provided information about Murillo's painting technique.[6] He prepared the canvas with a golden brown ground layer that contributes to the warm glow of the background and that under magnification can be seen to exist throughout the painting. Over this ground, Murillo applied a warm red priming layer under the passages of flesh and two gray layers under the Virgin's blue drapery, a darker tone for the overall body color and shadows, and a lighter one containing more white pigments for the highlights.

Over this gray underdrawing, Murillo glazed two different shades of pigment probably consisting of ultramarine blue. X-ray radiographs show that the hands were executed first, and then the blue drapery was laid in. (The gray underdrawing of the blue robe does not extend under the hand and fingers, but runs along the contours of the fingers.) Murillo seems to have had a clear idea of his intended design before he started painting—he usually made ample use of pen and chalk studies to lay out his compositions as well as for detailed figures for his works. Murillo's handling of paint in *The Virgin of the Annunciation* is expressive and lively, particularly in the passages of the blue drapery in the right half of the composition, and epitomizes the vaporous brushstrokes and soft coloring for which he is famous.

## Jacob Ferdinand Voet

Flemish (active in Italy), 1639–c. 1700

### *Cardinal Giulio Spinola,* c. 1675

Oil on canvas, 63 3/4 x 45 3/4 in. (161.9 x 116.2 cm)
Museum purchase with funds provided by Mary Alice Wilson
76.323

1. The principal study of Voet's paintings is the recent monographic article by Petrucci 1995.
2. Nordenfalk 1967, 124: "Instead of all the sublime ugliness of [the queen's] other portraits, Voet shows us a pretty doll's face with a rounded nose and hair adorned with pearls."
3. For Galleries of Famous Beauties, see Nikolenko 1966, and Nikolenko 1970.
4. Ademollo 1888, 152, citing an anonymous notice in the Archivio di Stato, Florence, *Avvisi di Roma,* 29 January 1678: "Monsù Ferdinando celebrato pittore in questa corte per la sublime maniera di far ritratti et in particolare di femmine adulandole non solo in bellezza ma in bizzarri portamenti d'abiti, è stato dal governo mandato via da Roma per essere il suo pennello strumento alla libidine e la sua casa un continuo ricetto di Dame et cavalieri che compravano ritratti."

Ferdinand Voet was among the leading portrait painters in late Baroque Rome, in demand as much for his elegant and refined portrayals of the Roman aristocracy as for his ecclesiastical representations.[1] Monsù Ferdinando, as he was known in Italy, was born in Antwerp and recorded as resident in Rome from 1663 to 1681. A measure of his importance (and his ability to produce a flattering likeness) is indicated by the presence of Queen Christina of Sweden (c. 1669; Galleria degli Uffizi, Florence) among his patrons.[2] He was admired by his contemporaries for his sensual half-length portraits of women and for his skill in rendering the details of costume with elegance and precision. Voet's sitters included a number of celebrated beauties from Roman noble families, the equivalent of today's "super models," whom he captured in all their extravagant couture, ornamented with bows and ribbons, in the latest French style.

Images of this kind were often gathered into so-called Galleries of Famous Beauties,

such as that of Cardinal Flavio Chigi (1631–1693) in the Palace of Ariccia near Rome.[3] In fact, Voet's society portraits and the often dissolute lives of his fashionable sitters were so intertwined that the painter was expelled from Rome briefly in January 1678 on the order of Pope Innocent XI, for his alleged encouragement of libertinism among the aristocracy.[4] He was in Florence in 1682 in the service of the grand duke of Tuscany, and in Turin in 1684, returning to the Netherlands from there. Following a short sojourn in Antwerp, Voet settled in France by 1689 where he painted court portraits at Paris and Versailles, and where he presumably died.

Voet appears to have broken into the lucrative field of ecclesiastical portraiture around 1669, and during his brief stay in Rome rivaled the leading specialists in the field at that time, Giovanni Battista Gaulli, known as Il Baciccio (1639–1709), and Giovanni Maria Morandi (1622–1717). Voet's sober and penetrating portraits of cardinals were engraved by various artists, and in-

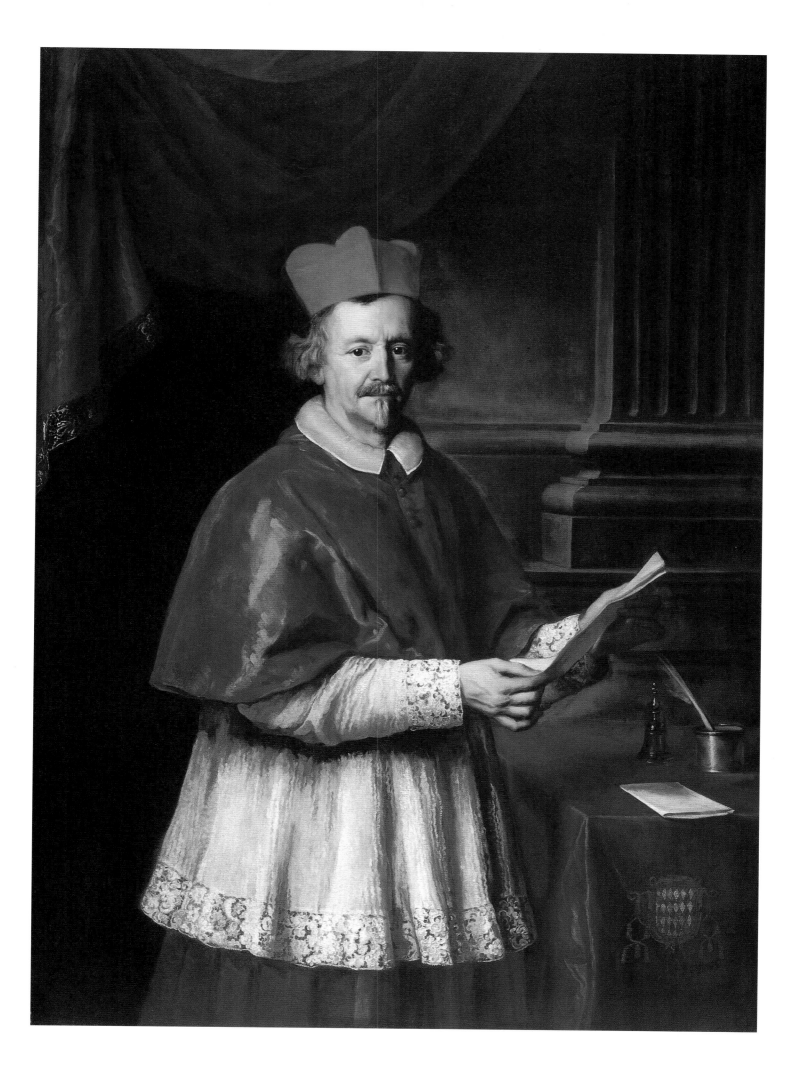

5. The stock was taken on in the eighteenth century by the *calcografia* "della Rev. Cam. Apost. a Pie di Marmo," and in the nineteenth continued by the Calcografia Nazionale. As the cardinals died, the dates of their deaths were added to the plate, and cumulative sets, which were kept up to date, were available for purchase (Waterhouse 1967, 119–20).

6. The portrait was acquired by the museum in 1976 with an attribution to Carlo Maratti, whose powerful conveyance of character it imitates. Edgar Peters Bowron identified Voet's authorship several years ago, and this was kindly confirmed (letter of 16 December 1998) by Architetto Francesco Petrucci, who supplied the identification of the sitter on the basis of Albert Clouwet's (1636–c. 1677) engraving for the *Effigies cardinalium.* I am further grateful to Architetto Petrucci for his assistance in providing biographical information about the sitter.

A replica of the model in "tela da testa" is in the Staatliche Kunsthalle, Karlsruhe, inv. 462, 27 3/4 x 21 5/8 in. (70.5 x 55 cm). A copy was once in Palazzo Altieri in Oriolo Romano.

7. Moroni 1840–61, 69:295–96.

cluded in a series known as *Effigies cardinalium nunc viventum,* a project initiated in 1658 by Giangiacomo de Rossi, a Roman print seller, to record the portraits of cardinals living during the reign of Pope Alexander VII (1655–67).[5] The painted or drawn likenesses were engraved in bust-length oval formats with a legend below giving the name and title of the sitter and also the artist responsible for the likeness. These images enjoyed the role photographs command today and remain the source by which the cardinals who sat to Voet have been identified, including the subject of the museum's portrait.[6]

Giulio Spinola (1612–1691), a member of a noble Genoese family, enjoyed a brilliant ecclesiastical career. He went to Rome to pursue studies in canon law and was appointed by Pope Urban VIII as governor of various towns in Umbria, Lazio, and the Marches. In 1653 he was made apostolic nuncio with plenipotentiary powers to the kingdom of Naples. He was transferred by Pope Alessandro VII in 1665 from Naples to the nunciature at the court of the Hapsburgs in Vienna. Already by 1664 he had been created cardinal *in petto,* and on 15 February 1666 he was made cardinal by the pope. In 1670 Clement X appointed him bishop of Sutri and Nepi; in 1677 Innocent XI transferred him to Lucca; he later served as legate to Poland.[7]

*Cardinal Giulio Spinola* reveals that Voet's artistic heritage is derived from both Flemish and Roman traditions of portrait painting, from the realism of Anthony van Dyck (1599–1641) and the sober elegance of Carlo Maratti (1625–1713), to whom the painting was traditionally attributed. Voet fully understood the conventions of official ecclesiastical portraiture based on the work of Raphael and the Roman High Renaissance and invested the sitter with similarly appropriate grand rhetorical splendor. The mise en scène suggests a typical Baroque interior, with the curtain behind the cardinal that symbolizes public or official circumstance balanced by a giant pilaster on the right. The cardinal's pose and paraphernalia offer the impression that he has been momentarily interrupted while reading, and his attention is fixed outside the painting on the spectator. The table at his right holds the standard accessories of Roman ecclesiastical portraits—a silver inkpot and summoning bell—and the velvet table covering bears the Spinola coat of arms.

Like all successful portrait painters, Voet subtly underplayed the physical imperfections of his sitters while still commemorating them with a distinguished, and in the case of his ecclesiastical sitters, an almost direct likeness. Voet's works are full of elegance and beauty of form, and the richness of his palette and polish of his handling are evident in the museum's portrait. Voet places the cardinal before a neutral background in order to dazzle us with the brilliance of the scarlet-and-white costume and to highlight his mastery of the details of ecclesiastical dress. These elements inspired a bravura display of brushwork in his description of the cardinal's watered silk *mozzetta* and cassock and the shimmering linen of his alb.

## Luca Giordano

Italian (Neapolitan), 1634–1705

*Allegory of Prudence,* c. 1682–85

Oil on canvas, 36 9/16 x 36 9/16 in. (92.9 x 92.9 cm)
Museum purchase with funds provided by the
Agnes Cullen Arnold Endowment Fund
75.33

One of the most celebrated European painters around 1700, Luca Giordano was also one of the most versatile and prolific. His vast output included altarpieces, mythological paintings, and decorative fresco cycles in both palaces and churches. He began his career in Naples in the circle of Jusepe de Ribera, but he was able to imitate other artists' styles with ease, and during his extensive travels he absorbed the influence of painters as various as Veronese, Pietro da Cortona (1596–1669), and Mattia Preti. He worked mainly in Naples, where he was the leading artistic personality in the second half of the seventeenth century, but he also painted extensively in Florence and Venice. It is impossible to overestimate Giordano's influence upon painting in Italy and in Spain, where he was invited by King Charles II and painted in Madrid, Toledo, and the Escorial from 1692 to 1702. His open, airy compositions; light, luminous colors; and free, painterly technique are generally cited as heralding the Rococo style of the early eighteenth century.[1]

Giordano's greatest achievements reside in his large decorative programs, for which he attained enormous renown. His rapid manner of working and enormous output were proverbial, earning him the nickname "Luca fa presto" (Luca works quickly). Among his most successful projects was the decoration of the Palazzo Medici Riccardi in Florence. The former Medici palace was acquired by the Riccardi family in 1659, and in 1669 construction was begun on a new wing that included a gallery on the first floor, intended to house a precious collection of antiquities and to function as a public reception room. In 1682 Marchese Francesco Riccardi (1648–1719) commissioned Giordano to decorate the ceiling of the galleria in fresco, although the actual technique he employed appears to have been *fresco secco*—that is, pigment applied to dry rather than fresh plaster. Giordano began work on the galleria frescoes in September 1682, but the work was interrupted by an extensive absence from Florence, and the entire ceiling was not finished until late 1685.[2]

Giordano's adviser for the complex iconographical program of the decoration was Alessandro Segni, a scholar and man of letters who had been Riccardi's tutor and traveling companion. His account of a reception held in the galleria in 1689 provides a description of the scheme:

*Another ball was held in the vast and no less magnificent palace of Sig. Marchese Riccardi, which reflects everywhere the greatness of its original owner Cosimo de' Medici, the Padre della Patria. . . . More than by anything else the eyes of the guests were attracted by the noble Gallery, which on this occasion was seen entirely finished for the first time. The floor of finest marble is as rich as it is well made. The walls are entirely decorated with exquisite stucco reliefs enhanced with gold, above which is a broad cornice, similarly decorated with gold, which serves both as a frame for the stuccowork and the base of the ceiling. The latter is by the celebrated brush of Luca Giordano and represents in a continuous narrative, comprising several hundred figures, all the theology of the Gentiles and the chief figures adored as divinities by that superstitious religion. Sky, Sea, Earth, and Fire are here represented by numerous figures expressing in a variety of different dramatic attitudes, the various strong passions with the Gentiles in their legendary tales attributed to their imaginary gods.*[3]

The vast composition of the gallery ceiling is conceived as a painted frieze in which the various episodes form part of a single sequence extending all around the room above the cornice, which divides the fresco from the stuccowork of the walls. Giordano's airy illusions strike the visitor as he enters the gallery and draw him into the fantastic world revolving about him. Besides providing a setting for receptions, the gallery was also intended to house the precious collection of rare antiquities that Riccardi avidly collected.

Giordano seldom made preparatory drawings and preferred to paint directly on the canvas. As with many Baroque artists, it was his habit to paint compositional oil sketches,

1. The standard monograph is Ferrari and Scavizzi 1992.
2. The project is discussed extensively by Millen 1976; Ferrari and Scavizzi 1992, 1:79–98; and Finaldi and Kitson 1997, 78–91.
3. Quoted in *The Twilight of the Medici: Late Baroque Art in Florence, 1670–1743*, exh. cat. (Detroit: Detroit Institute of Arts; Florence: Palazzo Pitti, 1974), 260.

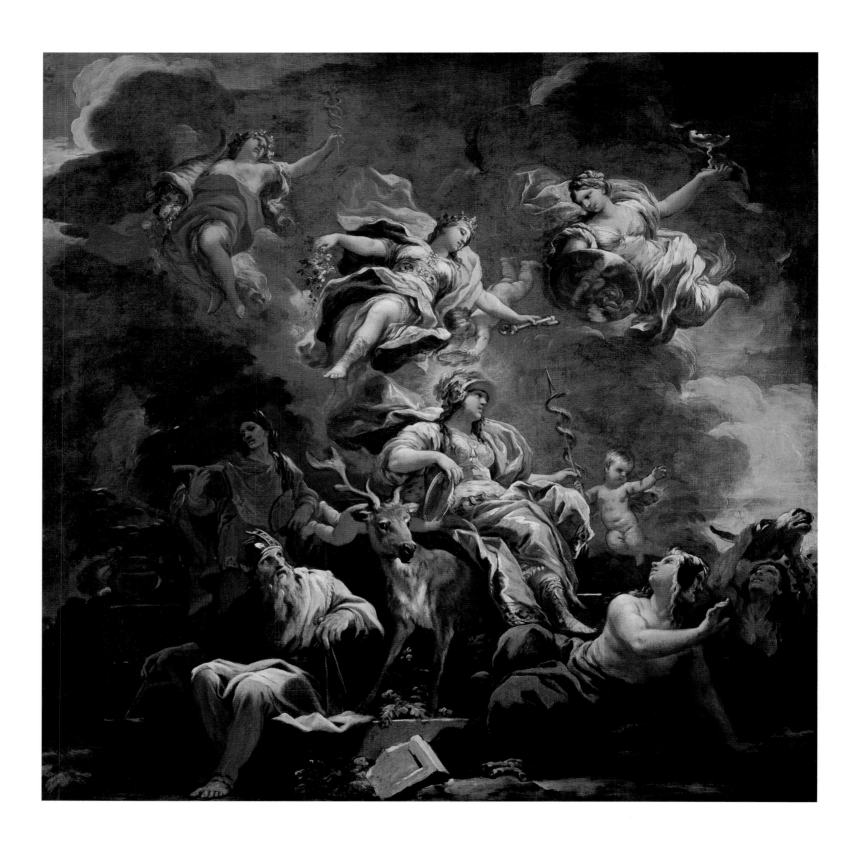

4. Finaldi and Kitson 1997, 82–90, nos. 29–38.

5. See Millen 1976, 298, for the distinctions among Giordano's *macchie, bozzetti,* and *modelli* and the respective differences in his handling of paint.

6. The painting was first published by Millen 1976, 307, fig. 14, as one of the finest and most painterly of all the known sketches of the four virtues; see J. Patrice Marandel in Museum of Fine Arts 1981, 59–60, no. 106. Ferrari and Scavizzi 1992, 1:315, 411, no. E36, citing Millen, inexplicably included the painting among the "copie" of the Medici-Riccardi ceiling and included it among the "opere di attribuzione non accolta."

7. See Finaldi and Kitson 1997, 85, fig. 25.

or *modelli,* for works he intended to carry out on a larger scale. A number of oil sketches for the Riccardi commission survive, notably ten *modelli* in the collection of Sir Denis Mahon, London.[4] These sketches document Giordano's habit of rendering directly in paint his visual ideas and then translating those ideas to the larger proportions of his frescoes and oil paintings. Unlike the swiftly painted *bozzetti,* or rough sketches, Giordano made for other projects, the Riccardi *modelli* were painted as fully finished preparatory studies, intended from the start to serve as small-scale versions of the final frescoes and to be rendered complete in all their details.[5]

The museum's oil sketch representing an *Allegory of Prudence* corresponds to the group of figures in the corner of the ceiling of the gallery between the entrance and the wall decorated with mirrors.[6] Prudence, one of the four cardinal virtues, is shown with her usual attributes: a mirror and a serpent twisted

around an arrow. The deer is also a symbol of prudence because it has to move cautiously, steadying the weight of its antlers, to retain its balance. The two-faced figure with animal feet represents Fraud, and to her right Ignorance (also called Obstinacy) holds aloft a donkey's head. In the fresco itself, Giordano made several minor changes in the disposition of the figures that suggest that the museum's sketch represents a preliminary stage in the evolution of the design.[7] Prudence, for example, faces away from the other figures and looks upward toward Abundance with a cornucopia and caduceus; Grace, carrying flowers and a key (the Riccardi emblem); and Health (or Well-being), holding a shield and a cup. On the left are two Oriental philosophers, one with a quadrant, the other with a compass, perhaps intended to represent Archimedes and Euclid, who personify Order and Reason (or Experience).

## Cristoforo Munari

Italian (Emilian), 1667–1720

## Still Life with Musical Instruments, c. 1700

Oil on canvas, 53 3/4 x 39 in. (136.5 x 99 cm)
The Samuel H. Kress Collection
61.60

1. See Bergamo 1996.

2. Briganti 1954, 42; Shapley 1973, 105–6; Baldassari 1998, 154–55, no. 34, with further bibliography.

3. Briganti 1954, 42.

4. Bergamo 1996, 250–79, nos. 50–60.

The museum possesses several extraordinary still lifes among its European paintings (see pp. 57, 80, 95), including this beautifully poised and polished assemblage of musical instruments and other objects by Cristoforo Munari. When first placed on view in Houston in 1953 with selections from the Samuel H. Kress Collection, the authorship of the painting was unknown. It was for many years thought to have been the work of a follower of the Italian still-life specialist Evaristo Baschenis (1617–1677),[1] whose luminous depiction of musical instruments in repose made him one of the most famous practitioners of the genre. But in 1954, Giuliano Briganti identified the painting as a work by Munari, based on a comparison with signed and dated works by him in Rome and Florence.[2]

Munari was a specialist in still-life painting who worked in his native Reggio Emilia, Rome, Florence, and Pisa and counted among his noble and aristocratic patrons Rinaldo I d'Este, duke of Modena; Grand Duke Cosimo III de' Medici; and Cardinal Francesco Maria de' Medici. The circumstances of his training are not known, but his contact in Rome with the German still-life painter Christian Berentz (1658–1722) has

been cited as influential.[3] Berentz specialized in Dutch-like still lifes of fine objects—crystal glasses, silver plates, Delftware—depicted in careful detail, and he employed tapestries in his compositions in a manner similar to that of Munari. Moreover, there were a number of Italian still-life painters specializing in the painting of musical instruments in the late seventeenth century, and their work must also have been known to Munari: Baschenis, the monogrammist B.B. (active in Bergamo around the middle of the century), Bartolomeo Bettera (1639–c. 1688), and Bonaventura Bettera (1663–c. 1718).[4] In the end, however, the details of Munari's early career remain murky and he appears to emerge with a full-blown talent in Rome at the turn of the century as demonstrated by such works as *Still Life with Musical Instruments.*

The museum's still life epitomizes Munari's precise and elegant repertory of Oriental tapestries, fruit of various seasons, musical and scientific instruments, Chinese porcelains, Mexican earthenware vases, Florentine *pietra dura* vases, Venetian glassware, and rock crystal. His realistic treatment of detail and subtle play of reflections and transparencies is suggestive of Dutch still-life painting, and, indeed, the musical instruments, porcelains,

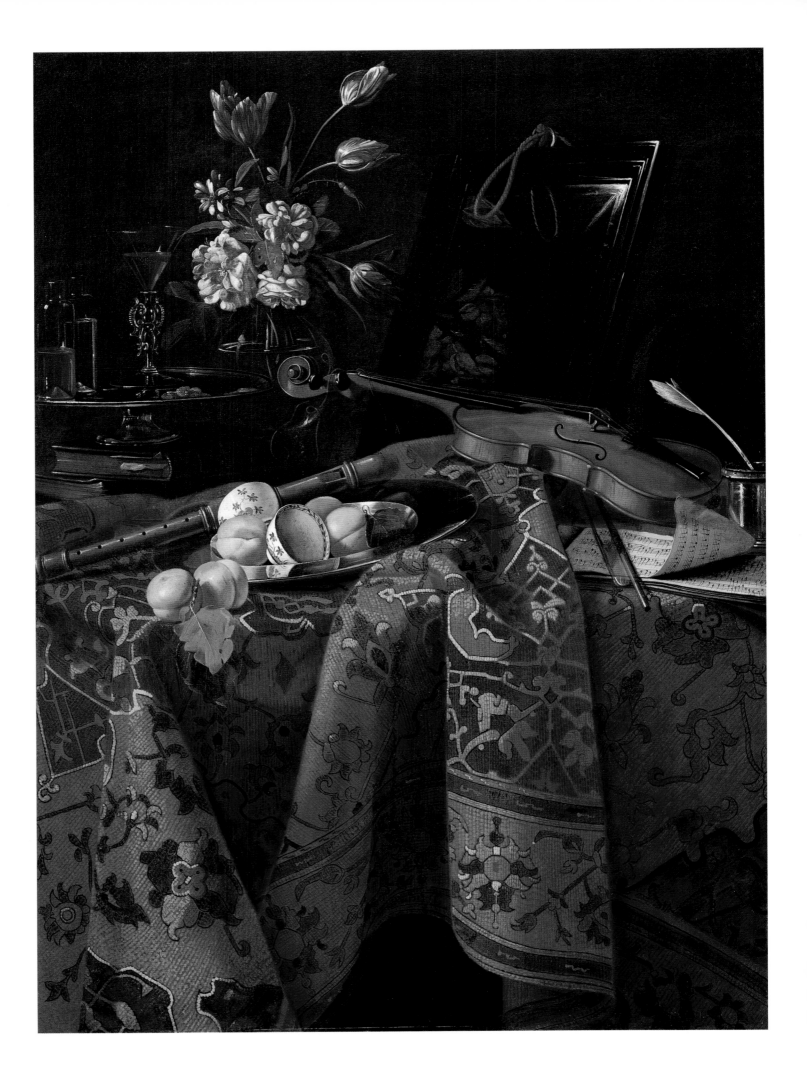

5. Salerno 1984, 338.

6. For examples of still-life representations of the five senses, see Ferino-Pagden 1996, 242–49, nos. IX.1–4.

7. Shapley 1973, 106; Sherrill 1976, 160–61, pl. XVII.

silver and cut-glass objects, and richly colored fruits in Munari's still lifes were commonly depicted by northern artists at least a half century earlier. Much like the Dutch burghers of the seventeenth century, Munari's patrons found the aura of luxury and cosmopolitan elegance of his still lifes enormously appealing. As one writer put it, "The world depicted is that of household treasures, of the porcelain table service (authentic Chinese even) and those other furnishings which were to remain the adjunct and boast—the indispensable sign of elegance and prosperity—of the modern middle classes until a very few years ago."[5] Although Munari is credited with spreading in Italy the type of still life associated with the seventeenth-century Dutch painter Jan Davidsz. De Heem (1606–1683/84), no one would mistake his lucid and disciplined vision, refined taste, and delicacy of handling with the work of his northern predecessors. Munari's still lifes are characterized by a clear and even tone and a purity of touch that is inevitably his own creation.

Beyond its significance as a representation of still life, the picture may be intended as an allegory of the five senses.[6] Thus hearing is associated with music, represented by the recorder (*flauto dolce*), violin and bow, and sheet music on the table. Sight is represented by the mirror and the reflections from the glass- and metalware, such as the silver inkpot at the right of the composition. Taste is symbolized by the fruit on the platter in the foreground and the wine in the Venetian glass on the silver plate in the background. Fruit and flowers are common attributes for the sense of smell in baroque art, but the manner of depicting touch varies considerably. Here, touch is represented by the pronounced texture of the rug upon which the still life is laid. This is clearly recognizable as a type of sixteenth- and seventeenth-century Turkish (western Anatolia) carpet known as a star Ushak. Carpets with similar patterns are seen in English, Flemish, and Italian paintings from the first half of the sixteenth century onward.[7]

## Jan van Huysum

Dutch, 1682–1749

### *Still Life of Flowers and Fruit,* c. 1715

Oil on wood, 31 x 23 1/2 in. (78.8 x 59.7 cm)
Museum purchase with funds provided by the Alice Pratt Brown Museum Fund and the Brown Foundation Accessions Endowment Fund
98.80

1. For van Huysum, see Slive 1995, 319–21; Taylor 1995, 188–93; and Taylor 1996, 84–93, nos. 28–32.

Jan van Huysum was the most successful flower painter in history. No other artist has matched either his technical virtuosity or his ability to create luxuriant arrangements of fruit and flowers. His fame derives in great measure from the extreme realism with which he could convey such details as the veins of individual petals, the filaments of the calyxes, drops of water, and insects. His contemporaries never learned how he achieved such highly finished, enameled surfaces because he was a notoriously secretive artist; he apparently hated the idea of taking on pupils, and he was afraid that they would steal his secrets. Van Huysum's still lifes were enormously popular with connoisseurs and collectors in his day, and it is said that he was the most highly paid Dutch artist of all time. He received commissions from many of the most powerful patrons and collectors of the day—Sir Robert Walpole (1676–1745), the kings of Poland and Prussia, the dukes of Orléans and Mecklenburg, and the elector of Saxony

among them—and a considerable amount of his work is still owned by noble and aristocratic families, particularly in England and France. His style was widely emulated, and his influence on flower and fruit painters persisted until well into the nineteenth century.[1]

Although van Huysum occasionally painted subjects other than still lifes, he owed his fame chiefly to his elaborate fruit and flower pictures. He painted a large number of pairs, usually consisting of a flower piece and a fruit piece with flowers. The companion paintings have often been separated in sales or during the division of estates, and where no documentation exists it is nearly impossible to reconstruct the relationship between individual paintings as most of the works were painted on standard-size mahogany panels, each measuring approximately 31 1/2 by 23 1/2 inches. Van Huysum was unusual among Dutch flower painters for the large number of drawings he produced. Some of his drawings are quick composition studies

2. Confusion is increased by the fact that his father, Justus van Huysum the Elder (1659–1716), and brothers, Justus the Younger (c. 1684–1707) and Jacob (c. 1687–1740), were also flower painters and signed their work "J. van Huysum."

3. Sam Segal (letter of 4 July 1998) has identified thirty-five species of flowers in the painting.

4. Segal 1990, 241.

5. Taylor 1995, 22–24, 191, pl. 12 (*Flower and Fruit Piece*, 1722, J. Paul Getty Museum, Los Angeles).

6. Segal 1990, 242, pl. 67.

7. Walsh and Schneider 1982, 66.

for flower pieces; others were intended as finished works. His paintings were frequently copied and his name frequently forged.[2]

In the museum's recently acquired painting, a rich profusion of flowers overflows its terra-cotta vase and spills over the gray stone ledge upon which it is placed. The curvaceous sweep of the arrangement, the lively chiaroscuro effects, and a delightful ornateness epitomize the eighteenth-century flower piece. The densely packed bouquet is composed of a variety of cultivated and indigenous species, some of which are van Huysum's trademarks.[3] The opium poppy seen from behind at the top is almost a signature of his work, and the white roses, cabbage rose, yellow-brown auricula, French marigolds, and carnations abound in other of his paintings around the same date. The grapes set on the foreground ledge add to the sense of abundance, and a wood snail and a variety of flies, wasps, and ants animate the composition.

Typical of van Huysum's still lifes are the cool palette and saturated blues and vivid greens. His bouquets always look fresh, and not only because of the droplets of water on them. Like many Dutch flower painters, he seems to have painted from life, and we know that on occasion when he could not obtain a certain desired flower or fruit, he postponed painting until it was available. In a letter of 1742 to the agent of one of his patrons he excused the late completion of a flower piece: "The flower piece is coming on well; I could not procure a yellow rose last year, otherwise it would have been finished; the grapes, figs, and pomegranate still have to be painted in the fruit piece."[4] The yellow rose must have been the yellow cabbage rose that he so often painted and was evidently a rare cultivated flower. The fact that some of his paintings bear two dates a year apart suggests that van Huysum waited for the flowers he needed until they were in season, rather than working from sketches. But what distinguishes the artist from other Dutch flower painters was his mastery of illusionistic effect and ability to employ a variety of devices to add to the atmosphere of freshness and naturalness in his pictures: subtle shadows that seem to detach the insects from the painting; droplets of water catching the light; the naturalistic overlapping of the petals and leaves.

Van Huysum's surviving dated paintings range from 1706 to 1743. The early still lifes are striking for the cool, vivid colors set against a slate-gray background. This device was used, for example, in two beautiful fruit and flower pieces of approximately the same period as the museum's painting, one recently acquired by the National Gallery of Art, Washington, D.C.; the other on long-term loan there from a London private collection. Van Huysum probably painted the museum's still life shortly after a flower piece in Karlsruhe, dated 1714, which also depicts a bouquet in a dark niche. He later replaced this format with floral arrangements set before inviting glimpses of landscape backgrounds suggestive of woodland estates.[5]

Although floral symbolism is more conspicuous in seventeenth-century Dutch flower painting, van Huysum too may have occasionally wanted to instruct onlookers as well as delight them. The text on a vase holding a bouquet of flowers in a painting now at the Amsterdam Historical Museum consists of fragments of Christ's famous Sermon on the Mount (Matthew 6:28–30): "Consider the lilies of the field, how they grow; they toil not, neither do they spin. And yet I say unto you, that even Solomon in all his glory was not arrayed like one of these. Wherefore, if God so clothe the grass of the field, which today is, and tomorrow is cast into the oven, shall he not much more clothe you, O ye of little faith?"[6] The reference in such a decorative work to Christ's message that there is no point in amassing worldly treasures, which do not last, confirms the tenacity of the moralizing tradition in Dutch flower painting. In the museum's still life, the blossoms that are beginning to wilt and droop (the striped tulip prominent in the upper right of the composition is a favorite motif of van Huysum intended to suggest the ephemeral nature of flowers), the insects, and the conspicuous dew drops on the petals may also allude to the theme of *vanitas* (the transience of beauty and earthly pleasures and the inevitability of death). Even the putti adorning the vases in van Huysum's flower pieces engage in frivolous activities such as drinking and dancing—fleeting moments of pleasure in man's earthly life.[7]

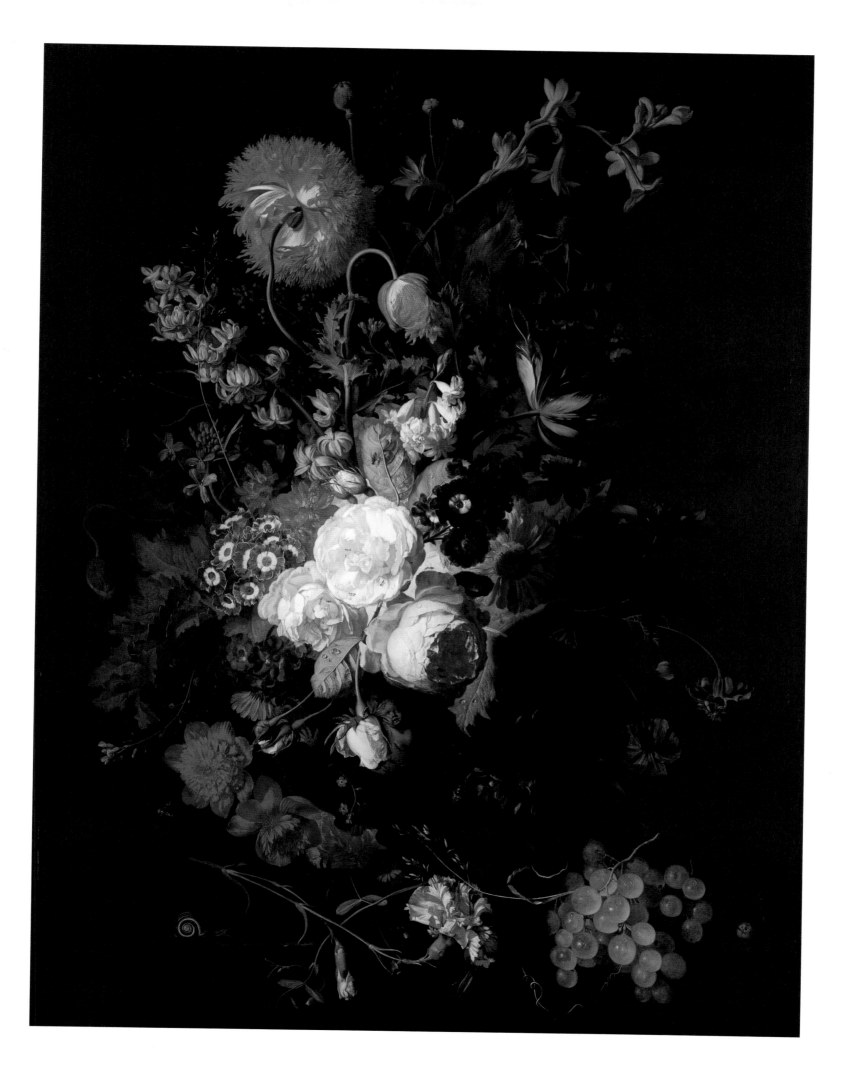

## Jean-Baptiste Pater

French, 1695–1736

### A Pastoral Concert, c. 1725

Oil on wood, 11 11/16 x 8 7/16 in. (29.6 x 21.4 cm)
The Edith A. and Percy S. Straus Collection
44.544

One of the oldest themes in the history of art is the garden of love and its depiction of romantic figures eating, drinking, flirting, or listening to music in idealized outdoor settings. Scenes of lovers in verdant parks abound in manuscript illuminations and chivalric poetry of the late Middle Ages, in paintings by the Venetian Renaissance masters Giorgione and Titian, and in the Baroque art of Sir Peter Paul Rubens. In eighteenth-century France, the theme enjoyed enormous popularity owing to the many variations produced by the painter Jean-Antoine Watteau (1684–1721). One of the key figures of Rococo art, Watteau invented an entirely new category of painting: representations of the *fête galante*, scenes of exquisitely dressed aristocratic men and women idling away their time in a dreamy, pastoral landscape. In 1717 he submitted his famous *Pilgrimage to Cythera* (Musée du Louvre, Paris) as his reception piece to the Académie Royale and was received as a *peintre de fêtes galantes*, a title created expressly for him.[1]

The *fête galante* was a real activity in the seventeenth and eighteenth centuries. It was a social entertainment that centered around amorous conversation and polite behavior. Outdoor gatherings in the Luxembourg gardens and the Bois de Boulogne in Paris were probably referred to as *fêtes galantes*, and the terms also described some plays written around 1700. When Watteau began to depict the everyday life of these well-bred people and give visual expression to the polite formulas of aristocratic manners, he created pictures with a definable subject matter, the *fête galante*. "By their nature Watteau's *fêtes galantes*, while about love, tell no love stores," Donald Posner has written. "There are no tragic heroines, no happy endings, no events to galvanize the players."[2]

Watteau's poetic, idealized scenes of flirtation and conversation exercised an enormous influence upon a group of French painters loosely categorized as "Les amis de Watteau" because of their allegiance to the *fêtes galantes*. Jean-Baptiste Pater in particular has been derogated as the *petit maître par excellence* and savaged as a mere follower of Watteau, from whom he borrowed his themes and figures. But artists like Pater and Nicolas Lancret (1690–1743) were gifted draftsmen and painters in their own right, and each developed his own distinctive style for portraying the amusements and entertainments of elegant society.

Pater spent a brief period as a pupil of Watteau in Paris around 1713 and then returned in 1718, making paintings in the style of his master. In 1728 he was accepted as a member of the Académie as a painter of "modern subjects," presenting a military piece in the style popularized by Watteau, *Soldiers Celebrating* (Musée du Louvre, Paris). Although Watteau treated him badly, upon his death he left Pater many clients. Pater has been regarded as a lesser painter than Watteau, but in fact he seems to have enjoyed a greater reputation than his master in the late eighteenth century. His paintings were highly prized by Frederick II (1712–1786), king of Prussia, who owned more than forty of his works. Pater derived many of his subjects from military life and was quite successful in his paintings of women bathing (he painted some fifty examples) such as *The Bathers* (c. 1725–30, Nelson-Atkins Museum of Art, Kansas City). His most innovative works are his crowded and lively scenes of country festivals as depicted in the *Fair at Bezons*, c. 1733 (The Metropolitan Museum of Art, New York), perhaps his largest work and his masterpiece.[3]

*A Pastoral Concert* is fairly well representative of Pater's treatment of the motif of the *fête galante* (and also shows why his paintings have been described as an "anthology of imitation" of Watteau).[4] The setting is the edge of a garden or park in which a man and woman have gathered to listen to a mandolin serenade by a musician. The verdant landscape, the herm of a satyr nestled in the foliage,[5] and the treatment of the figures and their dress could have been lifted from any one of a number of paintings by Watteau.

1. Posner 1984, 182–95, fig. 147.
2. Ibid., 151.
3. No modern monograph exists on Pater; see Roland Michel 1996b.
4. Levey 1994, 45.
5. A herm is a statue or monument in which only the head or bust is fully carved, with the rest of the figure a plain quadrangular column tapering downward.

6. J. Patrice Marandel in Museum of Fine Arts 1981, 66–67, no. 118. Although not mentioned in the most comprehensive publication on the artist (Florence Ingersoll-Smouse, *Pater* [Paris, 1928]), the painting can be attributed without hesitation to him. The work was recorded in Jean Baptiste Pierre Le Brun's handwritten list of pictures belonging to Richard Codman, dated 1 December 1796: "Etat des aubjets a chette pour Mr Codman. Par J. B. P. Le Brun, a paris rue du Gros Chenet/vis a vis celle du Croissant, no. 3." I am grateful to Joseph Baillio for confirming this information (letter of 19 January 1999).

7. Posner 1984, 151–55.

Yet, Pater possessed his individual graces, and his distinctive feathery brushwork and pale pastel color scheme express his own artistic personality. The charm and idyllic mood of Pater's pleasant costume pieces like the museum's little panel have epitomized for generations the grace of French eighteenth-century art.[6]

*A Pastoral Concert* reflects Pater's ambitions to convey subtle messages about the relationships between the sexes in the manner of Watteau. Because of the lack of overt narrative in Watteau's *fêtes galantes*, many observers have mistakenly assumed that they are vague or lack narrative content. In fact, as Posner has observed in a lengthy analysis of Watteau's paintings, the psychological construction of his paintings was as carefully considered as their visual configuration. Watteau's use of single figures, couples, or small groups was intended to convey specific dramatic and psychological meanings. The dress, pose, and gesture of each of Watteau's figures subtly define and refine the individual meaning of his pictures. Although his depictions of men and women listening to music often seem vaguely defined in content, in fact the attentiveness of one partner or the other to the song, the turn of a head, the choice of an instrument, all enrich and clarify the relationships between the figures.[7]

In the museum's painting, the troubadour guitarist plays before the woman, who remains attentive but hardly moved. Her back is nearly turned to her companion, suggesting the degree to which he needs to enchant her and arouse her from her passivity. To paraphrase Posner, a tune is being struck between the figures, but the woman, still uncommitted, awaits the development of the melody before deciding whether to heed its message. That the guitarist's song of love may in fact lead beyond this moment of amorous indecision, of emotional suspension, is suggested by the statue of a satyr, a traditional symbol of sexual activity and lust.

## Canaletto
Italian (Venetian), 1697–1768

*The Entrance to the Grand Canal, Venice,* c. 1730

Oil on canvas, 19 1/2 x 29 in. (49.7 x 73.6 cm)

*The Grand Canal near the Rialto Bridge, Venice,* c. 1730

Oil on canvas, 19 9/16 x 28 3/4 in. (49.7 x 73 cm)
The Robert Lee Blaffer Memorial Collection, gift of Sarah Campbell Blaffer
56.2, 55.103

View paintings, or *vedute*, as they are known in Italy, are among the most important and typical aspects of eighteenth-century Venetian art. Nowadays picture postcards or slides are sufficient souvenirs of a trip abroad; before the mid-nineteenth century, however, tourists—with more leisure and money than their modern counterparts—bought paintings to remember the cities and landscape of Italy. The Grand Tour, which brought visitors to Venice, Rome, Florence, and Naples, provided a ready market for the views of Canaletto, the most famous view painter of the eighteenth century, and other practitioners of the genre.[1]

For obvious reasons, the tendency toward accuracy and exactness was accentuated as the demand for this type of painting increased by commissions from foreign visitors. The creation of travel literature and guidebooks informed tourists of the famous sights of Venice even before their arrival, and within a few decades the square of Saint Mark's, the Doge's Palace, and the Rialto Bridge, for example, became familiar throughout eighteenth-century Europe by means of view paintings, prints and drawings, and illustrated books.

Canaletto's work appealed to the most unsophisticated tourists as attractive souvenirs of the sights of Venice, as well as to connoisseurs who recognized his paintings as great art. The period between 1730 and 1743 was the most productive of the artist's career. It was in these years that almost all of the paintings of Venice, for which he is best known,

1. For the Grand Tour, see Wilton and Bignamini 1996.
2. For Canaletto's life and work, see Links 1994.
3. Constable and Links 1989, 1:pls. 37, 46; 2:265–66, 292–93, nos. 166, 220; Baetjer and Links 1989, 150–53, nos. 35, 36; Links 1994, 78–79, pls. 63, 64.
4. Baetjer and Links 1989, 150.
5. Ibid., 152.
6. Redford 1996.
7. Baetjer and Links 1989, 149–50; Links 1994, 78–79.
8. Baetjer and Links 1989, 157–76.

were completed and during which he produced much of his best work. In his most successful paintings, Canaletto presented an accurate and detailed record of a particular scene, while capturing the light, the life, and the expanse of Venice with a perception and luminosity that established his reputation as one of the greatest topographical painters of all time.[2]

These precise descriptions of the entrance to the Grand Canal, with the church of Santa Maria della Salute on the left, and of the Grand Canal, looking southwest from near the Rialto Bridge toward the Palazzo Foscari, may be among the earliest of Canaletto's many versions of these popular sites that became his principal stock in trade.[3] Canaletto often paired his views by contrasting scenes, and here he has linked the entrance to the Grand Canal proper with a view taken considerably farther along its course of more than two miles. The left side of the composition is dominated by the undisputed architectural masterpiece of the Venetian Baroque, Baldassare Longhena's (1596–1682) church of Santa Maria della Salute. The church, which sits on a tongue of land adjacent to the custom-house, commemorates a terrible plague that ravaged Venice in 1630; it was not completed until more than half a century later in 1687.

Visible beyond the church are the nave and reverse of the façade of San Gregorio; the tall tower of Palazzo Venier dalle Torreselle; and in the distance, the campanile of the Chiesa della Carità, which collapsed in 1741. In the foreground to the right is a partial view of Palazzo Tiepolo, today part of the Hotel Europa and Britannia. The groups of sailing ships, barges, and rowboats on the water and details such as two Venetian senators in red entering Santa Maria della Salute reveal Canaletto's close observation of the city's daily life. The buildings are strangely narrowed and crowded together, suggesting that perhaps, under the terms of the commission, specific dimensions were required and the artist failed to take the requirements sufficiently into account.[4]

The companion painting shows part of the Riva del Ferro, now called the Pescheria (fish market) di San Bartolomeo, with the Palazzo Dolfin Manin (now the Banca d'Italia), Palazzo Bembo, and the huge Palazzo Grimani (now the Court of Appeals) beyond. Lottery tickets were sold from the hut on the quayside that is visible here and in some other views from the Rialto Bridge to the south. Ca' Foscari is in the far distance, at the turn of the canal. On the right, the Fondamenta (a street beside a canal) del Vin is shown with its shops, another example of Canaletto's fascination with daily life. The gondoliers rowing down the center of the canal are elaborately dressed in the sort of costume often worn for the regatta.[5]

Venice was a highlight on the Grand Tour, and throughout the century hundreds, perhaps thousands, of the most cultivated men and women poured into the city every year.[6] Foreign, and particularly British, patronage was therefore of importance to the careers of many of the key artists of eighteenth-century Venice. No foreign visitor played a greater role in Venetian art than the English merchant Joseph Smith (c. 1674–1770). Smith was not the first to act as an intermediary between British patrons and Venetian artists, but his activity was on an unprecedented scale. For more than half a century, every Venetian painter who secured significant patronage was in some way beholden to Smith, perhaps none more so than Canaletto.

Until 1955 the museum's paintings belonged to the Earls of Wicklow, in whose family archive is a copy of a memo that reads: "Aug 22 1730 Recd two pictures of Canaletti from Venice/ Pd Mr Smith Mercht 35 Venn. Zecni, Value £18.7. 11," with further items for freight, customs charges, and frames.[7] This dates the paintings in or slightly before 1730, making them among Canaletto's earliest known works and an important document in the artist's dealings with his patron. The pair are related to one of Canaletto's best-known series of Venetian views, of which twelve once belonging to Smith depict the Grand Canal and are now at Windsor Castle.[8]

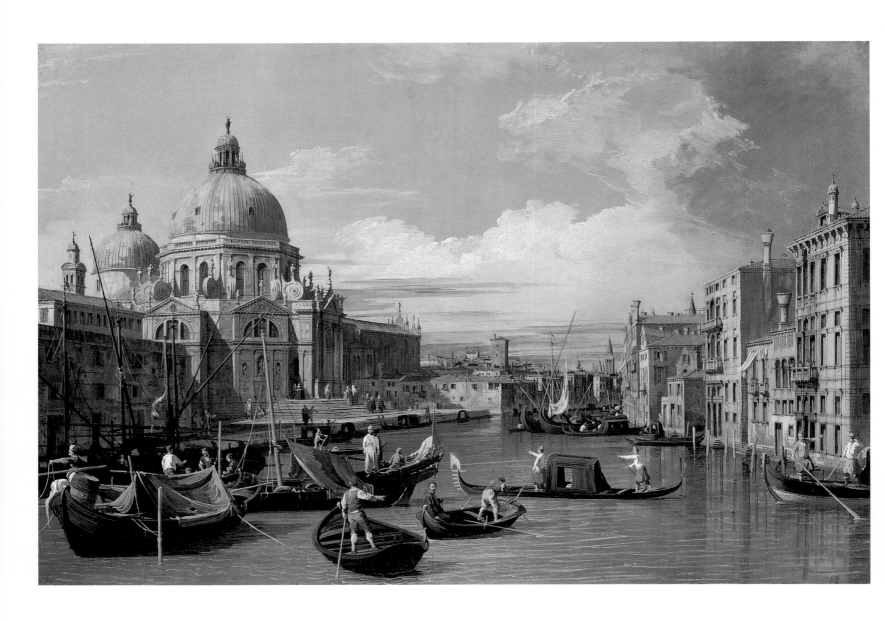

## Giovanni Paolo Panini

Italian (Roman), 1691–1765

### *Fantasy View with the Pantheon and Other Monuments of Ancient Rome,* 1737

Oil on canvas, 38 15/16 x 54 1/8 in. (98.9 x 137.4 cm.)
The Samuel H. Kress Collection
61.62

Giovanni Paolo Panini was the most celebrated and popular view painter in eighteenth-century Rome.[1] His views were of two main types, *vedute prese da i luoghi* (carefully and accurately rendered views of actual places) and *vedute ideate* (imaginary views and combinations of particularly notable buildings and monuments). His views of ancient and modern Rome encompassed practically everything worth noting in the eighteenth-century guidebooks to the Eternal City. These paintings were not idealized or symbolic representations of Rome's past and present grandeur, but accurate and objective portrayals of the most famous, most picturesque, or most memorable sights of the city.

In this imagined view of Roman ruins, Panini assembled several of the most famous monuments of ancient Rome.[2] Dominating the left half of the composition is the Pantheon, one of the most impressive and admired antique monuments in eighteenth-century Rome. The rotunda, originally part of the Baths of Agrippa, was rebuilt early in the second century by Hadrian and dedicated to the seven major gods worshiped by the Romans. In 609 the building was consecrated by Pope Boniface IV as a Christian church and mausoleum, Sancta Maria ad Martyres, and thereafter it was periodically altered and renovated, during the

seventeenth and eighteenth centuries in particular. Between 1730 and 1735 Panini painted a number of views of the interior of the Pantheon, emphasizing the immensity of the rotunda, as it rises to a coffered dome illuminated from above by a great oculus open to the sky. Here, in a single convincing view he has emphasized the Pantheon's most memorable architectural feature.

Panini has balanced the mass of the Pantheon on the right with the bronze equestrian statue of Marcus Aurelius and the ruined Temple of the Sibyl from Tivoli, both set against the open sky. One of the most important sculptures of antiquity to have remained intact and on public view through the centuries, the statue of Marcus Aurelius was familiar to every visitor to Rome after Pope Paul III had it transferred to the capitol in 1538 and Michelangelo designed a new marble base for the sculpture and installed it as the focal point around which he designed his famous piazza. Enthusiastic praise of the Marcus Aurelius reached its peak in the eighteenth century, and small copies in bronze, plaster, and on cameos and intaglios were common souvenirs of the Grand Tour.[3] The ruined Temple of the Sibyl from Tivoli was a picturesque monument that had attracted the attention of painters since the time of Claude Lorrain (see pp. 59–61).

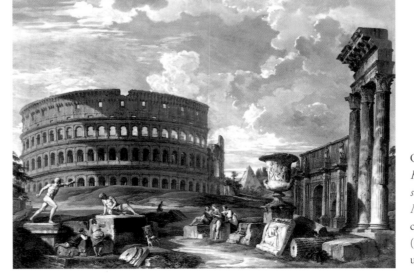

Giovanni Paolo Panini, *Fantasy View of the Colosseum and Other Antique Monuments,* 1737. Oil on canvas, 37 1/4 x 52 1/2 in. (99 x 134.5 cm). Location unknown

1. For Panini's life and work, see Arisi 1986.
2. J. Patrice Marandel in Museum of Fine Arts 1981, 71, no. 125; George Shackelford in Ishikawa 1994, 233–35, no. 44.
3. Haskell and Penny 1981, 252–55, fig. 129.

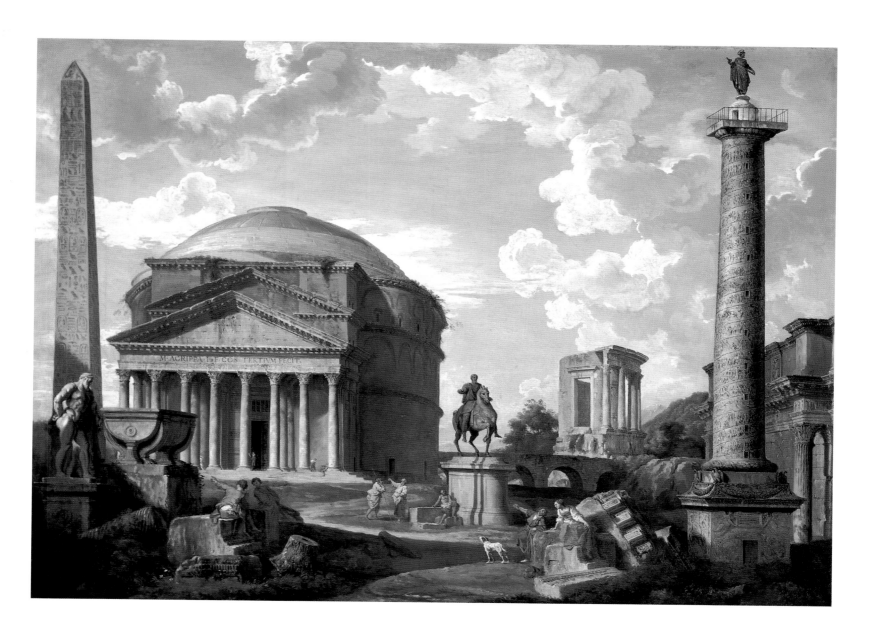

4. Ibid., 229–32.
5. Shackelford in Ishikawa 1994, 235.

At the far left stands an obelisk that was originally placed before the temple of Ammon at Thebes by Thutmose IV and brought to Rome in the fourth century by Emperor Constantine II to adorn the Circus Maximus. It was excavated from there in 1587 and placed in the piazza of San Giovanni in Laterano by Domenico Fontana in the next year. In front of the obelisk Panini has set the giant marble statue of Hercules, excavated during the Renaissance, and displayed from around 1556 until 1787 in the courtyard of the Palazzo Farnese.[4] To the right of the Hercules statue and the obelisk is a large, impressive porphyry basin that for centuries had stood near the Pantheon and which had been removed, in 1734, to the Basilica of San Giovanni in Laterano to serve as the future tomb of Pope Clement XII. The obelisk is balanced on the right by Trajan's Column, erected in the first decades of the second century A.D. by the emperor Trajan. Scenes in low relief spiral around its shaft and depict the emperor's campaigns in Dacia. At the extreme right edge of the painting can be seen part of the Forum of Neva.

In the 1730s Panini seized the commercial possibilities of small, topographically interesting paintings highlighting the sights of Rome for sale to visiting tourists. In order to present as many sights of the city as possible, he often paired his compositions, and the museum's fantasy view has a pendant, *Fantasy View of the Colosseum and Other Antique Monuments* (see p. 102). In both paintings, figures dressed in antique costumes are placed among the buildings, which are shown as they appeared in Panini's day. The figures behave much as modern tourists, pointing at the monuments and ruins around them. However, although the setting is presumably ancient, Panini does not hesitate to show the equestrian statue of Marcus Aurelius standing upon the base designed for it by Michelangelo, or the Column of Trajan topped by the statue of Saint Peter that was placed there as late as 1588.

The demand for Panini's productions was so great that he was forced to repeat his compositions again and again, often with only minor variations in the buildings, monuments, and figures. The Pantheon, for example, appears in at least forty paintings ascribed to Panini; the Farnese Hercules in forty-four; and the equestrian statue of Marcus Aurelius in twenty-two.[5] The tremendous size of Panini's oeuvre, the number of extant versions of certain compositions, and the mechanized routine handling characterizing many of these canvases confirm that he relied upon an extensive workshop to produce replicas and variants of his more popular compositions. However, the best of Panini's paintings show him to have been a skillful and versatile painter of figures whose supple brush could give individuality, vitality, and movement to his scenes. The brushwork, coloring, and handling of the figures in this *Fantasy View with the Pantheon and Other Monuments of Ancient Rome* are comparable to his finest paintings of the 1730s, and there can be little doubt that the painting was largely executed by his own hand.

## Charles-Joseph Natoire

French, 1700–1777

### Bacchanal, c. 1747

Oil on canvas, 31 7/8 x 39 7/8 in. (81 x 101.2 cm)
Museum purchase
84.200

Few paintings in the museum's collections epitomize the style of art and architecture known as the Rococo like Claude Joseph Natoire's *Bacchanal.* It possesses the grace, playfulness, and elegance that emerged in France early in the eighteenth century and spread to Germany, Austria, Russia, Spain, and northern Italy. Natoire's paintings and drawings mark the full flowering of the Rococo, and his lush colors, brilliant brushwork, and the outspoken eroticism of his figures and compositions are matched only by his great French rival, François Boucher (1703–1770).

Natoire was a prolific and prestigious painter who worked both in Paris and Versailles, and his art testifies to the sophistication and elegance of decorative painting during the reign of Louis XV. He received many commissions for historical and mythological subjects, the best known and most impressive of which is a series devoted to the history of Clovis, 1737 (Musée des Beaux-Arts, Troyes), as well as another made up of decorative panels illustrating the story of Psyche, 1737–39 (Hôtel de Soubise, Paris), which are among the most important contributions to French painting of the Rococo period. Natoire also painted many religious subjects, notably the spectacular decoration of the Chapelle de l'Hospice des Enfants-trouvés in Paris, 1746–50 (destroyed).[1]

In May 1751 Natoire became director of the French Academy in Rome, where he oversaw the training of such great painters as Jean-Honoré Fragonard (1732–1806) and Hubert Robert (1733–1808). His principal work in Rome was the fresco decoration for the ceiling of the French national church in Rome, San Luigi dei Francesi, painted in 1754–56. He also produced exceptionally sophisticated landscape drawings and watercolors that were inspired by the countryside surrounding Rome and that played an important role in the revival of landscape in French art.

The museum's *Bacchanal* was commissioned by Ange-Laurent de La Live de Jully

(1725–1770), one of the most distinguished French collectors and art patrons of the eighteenth century. He assembled a highly important collection of paintings and sculpture by contemporary French artists as well as by older masters.[2] Himself an accomplished draftsman and engraver, La Live was a frequent patron of Natoire, who had given him his first lessons in drawing. The *Bacchanal* was painted for him with a companion picture, *The Triumph of Amphitrite,* and hung in the *"première pièce sur le jardin"* of La Live's *hôtel,* or private residence, on the rue Saint-Honoré in Paris. The paintings are thought to have been commissioned to celebrate the marriage of La Live and Louise-Elisabeth Chambon (1729–1752), which took place on 26 June 1749.[3]

The mythological themes of the two pictures, each celebrating the triumphs of a male and female deity, honor the groom and his bride in equal measure. Bacchus, the god of wine, is shown at the center of the composition as a handsome naked youth, wearing a crown of vine leaves and grapes, receiving wine from a female attendant, or Bacchante, and grapes from a faun. He is surrounded by devotees of all ages, including a pair of lovers at the lower right. The man holds a thyrsus, a wand tipped with a pine cone (an ancient fertility symbol) and twined with ivy, which was sacred to Bacchus. His female companion carries a tambourine, a reference to the orgiastic song and dance of the Bacchic ritual. A garden statue of the satyr Pan, a member of Bacchus's retinue distinguished by his horns, ears, and reed pipes, overlooks the proceedings from atop a plinth at the right of the composition.

The companion painting depicts the triumphant procession of Amphitrite, the Nereid, or sea nymph, wooed by Neptune to be his bride. She rides on the back of a fantastic dolphinlike creature surrounded by Tritons, or mermen, and Nereids. The arch of drapery billowing over her head is a common feature of sea goddesses from antiquity. The composition and the subject of the painting

1. Bailey 1991, 333.
2. Scott 1973.
3. Bailey 1991, 364–69, no. 41, from whom the information presented here is largely drawn.

Charles-Joseph Natoire, *The Triumph of Amphitrite*, 1749. Oil on canvas. Location unknown

4. Ibid., 366. Unfortunately, as Bailey notes, 367, the marriage itself failed to fulfill the promise implied by Natoire's *Bacchanal:* the young couple lost a son in infancy; Chambon conducted a series of well-publicized affairs and died barely three years after the wedding.

5. Ibid., 366.

6. Ibid.

7. Ibid., 366, 369, figs. 4, 5.

8. Ibid., 364, 366–67.

9. Lempertz-Auktion, Cologne, 25 November 1976, no. 475. The painting was sold subsequently at Christie's, London, 29 May 1981, no. 4, again as by Hallé.

complement the *Bacchanal,* and both pictures convey, as one critic notes, "the easy sensuality and promise of physical pleasure appropriate for an impending wedding."[4]

In the *Bacchanal,* Natoire turned to a subject that he had depicted previously on several occasions. Yet, as Colin Bailey has remarked, "the Bacchanal painted for La Live de Jully is by far the most satisfying: it is brilliantly colored, elegantly drawn, and unusually harmonious in its ambitious grouping of figures."[5] Natoire's brushwork is breathtakingly facile and varies according to the passage at hand—soft and feathery in the handling of foliage and sky, more deliberate in the definition of the figures. The assurance of the artist's handling may owe something to his familiarity with the composition and the fact that the gestures and poses of several of the figures are paraphrased from his previous works.[6] Natoire returned to figure studies made for earlier compositions, such as a splendid red chalk drawing of the Bacchante who pours wine in a painting of *Jupiter Served by Hebe,* c. 1731–34 (Musée des Beaux-Arts, Troyes).[7]

During the eighteenth century La Live's mythologies were among Natoire's most highly prized cabinet pictures. The print dealer, collector, and writer Pierre-Jean Mariette (1694–1774) admired the paintings for their "softness in color and perfection of drawing." The *Bacchanal* and its pendant were engraved in October 1749 and carefully catalogued in at least three eighteenth-century sales. In one of these, in March 1778, the pair brought the substantial sum of three thousand livres. However, in a reversal of critical fortune common to the reputations of many seventeenth- and eighteenth-century painters, as early as 1808 Natoire was dismissed as a sterile imitator whose color was "livid and leaden" and whose brush was "mannered."[8] It was only in 1977, two hundred years after the artist's death, that Natoire's paintings and drawings would be brought together in a commemorative exhibition in Troyes, Nîmes, and Rome. And so neglected was the artist that even a year prior to this exhibition, Natoire's *Bacchanal* appeared at auction, separated from its pendant, and was sold with an attribution to his French contemporary Noël Hallé (1711–1781).[9]

## Jean-Siméon Chardin
French, 1699–1779

### The Good Education, c. 1753

Oil on canvas, 16 5/16 x 18 5/8 in. (41.5 x 47.3 cm.)
Gift in memory of George R. Brown by his wife and children
85.18

Although Jean-Siméon Chardin was received into the Paris Académie in 1728 on the strength of a still life, *The Skate* (Musée du Louvre, Paris), and achieved contemporary fame for his variations on the themes of dead game and everyday utensils and food, he is perhaps appreciated more highly today for his domestic genre paintings. His small canvases depicting modest scenes from the everyday life of the middle classes are in the tradition of Dutch cabinet pictures, which enjoyed great commercial success in France at the time. By comparison to the work of seventeenth-century Dutch and Flemish masters, however, Chardin's domestic interiors are serious minded and contemplative. His figure paintings are distinguished by the careful application of solid, textured paint and a great depth of tone, which he achieved by successive applications of the loaded brush and a subtle use of scumbled color. Chardin's genre scenes were very popular at the official art exhibitions held in the Salon d'Apollon in the Louvre and highly praised by the French philosopher and critic Denis Diderot (1713–1784). Though Chardin's reputation went into decline after his death, by the middle of the nineteenth century he was again among the most highly esteemed French painters.[1]

*The Good Education* is among the last of Chardin's domestic genre scenes.[2] A modest middle-class interior is the setting for a mother or governess instructing a young child. Viewers at the time understood the girl to be reciting from the gospels as the woman follows along with the text. The mother has set aside her needlework to give full attention to her daughter, who seems to have stumbled in her recitation. Scholars have pointed out the relationship of *The Good Education* to a passage in François Fénelon's *De l'education des filles* (1693), still an influential educational tract in Chardin's day: "It is necessary to prevail upon young ladies to read the Gospel. Accordingly, select for them a good time of day to read the word of God, just as one prepares to receive through communion the flesh of Jesus Christ. Above all, inspire young girls with that sober and restrained wisdom which Saint Paul commends."[3]

*The Good Education* was originally accompanied by a pendant, *The Drawing Lesson,* which shows a young artist seated in rapt concentration before a plaster cast of the French sculptor Jean-Baptiste Pigalle's (1714–1785) famous *Mercury* and sketching on a drawing pad. Education is also the subject here: the young draftsman, like the girl reciting from the Bible, also learns from an esteemed source, and his progress is evaluated by a second person, this time a fellow artist or instructor who looks over his shoulder.

The theme of an adult instructing a child

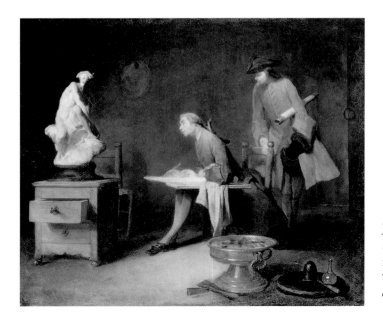

Jean-Siméon Chardin, *The Drawing Lesson,* c. 1753. Oil on canvas, 16 3/16 x 18 1/2 in. (41 x 47 cm). The Tokyo Fuji Art Museum Collection, Tokyo

1. For the most recent introductions to Chardin's life and work, see Conisbee 1996 and Roland Michel 1996a.
2. Rand 1997, 132–34, with earlier references.
3. Quoted in ibid., 132, 134 n. 4.

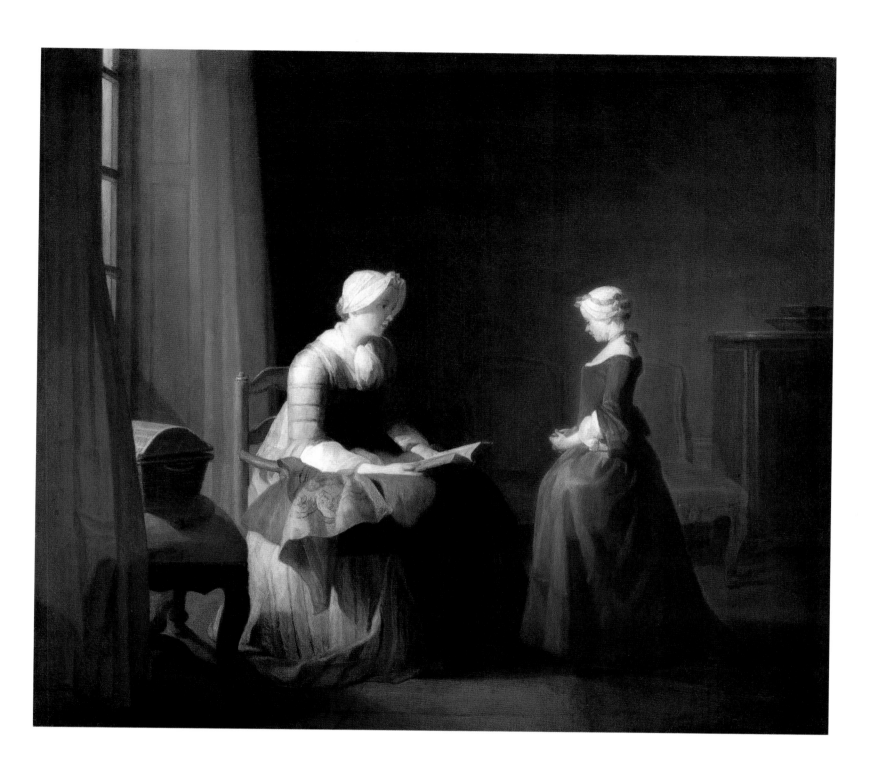

4. Ibid., 124
5. Quoted in Roland Michel 1996a, 269.
6. Rand 1997, 134.
7. Ibid.

occupied Chardin throughout his career as a genre painter. The work *The Governess* (National Gallery of Canada, Ottawa)—one of six genre paintings the artist exhibited at the Salon of 1739—was singled out as Chardin's greatest accomplishment and was the one that secured his reputation.[4] What Chardin was able to convey with a naturalism and charm familiar to both contemporary and modern viewers was the contrast between the world of adults and the world of children. As the art theorist Charles-Nicolas Cochin put it in Chardin's obituary of 1780: "[Chardin's] paintings had an extremely rare quality, that of truth and naïveté, both in his expressions and in his compositions. . . . It is truth and nature which most people seek out—that is why M. Chardin had so much success at all of his exhibitions."[5]

*The Good Education,* though similar in theme to *The Governess,* marks a distinct change in Chardin's approach to his genre subjects, as Richard Rand has noted. Unlike his previous work, the format is now horizontal, and the figures are placed farther back from the picture plane, giving them a doll-like appearance. However, the greatest distinction between this late work and Chardin's earlier genre paintings is in his handling of

paint. In the earlier paintings, Chardin's brushwork assumed "a rich physical presence"; here the paint is applied delicately in much smoother, more blended strokes, giving the overall image a blurred, gauzelike appearance that has been compared with pastel.[6]

Chardin's change in technique was noted by several critics when *The Good Education* was exhibited at the Salon of 1753: "It is a handling that produces its total effect only at a certain distance; at close range the painting presents only a kind of haze that seems to envelop all the objects." Some critics in the early 1970s regretted Chardin's more refined drawing and the less grainy texture of his paint as compared with earlier works. The abbé Garrigues de Froment compared the effect of this technique to "mist that does not dissipate" and wrote of Chardin: "Nowadays he labors over his work, he polishes it. Do we benefit from this change in manner and way of working? Informed connoisseurs maintain that we do not."[7] However, most observers today, standing before *The Good Education,* find great satisfaction in Chardin's smooth paint and silvery lighting and delicate contrasts of tone.

## Anton Raphael Mengs
German, 1728–1779

*Truth,* c. 1753–55

Pastel on vellum, 24 x 19 1/2 in. (61 x 49.7 cm)
Museum purchase with funds provided by
"One Great Night in November, 1998"
98.590

Pastel is the simplest and purest method of painting, since pure color is used without a fluid medium and applied instead directly to the surface of the support. The techniques of pastel manufacture date to the fifteenth century, and Renaissance artists made studies of single heads in pastels and colored chalks. The term *a pastello* was employed as early as 1584 in Giovanni Paolo Lomazzo's *Trattato dell'arte della pittura, scoltura, et architettura* to describe Leonardo's method of drawing with crayons prepared with powdered colors. By the late sixteenth century the application of colored chalks for special purposes had become an established procedure in many artists' studios, and the use of varicolored chalks as a rapid, manageable substitute for

paint gained a wide following throughout Europe during the following centuries.[1]

The three types of raw minerals that make up pastels are pigments, fillers like chalk, and a binding medium, usually gum arabic. Pastels vary according to the volume of chalk they contain; the deepest in tone are almost pure pigment. Although pastel is a technique of dry coloring, it is usually described as painting rather than drawing because the colors are applied in masses rather than in lines. As a medium, pastel has considerable advantages: it allows the artist to work swiftly, seizing an emotion or form immediately; it is easily erased and reworked; and its materials are easily prepared and portable. The painter may build up his colors without touching

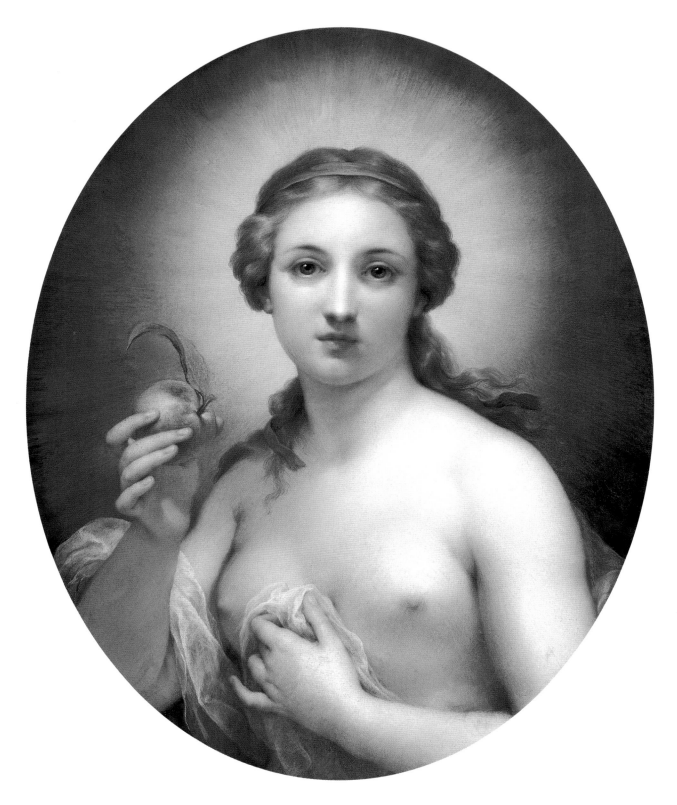

them once they are applied, or he may blend them in with the fingers or with an implement of paper, leather, or felt called a stump.[2]

Anton Raphael Mengs's personification of *Truth* exemplifies the eighteenth-century pastelist's art in its luminosity, velvetiness, and delicate surface texture. The artist learned the use of pastel from his father, Ismael (1688–1764), himself a painter, who intended his son to become a great painter from the moment of his birth. His namesakes

were the Renaissance painters Correggio and Raphael, and as a child Mengs was immersed in serious study of the works of antiquity, the Renaissance, and the Baroque.[3] Mengs established himself as a master of pastel while still in his teens, notably with a pair of remarkable half-length self-portraits completed in 1744 in the manner of Raphael (Gemäldegalerie Alte Meister, Dresden).[4]

The main influences on Mengs's development as a pastel painter were the intimate

1. For an introduction to pastel, see Monnier 1996.
2. Ibid., 241.
3. The best introduction in English to Mengs's life and career is Roettgen 1993.
4. Walther 1992, 441 repr. One of these, *Self-Portrait in a Blue Mantle*, was destroyed in 1945.

5. See ibid., 419–36, 440–46.

6. Roettgen 1999, vol. 1, 185–86, no. 124. The pastel first appeared in Christie's, London, *Old Master Drawings,* 6 July 1993, lot 189.

7. For the painting, see Chaucer Fine Arts 1988, no. 23. A drawing by Nikolaus Mosmann (1717–1787) in the British Museum, London, records the composition, although the fruit is held in a different position.

8. Warner 1985, 314–19.

9. Ripa [1603] 1971, 50.

10. Hall 1979, 313.

head-and-shoulders pastels by the Venetian Rosalba Carriera (1675–1757), whose work was especially popular at the court of Dresden and whose half-length religious and allegorical figures, singers, beauties, and portraits were a feature of the Royal Pastel Cabinet. A variety of Mengs's pastel portraits that included his father, court officials, musicians, and Friedrich August III, king of Poland and elector of Saxony, and his family survive in Dresden and elsewhere to demonstrate his brilliance in the technique and his position as a worthy successor to Rosalba.[5]

Mengs was appointed *Hofmaler,* or principal court painter, in March 1751, but in September of that year he left for Rome, where he largely remained until 1761. There he became one of the central figures in the circle gathered around Johann Joachim Winckelmann, a key figure in the development of Neoclassicism. Mengs's ceiling fresco *Parnassus* (1761) in the Villa Albani, Rome, is considered one of the principal pictorial monuments of the movement. In its chaste classicism and clear draftsmanship, *Truth* is similar in composition and subject to pastels produced by the artist in Rome around 1754–56.[6] A pastel personification of Truth was mentioned by the biographers of the artist as present in the Royal Collection in Dresden, but as not one is listed in the relevant inventories, they may have been mistaken; moreover, at the end of 1755 Mengs broke with the court of Dresden, when it ceased to pay his salary. Mengs evidently valued his conception of Truth, since he made at least one oil painting of the composition.[7]

From the Renaissance on, Truth was generally personified as a female form, often entirely naked, because Truth has nothing to hide and can never be less than whole. In Botticelli's *Calumny of Apelles* (Galleria degli Uffizi, Florence), for example, Truth is depicted as a serene and chaste nude pointing toward heaven, indicating the place where all will be revealed. In the sixteenth century Truth began to be depicted alongside a winged and muscular Father Time. The companion mottoes "Truth is the daughter of Time" and "Time unveils Truth" inspired much secular art in the seventeenth century, when the taste for emblems and allegories was at its height in courtly circles.[8]

The *Iconologia* of the Italian iconographer Cesare Ripa, published first in 1603 and a standard reference for artists of western Europe for its descriptions of allegorical figures of the virtues and vices, the arts, seasons, and parts of the world, also personified Truth as a naked female figure, modestly covered with a bit of drapery. Truth's nudity, according to Ripa, indicates that "truth is a natural state and, like a nude person, exists without need for any artificial embellishment."[9] Her ordinary attributes are the sun, in the form of a radiant disk (its light reveals the truth) and a mirror (which does not lie). Mengs chose a rarer interpretation of Truth, one that does not appear in the writings of Ripa. In her right hand Truth holds a peach with a single leaf, joint symbols of the heart and tongue, which when united speak the truth. As usual the figure of Truth is portrayed nearly naked and without jewelry or other adornments, and she is lightly covered by a veil, which in other renderings is drawn aside by the figure of Time.[10]

## Pompeo Batoni
Italian (Roman), 1708–1787

### *William Fermor,* 1758

Oil on canvas, 39 1/8 x 28 15/16 in. (99.4 x 73.1 cm)
The Samuel H. Kress Collection
61.76

1. Clark and Bowron 1985, 18.

One of eighteenth-century Rome's most notable painters, Pompeo Batoni was well known to residents and visitors alike. The American painter Benjamin West (1738–1820), who had lived in Italy from 1760 to 1763, remarked, "When I went to Rome, the Italian artists of that day thought of nothing, looked at nothing, but the work of Pompeo Batoni."[1] His religious and mythological paintings were sought after by the most eminent foreign patrons, but above all he is famous today as a portrait painter. For nearly half a century Batoni recorded the visits to Rome of international travelers in portraits that remain among the most memorable artistic accomplishments of the period. Many distinguished visitors including popes, emperors, dukes, and grand dukes arrived in his

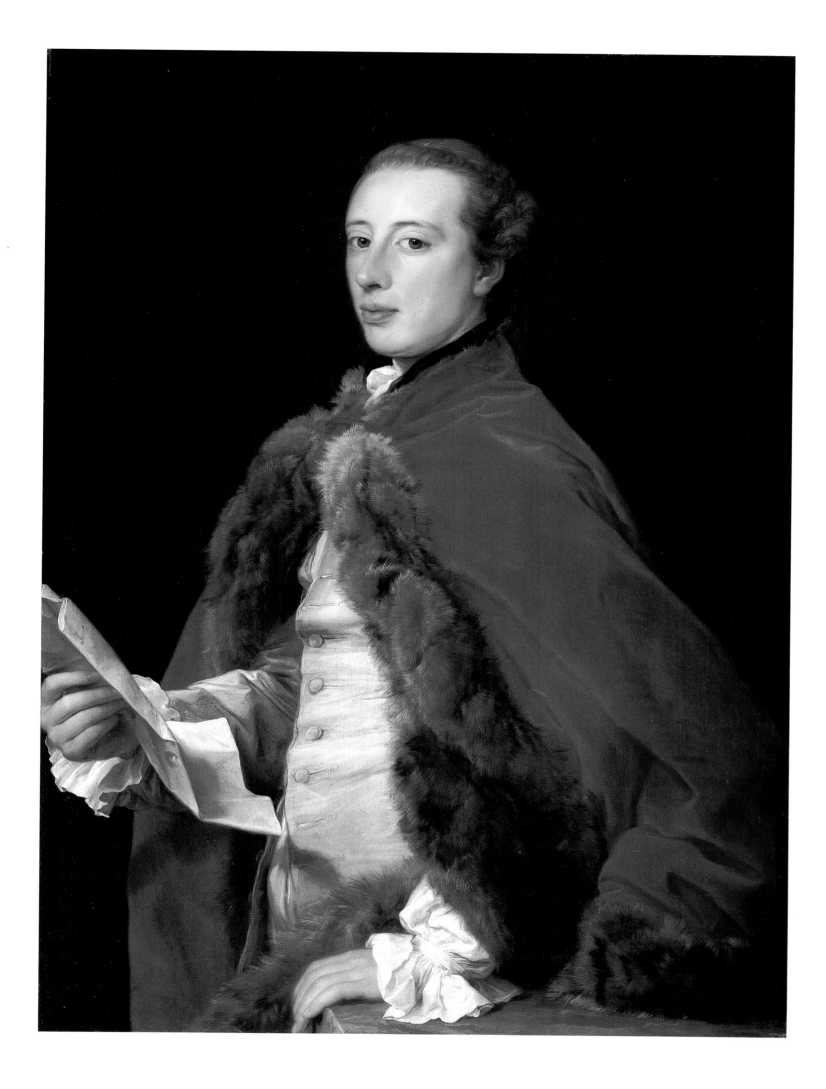

2. For Batoni's British portraits, see ibid., 42–48.

3. Ibid., 42, 321.

4. Ibid., 42.

5. Ibid., 271, no. 205, pl. 191; George Shackelford in Ishikawa 1994, 242–44, no. 46; Ingamells 1997, 353.

6. Roettgen 1993, 62–63, no. 8.

7. Father John Thorpe, letter of 25 May 1774 to Henry, 8th Baron Arundell; quoted in Clark and Bowron 1985, 31, 61 n. 69.

8. Clark and Bowron 1985, 30–31, 254.

studio daily, but none patronized him more enthusiastically than the British who thronged to Rome on their Grand Tour of Europe.[2]

Young British noblemen who made "the tour" usually spent several years traveling on the European continent, principally in Italy where they could collect antiquities and works of art to take home. By the middle of the eighteenth century Rome had developed into the principal destination for anyone traveling in Italy and had become a powerful magnet for the increasing number of young Irishmen, Englishmen, and Scots traveling abroad. The importance of these travelers to Batoni's career as a portrait painter is enormous: of the approximately 275 portraits that survive, more than 200, or 75 percent, depict British and Irish sitters.

For many British visitors on the Grand Tour, having their portrait painted by Batoni in Rome was a feature of their travels, and relatives at home eagerly awaited the result: "If Lord Cholmondely goes to Rome, pray tell him I wish he would bring me a head of himself by Pompeio Battoni [sic]," wrote Horace Walpole (1717–1797), the English collector, connoisseur, and man of letters, to Sir Horace Mann in 1771.[3] Batoni's virtuosity for depicting British milords on the grand tour was highly admired, and one traveler's acclamation that he was "the best painter in Italy" and another's that he was "esteemed the best portrait painter in the world" are typical contemporary estimations of his talent.[4]

William Fermor (1737–1806), of Oxfordshire, was a member of the landed gentry who presumably set out on the Grand Tour after leaving university.[5] Little is known of his activities in Italy except that he was in Rome in 1757–58 and also sat to Batoni's putative "rival," the German painter Anton Mengs (see pp. 110–12), for a portrait now in the Ashmolean Museum, Oxford.[6] Batoni's portrait of the young man reminds us that no contemporary portrait painter could draw more incisively than Batoni, and few could match his ability to produce an accurate likeness. Batoni "values himself for making a striking likeness of everyone he paints," wrote an English visitor to Rome,[7] and his sitters were almost always pleased with this aspect of their portraits. Accurate likenesses were highly valued in the eighteenth century, but Batoni's were more than accurate; they were vivid and powerfully compelling. In fact, his portrait of one Englishman was so memorable that a stranger, upon being introduced to the sitter at a dinner party in London, recalled seeing the picture several years earlier in an Italian customhouse.[8]

A striking feature of Batoni's portraits is the emblematic use of antiquities and views of Rome to establish both the sitter's presence in the city and his status as a learned, cultivated, yet leisured aristocrat. Batoni popularized the portrait type of a casually posed sitter in an open-air setting, surrounded by classical statuary and antique fragments and often against the backdrop of a classical building. Fermor is shown without any of these accessories, however, with the result that his features and the details of his clothing are highly pronounced. He is shown as a milord on the Grand Tour, dressed as a traveler and occupied with his letters to or from home. Over a cream-colored long-sleeved waistcoat, he wears a red velvet cloak lined with lynx. Fur-lined coats of this type were worn in Italy in the winter and evidently were quite fashionable in the late 1750s and popular with Batoni's British sitters. The black ribbon around Fermor's neck, a fashionable accoutrement of well-dressed men at this time known as a "solitaire," is actually part of the bag to carry his wig.

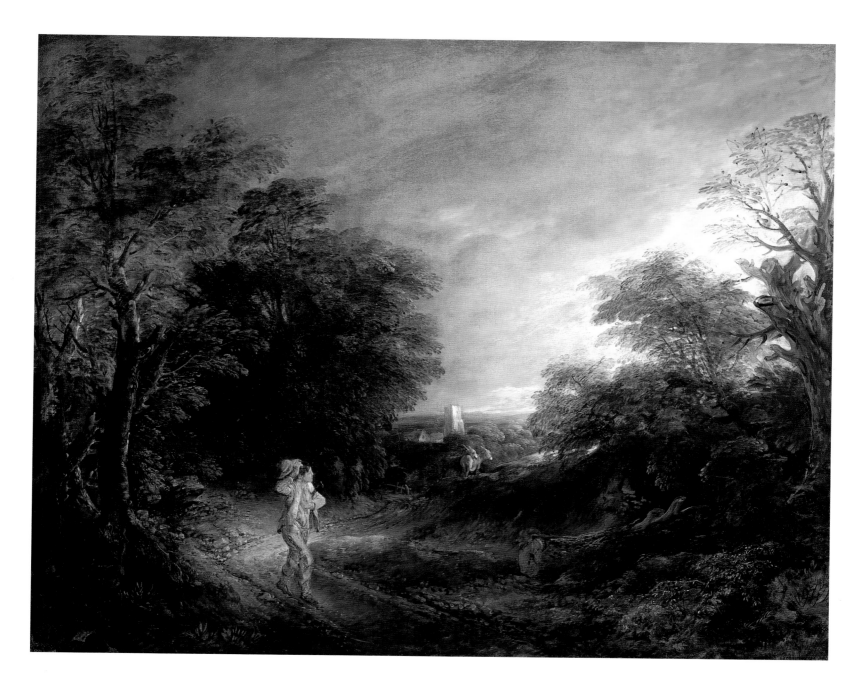

## Thomas Gainsborough

English, 1727–1788

*Wooded Landscape with Woodcutter,* c. 1762–63

Oil on canvas, 39 1/2 x 49 7/8 in. (110.3 x 126.7 cm)
Gift of Mrs. Elizabeth Wymond Clark in memory of
Harry C. Wiess
61.9

Thomas Gainsborough was one of the great lyrical geniuses of British painting. Unlike his great rival Sir Joshua Reynolds (see pp. 124–27), Gainsborough largely maintained his independence from Britain's official artistic life, practicing far from London for much of his career. Although he was sent to London at age thirteen to become an artist, after his training he returned to his native Suffolk, painting in Sudbury and Ipswich until 1759 when he moved to the spa town of Bath,

where he was an instant success. There he developed a free and elegant style of painting and recorded the fashionable visitors to Bath in a series of head-and-shoulder, half- and full-length portraits. In 1774 he moved to London, where he became a favorite painter of the royal family, although Reynolds was appointed the king's principal painter. Gainsborough worked with a light and rapid touch and employed delicate and evanescent colors that enabled him to render the silks and

1. Hayes 1992, 81.

2. Ibid.

3. For example, Barrell 1980.

4. Hayes 1973; Hayes 1982, 1:98–99, 2:415–16, no. 77.

5. Waterhouse 1978, 257.

6. Hayes 1973, 28, citing Woodall 1963, 99, no. 49 (Gainsborough to William Jackson, 23 August 1767).

7. The painting is quite likely one of the "several Landscapes of extraordinary Merit, that were mostly executed by Candle Light," seen in Gainsborough's studio by Ozias Humphry in the early 1760s; Hayes 1973, 28, quoting Humphry 1802.

8. Waterhouse 1978, 245.

9. Reynolds [1769–90] 1975, 250, 258.

satins of ladies' dresses brilliantly. His most original contribution to British portraiture was his ability to envelop his sitters in a landscape setting so that "they seemed to live and breathe in a romantic world of the artist's creation," as John Hayes has written.[1]

Gainsborough sometimes said that while portraiture was his profession, landscape painting was his pleasure, and he continued to paint landscapes long after he had left his native rural environs. The predominant sources for Gainsborough's landscape style are the compositions of Claude Lorrain (see pp. 59–61); Dutch seventeenth-century landscape paintings, notably those by Jacob van Ruisdael (1628/29–1682) and Jan Wijnants (active 1643–84); and Sir Peter Paul Rubens's landscapes. Gainsborough incorporated their compositions, motifs, and devices into his own manner, but his subject matter remained the ordinary rural life of the English countryside, which he infused with sentiment and nostalgia. The esteem held by Gainsborough's contemporaries for his landscapes is suggested by Horace Walpole's acclaim for *The Watering Place,* 1777 (National Gallery, London), which he praised as "In the style of Rubens, & by far the finest Landscape ever painted in England, & equal to the great Masters."[2] In his later years Gainsborough painted "fancy pictures" of pastoral subjects—sentimental scenes in which idealized peasants behave as if they are in the studio rather than the countryside—that have been the subject of considerable interest in the recent literature on art.[3]

The museum's *Wooded Landscape with Woodcutter,* painted in the early 1760s, has been cited as a splendid example of Gainsborough's landscape style during his first years in Bath.[4] The canvas depicts a woodcutter returning from the day's work, his hatchet under his arm. He is a familiar type in Gainsborough's landscapes, which are inhabited by members of the peasant class "whose life is unclouded by the existence of the world of towns or fashions—a sort of *faubourg* of Arcadia," as Ellis Waterhouse has remarked.[5] The handling of the foreground detail is crisp and precise, and the roadside on the right is dominated by russet tones characteristic of this period in the painter's career. Gainsborough's interest in the effects of light is evident here in the manner by which the woodcutter,

the donkeys, and church tower in the distance are spotlit by the evening light.

Certain features of the museum's landscape derive from the work of earlier masters; the broadly massed trees on either side of the composition that create a view into a distant panorama are a simplification of a formula of Claude, for example, and the fitful, stormy sky and the burst of the evening glow through the trees suggest the influence of Rubens. In this phase of his career, Gainsborough had eliminated the numerous little figures, animals, and other details of his landscapes of just a few years earlier in favor of a broader and more selective treatment. The pair of donkeys, which recur in a number of compositions of this date, remain as accents, in Gainsborough's words, to "fill a place (I won't say stop a Gap) or to create a little business for the Eye to be drawn from the Trees in order to return to them with more glee."[6]

The generally subdued tonality and the dramatic chiaroscuro of the landscape are the product of Gainsborough's habit at this time of painting by candlelight.[7] In his portraits, landscapes, and fancy pictures, as Waterhouse has noted, Gainsborough's prevailing interest as a painter was the same—the beauty of the fleeting effects of shadow and texture.[8] This led him not only to do much of his painting by candlelight, but also to cultivate an unfinished appearance in many of his canvases. He often created landscapes from little compositional models made up of moss, weeds, and pebbles, which he arranged in his studio.

The fluid brilliance of Gainsborough's brushwork in paintings like *Wooded Landscape with Woodcutter* must have been in Reynolds's mind when he paid posthumous tribute to Gainsborough in one of the *Discourses* (the fourteenth), which he delivered at the Royal Academy's prize-giving ceremony in 1788. Reynolds praised Gainsborough's flickering and evanescent touch, "his manner of forming all the parts of his picture together," and wrote of "all those odd scratches and marks . . . which by a kind of magick, at a certain distance assumes form, and all the parts seem to drop into their proper places."[9] Another contemporary critic hailed Gainsborough as one of the leading practitioners of landscape painting in England. He was probably thinking of later pictures like *The*

*Cottage Door,* 1780 (Huntington Library and Art Gallery, San Marino, California), when he wrote of Gainsborough that "upon maturer study and riper judgment, he seems to have aimed at something more elevated; he began to neglect the minuter characters of nature, and to depend upon the chiaroscuro, and upon the beauty of the figures."[10] Paintings like *Wooded Landscape with Woodcutter* stand at the beginning of this stylistic development.

Critical acclaim for Gainsborough's landscapes aside, they were never popular among collectors. Perhaps, as Hayes has suggested, they were a little too original, not enough like the Old Masters. The English painter Sir William Beechey (1753–1839) said such landscapes "stood ranged in long lines from his hall to his painting-room; and they who came to sit to him for their portraits . . .

rarely deigned to honor them with a look as they passed them."[11] As a result, Gainsborough gave some of these canvases away, as he did with nearly all of his landscape drawings. He gave the *Wooded Landscape with Woodcutter* to his physician, Rice Charlton, whose care and tenderness helped save the artist's life during a serious illness in September and October of 1763. This is probably about the date of the picture for at the time it must have been quite recently painted. While in Dr. Charlton's possession, it was seen by the youthful landscape painter Thomas Barker (1769–1847), who copied it twice.[12] When sold at auction at Christie's 1 March 1790, the picture was described as a "WOODMAN going out to WORK before SUNRISE" and as "one of the best landscapes ever painted" by Gainsborough.[13]

10. Hayes 1973, 28, 29, quoting Pott 1782, 73.
11. Ibid., 29, citing Fulcher 1856, 116.
12. Hayes 1982, 1:274–75, pl. 326.
13. Dr. Rice Charlton sale, Christie's, London, 1 March 1790, title page and lot 91.

# Bernardo Bellotto

Italian (Venetian), 1722–1780

## The Marketplace at Pirna, c. 1764

Oil on canvas, 19 x 31 5/16 in. (48.4 x 79.6 cm.)
The Samuel H. Kress Collection
61.71

Bernardo Bellotto was the nephew of the celebrated Venetian view painter Antonio Canaletto (see pp. 98–101), whose studio he entered around 1735. He so thoroughly assimilated the older painter's methods and style that the problem of attributing certain works to one painter or the other continues to the present day. Bellotto's youthful paintings exhibit a high standard of execution and handling, however, and by about 1740 the intense effects of light, shade, and color in his works anticipate his distinctive mature style and eventual divergence from the manner of his teacher. His first incontestable works are those he created during his Italian travels in the 1740s.[1]

In the period 1743–47 Bellotto traveled throughout Italy, first in central Italy and later in Lombardy, Piedmont, and Verona. For many, the Italian *vedute* are among his finest works, but it was in the north of Europe that he enjoyed his greatest success and forged his reputation. In July 1747, in response to an official invitation by the court of Dresden, Bellotto left Venice forever. From the moment of his arrival in the Saxon capital, he was engaged in the service of Augustus III, king of Poland and elector of Saxony, and of his powerful prime minister, Count Heinrich von Brühl. In 1748 the title court painter was officially conferred on the artist, and his annual salary was the highest ever paid by the king to a painter.

The Saxon capital had been transformed architecturally, artistically, and culturally in the first half of the eighteenth century by the elector's father, Augustus II (the Strong), and for its great beauty was christened Florence on the Elbe. From the moment of his arrival, Bellotto began the task of commemorating the most celebrated sites of Dresden and later, those of Pirna and Königstein, located in the countryside beyond the city. Between 1747 and 1753, Bellotto painted fourteen large paintings (52 by 92 inches) that show the city's Baroque and Rococo buildings to their best advantage. The Dresden views, which constitute the final stage of development ini-

tiated by the Italian views, are astonishing in their topographical precision, control of light and mathematical perspective, clarity, and organization. In size, scale, and ambition, the paintings reveal the differences between Bellotto and his teacher Canaletto and show how, in certain ways, Bellotto had surpassed Canaletto. Bellotto's views of Dresden and its environs not only constitute his greatest works, but are among the highest achievements of eighteenth-century view painting.

Between 1753 and the spring of 1756, Bellotto was assigned by the court to paint eleven views of Pirna. In almost all of these paintings the royal castle of Sonnenstein, rising above the town, is present, and it is the principal subject in three of the views, leading the Bellotto scholar Stefan Kozakiewicz to conjecture that at both Sonnenstein and Königstein the king wanted to spotlight the strategic significance of the two castles.[2] The views of Pirna, executed on canvases of the same size and format, were obviously intended to complement the earlier views of Dresden painted for Augustus III and placed in the Stallgebaude, the wing of the royal palace that housed the Dresden paintings collection after about 1731. In depicting Pirna, Bellotto chose to emphasize the rural or suburban quality of the town: three views capture the appearance of the town when it is seen at a distance from Posta and Kopitz on the right bank of the Elbe; another four describe the outskirts of the town, including its gates and outlying quarters, and three concentrate on Sonnenstein, the fortified castle that overlooks the town.[3]

In only *The Marketplace at Pirna,* the subject of the museum's painting, did Bellotto depict the interior of the town, focusing on the market square at its center.[4] Viewed from the west, the square is defined by the imposing building to the left of center, the Rathaus, or city hall, with the municipal scales under the lean-to roof at the west end. Beyond the Rathaus rises the spire of the parish church of Sankt Marien. Private houses bound both sides of the square, which is enclosed at the

right by the courts, before which stand public water troughs. The composition converges on two buildings: the façade of the Canaletto-Haus located at the rear of the marketplace, and so called because Bellotto, who was known as "Canaletto" in the Germanic countries, lived there for a time; and Sonnenstein Castle, which can be seen in the distance, beyond the rooftops.

The original twenty-five views of Dresden and Pirna ordered by Augustus III are today in the Gemäldegalerie Alte Meister, Dresden. Bellotto produced numerous replicas of his royal commissions, the most important of which was a full-scale set begun for the prime minister, Count Brühl, that was dispersed and is now located in Moscow, St. Petersburg, Madrid, and Raleigh, North Carolina. Reduced versions of each of the views were

produced for other patrons, particularly during the 1760s when Bellotto needed money following the disruptions of the Seven Years' War. The museum's *Marketplace at Pirna* is among the best of Bellotto's autograph replicas and is particularly close in details to the prime version in Dresden.

For part of the period of the Seven Years' War Bellotto worked in Vienna (1759–61) and Munich (1761); he returned to Dresden for five years before he departed in 1767 for Russia. On the way to St. Petersburg, however, he was invited by King Stansilaus II Augustus to join his court in Warsaw, and he remained there as court painter until his death. Bellotto's views of the late Baroque capitals of northern Europe remain unrivalled in their topographical accuracy, flawless draftsmanship, and dramatic

1. The definitive study of Bellotto is Kozakiewicz 1972; for more recent literature, see Bowron 1994a.
2. Kozakiewicz 1972, 1:84–85.
3. Ibid., 2:154–83, nos. 188–230.
4. Ibid., 166–74, nos. 211–15 (reversing the illustrations for nos. 214 and 215); George Shackelford in Ishikawa 1994, 226–29, no. 42.

compositional structure. His genius lay in his ability to take ordinary urban terrain and with grand, theatrical effects beyond the grasp of most topographical painters offer views that leave indelible impressions. Even today, Dresden, Vienna, and Warsaw are familiar to many who have never visited eastern Europe but who have seen Bellotto's depictions of them. So accurate were the artist's descriptions of those cities that in their rebuilding after World War II his paintings were used as guides, even in the reconstruction of architectural ornament.

# Jean-Etienne Liotard

Swiss, 1702–1789

## *Jean-Louis Buisson-Boissier,* c. 1764

Pastel on vellum, 24 7/16 x 19 1/4 in. (62.1 x 48.9 cm)
Museum purchase
86.28

The vogue for pastel portraits reached its height in the eighteenth century. In the seventeenth century, full-length pastel portraits were common, and toward 1700 the bust-length format, with the subject seated, one elbow resting on the edge of a table or on a book, was revived. The prototype of the familiar, intimate, near life-size bust-length portrait so common in the eighteenth century was created by Joseph Vivien (1657–1734), who in 1698 was received into the Académie Royale de Peinture et de Sculpture in Paris as a *peinture en pastel* for his pastel portraits of the sculptor François Girardon (1628–1715) and the architect Robert de Cotte (1656/57–1735) (both Musée du Louvre, Paris). In the eighteenth century the pastel was no longer simply a preparatory study (as it had been for Renaissance painters); it was a finished work in its own right, of dimensions as imposing as those of an oil painting, all the effects of which it copied. An enormous output of pastel portraits was developed from Vivien's example, in which the sitters are generally presented bust- and half-length and are accompanied by attributes that identify them socially or professionally.[1]

The pastel portrait was especially popular in eighteenth-century France, and the very mention of the technique invokes the name of several French painters, notably Jean-Baptiste Perroneau (1715–1783), Maurice-Quentin de La Tour (1704–1788), and Jean-Siméon Chardin (see pp. 108–10). But pastel also flourished at the hands of artists of other nationalities, notably the Italian painter Rosalba Carriera and the Swiss Jean-Etienne Liotard. Active principally in France (where he probably learned the technique of pastel) and in Switzerland, Liotard traveled extensively throughout Europe. He visited the Near East and from 1738 to 1742 spent time in Constantinople (now Istanbul), a period in which he painted pastel portraits of the British colony. He adopted Turkish dress and grew a long beard, and his eccentric appearance, familiar from his numerous self-portraits, earned him the nickname "the Turkish painter" and inevitably contributed to his celebrity on his return to Europe.[2]

From 1743 to 1745 Liotard painted at the court of the Empress Maria Theresa in Vienna, where he produced his most famous pastel, a full-length figure of a chambermaid carrying a tray with a cup of chocolate (Gemäldegalerie Alte Meister, Dresden). Liotard continued to travel until the end of his life, visiting France, Italy, the Netherlands, and England. In addition to work in oil and pastel (which included a number of astonishingly modern still lifes that owe a great deal to the work of Chardin), Liotard painted enamel miniatures, experimented with painting on glass and porcelain, and made a number of etchings.

Liotard treated his portrait sitters with startling directness, whether they were of the nobility or of the bourgeoisie, like the subject of the museum's portrait, Jean-Louis Buisson-Boissier (1731–1805), a Geneva lawyer about whom little is known. Nicole Parmantier-Lallement's instructive summary of Liotard's style aptly characterizes this pastel:

1. Monnier 1996, 242.
2. For Liotard, see Parmantier-Lallement 1996, with further bibliography.

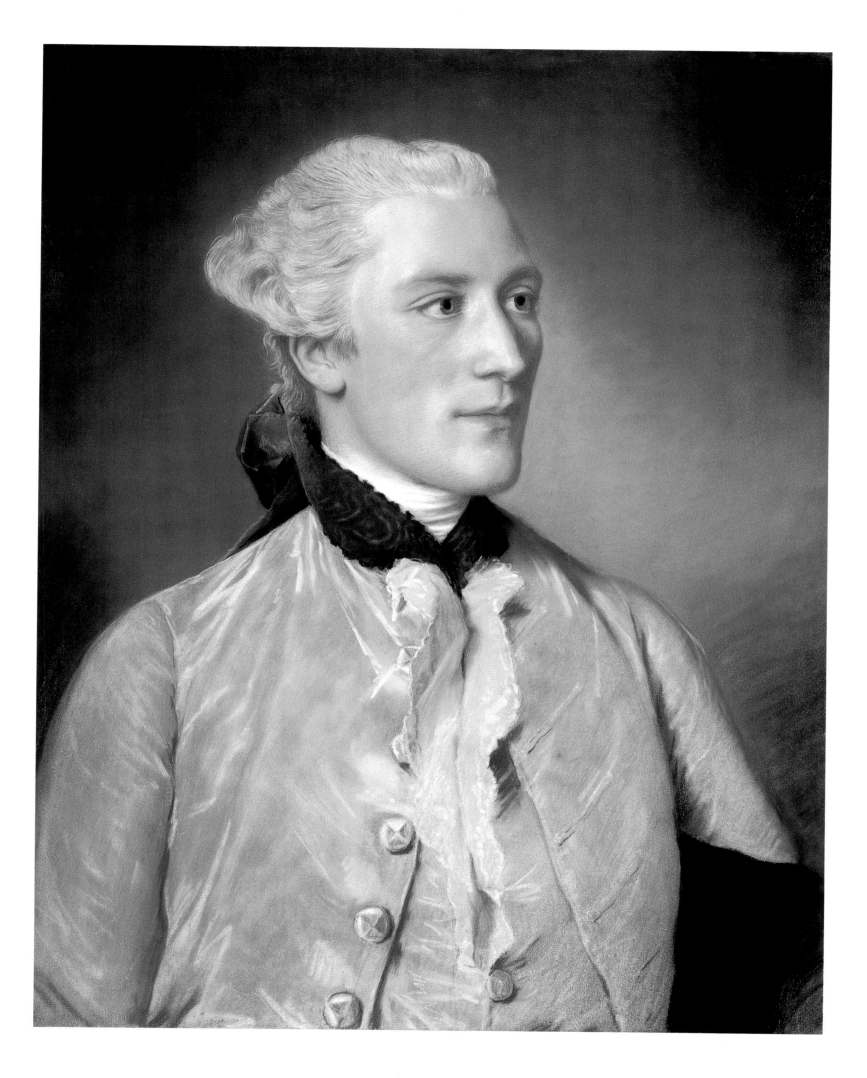

3. Ibid., 437.
4. Mitchell and Roberts 1996, 226–27, 445 n. 36, pl. 173.

*His models are depicted firmly against a plain background (usually gray-brown), simply lit and set in a space with little depth. He never sought to embellish his subjects nor to flatter them by means of the pose selected, and he used no ornaments, drapery or symbols of rank or office to distract the eye. Liotard's success as a portrait painter rested on the care he took to achieve a close likeness, his unreserved submission to the real, his sober and incisive style and the simplicity of the composition of his works.*[3]

On a technical level, as the portrait of Buisson-Boissier reveals, Liotard was almost without rival. The pastel is applied to the suede side of a sheepskin for optimum richness of surface and the greatest adherence to the medium. Impeccably preserved, the brilliantly colored chalks are blended and stumped to suggest the various surfaces of velvet, flesh, and hair. The rich pinks and whites of the sitter's face and coiffure are applied in meticulous hatchings; the iridescent lavender coat reflects the play of light on the fabric; and the astonishing chartreuse-and-olive background has a smooth, uninterrupted surface.

The magnificent French Rococo frame on the portrait is a type that has been recorded on several pastels by the artist. Pastels were less likely to be reframed than paintings in oil, and thus they provide a reliable and tangible record of eighteenth-century taste in frames. This particular frame is typically French, but its robust, asymmetrical flourishes are highly unusual for a pastel frame. Liotard is known to have provided frames for his pastel portraits, but whether the museum's example reflects his choice for this portrait is not known.[4]

## Angelica Kauffman

Swiss (active in Italy and England), 1741–1807

*Ariadne Abandoned by Theseus,*
1774

Oil on canvas, 25 1/8 x 35 13/16 in. (63.8 x 91 cm)
Gift of Mr. and Mrs. Harris Masterston III in memory of Neill Turner Masterston, Jr.
69.23

Angelica Kauffman was among the most admired and successful eighteenth-century European artists. Over an exceptionally prolific career of nearly half a century, she earned large sums of money from commissions, the sale of her pictures, and the reproduction of her compositions in a variety of media. She painted fashionable oil portraits for a large international clientele and produced a broad range of mythological, religious, and literary paintings. She established friendships with many of the leading international intellectuals and artists of the second half of the century, including the antiquarian Johann Joachim Winckelmann, the poet Johann Wolfgang von Goethe, and the painter Sir Joshua Reynolds (see pp. 124–27). As a result of Kauffman's remarkable popularity and critical acclaim, she remains one of the few female artists whose name has never entirely disappeared from the history of art.[1]

Although Kauffman distinguished herself both through her portraits (always the most lucrative branch of her career) and her subject pictures, she identified herself primarily as a history painter, enlisting in a prestigious branch of art that largely excluded women because of prejudices against their studying anatomy. History painting, as defined in academic art theory, was classified as the most noble branch of painting. Its subject matter, the representation of human actions based on themes from history, mythology, literature, and Scripture, required extensive learning in biblical and classical literature, knowledge of art theory, and a practical training that included the study of anatomy from a male model. Kauffman evaded this last difficulty by substituting classical statuary for the living model, managing to cross the gender boundary and acquire the necessary skills to build a reputation as a successful history painter.[2]

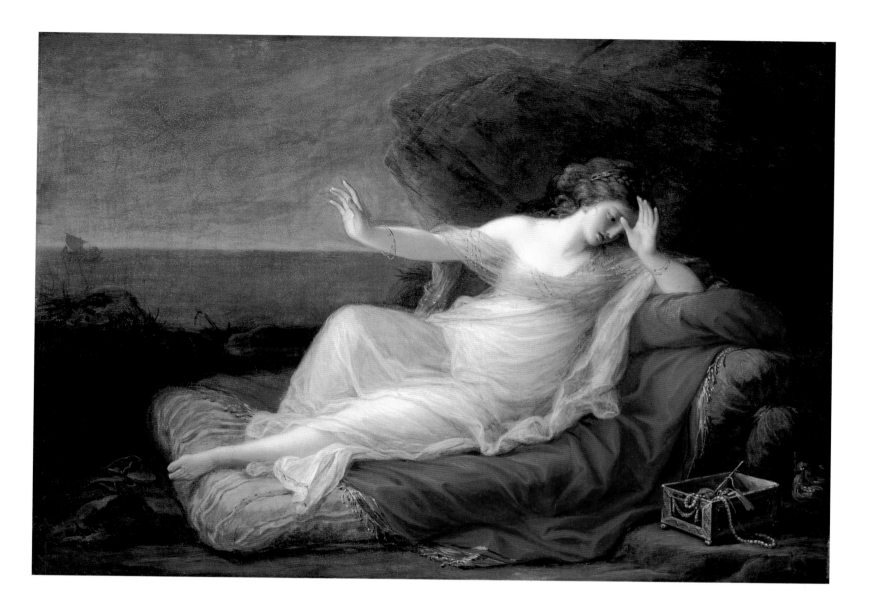

Kauffman, of all the artists working in London during the later eighteenth century, came as close as any to fulfilling Reynolds's dictates concerning history painting. English patrons on the whole preferred her portraits, however, and without a steady market for history paintings, Kauffman had to earn the greater portion of her income from portraits. Among her most enthusiastic English patrons was George Bowles, of Wanstead, Essex, who at one time owned fifty of her works, one of the earliest of which was the museum's *Ariadne Abandoned by Theseus.* The painting was exhibited in 1774 at the Royal Academy of Arts.[3]

One of the famous heroines of classical mythology, Ariadne, the daughter of King Minos of Crete, loved the legendary Greek hero Theseus, king of Athens. She helped him to escape the labyrinth of the Minotaur, the bull-headed monster, with a ball of string that enabled him to retrace his steps out of the maze after he slew the Minotaur. The pair fled to the island of Naxos where Theseus then abandoned her (Ovid, *Metamorphoses,* 8:169–73). She is usually shown in grief and despair over the discovery of her desertion, often indicated by Theseus's tiny ship departing on the horizon. Moralizing sentimental themes from classical literature, such as the personal grief of tragic heroines, were quite popular among the British at the time, and Kauffman painted such scenes as Calypso mourning the departure of Ulysses, Andromache weeping over the ashes of Hector, Penelope weeping over the bow of Ulysses, and Andromache fainting at the unexpected sight of Aeneas on his arrival in Epirus.[4]

The myth of Ariadne abandoned by Theseus and her subsequent rescue and consolation by Bacchus (*Metamorphoses* 8:175–82) was painted in the Renaissance, most memo-

1. Roworth 1997, 2:766. For Kauffman, see Roworth 1992; Roworth 1997, 2:764–70; and Baumgärtel 1998.
2. Roworth 1997, 2:766.
3. Walch 1968, 228. For Kauffman's commissions from Bowles, see Baumgärtel 1998, nos. 112, 195–97, 226, 229, 230, 247. The museum's painting was engraved by Jean-Marie Delattre (1745–1840) in 1785 (Baumgärtel 1998, fig. 99).
4. Roworth 1992, 33.

5. Walch 1968, 228.
6. Baumgärtel 1998, 134–36, 411, nos. 25, 249; Roworth 1992, fig. 61.
7. Haskell and Penny 1981, 184–87, fig. 96.
8. For example, Roworth 1992, figs. 33, 61, 63, 113.
9. Walch 1968, 229: "The symbolism of these jewels is, however, reasonably clear: Theseus leaves [Ariadne] material wealth, while abusing her soul; Bacchus, who is to bring her faithful love, also will transform the earthly jewels of Ariadne's crown into an eternal constellation in the heavens."

rably by Titian, *Bacchus and Ariadne,* 1522–23 (National Gallery, London), but became especially popular in the seventeenth and eighteenth centuries. Ariadne's grief and desolation also found expression in the writings of Winckelmann; in contemporary theater and opera; and in Emma Hamilton's "Attitudes," a series of Classical tableaux vivants she performed to great notoriety. There are several beautiful passages in ancient literature that describe Ariadne's despair at her desertion, one of the most eloquent of these probably being that of Catullus's *Epithalamium.* Also of interest to any Neoclassical painter would be the several Roman wall paintings of this subject that had been unearthed at Herculaenum and published in *Le pitture antiche d'Ercolano* in 1760 and thereafter.[5]

Kauffman painted the episode of Ariadne's abandonment and its aftermath several times, notably *Bacchus and Ariadne,* 1764 (Vorarlberger Landesmuseum, Bregenz); *Ariadne Abandoned by Theseus,* c. 1775 (Gemäldegalerie Alte Meister, Dresden); and *Bacchus and Ariadne,* 1794 (The National Trust, Attingham Park, Shropshire).[6] In her treatment of the subject in the museum's painting, Kauffman used one of the most famous ancient marbles found in the Vatican sculpture collections, a reclining female figure, for the

pose of the abandoned heroine. The statue, which was employed as a model by Pompeo Batoni (see pp. 112–14) and other eighteenth-century painters in various ways, was traditionally known as Cleopatra, although a decade after Kauffman painted the museum's picture, it was proposed that the sculpture actually represented an abandoned Ariadne, an identification now universally accepted. Kauffman made reference to the sculpture repeatedly, rendering it in a variety of innovative poses both in her portraits and subject pictures.[8]

In *Ariadne Abandoned by Theseus,* Kauffman has altered considerably the pose of the Vatican "Cleopatra," particularly in the highly Baroque gesture of Ariadne's upthrown hands, although no informed contemporary observer of the painting would have failed to recognize the antique source. The open jewel box by the side of Ariadne's pallet is an iconographical element that may be unique to the museum's painting. Peter Walch has explained the presence of the jewels as a reference to the episode following Ariadne's abandonment, the arrival of Bacchus. According to several classical sources, Bacchus took Ariadne's jeweled crown and flung it into the heavens where it became a constellation. He then consoled Ariadne and married her shortly thereafter.[9]

# Sir Joshua Reynolds
English, 1723–1792

## *Mrs. Elisha Mathew,* 1777

Oil on canvas, 93 1/2 x 57 5/8 in. (237.5 x 146.4 cm)
Museum purchase with funds provided by the Brown Foundation Accessions Endowment Fund
89.253

1. Hayes 1992, 209.
2. Reynolds [1769–90] 1975, 42, 59.

A painter and writer, first president of the Royal Academy of the Arts, and the leading portraitist of his day, Sir Joshua Reynolds is perhaps the most important figure in the history of English painting. Although he received no academic training, his experience of Italy, his admiration for Raphael, Michelangelo, and the Venetians, and his devoted study of classical antiquity and the Old Masters were the foundation of his ideals and practice as a painter. From these sources Reynolds forged the concept of the "Great Style," an idealized attitude toward painting reflecting objective standards of beauty based

on a study of the great art and literature of the past.[1]

Although history painting (serious and elevated subjects from Greek and Roman history and mythology, the Bible, Dante, and Shakespeare) was thought at the time to be the highest branch of art, Reynolds believed that British portraiture could be raised above its traditional status as mere "face-painting" by infusing it with the principles of the Great Style. For Reynolds, "the great end of the art is to strike the imagination," and the painter's goal is to pursue "an ideal beauty, superior to what is to be found in individual nature."[2] In

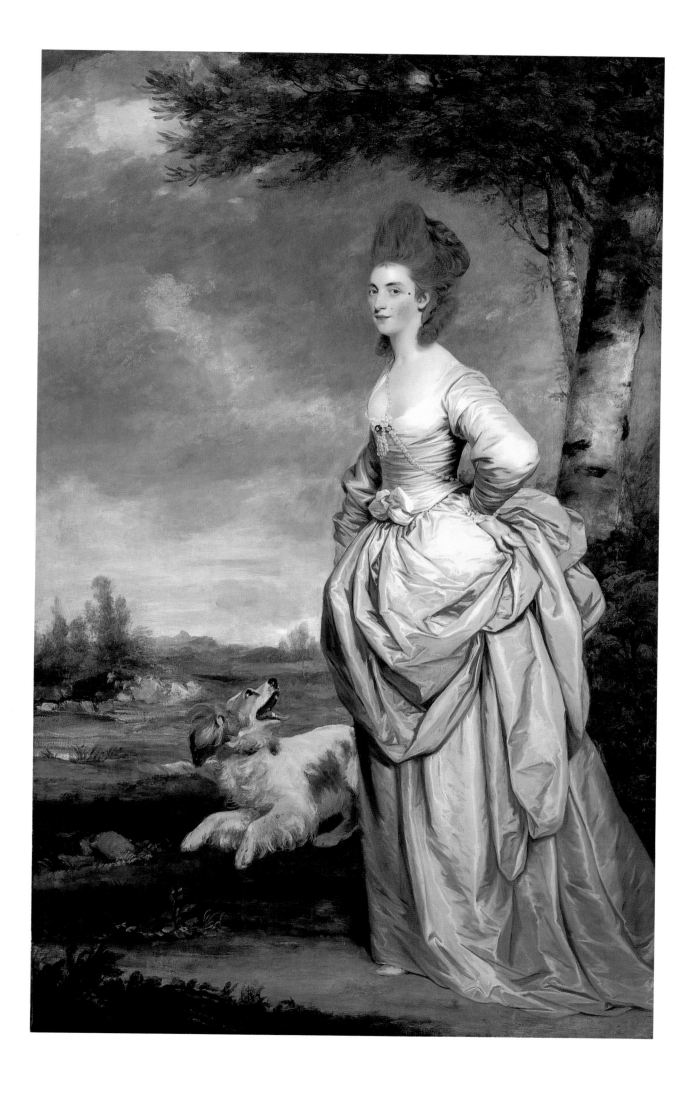

3. Ibid., 41.

4. Hayes 1992, 209–10. That more is not known of the biographical details of many of Reynolds's sitters is not necessarily to be lamented because a minute record of the character and personality was not the goal of these flattering and idealizing portraits. As Nicholas Penny, (1986, 17) has observed of Reynolds: "He knew that many of his fashionable ladies were less gracious, his mothers less loving, his princes less dignified, his bishops less wise, and his commanders less valiant than he makes us believe."

5. Tatlock (1923, 34) described the painting as follows: "The spruce elegance of his *Mrs. Matthew* . . . may be a trifle studied, but the craftsmanship is so neat and clever, the drawing so expressive, and everything in the composition so prettily placed, that it continues to attract us as long as we care to look. In the background is an engaging trifle of landscape painting."

6. Penny 1986, 17.

7. Reynolds [1769–90] 1975, 140. On Reynolds's female sitters' dress, see also Penny 1986, 27.

8. Penny 1986, 30.

9. Mrs. Mathew's given name has also been cited as Ellis and Elizabeth. Her husband was M.P. for Tipperary from 1768 to 1783 when he was created Baron Landaff. He was elevated to viscount in 1793 and earl of Landaff in 1797.

10. All quotations are from Walpole [1777–97] 1965, 32:111 n. 32.

11. *The Gentleman's Magazine* (London), 1781, 343.

12. Cormack 1968–70, 158: "Ledger vol. 2, f. 45.r: July 15, 1777 Mrs. Mathew."

13. Penny 1986, 35–36.

his *Discourses on Art* delivered to the students at the prize-giving ceremonies of the Royal Academy schools in 1770 and 1771, Reynolds exhorted the painter to raise his art beyond the mere imitation of nature (which can never "warm the heart of the spectator")[3] by employing idealized expressions; ennobling poses and gestures with "quotations" from the art of the past; and enriching paintings with allegories, attributes, and other learned accessories. Thus, as John Hayes has written, "Women were often portrayed as characters from mythology, and men as exemplars of their profession: a writer has a hand pressed to his forehead, an admiral an alert turn of the head, a general a cannon or storm clouds."[4]

Reynolds's idea of the Great Style can be illustrated by a group of full-length female portraits that he exhibited at the Royal Academy in the second half of the 1770s. Among these are *Georgina, Duchess of Devonshire,* 1776 (Huntington Art Gallery, San Marino); *Mrs. Lloyd,* 1776 (private collection); *Lady Bampfylde,* 1777 (Tate Gallery, London); and *Diana, Viscountess Crosbie,* 1779 (Huntington Art Gallery, San Marino). The "spruce elegance" of *Mrs. Mathew* is comparable to these masterpieces of portraiture in its breadth of conception and execution.[5] As with the great full-lengths cited above, the museum's portrait was more likely intended to hang in a grand reception room rather than in a more intimate domestic interior.

Reynolds has shown Mrs. Mathew, a celebrated beauty, standing full length in a landscape, wearing a shot silk dress with a string of pearls. The boldly painted park landscape was not intended to represent a specific place nor a specific event in the life of the sitter. One of Reynolds's gifts was his ability to combine truth with fiction, and his paintings of women, especially young women, were intended to be explicitly flattering.[6] He endows Mrs. Mathew with unusual glamour and poise that is enhanced by the folds and highlights in her beautifully painted dress. Reynolds shrewdly grasped that for his female sitters, generalizing classical drapery rather than contemporary fashionable dress— "something with the general air of the antique for the sake of dignity, and . . . something modern for the sake of likeness"[7] would imbue their portraits with a sense of timeless-

ness. The spaniel leaping at Mrs. Mathew's side further accentuates not only her graceful movement but also her serene calm, and to contemporary eyes, her social status and breeding.[8]

The sitter, Elisha Smyth (1746–1781), second daughter of James Smyth of Tinney Park, County Wicklow, Ireland, married in 1764 at the age of eighteen Francis Mathew (1738/44–1806) of Thomastown and Thurles Castle, County Tipperary.[9] In 1761, while still an adolescent, she was admired by Horace Walpole as "a most perfect beauty"; twelve years later he observed her at the French ambassador's ball in London where in her splendid costume "in white trimmed down all the neck and petticoat with scarlet cock's feathers, [she] appeared like a macaw brought from Otahitee." In September 1776, the year before she sat to Reynolds, Elisha Matthew was listed in the *London Chronicle* among twelve noted British and Irish beauties. Described as "one of the finest women of this age" by one observer, she died at sea on a journey between Paris and Ireland in 1781.[10] *The Gentleman's Magazine* published an account of Mrs. Mathew's elaborate funeral at Tipperary: "The aged, the young, and infant tears were shed for the death of this beauteous, worthy, and accomplished woman. Nor was this tribute more than justly due to so much virtue and exalted merit. One hundred and fifty mourning coaches, fifty four of which were drawn by six horses, with a great number of servants, were sent by them to join the funeral procession; and when it arrived within a few miles of the place of interment, everything was arranged in melancholy state and funeral order." This procession of nearly five miles was swelled by "one hundred and twenty domestics dressed in black, and a numerous train of old men and women in deep mourning, pensioners, who were clothed and fed by the humane hand of this charitable woman, and almost all the inhabitants of the country round."[11]

In the 1770s Reynolds was charging 150 guineas (157 pounds) for a full-length portrait, considerably more than any of his rivals, including Gainsborough (see pp. 115–17), who was then charging 100 guineas. Reynolds's ledgers record that a first payment of 75 pounds was made on 15 July 1777, presumably at the time of Mrs. Mathew's first sitting.[12] The

finished portrait was exhibited the following year at the Royal Academy, but for reasons that are not known, payment was never completed and the canvas remained in Reynolds's studio. At his death the portrait was left, along with his other studio contents and collections, to Lady Thomond, the artist's niece.

Reynolds encouraged the publication of mezzotint engravings of his portraits. In addition to publicizing the portraits and thus bringing Reynolds's work to the attention of a wider public, the engravings were much appreciated by his sitters so that they could present prints of their portraits to their friends.[13] The portrait of Mrs. Mathew was engraved by William Dickson in 1780.

# François Gérard
French, 1770–1837

## *Marius Returning to Rome,* 1789

Oil on paper mounted to canvas, 9 1/4 x 12 1/4 in. (23.5 x 31.2 cm)
Museum purchase with funds provided by the estate of Mary Alice Wilson and the Director's Accession Fund
91.39

This dramatic sketch by François Gérard portrays a moment from the ancient Greek author Plutarch's *Lives.* The heroic Roman general Marius is pictured leading a "funeral march" into the capital city of Rome. Born not into the Roman elite but of plebian background, Marius became a popular idol through his victorious military campaigns and his democratic innovations as a consul of the Roman state. His opponent Sylla, threatened by Marius's increasing power, had his soldiers chase Marius from Rome. Hiding in the swamps of Minturnes, he stewed in hatred and resentment, eventually making his way back to Rome with an army. Gérard depicts the vengeful, glowering Marius at the head of his loyal soldiers, who have been instructed to exterminate instantly anyone Marius greets with disdain. One of a group of senators loyal to Sylla steps forward to take the fearful military man's hand, receiving a virtual death sentence in the form of Marius's indifference. The palpable terror of the central group is heightened by the depictions of chaos and violence surrounding them: merciless soldiers striking people down, leaving a wake of dead bodies. Through the smoke, above the sharp points of swords and spikes, bob the grim faces of decapitated heads. A stone lying amid the rubble in the left foreground is engraved with the letters of Marius's enemy, "SILLA," signifying the success of Marius's campaign of destruction.

This gory scene was composed during the bloody first year of the French Revolution. Gérard's topic is no doubt a commentary on the wave of violence ignited by the fall of the Bastille in July 1789. The Terror, as the period is known, was characterized by reckless tyranny, summary executions, and sporadic riots, instilling even the most liberal minds with fear. Gérard was hardly liberal, having been born into a cultivated family and having benefited throughout his young life from royal support. *Marius Returning to Rome* is a brutal expression of civil war, an evocation of the threat posed by insatiable, vengeful power to the classical values of civic piety and established hierarchy.[1]

Though this painting is a sketch and was never realized as a large scale Salon work, it belongs to the grand genre of history painting, conceived with a broad audience in mind. The Salon public during the late eighteenth century had been conditioned to see metaphors for contemporary political events conveyed through the history of early Rome.[2] Political pamphleteers regularly drew from the ancient historians Livy and Plutarch. The greatest history painter of the day was Jacques-Louis David (1748–1825), Gérard's master. David and his school, the leaders of which were Gérard, Antoine-Jean Gros (1771–1835), and Anne-Louise Girodet (1767–1824), painted works with a moral, social, and political aim.[3] Their art was decidedly public, and they saw themselves as

1. Regis 1989, 109–10.
2. See Crow 1985, 228.
3. Friedlander 1952.

public servants—very different from the perception of art as a form of personal expression or aesthetic experiment that would dominate the latter two-thirds of the nineteenth century.

Gérard entered David's studio in 1786 at the age of sixteen. He quickly became one of David's favorites, and it was thanks to his master's Revolutionary politics and protection that the more politically conservative Gérard survived the Revolution unscathed. *Marius Returning to Rome* was executed for a competition in David's studio and won first prize. Gérard then gave it to his close friend and fellow "Davidian" Girodet. Elements of David's style are much in evidence here: the figures seen in profile; the archaeological details; the shallow, stagelike space. David's masterful *Lictors Reporting to Brutus the Bod-*

*ies of His Sons* (Musée du Louvre, Paris), exhibited the same year as the competition, may have influenced Gérard's composition.

Works such as *Belisarius* (1785; private collection, Munich) and *Cupid and Psyche* (1798; Musée du Louvre, Paris) earned Gérard early success as a history painter. However, his greatest fame came later in life from his work as a portraitist. In 1800 he was commissioned by Napoleon to make official court portraits. He received every honor available to an artist: knight of the Legion of Honor, first painter to Empress Josephine, professor at the Ecole des Beaux-Arts, member of the Institut, first painter to King Louis XVIII, and in 1819 he was made a baron. With the passing of Napoleon's empire, however, and the death of David, the School of David lost much of its inspiration, and the Neoclassical style that

4. Gérard 1867, 12.

had initially so moved a generation grew stale with repetition. In the following response made in 1867 by the historian and architect Viollet-le-Duc to the museum's *Marius Returning to Rome,* one senses the effectiveness of the School of David at its best : "Our opinion will be confirmed by a small but very accomplished sketch, earlier than the paint-

ing of *Psyche,* which represents *Marius Returning to Rome.* The grandeur that dominates this composition, its effect, the sinister coloring of the landscape, make this simple sketch a scene filled with emotion, fortified with power and energy; it elevates the talent of Gérard to a very lofty sphere, one beyond the reach of false and affected taste." [4]

# Francisco de Goya

Spanish, 1746–1828

## Still Life with Golden Bream, 1808–12

Oil on canvas, 17 5/8 x 24 5/8 in. (44.8 x 62.5 cm)
Museum purchase with funds provided by the Alice Pratt Brown Museum Fund and the Brown Foundation Accessions Endowment Fund
94.245

William Jordan has grasped the essence of Francisco de Goya's still lifes: "They are at once beautiful and poignant objects; all but one depict dead animals. Not the courtly game of a hunter's trophy, nor the meat on a butcher's stall, nor the dead beasts traditionally symbolizing life's brevity or Nature's bounty—but animals that have been slaughtered, from whom life has been violently torn, in whose images there is a depth of pathos as life-affirming as anything to be found in the greatest works of Velázquez or Zurbarán." [1] Although Goya completed some five hundred oil paintings and murals, about three hundred etchings and lithographs, and many hundreds of drawings, he painted perhaps only a dozen still lifes and, as far as we know, none until he was over sixty years old.

The backdrop for Goya's still-life paintings was a period of political upheaval and the war between Spain and France. During the worst years of the war, 1808–14, Goya worked increasingly in solitude and for himself. Among the greatest works of art he produced during this period were the drawings for his private use and the second series of etchings derived from them, which have come to be known as *The Disasters of War.* Many of his greatest and most original paintings also date from this time, as do all of his surviving still lifes. Indeed, José López-Rey observed more than half a century ago the creative link between the still lifes and *The Disasters of War* that is crucial to a complete understanding of the artist's mind at this time in his life. [2]

In June 1812 Josefa Bayeu, Goya's wife of

thirty-nine years, died in their house in Madrid. The documents concerning the settlement of her estate are extremely informative about the artist's way of life, and it is from the inventory made at that time that we learn of Goya's activity as a still-life painter. According to the will that Josefa and her husband signed in 1811, the estate of whichever one of them died first was to be divided equally between the surviving marriage partner and their only son, Javier. In the inventory of paintings given to Javier in 1812, item 11 mentions "twelve still lifes," without describing them individually. They are valued collectively at 1,200 reales, far less than their actual worth at the time. It is assumed that the paintings decorated the dining room of Goya's house and probably remained there until 1819, when Goya moved to the Quinta del Sordo on the outskirts of Madrid and began work on a set of decorations for his new dining room—the works we know as the *Black Paintings.* Ten still lifes verified as by Goya are known today; although now dispersed throughout the world, all can be identified as part of item 11 in the inventory of 1812.

In *Still Life with Golden Bream,* the scene is illuminated by moonlight, which glints across the wet, scaly bodies of the fish and is reflected in their large, staring eyes. The fish appear to be piled on a grassy knoll at an indeterminate distance from the beach, which Goya has deftly suggested by the foam of a wave breaking diagonally from lower right to upper left. There is a long tradition of depict-

1. Jordan and Cherry 1995, 175.
2. López-Rey 1948, 253.

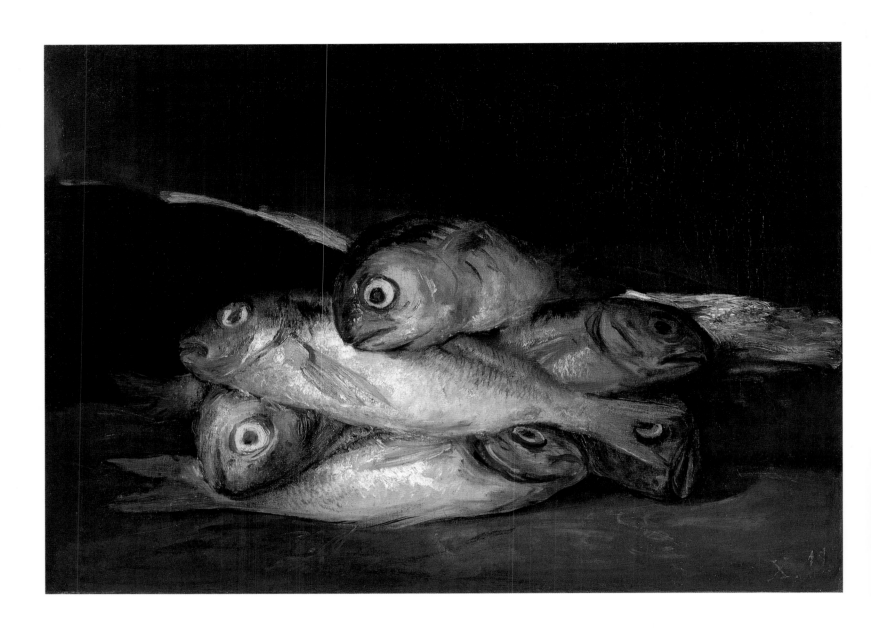

3. Jordan 1997, 151.
4. Ibid., 150–51.

ing dead animals in still lifes, and in Goya's still lifes dead fish, woodcocks, hares, ducks, and turkeys represent a continuation of this conceit within the genre. Yet Goya departs from his predecessors by the great pathos with which he invests his still lifes and the strong sense of identification with the animals' demise. There are certainly parallels between Goya's treatment of human corpses in images of *The Disasters of War* and his representation of animals; as Jordan has observed: "What makes this pathos doubly chilling is the detachment with which the artist has observed the physical beauty of what he regarded: the shimmering, silver scales of the fish; the delicate plumage and graceful bodies of the birds. These visual stimuli motivated him to try every trick he knew, or could imagine, to recreate these effects on the canvases." [3]

Jordan has vividly described Goya's unorthodox technical methods in the still lifes and the manner with which he expanded the reach of his medium beyond the limits previously known in his work. Here,

*the fish's bodies, deftly drawn and foreshortened, are modelled by a combination of unorthodox techniques. Working from a ground of warm, light grey, which is allowed to show in parts, Goya has rubbed light brownish and bluish grey pigment on top. He has defined the gleaming bellies by jabbing at the canvas with a brush heavily loaded with white paint, overlaid in places with a yellowish glaze. Details of the scales and gills are defined in black and grey applied with the brush and the knife. The fins are painted in a salmon-colored paint, with unblended streaks of white applied with a white brush. The yellow pigment of the eyes is boldly placed with single, circular strokes. Touches of red along the gills and mouths, which appear to be applied with the knife and the butt-end of a brush, provide the final accent to this vibrant, coherent work.* [4]

All the paintings described in the inventory of 1812 that were given to Javier Goya are marked with a white "X" followed by an inventory number. The "X" stands for "Xavier," the alternative spelling of Javier's name. In *Still Life with Golden Bream*, remnants of this inscription, "X. 11" (Xavier, item 11 of the inventory), are still visible at the lower right. Javier Goya bequeathed the still lifes he had inherited from his father to his own son, Mariano. In 1846 Mariano Goya defaulted on a loan he had received from the Conde de Yumuri and the still lifes were taken as collateral and displayed in the dining room of Yumuri's villa near Madrid. Following the death of the Conde de Yumuri in 1865, the group of still lifes was sold and dispersed. Shortly thereafter, some of the paintings were taken to Paris where, during the formative years of Impressionism, they were acquired by collectors of avant-garde taste. *Still Life with Golden Bream* was owned by the influential art critic Zacharie Astruc, who also owned other paintings by Goya.

# Théodore Chassériau

French, 1819–1856

## Woman and Little Girl of Constantine with a Gazelle, 1849

Oil on wood, 11 9/16 x 14 5/8 in. (29.4 x 37.1 cm)
Museum purchase with funds provided by the
Agnes Cullen Arnold Endowment Fund
74.265

Despite his importance in the history of nineteenth-century French painting, Théodore Chassériau is not a well-known painter of his period. He died relatively young (in 1856 at the age of thirty-seven), and his masterpiece, a series of allegorical paintings on the subject of war and peace decorating the grand staircase of the Palais d'Orsay, was largely destroyed by fire in 1871. His short career is marked by his conversion, within the radically polarized world of mid-century French painting, from the academic style of Neoclassicism to that style's ideological and artistic opposite: Romanticism. Chassériau studied with the Neoclassical master J. A. D. Ingres (1780–1867) through the

1. Sandoz 1974, 276, no. 138.
2. Rosenblum 1984, 149.

1830s, mastering Ingres's linear, highly finished style. After a year in Rome—that center of Neoclassicism—from 1840 to 1841, Chassériau grew dissatisfied with the retrospective obsolescence of Ingres's style, particularly in comparison with the innovational work of the arch-Romantic painter Eugène Delacroix (see pp. 136–38). For the duration of his short career, Chassériau committed himself to the freer, more expressive technique of Romanticism.

A major source of inspiration for Delacroix and the converted Chassériau was the culture of North Africa, and in particular of Algeria, a French colony only three days' journey from Marseille. Delacroix's momentous trip to Algeria and Morocco in 1832 instilled in him a passion for the exoticism and rich sensualism of this non-Christian culture, and provided him with an infinite source of vivid imagery. Removed from the restrictive routines of Western life, Delacroix's imagination blossomed, stimulated by the profound differences he found in Muslim culture. He sketched furiously, in pencil and watercolor, recording the raw material from which he would later create a stream of fantastic paintings. Chassériau followed suit in 1846, playing the artist-tourist for two months in Constantine, Algeria. He made detailed drawings of the local populace, which provided the basis for numerous painted canvases produced during the last decade of his life (many of which are today in the Louvre). Together with Eugène Fromentin (1820–1876), Delacroix and Chassériau initiated a distinct genre of painting based on images of the Near East. Orientalism, as the genre was known, had an equally strong counterpart in literature, and by the end of the nineteenth century it had become a fashionable strain of both elite and popular French culture.

*Woman and Little Girl of Constantine with a Gazelle* was exhibited at the Salon of 1850–51. No sketch in Chassériau's Algerian notebooks is directly linked to this painting, but it may have been composed from his numerous sketches of local figures and analogous scenes. It may also have been inspired by Romantic authors: *The Wild Gazelle,* from Lord Byron's *Hebrew Melodies* of 1815 (and translated into French almost immediately); *La Gazelle,* from Millevoye's *Chants élégiaques* of 1837; or perhaps Théophile Gautier's dramatic comedy of 1846, *La Juive de Constantine.*[1] The theme of the harem, of Arab women at leisure dressed in exquisite fabrics, was one of the most appealing facets of Orientalism. The fact that most men, and certainly Western men, were forbidden entry to the harem made it particularly ripe for exotic and erotic fantasies. Robert Rosenblum describes the "narcotic atmosphere" and "timeless torpor" of perhaps the most famous harem painting, Delacroix's *Women of Algiers,* 1834 (Musée du Louvre, Paris): "These cloistered creatures were a living incarnation of a recurrent nineteenth-century dream of Western male tourists and spectators, a dream of women as carnal beings adorned by flowers, fragrances, jewels, exquisite fabrics."[2]

The small size of Chassériau's painting invites the kind of intimate perusal appropriate for the imaged fantasy Rosenblum describes. The woman and her young cohort are dressed in sumptuous textiles and sit on opulent pillows and carpets. The girl gracefully holds the leash of a delicate gazelle, an exotic domestic pet. The sensuality of the motif is amplified by Chassériau's luscious painting technique. The tones are warm and intense—oranges, yellows, and pinks are set off by the deep green and purple of the girl's robe. Chassériau's loose brushwork deftly describes the shimmer of the layered fabrics and the fine features of the women's faces. The picture exudes the cloistered, decorative richness common to the harem scene, but is tinged with a note of melancholy unique to Chassériau's strain of Orientalism. This empathetic touch would become still more anomalous in the sea of harem paintings that flooded the art market later in the century.

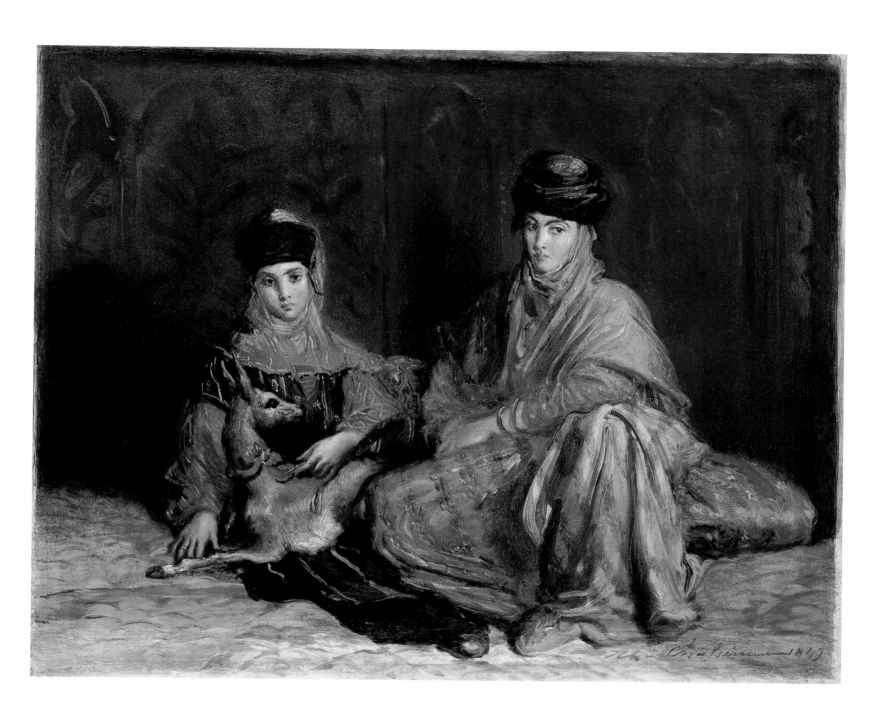

# Eugène Isabey

French, 1803–1886

## *View along the Norman Coast,* 1852

Oil on canvas, 17 3/8 x 25 5/8 in. (44.1 x 65.1 cm)
Museum purchase with funds provided by Craig F. Cullinan, Jr., in memory of Olga Keith Weiss
78.126

Eugène Isabey's *View along the Norman Coast* is a brilliant example of the dynamism injected into French landscape painting in the early nineteenth century by contemporary English painters. The genre of landscape painting in France was not a prestigious one during the eighteenth century, taking second seat to both history painting and portraiture. Landscape painters were restricted to a classical stylistic formula established in the seventeenth century by the great classical masters Nicolas Poussin and Claude Lorrain. Successful landscape paintings, though usually based on sketches done from nature, were studio productions carefully and rationally organized according to classical precedent. The influence of English landscape painting in the 1820s broke the academic mold, returning the artist to more immediate transcriptions of nature.

Isabey served as the central conduit of this refreshing English influence on French landscape painting.[1] On a trip across the channel in 1821, he was greatly impressed by the work of the English watercolorist Richard Parkes Bonington (1802–1828) and by the landscape paintings of John Constable (1776–1837). English landscape painting itself derived from the seventeenth-century Dutch landscapes that were so popular among English collectors. Dutch masters like Meindert Hobbema (1638–1709) and Jacob van Ruisdael celebrated actual nature—real scenes of local countryside—as opposed to the classical fantasies of Italian landscape favored by French academics. In concentrating on his native land, Isabey's example encouraged French painters to turn their gaze homeward from the fantasy land of Italian Arcadia.

The son of Jean-Baptiste Isabey (1767–1855), an active member of Parisian artistic and social circles who made his name painting portrait miniatures, Eugène began his career working in a variety of styles and subject matter. In the 1850s he began to focus on the site of his earliest artistic success—the northern coast (at the age of twenty-one he had won a gold medal at the Salon for a northern seascape). *View along the Norman Coast* shows a beach populated by local fishermen and their boats, made delightfully picturesque by Isabey's compact composition, light palette, and free brushwork. Such pictures found an eager audience not only at the Salon but in the art market as well, where middle-class collectors sought souvenirs of popular tourist destinations.

Isabey's scenes along the Normandy coast inspired the younger generation of landscape painters, including Eugène Boudin, Johan Barthold Jongkind (1819–1891), and Claude Monet, who would themselves capitalize on views of this increasingly fashionable shore. Painters admired the crisp, fresh light with which Isabey infused his paintings, in which the constant referencing of the landscape motif kept the image vivid. In a comment made by the art critic Maxime Du Camp in a review of the Paris World's Fair in 1855, the proto-Impressionist implications of Isabey's work are clear: "At first exclusively a painter of marines, he dwelt on the beaches and on the cliffs, in direct communication with nature, and derived from his contemplations a profound understanding of light and all its secrets; an intimacy which can be possessed only by those who work often outside of the . . . studio, under the eye of Jove."[2]

Inspired by the English watercolor technique, Isabey used a white ground over which he brushed layers of nearly transparent color, allowing the light whiteness to gleam through. He taught this lesson directly to his pupil Jongkind, who came from Holland in the 1850s to study with him, and who in turn passed it on to his young friend, Monet. The effect is gloriously apparent in the museum's shimmering *View along the Norman Coast,* which also reveals Isabey's personal passion for the sensuousness of oil paint. Using brushes thickly and thinly loaded, dry and wet, he developed surface textures that are marvelously rich. Paintings such as this one illustrate Isabey's crucial role in the evolution of nineteenth-century landscape painting and earn him the title of "greatest of the minor masters."

1. Champa 1991, 168.
2. Quoted from Fogg Art Museum 1967, n. 34.

## Eugène Delacroix

French, 1798–1863

### Andromeda, 1852

Oil on canvas, 13 x 9 7/8 in. (33 x 25.1 cm)
Gift of Mr. and Mrs. Raymond H. Goodrich,
by exchange
85.1

Eugène Delacroix's *Andromeda* exemplifies the painter's extraordinary versatility, matched in the history of French painting perhaps only by the great seventeenth-century master Nicolas Poussin. Completed during Delacroix's mature later years, *Andromeda* is Neoclassical in subject matter and Romantic in painterly expression, a stylistic fusion that defied the polarized art world of the first half of the nineteenth century. Indeed, after a century and a half of art writing in which Delacroix signified anticlassical Romanticism with a capital "R," a view that limited our understanding of the spectrum of Delacroix's achievement, we are only now beginning to fully grasp his complexity.[1]

Though the significant works of Delacroix's early career avoided subjects from antiquity, as he matured ancient mythology became a major source of inspiration. He was academically trained and educated, having studied with the academic Pierre-Narcisse Guérin (1774–1833) and at the Ecole des Beaux-Arts, and he was intimately familiar with classical sources. He was particularly interested in what has been called primitive antiquity—stories about the origins of Greek civilization full of mystery and "blood and fury."[2] The subject of *Andromeda* is drawn from the ancient literary masterpiece Ovid's *Metamorphoses*. In the story, Andromeda's mother, Queen Cassiopeia of Ethiopia, brags that her daughter's beauty surpasses even that of Poseidon's daughters, the Nereids. The outraged god of the sea, responding to his daughters' wounded vanity, sends floods and a sea monster to ravage Ethiopia. Andromeda's father, King Cepheus, learns from a sage that the only way to save his land and people is to sacrifice his daughter, exposing her to the murderous jaws of the sea monster. King Cepheus consents, and Andromeda is chained to a rock on the shore to await her fate. Just as the monster prepares to attack, however, Andromeda is discovered by the Greek hero Perseus, who falls instantly in love with her, kills the monster, and marries her, saving Ethiopia. According to the play-wright Euripedes, Andromeda, Perseus, Cassiopeia, Cepheus, and the sea monster were all turned into constellations, their story immortalized in the night sky.

The image of the chained Andromeda had been popular among painters since Titian's brilliant version done in the mid-sixteenth century (Wallace Collection, London). Delacroix had seen Titian's painting in printed reproduction and was also inspired by Rubens's version of the story, studio copies of which he had seen in private collections in Marseille and Paris.[3] Titian and Rubens, along with Veronese, were Delacroix's most consistent models, for among the Old Masters, these painters shared Delacroix's love of the sensual, viscous medium of oil paint and the richness of colored pigment.

One of the paradoxes of Delacroix's career was his profound respect for the tradition of *grande peinture* established by these Old Masters on the one hand, and his central role in the dismantling of that very tradition on the other. Though he consistently claimed himself a classicist, and remained indebted to the masterpieces he so studiously copied in the Louvre, Delacroix spearheaded an artistic movement aggressively antagonistic to the classical style of painting upheld by Jacques-Louis David and his student J. A. D. Ingres. That movement was known as Romanticism, and Delacroix was felt to be its embodiment in the visual arts, though even he did not consistently fulfill its tenets. Romanticism was enormously influential, traversing both nationalities and artistic mediums. Roughly defined, the movement was born in reaction to eighteenth-century Enlightenment rationalism; it favored emotion and intuition, the subjective and the personal. Disillusioned by the horrors of revolution and war that bloodied much of western Europe at the turn of the century, Romantics turned away from the faith in reason and progress that had characterized Western thought since the fifteenth century, indulging instead in the irrational, dark side of human experience.

1. See Sérullaz 1998.
2. Vincent Pomarède in ibid., 167–68.
3. Johnson 1986, 3:128.

4. Joseph J. Rishel in Sérullaz 1998, 169.
5. For the other versions of Perseus and Andromeda, see Johnson 1986, 3 and 4:nos. 306, 314.
6. See Baudelaire 1981.

Indeed, though classical in subject, *Andromeda* exudes the passionate mood characteristic of Delacroix's most celebrated work. As Delacroix pictures her, the heroine Andromeda is not a replication but a renovation of the classical ideal of the female nude.[4] Drawing on his direct observations of the complex coloring of flesh exposed to air and light, and his intent investigations into color theory, Delacroix makes Andromeda's nude body pulsate with life. The delicate pinks and pale green hatchings of the woman's flesh are set aglow by the bold Prussian blue of the sea at the left and by the rich yellow and vermilion of her drapes. All is laid down in Delacroix's signature loose brushstrokes, which enliven the surface of the canvas as they describe contour, texture, light, and shadow. True to his romantic temperament, Delacroix was drawn to mythological and biblical stories of suffering, longing, and violence. He must have enjoyed the motif of the helpless, naked beauty, exposed to imminent physical danger, for he completed at least two more versions of the theme of Perseus and Andromeda (Staatsgalerie, Stuttgart, and Baltimore Museum of Art), as well as paintings of the similar theme of Ruggiero rescuing the naked Angelica.[5]

Proclaimed by the poet and art critic Charles Baudelaire as the greatest painter of all time, Delacroix died in 1863, four years before the death of his archenemy and academic opposite, Ingres. With the loss of Delacroix, Baudelaire feared, great French painting would die, and he called fervently for something new. The "modern" painter he prescribed in his famous essay "The Painter of Modern Life" contained many of the attributes he so loved in Delacroix: a rich and cultivated internal life; a spontaneous, passionate temperament; a vivid imagination; and above all, a heightened sensitivity to color.[6] The modern movement in painting, initiated by artists like Edouard Manet (Baudelaire's true "painter of modern life") and Claude Monet, is inconceivable without the technical and stylistic innovations of Delacroix. His historical significance was commemorated a year after his death by Henri Fantin-Latour in his *Homage à Delacroix,* a group portrait picturing the young generation of avant-garde artists and critics, including Manet and Baudelaire, assembled around a portrait of the master. In the final decade of the century, Delacroix was again invoked by the avant-garde, and established as the seminal force of modern painting, by Paul Signac's 1899 treatise *D'Eugène Delacroix au néo-impressionnisme* (see pp. 184–85).

## Charles-François Daubigny

French, 1817–1878

*Sluice in the Optevoz Valley,* 1854

Oil on canvas, 35 1/2 x 63 1/4 in. (90.2 x 160.7 cm)
Museum purchase with funds provided by
Anaruth and Aron S. Gordon
79.122

Though Charles-François Daubigny is frequently associated with the band of landscape painters working in the village of Barbizon, known as the Barbizon School, he is equally related to the later, more radical generation of Impressionists who so admired him. Working under the influence of his father, Edmé-François, and of his Ecole des Beaux-Arts professor Paul Delaroche (1797–1856), Daubigny began his career as a landscape painter fulfilling the academic prescriptions of compositional precision and painterly meticulousness. His encounter with contemporary English landscape painters, and his rediscovery of the seventeenth-century Dutch masters who in turn had inspired them, directed him away from academic conventions toward a naturalist aesthetic. It was an aesthetic championed by artists like Théodore Rousseau, Camille Corot, and Jules Dupré (1811–1889) who painted in the Forest of Fontainebleau surrounding Barbizon. In the 1840s Daubigny joined them and devoted himself to their artistic mission: the direct transcription of the French countryside, free from references to classical antiquity and its homeland, Italy.

By the 1850s and 1860s, Daubigny was spending more time painting outdoors than his Barbizon contemporaries, almost entirely

finishing canvases directly in front of his motif, as opposed to returning to his studio for the final phase of completion.[1] He was obsessed with the fleeting effects of natural sunlight and its myriad states of refraction and absorption on watery surfaces. He built himself a floating studio from which to paint a variety of river scenes (some years later Claude Monet would follow suit, creating his own boat-studio). The intensity of his empiricism left little room for the kind of Romantic projection of nature found in the landscapes of Rousseau and Jean-François Millet (1814–1875).

Daubigny's most mature work was done not in the Forest of Fontainebleau, but in the river valleys of Oise and Optevoz around Lyon. *Sluice in the Optevoz Valley* was commissioned by the French state in June 1854 and painted on site the following October. Daubigny later completed a second version (now in Rouen) to submit to the Paris World's Fair of 1855. A final version (now in the Louvre) was painted in 1859; it is somewhat smaller and more finished than the others.[2] Though the extraordinary size of the museum's *Sluice* confirms Daubigny's serious intentions about the work, its lack of compositional focus and its concern only with the effects of light made it too imprecise for con-

1. Champa 1991, 146; Herbert 1962.
2. Bailly-Herzberg and Fidell-Beaufort 1975, 50.

3. Quoted in Pauchet-Warlop 1986, 539.
4. Bailly-Herzberg and Fidell-Beaufort 1975, 48.

temporary viewers to fully appreciate. The art critic Théophile Gautier wrote about Daubigny's work in 1861: "It is really a pity that this landscape artist, having so true, so apt and so natural a feeling for his subject, should content himself with an 'impression' and should neglect detail to such an extent."[3]

Viewing the museum's *Sluice in the Optevoz Valley* with Gautier's reference to the "impression"-ist nature of Daubigny's work in mind, it is hardly surprising that avant-garde landscape painters from Boudin and Jongkind to Pissarro and Monet found inspiration in his work. The simplicity of the motif, the luminosity and fluidity of atmosphere captured with swift, spontaneous brushstrokes, and the subtlety of the color composition enhance the originality of this striking work. In 1857 Daubigny's friend and fellow landscape painter Adolphe Appian (1815–1901) described Daubigny's accomplishment this way: "As far as I am

concerned, [Daubigny] is the strongest of us all, since I find that he paints not just the objects in front of his eyes, but the air which surrounds them and the light which colors them as well. He paints the important; and that I believe is all the fascination of the landscape."[4]

Daubigny recognized his aesthetic in the work of the young Impressionists and supported them when many others would not. In 1866 he sat on the Salon jury with Corot and persuaded his peers to accept two works by Monet. In 1868 he again stood up for the experimental painters at the Salon and the same year introduced Monet and Pissarro to his dealer Paul Durand-Ruel (who would soon become famous as the Impressionist dealer, making Monet, at least, very wealthy). In more ways than one, then, Daubigny helped bridge the innovations of the Barbizon School and the succeeding school of Impressionism.

## Honoré Daumier

French, 1808–1879

## A Meeting of Lawyers, c. 1860

Oil on wood, 7 5/16 x 9 3/8 in. (18.6 x 23.8 cm)
Gift of Audrey Jones Beck
74.137

Although Honoré Daumier is regularly included in the canon of great nineteenth-century artists, holding his own with Ingres and Delacroix, Courbet and Manet, Monet and Cézanne, his life and art have little in common with these painters. While Daumier considered himself primarily a "fine artist," working in both painting and sculpture, the vast majority of his creative energy and his artistic output was in the form of lithography, the process used by the popular press for reproducing images. As a printmaker, he targeted his work not to a Salon jury or a small effete group of art collectors, but to the masses for whom, given the high rate of illiteracy at that time, lively images were enormously appealing.

Daumier was essentially a caricaturist, and he took the genre of caricature to the level of great art. His gift for insight and empathy, his

extraordinary powers of social observation—an activity of which he never seemed to tire—his committed sense of justice, his political engagement, and most important, his ability to translate social satire into a pictorial language of dramatic yet economic impact, all enabled Daumier to produce a body of work as prolific as it is compelling. Through his lithographs, wood engravings, paintings, and sculptures, Daumier more than fulfilled his often repeated credo, "Il faut etre de son temp!" (One must be of one's time!).

Of humble origins, Daumier began his graphic career as an assistant to the lithographer Zéphirin Béliard. He published his first lithograph one year before the revolution of July 1830 deposed King Charles X and installed Louis-Philippe as constitutional monarch. A staunch democrat, Daumier did not fare well under authoritarian regimes, as

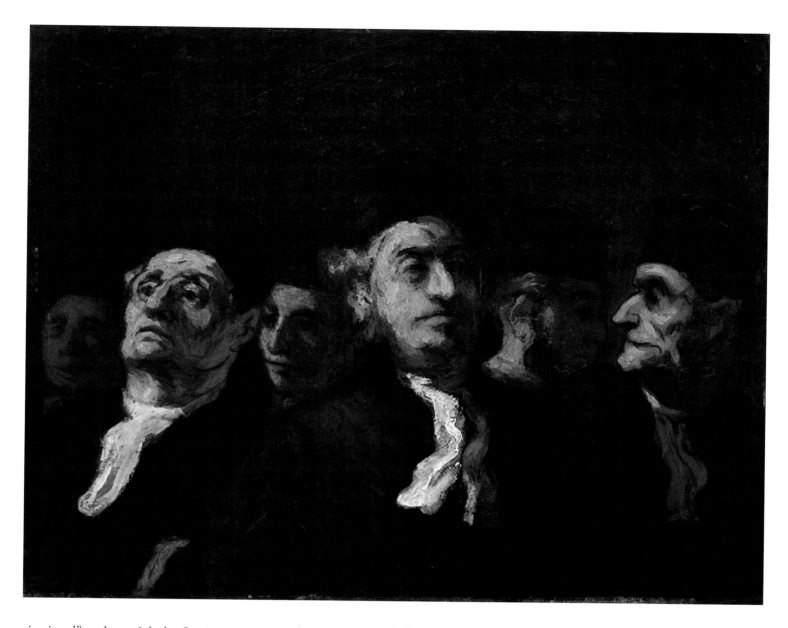

"constitutional" as they might be. In 1832, early in his tenure on the staff of the illustrated satirical journal *Le Charivari,* Daumier was jailed for six months for one of his prints; the official charge was inciting contempt of the government and insulting the king. The freedom of the press was curtailed even more severely after 1835, a development that discouraged Daumier from directly political subjects. Yet Daumier's acute sensitivity to the hypocrisy of public life and the manipulation of the defenseless by the powerful continued to influence his work. Daumier's art maintained its critical edge, evidenced by the acts of censorship and punitive action his work provoked throughout his career.

Daumier was particularly drawn to lawyers as subjects; his catalogue raisonné lists 18 paintings and 131 drawings of lawyers. With a mix of disgust and amusement, Daumier

spent hours at the Palais de Justice in Paris observing and recording the "performances" of these paid actors. In *A Meeting of Lawyers,* Daumier unmasks the duplicity, venality, and self-absorption that he perceived in the legal profession. This gaggle of lawyers seems more concerned with itself and its own questionable schemes than with a dedication to justice and the clients served. With a deft brush loaded thick with paint, Daumier captures the distinct character of each swollen, creased face. The figures are pressed together in a dark, narrow register of murky tonality, adding to the sinister aura of the scene. The rapidity and vigor of Daumier's brushwork combine with his dramatic light effects to create a sense of immediacy, as if the viewer himself stands among these dubious figures, offered an insider's moment of critical insight.[1]

1. See Maison 1968, and Childs 1989.

## Camille Corot

French, 1796–1875

### Orpheus Leading Eurydice from the Underworld, 1861

Oil on canvas, 44 1/4 x 54 in. (112.3 x 137.1 cm)
Museum purchase with funds provided by the
Agnes Cullen Arnold Endowment Fund
87.190

Today Claude Monet is popularly acclaimed as the greatest landscape painter of the nineteenth century. But among those involved in the world of French painting prior to 1900, the dominant figure of landscape painting was Camille Corot.[1] In 1897 Monet himself echoed popular opinion when he said: "There is only one master here—Corot. We are nothing compared to him, nothing."[2] Corot produced an enormous number of paintings during his long life, and he established a distinctive style of landscape painting that was widely imitated and too often forged. It was said during the peak of his career that a Corot hung in the living room of every good French home.

In addition to the success he experienced in both the official Salon and the burgeoning art market, Corot enjoyed the admiration of the younger generation of avant-garde painters, including Cézanne and Pissarro as well as Monet. Corot played the central role in one of the great dramas of nineteenth-century painting: the rise of landscape as *the* genre of ambitious painting. He formed a bridge between traditional landscape painting, with its roots in seventeenth-century classicism, and the modern movements of Impressionism and Post-Impressionism.

By 1861, the year the museum's *Orpheus Leading Eurydice from the Underworld* was first exhibited, landscape painting was not yet considered worthy of a serious painter's attention. The most prestigious kind of painting at the annual Paris Salon remained history painting. In this painting, Corot draws his subject from the ancient Greek myth of Orpheus, the god of music. Having lost his beautiful young wife, the wood nymph Eurydice, to a fatal snake bite, Orpheus journeys to Hades to win her back with his enchanting music. Strumming his lyre, he seduces the rulers of Hades with a melancholic song of lost love. Orpheus earns his wife's freedom on the condition that he lead her back from the underworld without looking at her. Corot depicts the couple on their hopeful return to the world of light, prior to that tragic moment when Orpheus's will falters, he looks back, and loses Eurydice forever.

By choosing Orpheus as his subject, Corot participated in a contemporary vogue for the bittersweet myth, which was fed by Hector Berlioz's 1859 revival of Cristophe Gluck's classic opera *Orfeo ed Euridice* presented in November 1859 at the Théâtre-Lyrique in Paris.[3] Corot was deeply impressed by the performance, and he styled his painting in part after a scene at the beginning of the opera's third act. The myth of Orpheus continued to captivate Corot for many years, and he made several drawings and at least four paintings of the subject across his career. Perhaps he was drawn to Orpheus as a symbol of both the struggle of the creative artist and the importance of the muse for inspiration. Or, as an avid music fan and opera devotee, he may also have been attracted to Orpheus's musical power to move and seduce listeners.

Indeed, there is something musical about Corot's painterly aesthetic. Particularly in his later landscapes, Corot aspired to music's transcendent ability to transport the listener to an unreal world of mythological enchantment and fantasy.[4] Corot's *Orpheus* offers the patient beholder entry into a kind of reverie, into an ephemeral world glimpsed through a softly shimmering veil. The drama unfolds gently: we see the couple moving gracefully across the foreground, Eurydice herself in a trance and Orpheus raising his lyre to the light, while mute figures, half obscured, swoon in the background. This sense of filtered reality is enhanced by Corot's extraordinarily subtle use of color. He strikes a wistfully sweet tonal chord, carefully modulating a narrow range of grays, greens, and blues. This work looks forward to the artist's signature paintings, the *Souvenirs* and *Memoires* of the later 1860s, in which Corot removes all narrative elements from his landscapes and lets them stand as "pure" objects of visual pleasure. These paintings operate in ways not unlike Monet's later water lily paintings (see, for example, p. 201), equally delicate works of rich color, painted in the artist's idyllic retreat of Giverny.

1. For Corot's place in nineteenth-century painting, see Wintermute 1990, Clarke 1991, and Tinterow 1996.
2. Koechlin 1927, 47, quoted in Tinterow 1996, xiv.
3. For the context of the museum's *Orpheus Leading Eurydice* in midcentury Parisian culture, see Stein 1992.
4. For an elaboration of Corot's conformity to a musical aesthetic model, see Champa 1991.

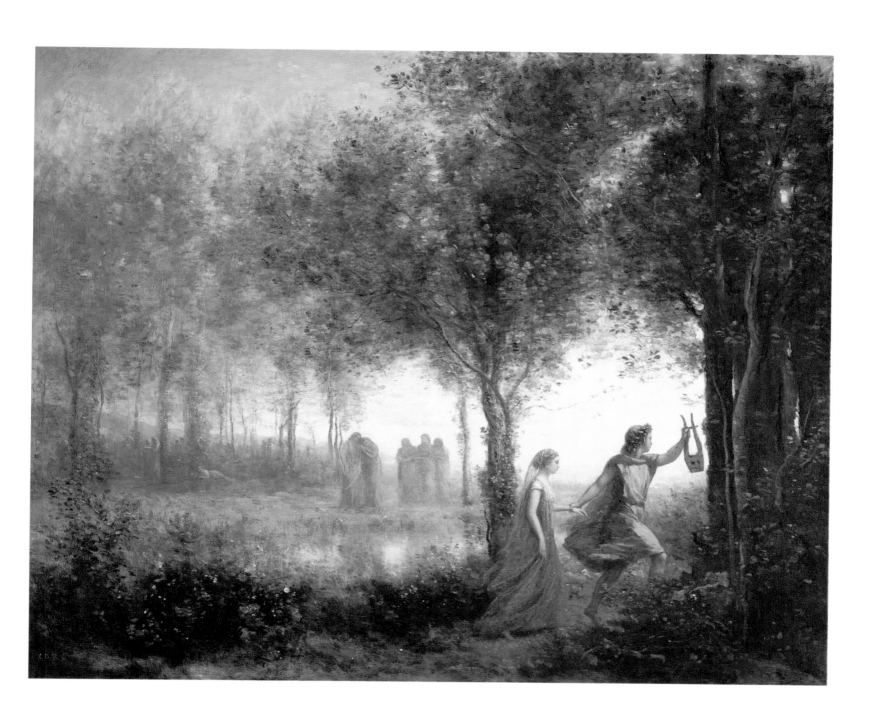

## Théodore Rousseau
French, 1812–1867

### The Great Oaks of Old Bas-Bréau, 1864

Oil on canvas, 35 1/2 x 46 in. (90.2 x 116.8 cm)
Museum purchase with funds provided by the
Agnes Cullen Arnold Endowment Fund
72.87

Théodore Rousseau was the leader of a group of landscape painters that came to be known as the Barbizon School, named after a small village in the Forest of Fontainebleau. About thirty miles southeast of Paris and easily accessible by train, the forest attracted painters such as Camille Corot, François Millet, Jules Dupré, and Narcisse Diaz de la Peña (1807–1876), among the most notable. The artists spent summers in Barbizon, living together in inns, painting outdoors in the forest during the day, and talking by the fire in the evenings. There was a sense of communal excitement among them; they were doing something revolutionary in the genre of landscape painting, initiating a new approach that would culminate in the radical work of the Impressionists later in the century.[1]

Rousseau began his career in the studios of history painters and classical landscape painters, competing in 1829 for an academic prize in "historic landscape." Ambitious landscape painters at the time conformed to a centuries-old tradition, established by Nicolas Poussin and Claude Lorrain in the seventeenth century, in which landscapes were rationally composed, included elevated references to antiquity, and were set in an idealized Italianate land. Academic painters like Pierre-Henri Valenciennes (1750–1819) and Jean-Victor Bertin (1767–1842) only occasionally painted outdoors directly from nature, but they considered their outdoor work as exercises far removed from their finished studio productions. Rousseau, a definitive member of the Romantic generation of 1830, was frustrated by this rigid, stultifying approach to landscape painting, finding in it no opportunity to express his passionate feelings for nature. In the vibrantly empirical work of the English landscapist John Constable, which was exhibited to much acclaim at the Salon of 1824, Rousseau found his dreams justified; great landscape painting did not have to idealize and elevate according to convention, but instead could be based on the pure observation of nature. Rousseau turned to the Dutch landscape painters of the seven-

teenth century (who had inspired Constable in the first place), buying with Millet a painting by Jan van Goyen (1595–1656), and collecting some fifty prints after Dutch paintings including reproductions of landscapes by Jacob van Ruisdael. The Dutch painters' focused attention on common, native countryside encouraged Rousseau's naturalist zeal.

Perhaps even more than his fellow Barbizon painters, Rousseau was profoundly moved by the grandeur and mystery of nature's awesome beauty. His canvases convey a sense of the city man's nostalgia for the timeless, ancient ways of rural life and the constant rhythms of weather and the seasons. Rousseau was particularly taken with old trees, what he perceived as their solidity and stoicism, and he produced numerous sketches in oil and pencil.[2] *The Great Oaks of Old Bas-Bréau,* painted during Rousseau's twilight years, is an ode to these gigantic aged oaks, their wild branches and gnarled limbs stretching up toward the blue sky, year after year for centuries. In this unusually monumental canvas, the miniscule hunter, rather lost among the trunks, is almost consumed by their presence. In contrast to the violently rapid pace of industrialization and urbanization, and to the whirlwind speed of modernity, the Forest of Fontainebleau held profound meaning for Rousseau, as he so movingly expresses here.[3]

Rousseau's painterly eloquence was not always appreciated by his contemporaries. As the recognized leader of a group of artistic rebels, he was systematically excluded from the Salon from 1836 to 1841, and he abstained from submitting to the jury from 1842 to 1849.[4] He became known as "le grand refusé," but after the 1848 revolution this rebellious reputation only added to swelling interest in his work. In the 1850s the demand by city dwellers for the pictures of unspoiled nature that were produced by the Barbizon School created a healthy market. At the 1855 Paris World's Fair, Rousseau's work was granted a whole gallery, confirming his status and expanding his international reputation.

1. For the development of French landscape painting in the nineteenth century, see Herbert 1962, Galassi 1990, and Champa 1991.
2. A preparatory drawing for *The Great Oaks of Old Bas-Bréau,* dated 1857, is in the Musée Mesdag, The Hague. See Schulman 1997, no. 516.
3. For further discussion of this work, see Lee 1974, 62–67.
4. Beard 1996, 265–68.

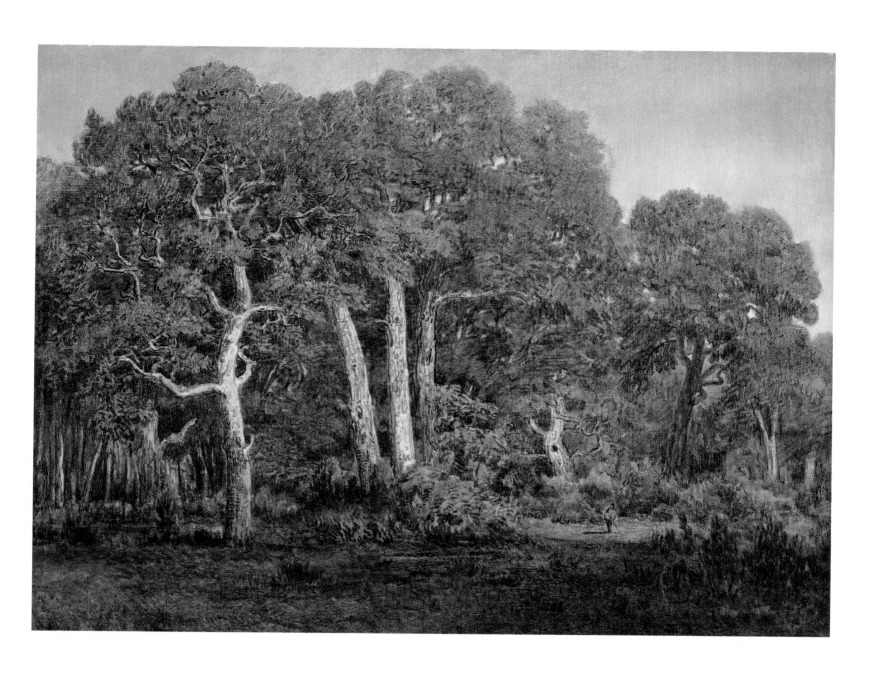

# Gustave Courbet

French, 1819–1877

## Seascape, c. 1865

Oil on canvas, 35 1/4 x 45 3/4 in. (89.5 x 116.2 cm)
Gift of Mr. and Mrs. Jack I. Poses
57.51

Gustave Courbet was the provocative proponent of French Realism in painting, a movement that superceded Romanticism in the middle of the nineteenth century as the current avant-garde. With works like the *Stone-Breakers,* 1849–50 (destroyed), and the monumental *Burial at Ornans,* 1850 (Musée d'Orsay, Paris), Courbet assaulted the conventions of mainstream painting. These works addressed the mundane toil of daily life among social classes rarely represented with such seriousness in contemporary French painting. In an attempt to capture the authentic "truth" of existence, Courbet stripped away the heroism and sentimentality characteristic of Salon painting, leaving on the canvas only what he could directly observe and transpose with brush, palette knife, and oil paint.

In 1855 Courbet completed his most ambitious work, *The Studio: A Real Allegory Summing Up Seven Years of My Artistic Life* (Musée d'Orsay, Paris). This enormous painting, which measures approximately twelve by nineteen feet, was rejected by the Salon jury for exhibition at the 1855 Paris World's Fair. Courbet reacted by creating his own exhibition pavilion with a large sign proclaiming "Le Réalisme" over its entrance and proudly displayed *The Studio* himself. The painting is a visual résumé of sorts: on the left a group of social types the artist considered appropriate Realist subject matter, and on the right a group of Courbet's supporters, including his friend and patron Alfred de Bruyas and the poet and art critic Charles Baudelaire. At the center sits Courbet, brush poised before a landscape painting, as a nude model and a small boy attentively look on. The artist's central focus on landscape painting is significant. Courbet was an avid landscape painter, and by spotlighting the genre, he makes a prescient announcement of the arrival of landscape painting as the ultimate arena for painterly expression. Literature, religion, history, and even the nude would all become secondary to the natural landscape as subject matter for the ambitious paintings of the future.

Though somewhat overshadowed by his more sensational figurative works, Courbet's landscape paintings constitute the majority of his oeuvre and much of its radicalism. His most consistent subject was his beloved native countryside near the French-Swiss border, but in the 1850s he tried his hand at seascapes. In 1854 and again in 1857 he visited Bruyas at his home in Montpellier on the Mediterranean. Taken with the crystalline light of this shore, he painted *Souvenirs de cabanes,* or *Coast Scene,* 1854 (Philadelphia Museum of Art), a radically reductive seascape of a stretch of beach near Les Cabanes (The Cabins), a small, sparsely inhabited colony of fishermen near Palavas.[1] The museum's *Seascape* is a slightly altered version of this painting done a decade later. With striking simplicity, Courbet conveys the vast emptiness of the shoreline that had so impressed him. On encountering the sea as a young man some twenty years earlier, he had written to his parents: "We have at last seen the horizonless sea; how strange it is for a valley dweller. You feel as if you are carried away; you want to take and see the whole world."[2] Courbet's youthful inspiration and passionate ambition did not diminish with age.

By the late 1860s Courbet was painting more landscapes than ever, and they were selling well on the art market. The freedom of landscape painting relative to the much more determined genre of history painting allowed Courbet greater personal expression and technical innovation.[3] In *Seascape,* Courbet eliminated the narrative vignette of fishermen pulling nets up the beach that are included in the Philadelphia *Coast Scene.*[4] The only signs of human existence are the briefly noted cabins at the lower right and the small sails of boats on the sea. The minimalism of *Seascape,* particularly given its large scale, is surprisingly modern. The painting is composed of three bands of color: the pale turquoise of the sky, the narrow strip of deeper blue ocean, and the yellow-green and earthy browns of the grassy shore. The surface is varied, from delicate, thin washes to

1. Bordes 1985, 31–32.
2. Lindsay 1973, 21–22.
3. For the role of landscape painting in Courbet's oeuvre, see Champa 1991, 136–39.
4. Compare these works in the catalogue raisonné, no. 151, p. 95 (Philadelphia) versus no. 507, p. 268 (Houston); Fernier 1977.

textured brushstrokes and thicker smears of the palette knife. Objects are left rather undefined, and the "subject" is so uneventful that the viewer's attention is returned to the textural complexities of the picture's surface. Like Courbet's greatest landscapes, this work is as much about the materiality of paint laboriously applied to canvas as it is about depicting the subject at hand. The younger generation of avant-garde painters—Cézanne, Manet, and Monet among them—took note, and indeed, without Courbet, the innovations of Impressionism would have been unthinkable.

## William Bouguereau

French, 1825–1905

### The Elder Sister, 1869

Oil on canvas, 51 1/4 x 38 1/4 in. (130.2 x 97.2 cm)
Gift of an Anonymous Lady in memory of
her father
92.123

Among the most successful professional painters of his time, William Bouguereau was the prized product of an arts educational system developed over two centuries and copied by art schools throughout western Europe. The Ecole des Beaux-Arts curriculum centered on draftsmanship as the most fundamental, essential artistic skill. Continuing a tradition initiated during the Renaissance by artists like Raphael and Michelangelo, the academic system trained art students to create heroic nude and seminude figures in crisply delineated, carefully conceived narratives drawn from history, classical mythology, and the Bible. Bouguereau excelled as a student and was rewarded with the prestigious Prix de Rome, a fellowship at the French Academy in Rome to study ancient Greek and Roman art as well as the Italian Old Masters. There he honed his drawing skills and absorbed the classical figurative ideal characterized by symmetry, smoothness, and grace. Bouguereau's dutiful commitment to the academic mission of perpetuating the great tradition of Western painting earned him membership in the elite French Academy and election to the Legion of Honor, the highest official honors awarded to an artist in France.

There is another, equally impressive aspect to Bouguereau's career: his virtually unparalleled success in the art market. Beginning in the 1860s, the decade that produced *The Elder Sister,* Bouguereau's paintings were avidly collected in France and even more zealously in Holland, England, and the United States. Responding to market demands, Bouguereau branched out from strictly classical and historical subject matter to idealized scenes of childhood and family life, as well as images of erotically charged, nubile female nudes. These subjects were much more appealing to the burgeoning audience of middle-class buyers than were obscure stories culled from classical history.

Executed with extraordinary painterly skill, *The Elder Sister* is a sentimental scene of a pretty young girl holding her baby sibling in her lap. Following his classical ideal, the artist has stripped his real-life subjects (his daughter Henriette and son Paul) of the imperfections of reality, portraying children with perfect features, dressed in clean garments, and posed against an undisturbed backdrop of rural idyll. The composition is unified and balanced, with the children's arms and legs converging neatly at the center of the canvas. Bougeureau's smooth paint application and diligent attention to detail result in an almost hyperrealistic representation. The children are attired in faux-peasant costume, a regional, Italianate garb very popular for models of this genre of picturesque painting. Exhibiting the same sweet, light style as Raphael's paintings of the Virgin and Child, this image of barefoot children in rustic dress in a quaint outdoor setting evokes the charm of childlike innocence and simplicity, a fledgling maternal instinct, and the pure state of sibling affection. Although Bougeureau's works were originally inspired by classicism and antique idealism, images like this one present an emphatically Victorian ideal.

This ideal was not shared by all artists or by all parts of the population. In fact, for the artistic avant-garde of the second half of the nineteenth century, who aligned themselves against the Salon system and the academic ideal, Bouguereau was the enemy. Artists like Cézanne, Degas, Manet, and Monet singled out Bouguereau's oeuvre for derision, attacking it as a commercialized sellout to an obsolete tradition. (Degas referred to academic art he didn't like as "bouguerized.") Unfortunately for Bouguereau, the heroic narrative of modernist art, which dominated art history for the next century, continued his vilification, branding his work as false and aesthetically if not morally corrupt. In recent years, however, interest in Bouguereau's work has revived, and his great skill is widely admired once again.[1]

1. See Petit-Palais 1984, Wissman 1996, and Borghi and Company 1991.

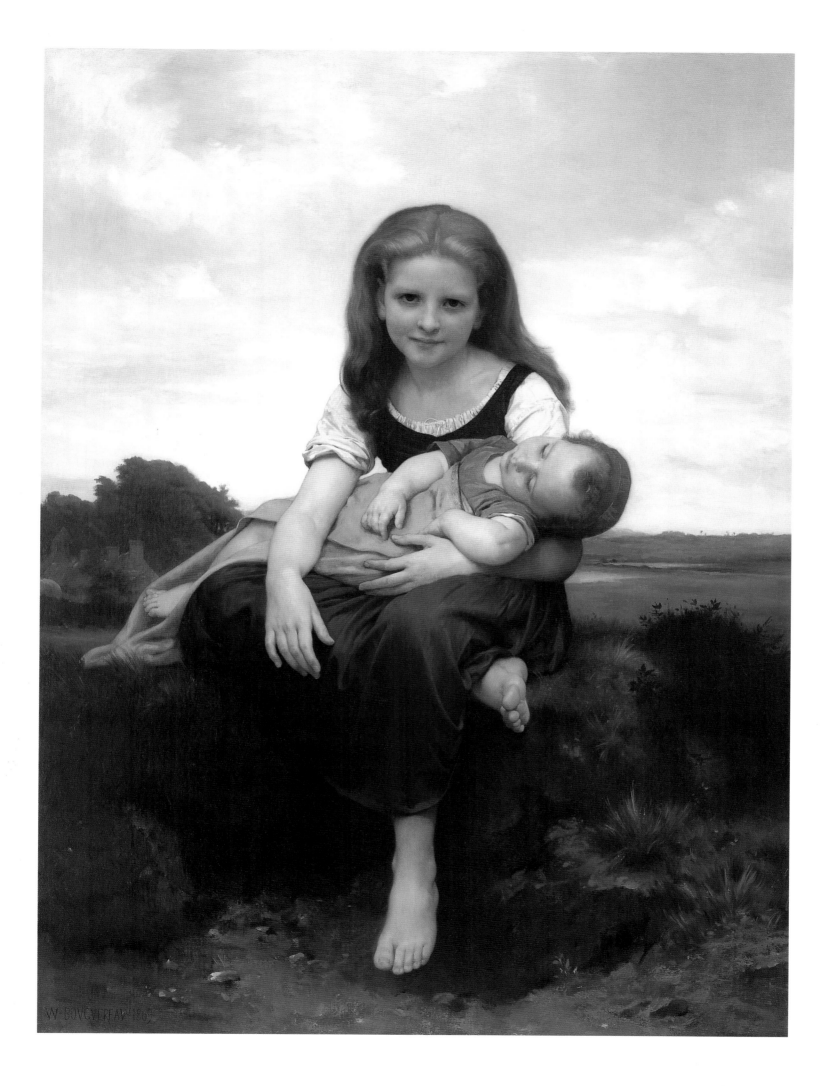

## Henri Fantin-Latour

French, 1836–1904

### *White Roses,* 1870

Oil on canvas, 12 1/4 x 18 1/2 in. (31.1 x 47 cm)
Gift of Ann Eden Woodward
79.183

Henri Fantin-Latour painted *White Roses* the same year he presented *Studio in the Batignolles* (Musée d'Orsay, Paris), a group portrait of the artistic avant-garde, at the Salon of 1870. *Studio* pictures a group of artists and critics who rallied around Edouard Manet in the late 1860s, among them Emile Zola, Auguste Renoir, Frédéric Bazille (1841–1870), and Claude Monet. Manet, sitting at an easel, his brush poised, is softly spotlit at the center of the composition. Significantly, Fantin does not include himself in the portrait, as he did in his earlier group portrait, *Homage to Delacroix,* painted in 1864 (Musée d'Orsay, Paris). Fantin's relationship with the Parisian avant-garde was ambivalent; he identified with many of their central claims but never fully allied with a single camp.

The avant-garde was, of course (as it still is), a contested category. In mid- to late-nineteenth-century Paris, however, it was easier to recognize than it is today, for it defined itself in opposition to one thing: the conventions of mainstream academic painting. In the 1860s French painting was in crisis, its present state weak and unsure, its future undecided. Two major alternatives presented themselves to young artists: naturalism (or "realism") and aestheticism or what is known as "art for art's sake." Fantin worked between the two.

Early in his career he was quite taken with the modern Realism of Courbet, with whom he studied for several months in 1861, and of Manet, whom he met in 1857. Fantin's *Studio in the Batignolles* and his famous portrait of Manet done in 1867 (The Art Institute of Chicago) signified his respect for Manet's scenes of contemporary life stripped of anecdote, and for his unique representations of light effects. The vast majority of Fantin's oeuvre is Realist, consisting of still-life paintings and portraits—genres based on the exercise of close observation. His work in these genres displays the artist's intense, patient scrutiny of his subjects. His flower paintings, in particular, are extraordinary in their preci-

sion. Fantin's contemporary, the painter Jacques-Emile Blanche (1861–1942), summarized, "Fantin studied each flower, its grain, its tissue, as if it were a human face."[1]

Faces and flowers were not Fantin's sole subjects, however. When he was not painting still lifes and portraits, Fantin indulged in figurative scenes drawn from the imagination. His most ambitious figurative work was inspired by his great passion for music, and for modern German composers in particular: Schumann, Brahms, and above all, Wagner.[2] Participating in the cult of Wagner that raged through Paris in the 1860s, Fantin produced ethereal, otherworldly scenes from *Tannhäuser, Lohengrin,* and, after visiting Bayreuth in 1876, the *Ring of the Nibelung.* Through such works Fantin tried to represent the intense but abstract feelings that music inspired in him, to bring painting from the world of the real to the escapist realm of beauty and fantasy. In 1862, in the midst of his passionate friendship with the great proponent of art for art's sake, James McNeill Whistler (1834–1903), Fantin wrote that he aspired to the company of "those few Artists who knew what art really was: that beauty which is timeless and universal, founded in mysterious harmonies and relationships."[3]

Fantin's critically acclaimed flower paintings, it could be argued, were also inspired by his love of music. What makes them so successful is their combination of Realist observation and aesthetic otherworldliness. The avant-garde art critic Zacharie Astruc wrote of them in 1863: "They are as compelling as they are charming, in fact one might even call them moving. They are tonal rhythms, freshness, abandon, surprising vivacity. Their beauty captivates. . . . Delicacy of expression being the essence of his art, Fantin seems to be the visual poet of flowers."[4] Each of the blossoms in *White Roses* has the individuality and complexity that could only come from intimate visual analysis. The realness of these rambler roses, cut from a wild bush and brought into the studio to be recorded, is palpable. But the

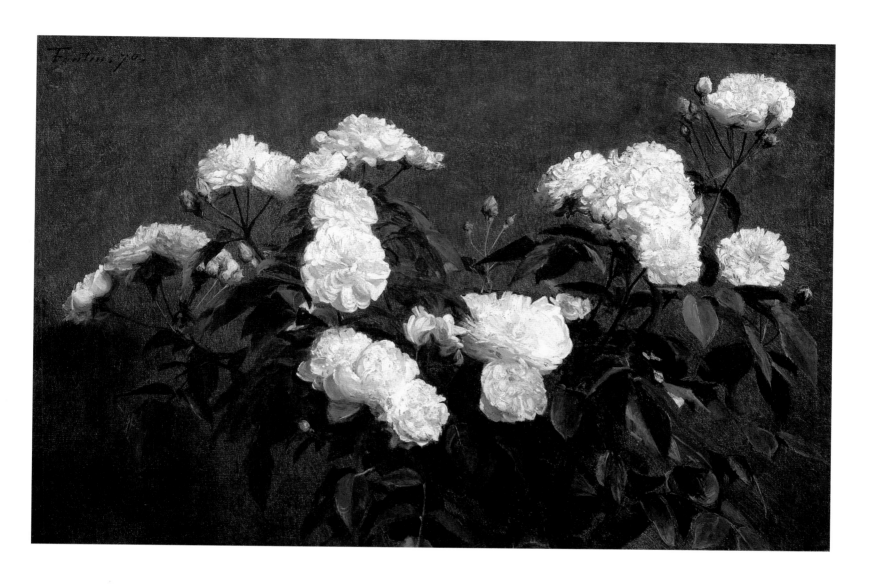

picture is also a painterly performance—the subtle variations of white and the variety of brushstrokes that physically construct each petal, are all set against Fantin's signature rich brown-gray background. The pictured roses, absent from their anchoring vase, transport the viewer to a quiet, solitary realm of contemplated beauty. Fantin offers an experience that is simultaneously Realist and escapist, an experience made more poignant by the historical context of the picture; Douglas Druick suggests, in pointing out the French name for the rambler rose, *felicité et perpétuité* (happiness and perpetuity), that Fantin's selection of these flowers to paint on the eve of the Franco-Prussian War may have been a hopeful premonition of the sad months ahead.[5]

1. Quoted in Lucie-Smith 1977, 22.
2. See in particular chap. 3 in Jullien 1909.
3. Quoted in Druick and Hoog 1983, 97.
4. Quoted in ibid., 114.
5. Ibid., 258. According to Druick, the rambler rose blooms in early to mid-July, and the war between Germany and France broke out on 18 July 1870.

## Armand Guillaumin

French, 1841–1927

### View of the Seine, Paris, 1871

Oil on canvas, 49 3/4 x 71 3/8 in. (126.4 x 181.3 cm)
Gift of Audrey Jones Beck
71.5

*View of the Seine, Paris* was included in the first Impressionist exhibition of 1874 and stands as a monument in the evolution of that avant-garde movement. It was actually painted in 1871, immediately following the wrenching events of the Franco-Prussian War and the period of civil strife known as the Commune. These events, which so divided the city of Paris not only socially and politically but physically as well, momentarily derailed the group of young painters who, inspired by the artistic audacity of Courbet and Manet, were plotting their own artistic revolution. Along with Cézanne, Pissarro, and Manet, Armand Guillaumin had exhibited his work at the groundbreaking Salon des Refusés in 1863 and had taken part in the heated discussions about art and culture led by Manet and his champion Emile Zola at the Café Guerbois in the late 1860s. *View of the Seine, Paris,* painted on a grand scale, may have been Guillaumin's attempt to reignite those artistic energies for a new decade. Indeed, the painting appears in the background of one of Cézanne's early self-portraits, a sign of Guillaumin's important role in the development of that modern master. The two painters met at the Académie Suisse in the early 1860s, and Guillaumin's friendship would prove one of the few lasting relationships in Cézanne's life.[1]

*View of the Seine, Paris* is a fascinating example of Impressionism in its early stages. Guillaumin paints the cityscape of Paris, that iconic capital of modernity that would become a favored Impressionist subject. He depicts a view of the Seine just upstream from the Ile St.-Louis, seen at the right in direct sunlight. Notre Dame stands at the center of the composition, while stretched out before it the river bustles with commercial life. The opposite bank along the left of the picture is piled high with coal, waiting to be loaded on the adjacent barges.

In its deliberate composition—the strong horizontal axis of the riverbank punctuated by trees set at even intervals—the painting shows the influence of Cézanne. The palette of strong lights and darks, and particularly the turquoise of the Seine accented by the red boat hulls, reveals Manet's effect. And the dramatic sky, crowded with dark clouds lined in purple and pink, suggests Monet's influence. Like the brushwork of Manet's paintings of the 1860s and in Monet's early works, Guillaumin's stroke is still relatively smooth, not yet broken into the characteristic Impressionist dash. Unusual in this work, however, is the insertion of a subtle narrative into Guillaumin's cityscape. Groups of workmen (judging from their attire) stand on the *quai* at the river railing, relaxing and chatting. At the right, two fellows turn to notice the entrance of a lone woman, gathering her skirts as she walks, self-absorbed in song. It is a mundane vignette carefully recorded, enlivening with a human element what is essentially a landscape painting.

The portrayal of human drama was not part of the Impressionist agenda, however. In accord with the Impressionist emphasis on the representation of the changing conditions of nature, Guillaumin's painting was shown at the 1874 exhibition with the title *Temps pluvieux* (*Rainy Weather*). Armand Silvestre, art critic and early supporter of Impressionism, wrote in his review of the 1874 exhibition: "I have received no richer impressions than those from *Temps pluvieux* by Guillaumin."[2] Indeed, such promise did not go unfulfilled. Despite having to dig ditches at night for the Paris department of public roads to support himself financially, Guillaumin produced a significant body of work, participating in six of the eight Impressionist exhibitions. In 1891 he won the state lottery, enabling him to fully devote himself to his painting. He proved an accomplished painter and a classic Impressionist, as well as a much admired and loyal friend to not only Cézanne but also Pissarro, van Gogh, and Gauguin.

1. See Gray 1972, 2, and Rewald 1985, 105.
2. Quoted in Moffett 1986, 128.

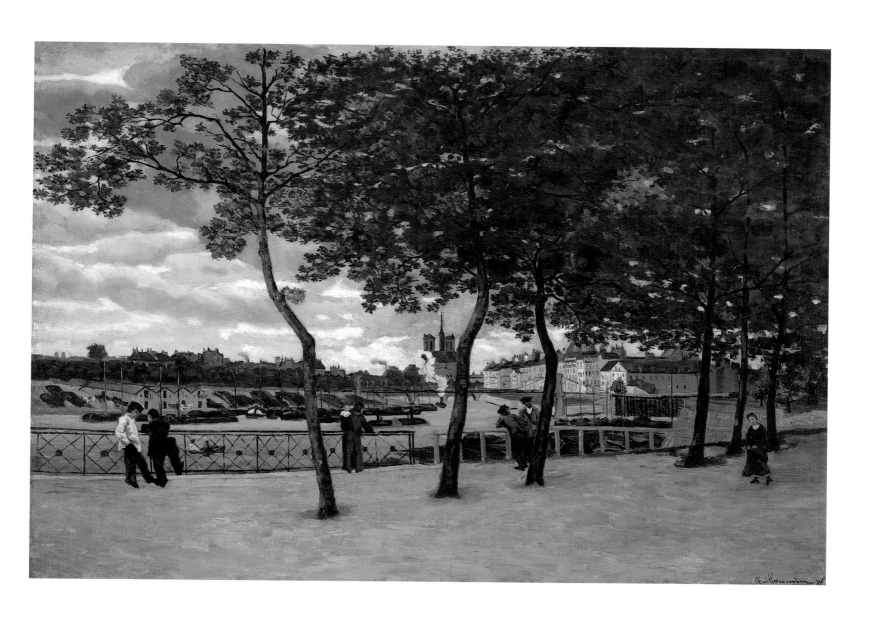

## Auguste Renoir

French, 1841–1919

## *Still Life with Bouquet*, 1871

Oil on canvas, 28 13/16 x 23 3/16 in. (73.3 x 58.9 cm)
The Robert Lee Blaffer Memorial Collection, gift of
Sarah Campbell Blaffer
51.7

Painted at an early moment in his career when he was still defining his aesthetic, Auguste Renoir's *Still Life with Bouquet* is a summation of the artist's interests at the time. In the 1860s and 1870s Renoir aligned himself socially and professionally with the young painters following the artistic precepts of Manet. The group, which included Bazille and Monet, met regularly at the Café Guerbois in the Batignolles section of Paris to discuss their revolutionary ideas and plot their artistic ascendancy. Particularly during this period, Renoir sought to capture the energy and flair of contemporary Parisian life. In such famous paintings as *La Grenouillère,* 1869 (Nationalmuseum, Stockholm), *Luncheon of the Boating Party,* 1881 (Phillips Collection, Washington, D.C.), and *Ball at the Moulin de la Galette,* 1876 (Musée d'Orsay, Paris), and in numerous society portraits, Renoir appealed to increasingly affluent members of the middle class who wanted images of themselves, their city, and their lives at leisure.

Renoir's patrons also wanted to decorate their modern apartments with paintings that were simply pretty to admire. Ever unapologetic, Renoir himself defined his artistic mission: "Painting is done to decorate walls. So it should be as rich as possible. For me a picture . . . should be something likeable, joyous and pretty—yes, pretty. There are enough ugly things in life for us not to add to them."[1] *Still Life with Bouquet* addresses the pleasures of acquisition and consumption. Above all, the painting offers an exceedingly sensual visual experience. Coloristically varied, the painting's tones range from pure black and white, to red and yellow, to more subtle grades of rust and terra cotta. The paint is applied fluidly with a lively touch, evoking the rich textures of the assembled objects—the crispness

of the florist's pure white paper; the soft moistness of the fresh flower petals; the hard reflective surface of the print's protective glass; the dry, prickly sheath of grass; the lustrous painted glaze of the vase; the soft fringe of the tablecloth; and the dusty leather book covers.

It is hardly surprising that Renoir's favorite painters were Boucher and Fragonard, the eighteenth-century masters who specialized in pretty paintings produced for an audience concerned, above all, with pleasure. The most directly referenced influence in *Still Life with Bouquet,* however, is the tradition of Realism that Manet was so thrillingly reviving. Included in the still life is Manet's etched reproduction of *Little Cavaliers,* a painting by the seventeenth-century Spanish master of realism, Velázquez.[2] The pure, bright colors of the bouquet and Renoir's loose brushwork further index Manet and Monet as artistic inspirations. The warm ocher and umber tones that dominate the work also suggest the influence of the arch-Romanticist Eugène Delacroix. His exotic images of North Africa inspired several of Renoir's works of these years, including his *Woman of Algiers,* 1870 (National Gallery of Art, Washington, D.C.).

Renoir's inclusion of the Japanese fan and porcelain vase further enhances this image as an icon of fashionable modernity. The reopening of Japan to the West in the 1850s fueled a Parisian vogue for all things Japanese. This vogue was so prevalent that it became known simply as *japonisme.* Renoir's *Still Life,* with these *japoniste* objects, prominently displayed art print, tightly wound bouquet (a common item of exchange on the Parisian social circuit), and the leather-bound books lying on a fine satin textile, all combine to strike a tone of urban sophistication à la mode.

1. André 1928, 30.
2. Adler 1986, 86–88, no. 74, ill. See also House 1994, 56, and Hayward Gallery 1985, no. 18.

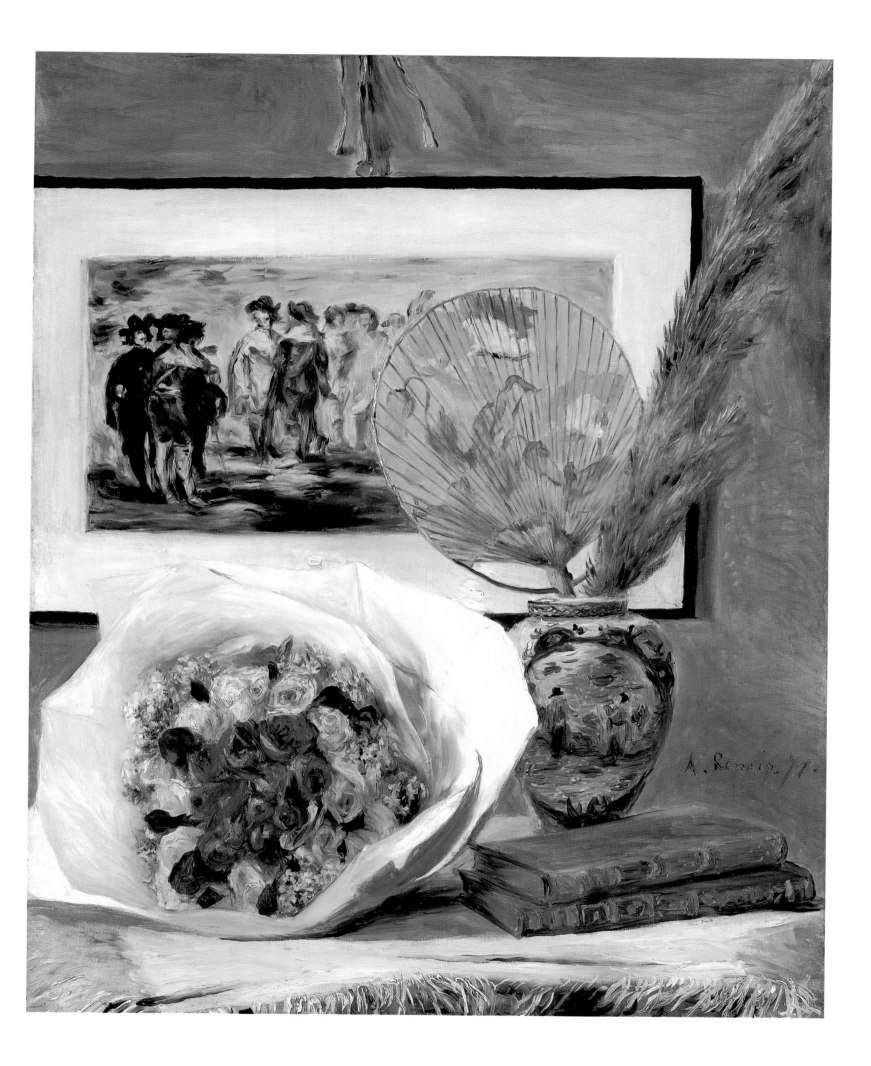

# Eugène Boudin

French, 1824–1898

## Fishermen's Wives at the Seaside, 1872

Oil on canvas, 15 1/4 x 22 in. (38.7 x 55.9 cm)
Gift of Audrey Jones Beck
98.270

The most striking effect of Eugène Boudin's *Fishermen's Wives at the Seaside* is its extraordinary sense of freshness, its revelation of the crisp luminosity particular to the beaches of the northern coast of France. Boudin expertly captures the distinctive silvery gray light that pervades the coastal atmosphere, as it refracts through the clouds and reflects off the water and pale sand. One senses the wind as it tousles the clouds against an imminent blue sky. Indeed the sky, taking up almost three-quarters of the composition, is as much the focus of this painting as are the shoreline and the figures along the bottom register. It was Camille Corot (see pp. 142–143), Boudin's contemporary in the field of landscape painting, who bestowed on Boudin his often noted appellation: "king of the skies." [1]

Boudin's successful transcription of light, atmosphere, and the ephemeral conditions of weather, did not go unnoticed by the group of young Impressionist painters. Charles Baudelaire noted the acute skills of observation expressed in Boudin's sketches: "so rapidly and so faithfully sketched from what is the most inconstant, incomprehensible of forces and colors, the waves and clouds, always with the dates, hours and [direction of] the wind noted in the margin." [2] Claude Monet maintained that were it not for an invitation when he was seventeen to accompany Boudin, then in his thirties, on an outdoor sketching excursion, the younger man would never have become a painter. Monet was impressed by Boudin's absorption in his work, as he carefully recorded his observations from nature, and by his ability to preserve the vivacity of his first impression from his sketches to his final studio paintings. Boudin exhibited three paintings in the first Impressionist exhibition of 1874.

As a young painter in the 1850s, Boudin had been inspired by landscapes of both the seventeenth-century Dutch school and the mid-nineteenth-century French Barbizon painters. Eugène Isabey (see pp. 134–35), Charles-François Daubigny (see pp. 138–40), and Corot were particularly influential. In the 1860s Boudin met Johan Barthold Jongkind, a student of Isabey's, who guided Boudin toward a looser, more spontaneous brush. Boudin's mature style culminated in the 1870s, and he acquired a reputation as the preeminent marine painter of the day. Eschewing the traditional elements of Romantic seascapes, such as storms and shipwrecks, that had characterized the genre in earlier generations, Boudin produced intimate pictures of life on the northern shore of France. He was best known for his picturesque portraits of the fashionable middle class at leisure on the beach, with their top hats, crinoline dresses, gauzy bonnets, and frilly parasols shimmering in the sun. His paintings of Normandy beach resorts such as Trouville and Deauville afforded him considerable success, both at the Salon and in the art market. The Impressionist dealer Durand-Ruel began to buy his work in 1881.

The museum's painting is somewhat unusual in Boudin's oeuvre, as it represents members of the working class on the more remote coast of Brittany. Boudin occasionally tired of painting resort scenes. In August 1867, upon his return from a trip to Brittany, he complained: "The beach at Trouville that I once so loved on my return no more than a hideous masquerade. . . . After spending a month with the peasants inured to backbreaking labor in the fields, black bread, and water, the sight of the hordes of gilded parasites with their triumphant airs seems somehow pitiful, and one feels almost ashamed at painting the idle rich." [3] There is little sign in *Fishermen's Wives* of this socially critical tone, however. Like Boudin's paintings of washer-

1. Preston 1996, 523. See also Selz 1982.
2. Sutton 1991, 19.
3. Ibid., 19–26.

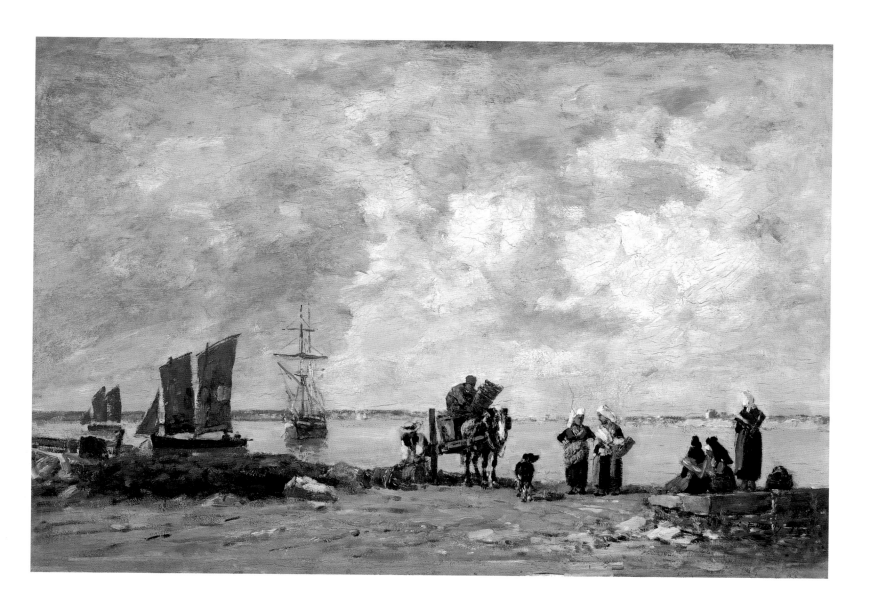

women scrubbing laundry on a riverbank, the painting is essentially a lovely landscape, its intent an evocation of pleasure and apolitical interest. The delightful native costumes of the Breton women provide delicate counterpoints of pure color within the overall scheme of pearly gray, blue, and white, fulfilling the same function as the bourgeois costumes in his scenes of Trouville. Boudin's oeuvre challenged painters from Courbet to Monet and Whistler to match him in capturing the particular magic of light at the seashore.

# Edouard Manet

French, 1832–1883

## The Toilers of the Sea, 1873

Oil on canvas, 25 x 31 1/4 in. (63 x 79.3 cm)
Gift of Audrey Jones Beck
92.171

By 1873, the year he painted this work, Edouard Manet was the unofficial leader of the group of young Parisian painters who would soon become known as the Impressionists. During the previous decade Manet had shaken the world of official French painting with two consecutive submissions to the annual Salon exhibition: *Dejeuner sur l'herbe (Luncheon on the Grass)* in 1863 and the equally scandalous *Olympia* in 1865 (both Musée d'Orsay, Paris). In an event since canonized as the birth of modern painting, *Luncheon on the Grass* was rejected by the Salon jury and instead hung along with hundreds of other rejected paintings at the famous Salon des Refusés (Salon of the Refused) where it was anointed an exemplary *succés de scandale.* Manet's heroic presence among young avant-garde painters is documented by Fantin-Latour's *Studio in the Batignolles.*

Having inspired these young artists in the early 1870s, Manet was in turn inspired by them. *The Toilers of the Sea* is a transitional work, evidence of Manet's move from the darker palette and smoother brushwork of his 1860s figure paintings toward the lighter, more sketchlike plein air works characteristic of the Impressionists. The painting is as radical as Manet's paintings of the 1860s, but in different ways. In the politically tinged Realist tradition of Daumier, Millet, and Courbet, Manet depicts members of the working class: fishermen in the midst of their labor. The subject is not political, however, nor is it literary or historical, as were more traditional forms of painting. These fishermen are mundane and anonymous. The scene was probably done from life, painted during Manet's stay in Berck-sur-Mer on the Norman coast where he regularly summered with his family. Manet painted several scenes of this English Channel resort, including *On the Beach,* 1873 (Musée d'Orsay, Paris), and *Tarring the Boat,* 1873 (Barnes Collection, Merion, Pa.). As with these works, Manet's goal in painting *The Toilers of the Sea* was not to tell a story, or to educate historically or morally, but rather to re-create a vivid sense of the moment depicted, sitting in a boat tossing on the sea with real fishermen.

The life of the sea was one with which Manet was familiar on a firsthand basis. As a teenager he appeased his father, disgruntled by his son's refusal to go to law school, by joining the merchant marines. Though his stint as a sailor was equally unsuccessful in diverting him from a career as an artist, his months spent sailing back and forth from France to Latin America left a lasting impression. In the mid-1860s he painted several maritime landscapes, including his famous *Battle of the "Kearsarge" and the "Alabama"* of 1864 (Philadelphia Museum of Art). Manet's paintings of the summer of 1873, however, are less concerned with recording significant events than with re-creating the everyday, and indeed the most striking effect of *The Toilers of the Sea* is the exhilarating sense of the immediacy of the scene. It is not an exacting, photographic realism, but one that is perceptually fresh and sensually direct. Using a variety of brush marks, Manet convincingly evokes the wind blowing off the waves, casting sea spray up the side of the boat and over the captain's shoulder; the momentum of the hull as it makes its unsteady way through the water; the gesture of the fisherman on the right, down on one knee as he hauls a heavy basket of fish that glisten in the sunlight. In Manet's extraordinary composition, the boat's bow pitches up, advancing toward the picture plane and enveloping the viewer. The whole image presses forward—the thick mast and full sail, the advancing boom, and the boat rim that Manet paints in flat, unmodeled brush marks. All is laid down in loose, sketchy strokes, which not only suggest artistic spontaneity, but also create a unified impression, undistracted by local detail.

*The Toilers of the Sea* was painted a few months after Manet's *Le Bon Bock* (Philadelphia Museum of Art)—a picture of a jolly

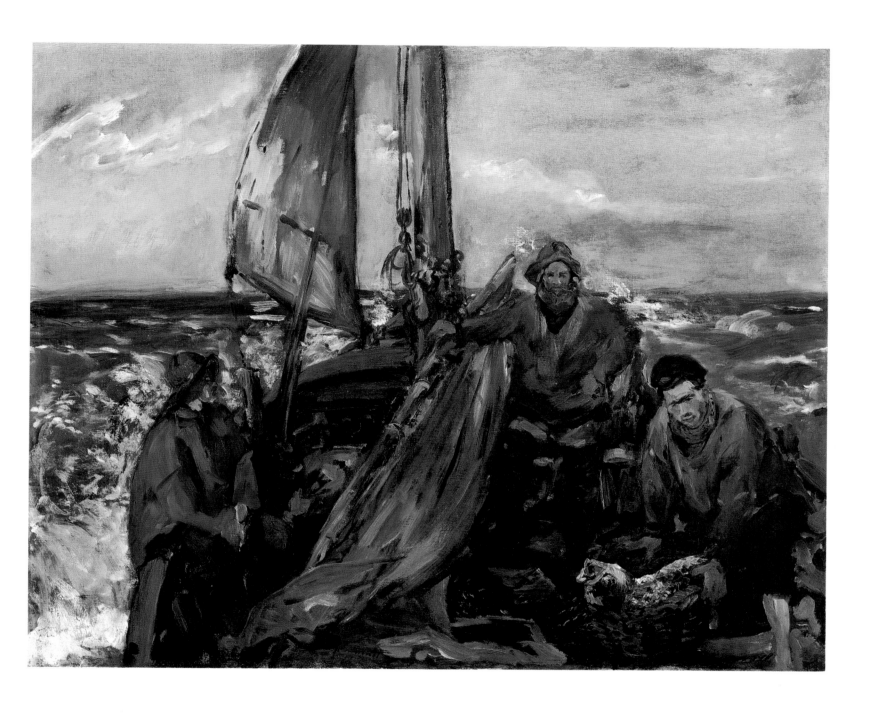

beer drinker inspired by the seventeenth-century Dutch master Franz Hals—was not only accepted by the Salon jury, but was greeted with unusually positive critical reviews. Perhaps encouraged by official success, his weeks on the Norman coast were spent painting more experimental works such as this one. Both paintings were purchased in November 1873, along with three others, by Jean-Baptiste Faure, the famous baritone from the Paris Opera, who would become Manet's most devoted collector.[1]

1. Tabarant 1947, 233. See also Rouart and Wildenstein 1975, 1:168, no. 192, ill. and Cachin 1983.

## Camille Pissarro

French, 1830–1903

### The Goose Girl at Montfoucault (White Frost), 1875

Oil on canvas, 22 3/4 x 28 3/4 in. (57.8 x 73 cm)
Gift of Audrey Jones Beck
98.295

Camille Pissarro, nicknamed "Père Pissarro" by friends and family for his generous, paternalistic spirit, was committed to the group of young, rebellious artists who exhibited together under the tag of "Impressionists" during the 1870s and 1880s. He was, in fact, the only artist who exhibited at each of the eight Impressionist shows. Equally committed to the art of painting, he engaged in intense artistic relationships with Cézanne, Degas, Gauguin, Monet, Seurat, Signac, and Maximilien Luce (1858–1941). For each of these artists Pissarro served as a rich source of artistic inspiration, technical training, and personal support.

Both passionate and disciplined, Pissarro produced an enormous body of work during his long life. The decade in which he painted *The Goose Girl at Montfoucault* was perhaps his most artistically successful. Although his works of the 1870s retain elements of what he learned from his earliest artistic mentors, Daubigny, Courbet, and above all, Corot, Pissarro exhibits a unique intensity in these paintings, a formal energy that may have been derived from his partnership with Cézanne during these years. In the early 1870s, Cézanne, in his twenties, and Pissarro, in his thirties, painted together in and around the Parisian suburb of Pontoise— Pissarro's hometown—often side by side, often exploring the same motif. In canvases such as Cézanne's *House of the Hanged Man,* 1873 (Musée d'Orsay, Paris), and Pissarro's *Farm at Montfoucault,* 1874 (Musée d'Art et d'Histoire, Geneva), color harmonies, compositional patterns, and richly textured surfaces compete in a tense but lively flicker with representations of solid mass and recessional space. Working together, Cézanne and Pissarro ingeniously recast that timeless painter's quandary: the creation of the illusion of three dimensions on a stubbornly two-dimensional plane.[1]

*The Goose Girl,* a charming depiction of a local farm girl ushering her flock of large strutting birds through a green gate, is more picturesque than most of the paintings Pissarro produced during these fertile years. Montfoucault, located in Brittany, was considerably more rural than Pontoise. Traveling to Montfoucault was a grueling day's journey by train and by cart, and when Pissarro arrived, his large family in tow, he was determined to make the most of his communion with nature. This submersion in rural life is reflected in Pissarro's paintings, a development perhaps encouraged by the art critic (and first historian of Impressionism) Théodore Duret, who wrote to the artist in December 1873: "I persist in thinking that nature, with its rustic fields and its animals, is that which corresponds best to your talent. You do not have the decorative feeling of Sisley, nor the fantastic eye of Monet, but you do have what they don't, an intimate and profound feeling for nature, and a power in your brush that makes a good painting by you something with an absolute presence."[2]

Indeed, while *The Goose Girl* is a rather intimate picture, with its enclosed sense of space, quaint subject, and subtle color chords, it is at the same time a painterly tour de force. Pissarro creates a strong sense of three-dimensionality at the center of the canvas, at the vertical and horizontal nexus of the tree and enclosure wall. Having firmly established his compositional structure, the artist thus frees his brush to explore intricate color harmonies with a variety of light touches across the canvas, creating an image that is both unified in presentation and sophisticated in modulation. The regularity of Pissarro's brushstrokes creates a richly textured pattern on the painting's surface. The work's originality derives not only from Pissarro's cultivated formal imagination, but also from his capacity for sensitive observation, or in nineteenth-century terminology, from his "truth to nature."[3]

1. Christopher Lloyd claims that Cézanne and Pissarro "laid the foundations of modern painting during the second half of the 1870s" (Lloyd 1981, 72).
2. Bailly-Herzberg 1980, 87–88; quoted in Brettell 1990, 165.
3. See also Pissarro and Venturi 1939, no. 324.

# Gustave Caillebotte

French, 1848–1894

## The Orange Trees, 1878

Oil on canvas, 61 x 46 in. (154.9 x 116.8 cm)
Gift of Audrey Jones Beck
98.273

Since the Museum of Fine Arts, Houston, organized his first major retrospective in 1976, Gustave Caillebotte has vaulted from the neglected ranks of a putative second-rate Impressionist to the status of a favorite painter admired by both the public and scholars.[1] He began painting seriously in the 1870s and became acquainted early on with the group of artists known as Impressionists. Supported by his family's considerable wealth, he helped sponsor the second Impressionist exhibition of 1876, from which he purchased several of Monet's works for his personal collection. In the 1877 exhibition he exhibited six works himself, including two of the most ambitious paintings of his career: *Paris Street: Rainy Day,* 1877 (The Art Institute of Chicago), and *Pont de l'Europe,* 1876 (Musée du Petit Palais, Geneva). Although these early paintings earned significant critical response (both positive and negative), Caillebotte was better known as an avant-garde collector and early supporter of Cézanne, Manet, Monet, and Renoir than as an artist in his own right. Upon his early death at age forty-six, Caillebotte's impressive collection of some forty works was given to the French state, helping establish Impressionist paintings within official French museums. Today his bequest is one of the great strengths of the Musée d'Orsay.

*The Orange Trees,* included in the 1876 Impressionist exhibition, contains basic elements of the modern style. The painting portrays Caillebotte's brother Martial and his young cousin Zoë relaxing in the garden of the family villa in Yerres, about twelve miles outside Paris.[1] Caillebotte employs a bright palette of pure hues and complementary contrasts—unmediated reds and greens shimmer in the direct sunlight, contrasting with the more subtle play of purples, greens, and yellows in the shaded foreground. The painting is a portrait of fashionable leisure, with Zoë in her striped chiffon and red boots and Martial in his purple slippers and straw hat, surrounded by elegant boxed orange trees and "the latest" in patio furniture. The scene has the look of having been painted on site, outdoors, and is as much a painting about the effects of sunlight as it is about Caillebotte's family.

Yet even these Impressionist aspects, considered radical within the context of mainstream Salon painting of the 1870s, do not fully account for the striking nature of this canvas. Inspired by photography, Japanese prints, and the newly constructed urban landscape of Baron Haussmann's Paris (the broad boulevards, bordered by uniform four-story apartment buildings projecting to infinity, and opening out into spacious plazas), Caillebotte explored a new way of seeing and of transposing that vision onto a two-dimensional plane. In *The Orange Trees,* although a sense of space is established logically in the foreground through the sequential placement of furniture and figures, the composition feels compressed and slightly tilted up. As the path moves out into the bright sunshine, it melts into a flat pattern of stippled red, green, and yellow flora, casting the middle-ground figures into silhouette. The sense of spatial recession is barely maintained by the presence of Caillebotte's dog stretched out along the path's border and by the path's sweeping linear curve to the left.

Also particular to Caillebotte's idiosyncratic vision is a sense of social alienation. Martial and Zoë are each fully absorbed in their activities, showing no signs of interacting with one another. Enhancing the sense of dissociation, Caillebotte places Martial in the foreground and Zoë in the middle, inserting physical barriers between them. Martial's turned back and the strange presence of an empty metal chair between him and the viewer further distances him from social engagement. This psychological tone of individualized concentration and detachment from the external environment is characteristic of Caillebotte's work, a telling commentary, conscious or unintended, on the moment of modernity with which he was so enthralled.[3]

1. See Museum of Fine Arts 1976, Varnedoe 1987, and Musée d'Orsay 1995.
2. See Wittmer 1991.
3. See also Berhaut 1994, 117, no. 114, ill.

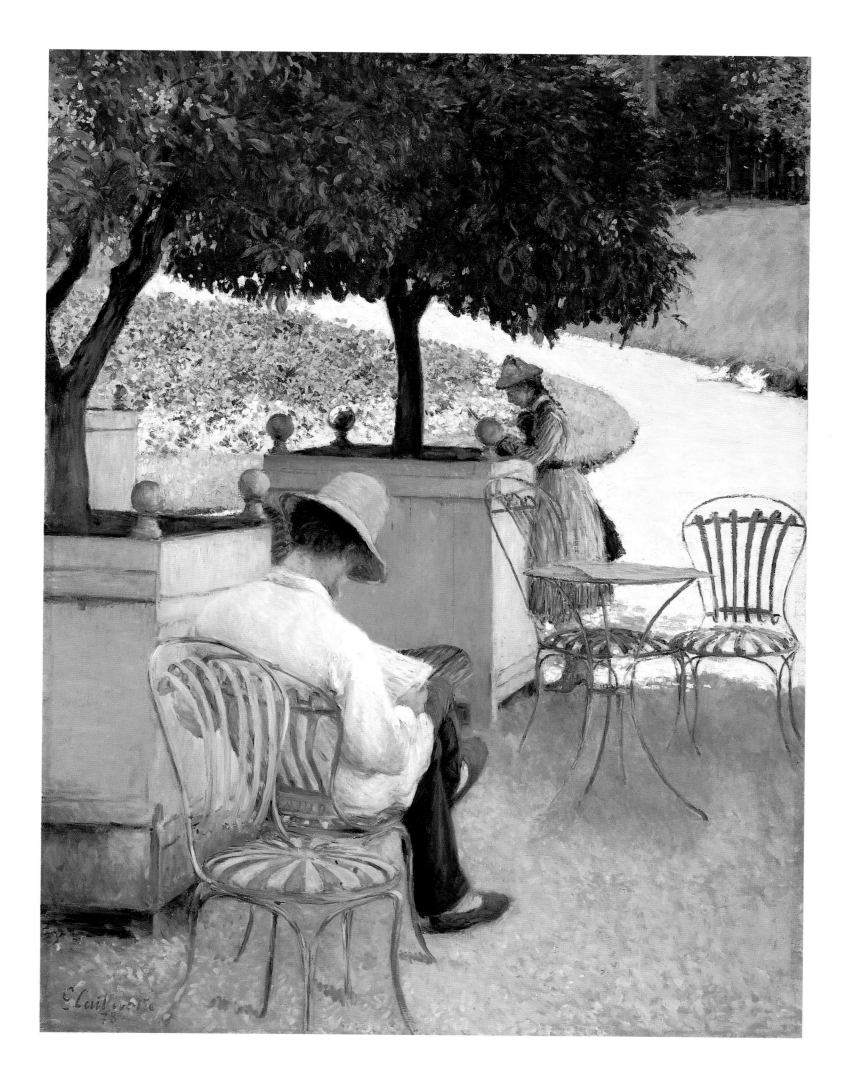

## Paul Cézanne

French, 1839–1906

### Bottom of the Ravine, c. 1879

Oil on canvas, 28 3/4 x 21 1/4 in. (73 x 54 cm)
Gift of Audrey Jones Beck
98.274

One of the most striking events in Paul Cézanne's career is the shift away from the Romantic evocations of passion and violence of his early paintings, inspired by literature and by the work of Delacroix, to the scrupulously empirical still-life, landscape, and portrait paintings with which Cézanne is generally identified. He owed this conversion to the Impressionist revolution, and in particular to Camille Pissarro, with whom he painted on and off throughout the 1870s. Pissarro introduced Cézanne to the bright, clear Impressionist palette and trained his focus on "nature" (the external world), steering him away from the dramatic emotional and psychological themes of his early career.

*Bottom of the Ravine* fulfills a primary Impressionist dictate: it captures a moment in the daily life of a particular landscape, revealing evidence of the artist's constant and intimate referencing of his motif. During one of his reprieves from the hustle and stimulation of Paris, Cézanne painted this work while visiting his mother just outside the southern French village of L'Estaque. The museum's painting is one of two remaining works inspired by Cézanne's hikes in the rugged hills behind the village. The other work, *Rocks at L'Estaque,* 1879–82 (Museu de Arte de São Paulo), portrays a view higher up in the same ravine, where the smooth stretch of sea and its bordering hills are visible. For *Bottom of the Ravine,* Cézanne has dropped down into the canyon to concentrate on the sculptural facets of the rock face.[1] He re-creates the experience of standing in the intensely bright light of the sun-baked, rocky terrain bordering the Mediterranean Sea. The landscape shimmers in the heat. The pure blue sky, green shrubbery, and beige and terracotta rock outcroppings complement one another in a vibrant color harmony. The image presses toward the picture plane, flattening out completely in certain passages, which creates a tension between the convincing representation of three-dimensional space and the immediacy of pigment smeared on a two-dimensional canvas. Cézanne has so encrusted his canvas with paint, adding layer upon layer of carefully placed and replaced brushstrokes, that the temptation for the viewer to touch the surface is almost irresistible.

The work's thick accretions of paint and carefully considered, architectonic composition hint at Cézanne's Post-Impressionist tendencies. The emphasis in Impressionist rhetoric on the fleeting and the ephemeral, and on the representation of purely optical effects, is both realized and transcended by works like *Bottom of the Ravine.* The longer one looks, the more one becomes aware of the structural intricacy of Cézanne's works, of their almost classical sensibility. Cézanne endows his paintings with a sense of solidity and timelessness, while maintaining their liveliness by constantly and insistently responding to his natural surroundings.

The originality of Cézanne's work owes something to the hermetic nature of his life. He spent most of his years in rural southern France, painting the landscape of his native Aix-en-Provence, or arranging still lifes and portrait sitters in his studio. He received very little attention from the Parisian art world until 1895 when his dealer, Ambroise Vollard, brought him to light with a one-man show. Cézanne's posthumous exhibition at the Salon d'Automne in 1907 had a deep influence on a new generation of artists, fueling two of the revolutionary movements of the early twentieth century, Fauvism and Cubism. The achievements of both Matisse and Picasso, the two "fathers" of twentieth-century modernist painting, owe a great debt to Cézanne—in many ways they picked up where the nineteenth-century master left off.[2]

1. Joseph Rishel in Cachin 1996, 186.
2. See Museum of Modern Art 1977; also Rewald 1996, 1:262, no. 393.

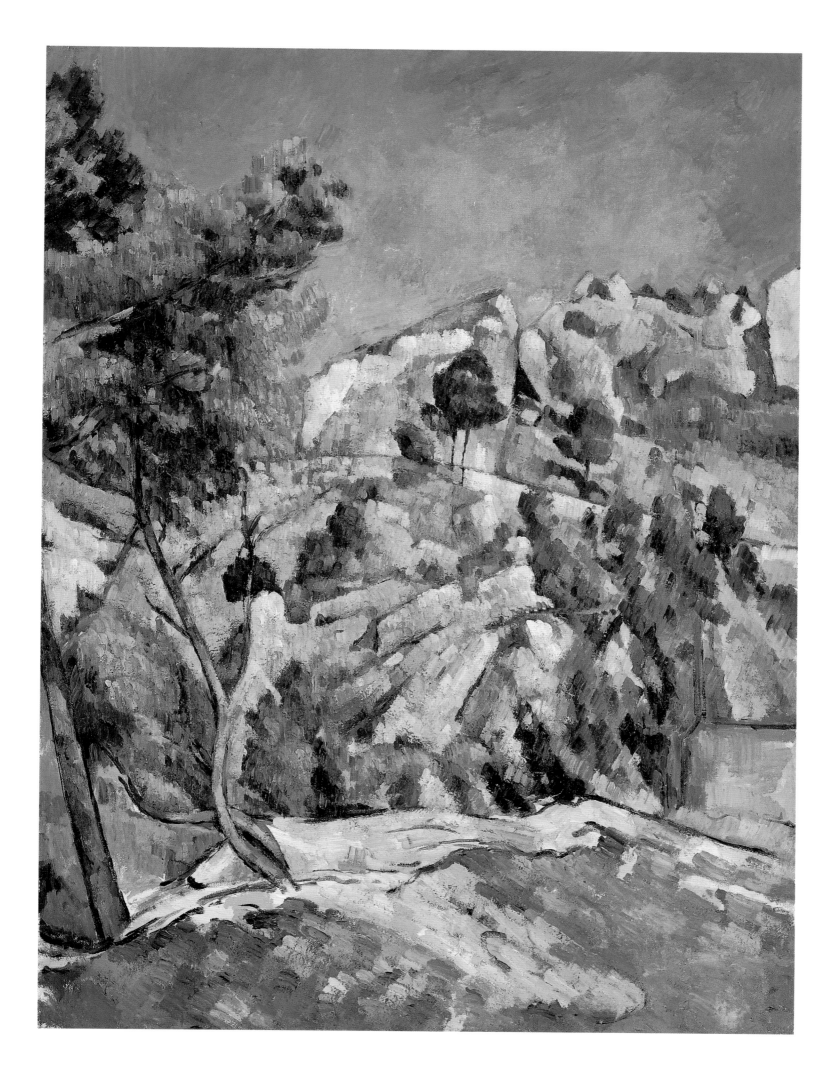

## Mary Cassatt
American, 1844–1926

### Susan Comforting the Baby, 1881

Oil on canvas, 25 5/8 x 39 3/8 in. (65.1 x 100 cm)
Gift of Audrey Jones Beck
74.136

Among the painters exhibiting in the Impressionist exhibitions of 1874–86, Mary Cassatt had the double distinction of being the only American and, along with Berthe Morisot, one of only two women. Born to a wealthy family in a suburb of Philadelphia, Cassatt was introduced to European culture in the 1850s during the five years her family spent abroad in Darmstadt, Heidelberg, and Paris. She enrolled in the Pennsylvania Academy of the Fine Arts from 1861 to 1864 and overcame her father's resistance to take the next, crucial step in becoming a serious artist: traveling to Europe's great museums to study the Old Masters firsthand. By the mid-1870s Cassatt was exhibiting her work at the annual Paris Salons. As she began to develop her own artistic style, she met with rejection from the Salon, which embittered her toward the official state art system. When Edgar Degas asked her to show her work with other "independents" at the Impressionist exhibition planned for 1878, she happily accepted.

Although she had been inspired by the work of both Manet and Courbet, Cassatt found her most impressive artistic model in Degas. He was ten years her senior and, like Cassatt, from an upper-middle-class background, well educated and financially independent. Degas introduced Cassatt to artists like Cézanne, Monet, and Renoir, as well as to avant-garde aesthetic influences such as photography and Japanese woodblock prints. The Impressionist influence on Cassatt's painting is clearly legible in her bright palette, loose brushwork, and contemporary subject matter. Her work stands apart, however, as it is informed by a distinctly female perspective. From her vantage point, Cassatt captured the world she knew so well with extraordinary perceptual and aesthetic sensitivity.

On several levels, Cassatt's gender is a significant factor in understanding her artistic accomplishments and in fully appreciating works like *Susan Comforting the Baby*. As a woman artist, she confronted formidable hurdles, ranging from the overt (being denied the opportunity to study from the live male

nude and have unfettered access to the kinds of public modern spaces that provided such rich motifs for painters like Degas and Manet) to the subtle and covert (the lack of encouragement from her family; the prejudice from collectors and critics; the condescension from professional peers). While painting was an appropriate hobby for women of Cassatt's social position, it was not condoned as a serious vocation. Neither wife nor mother, Cassatt was an anomaly within her social class; she inhabited an uncertain position, which undermined her professional self-confidence .

Perhaps most important, Cassatt's position as a female painter led her to depictions of domestic life that are unparalleled in their sense of intimacy and in their naturalism and "truth." Her images of mothers with children, in particular, contain an empathetic realism largely absent in the sentimentalizing images of artists as diverse as Bouguereau and Renoir (pp. 149, 179). *Susan Comforting the Baby* depicts one of the Cassatt family maids trying to placate a toddler on the verge of tears. The baby probably belonged to Mary's brother Alexander, who brought his family of four children to spend the summer of 1880 with the Cassatts in France. Mary entertained them in a rented chateau in the suburbs of Paris, where she painted numerous pictures of her nieces and nephews. In the museum's work, Cassatt conveys the sense of intent, though gentle, concern for the infant—his eyes welling up with tears, his hand raised to the pain in his head—through the expression on Susan's face and her physical gestures. Cassatt has skillfully structured her composition to enhance the sense of intimate, protective concern. The rim of the carriage tilts up at the right, fusing with the carriage hood, which merges with the curved back of Susan's crouched figure to form an enclosed, comforting space. A lively background, dabbed in sketchy strokes of bold red and green, creates a clamor around this quiet drama, intensifying the delicacy of the moment. From a mundane event of family life, Cassatt has created a pictorially rich, moving image.[1]

1. See Breeskin 1970, 68–69, no. 112, and Mathews 1996, no. 28.

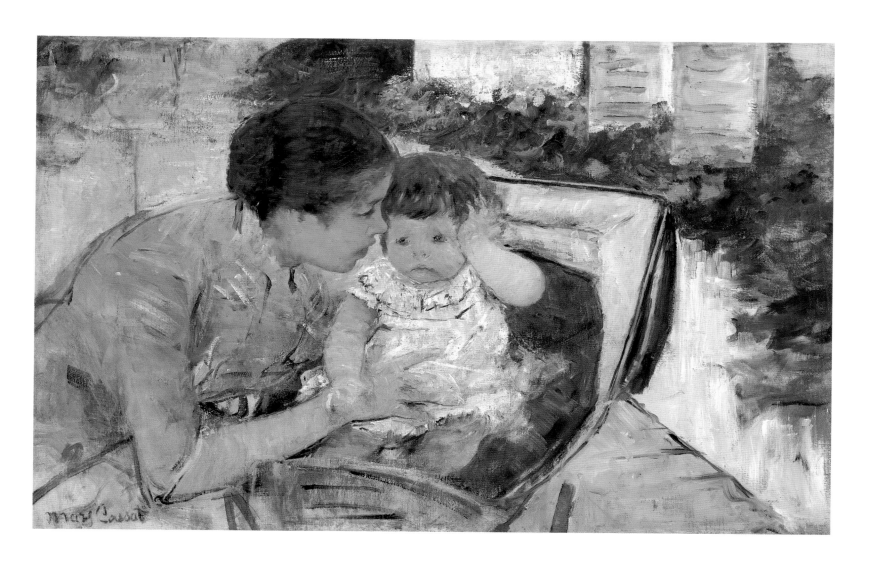

## Berthe Morisot

French, 1841–1895

### The Basket Chair, 1885

Oil on canvas 24 1/8 x 29 3/4 in. (61.3 x 75.6 cm)
Gift of Audrey Jones Beck
98.294

As with Berthe Morisot's best paintings, *The Basket Chair* demands a degree of active participation from the viewer. Standing close to the canvas, one is offered a rich surface of thick and thin brushstrokes applied in a variety of shapes and lengths. Much like Auguste Renoir, who was her good friend, Morisot manipulated her brush with great sensitivity and bold experimentation. The linear crosshatchings that define the trellis as well as the basket weave of the chair; the thicker dabs that form the foliage; the feathery, undefined marks that hover around the watering can and the girl at the fence; and the ghostly arabesques of the fence itself are the work of a painter enamored with the physical properties of paint.

Stepping back from the painting, one experiences the more psychological dimension to Morisot's work. With distance, the composition comes alive as a coherent scene of a garden dappled with sunlight. The bench at the end of the path anchors the background, a little girl, the artist's niece Jeannie Gobillard, plays in the middle ground, and in the foreground loom the basket chair at the left, a blue watering can, and an iron fence with a second little girl looking over. The composition focuses on this child, the artist's daughter Julie Manet, as the bright sunlight strikes her forearms, her dress, and her boldly painted bonnet, calling attention to her round, smoothly painted face. The painting re-creates the sensation of a glance, slightly blurred and not strictly coherent, in which the eye takes in light and color and the peering presence of a little girl in white. As Morisot scholar Charles Stuckey puts it, "her stenographic way of translating forms and light into atomic units of brushed color analogous to raw retinal stimuli is fully Impressionist."[1]

Though she had exhibited with some success at the official Salon, after her participation in the first Impressionist exhibition in 1874 she never again submitted work to the Salon jury. She was a central member of the Impressionist group, showing in seven of the eight Impressionist exhibitions and selling her work through Paul Durand-Ruel. Her home was a meeting place for Mary Cassatt, Edgar Degas, Renoir, and until his death in 1883, Edouard Manet. Morisot and Manet were particularly close friends (she married Manet's brother Eugène in 1874), and they shared an exciting reciprocal artistic relationship.

An equally significant friend and artistic influence was the Symbolist poet Stephen Mallarmé, whom Morisot met in the mid-1870s. Particularly in Morisot's later work there is something of the ephemeral, the suggested-but-not-defined, that correlates to the Symbolist aesthetic developing in literature in the 1880s (see p. 218). *The Basket Chair* marks an important shift in Morisot's painting in which she begins to preconceptualize motifs. True to the Impressionist ethic, Morisot's earlier work was not based on preliminary drawings but done on site, directly from nature. In the mid-1880s, however, she started to make sketches, and the presence of a pastel sketch of the garden pictured in *The Basket Chair*, in which the composition is differently configured, suggests that the painting was not created completely on site. Although Morisot's later paintings have the look of the spontaneously captured, they are in fact more studiously composed.[2]

Morisot's highly accomplished work in pastel and watercolor, mediums in which the paper support plays such an active role in the tonal construction of the image, led her in the early 1880s to experiment with painting on unprimed canvas. *The Basket Chair* was painted on slightly off-white, finely woven linen that the artist did not "prime," or seal with the white gesso painters use prior to applying pigment. Unfortunately, as with most of Morisot's paintings on unprimed canvas, when *The Basket Chair* was relined with wax-resin, the wax soaked through the canvas, turning it brownish orange.[3] One must imagine this painting as it once was, on a white

1. Stuckey 1987, 39.
2. Ibid., 106.
3. William P. Scott, "Morisot's Style and Technique," in Stuckey 1987, 194–95.

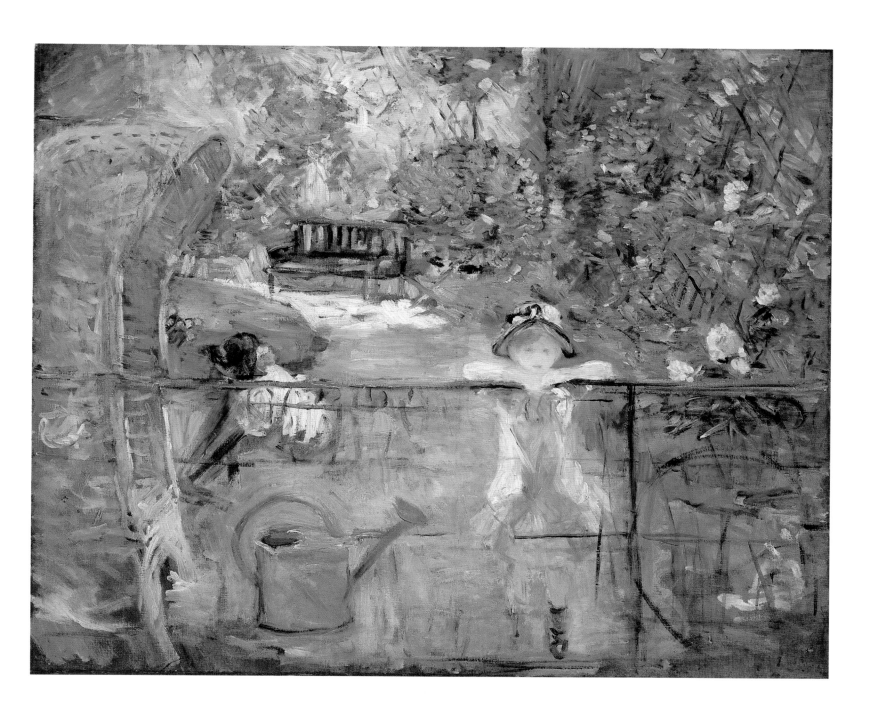

background, even more luminous and sparkling than it now appears.

That Morisot accomplished as much as she did, given the limitations of a relatively short life and of a gender-restrictive society in which "lady painters" rarely transcended amateur status, is a testament to her will and her profound passion for painting.[4] Like Cassatt, she enacted the revolution of Impressionism within the confines of the domestic sphere. *The Basket Chair* depicts the enclosed garden of her Paris home on rue Villejust, a view she had through the window in the privacy of her own studio.

4. For an account of the relationship between Morisot's gender and her accomplishment, see Kathleen Adler and Tamar Garb, "The Painting of Bourgeois Life," in Stuckey 1987.

## Paul Cézanne
French, 1839–1906

### Madame Cézanne in Blue, 1888–90

Oil on canvas, 29 3/16 x 24 in. (74.1 x 61 cm)
The Robert Lee Blaffer Memorial Collection,
gift of Sarah Campbell Blaffer
47.29

Paul Cézanne completed a total of forty-four portraits and numerous drawings of his wife, Hortense Fiquet, during their roughly three decades together. The couple met in 1869, when the nineteen-year-old Fiquet, a professional artists' model, posed for Cézanne. Cézanne was painfully shy and related to women with great difficulty. He responded to the calm, docile Fiquet, however, and they had a son in 1872, their only child. The couple did not marry until 1886, just months before Cézanne's father died.[1] The nature of their relationship is not entirely clear; though Cézanne refers to his wife fondly in his numerous letters to his son Paul, she spent a great deal of time in Paris, away from her self-sequestered husband in Aix-en-Provence.

There is some disagreement among scholars over the significance of Madame Cézanne's frequent appearance in the painter's work. Some feel that, like other portrait sitters drawn from Cézanne's immediate environment—his son, Paul, his patrons Victor Chocquet and Ambroise Vollard, and various Provençal locals—Madame Cézanne is just another formal motif, no different from the apples and jars in his still lifes. In this view, the drama of the portraits comes first and foremost from the artist's complex arrangement of color and space, the psychological content subsumed by aesthetic effect. Other scholars are intrigued by the intimations in the Madame Cézanne series of complex marital emotions. In such readings, Cézanne's sophisticated compositions betray a psychological and emotional depth central to the paintings' impact.[2] Indeed, as the following description of *Madame Cézanne in Blue* reveals, it is difficult to definitively account for the complex effect of Cézanne's portraits.

The sitter in *Madame Cézanne in Blue* is striking in her plainness; she verges on androgyny in her almost complete lack of distinguishing physical features. At first glance, her frontal pose is rather rigid, her head locked into the horizontal center and her shoulders squarely and boldly set perpendicular to her face and to the ruffle running down the front of her blouse. All seems to be static and stable. However, there are disjunctures that belie the initial reading. The dark edge of the brown wallpaper behind Madame Cézanne's head does not quite align with the deep part in her hair, and her head is in fact tilted slightly off axis. Her head, striking in its reductive simplicity, does not rest on the firmly sculpted pedestal of her neck, but rather appears to hover over it, disconnected from her body. From this essential dislocation, the rigidity of the composition begins to loosen. The right side of her face is more softly modeled than the left and is set against a more luminous background, opening up the composition at the right. The brown shapes that advance toward the sitter at the left are distinctive yet undefined, mysterious in their dark, looming nature. The composition fluctuates between legibility and ambiguity, stability and chaos, and it is this tension that ensures the dramatic life of the painting.

Cézanne plays this game of representation in an irresistibly rich, finely tuned palette. For all his compositional acumen, Cézanne is a master colorist, utterly original in the harmonies he evokes with clear blues, warm beiges and browns, and accents of green and rose. He develops a kind of chromatic modeling, creating a sense of volume by juxtaposing strokes of differently colored pigment, as opposed to using the academic *chiaroscuro* method of shading in lights and darks that had served as artistic convention for centuries.

Though his artistic development owes a great debt to Impressionism, in the 1880s Cézanne moved away from the emphasis on ephemeral optical effects that formed the basis of the Impressionist agenda. Cézanne craved solidity, construction, and volumetric mass, elements of a more classical sensibility. He was in no way reactionary, however. Holed up like a hermit in his native southern France, he created a pictorial language of his own, capable of conveying complex visual experience as intellectually challenging as it is delightful to the eye.[3]

1. Joseph Rishel in Cachin 1996, 318.
2. Nochlin 1996, 65–66.
3. See Rewald 1996, 1:421, no. 650.

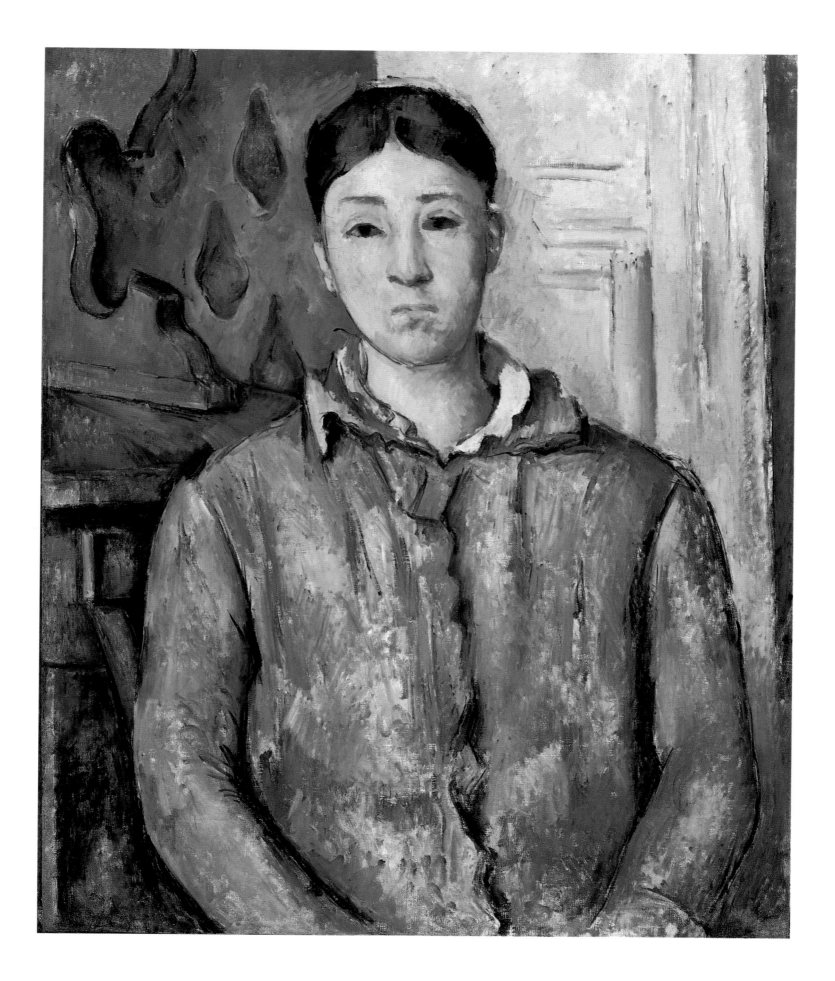

# Vincent van Gogh

French, 1853–1890

## The Rocks, 1888

Oil on canvas, 21 5/8 x 25 7/8 in. (54.9 x 65.7 cm)
Gift of Audrey Jones Beck
74.139

Vincent van Gogh painted *The Rocks* during his residence in the Provence region of southern France, near the town of Arles, about twenty miles from the Mediterranean Sea. He arrived in Arles in February 1888, after several thrilling years in Paris during which his art underwent a stylistic revolution. The lessons of Impressionism and the influence of Japanese woodblock prints inspired him to replace his dark-brown, earth-toned palette with one of unmediated color. Intoxicated by the expressive potential of color liberated from its naturalist, descriptive duty, van Gogh yearned for a landscape of light that would inspire him to new heights of artistic achievement. Arles and its environs were that landscape. Isolated in the south from the distracting ferment of the Parisian art community, van Gogh reached the high point of his short artistic career, producing some two hundred paintings and one hundred drawings and watercolors. He also wrote more than two hundred letters to his brother Theo in Paris, providing a compelling testament to the intellectual and emotional context of this extraordinary body of work.

Although he refers specifically to *The Rocks* only in passing, van Gogh rhapsodizes at great length in his letters about the awesome beauty of the southern landscape he painted and sketched. Having spent most of his life in the northernmost regions of Europe, where cold, wet, dark winters can stretch on for months, van Gogh dreamed of a land warmed by brilliant sunshine. *The Rocks* depicts a specific area called Montmajour—a romantic, rocky terrain about three miles north of Arles. In his letters van Gogh comments on the fierce winds that blasted through this particular region, complicating any prolonged attempt at painting; in fact, this is the only painting the artist made of the location, although he completed several drawings of similar motifs. Van Gogh was economizing, curbing his use of expensive oil paints and canvas out of consideration for Theo's dwindling financial resources.

One drawing, *Rocky Ground: Montmajour* (collection of Mrs. M. L. Caturia, Madrid), depicts the exact site of *The Rocks*.[1] The drawing reveals the degree to which van Gogh developed the museum's painting through a graphic exploration of the motif. Using reed pens to create heavier lines, along with a metal-tipped pen for finer detail, the artist renders various planes and textures using a system of short or long lines and dense or light dabs. The rich variety of marks that weave the work together is extraordinary: long, linear strokes defining the outlines of smooth rock face; regulated short marks sketching various patches and species of grass; oily squiggles depicting the lush foliage of the tree; stipples evoking the dry flowers of the region; and broad smears of delicate hue fleshing out the sky.

The impressive variety of van Gogh's brushwork is unified by his autographic energy—the forceful way he moves paint around on the canvas that makes his work so recognizable. One senses the speed and vigor with which van Gogh transcribed this scene to canvas, capturing the wild, almost electric presence of the site. Van Gogh's manic mark making, combined with his broad exploitation of greens, blues, and yellows, make for an exceedingly lively image. The strong, simplified composition, with the rocks stepping their way back to the craggy tree, grounds the potential chaos of colors and marks. Theo, the intimate arbiter of his brother's production, was so taken with this painting that he immediately framed and hung it beside *The Sower* (Rijksmuseum Kröller-Müller, Otterlo), one of the artist's undisputed masterpieces.[2]

1. Faille 1970, no. 1554
2. Pickvance 1984, 118–20, no. 59. See also Faille 1970, no. 466, and Hulsker 1996, no. 1489.

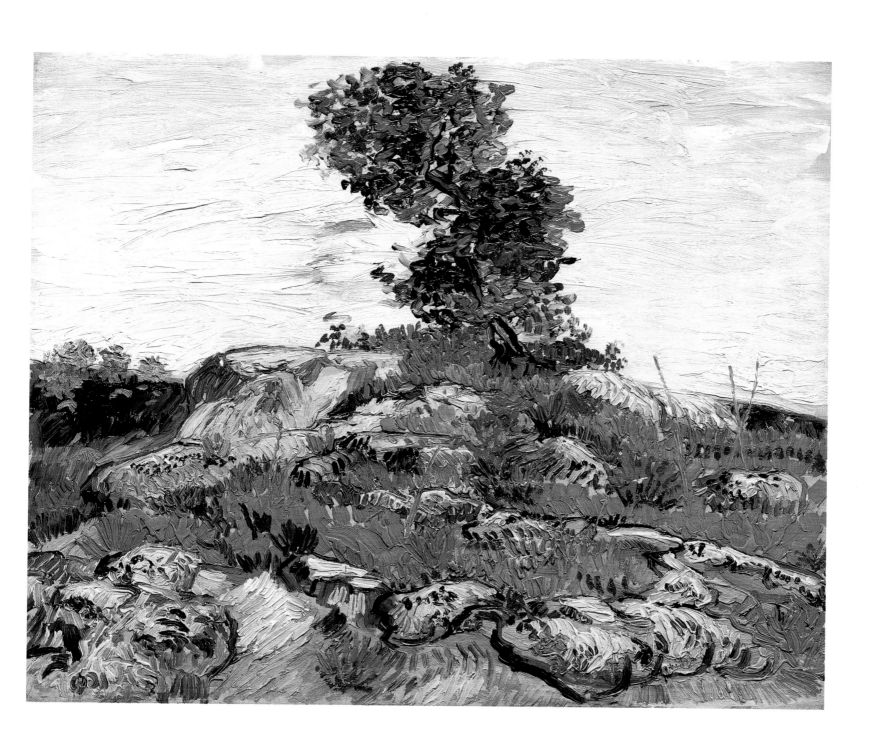

# Jean-Léon Gérôme

French, 1824–1904

## Tiger on the Watch, c. 1888

Oil on canvas, 25 x 35 5/8 in. (63.5 x 90.5 cm)
Gift of the Houston Art League, the George
M. Dickson Bequest
AL.21

Jean-Léon Gérôme was among the great professional artists of the late nineteenth century. He received a traditional academic training in the studios of Paul Delaroche (1797–1856) and Charles Gleyre (1808–1874), attended the Ecole des Beaux-Arts, and competed for the prestigious Prix de Rome. He was institutionally rewarded, appointed one of three professors at the Ecole des Beaux-Arts in 1863, and awarded officer of the Legion of Honor in 1867. Strikingly handsome and well dressed, Gérôme was invited to the most fashionable salons, including that of Princess Mathilde Bonaparte, whose guests included Berlioz, Brahms, Rossini, George Sand, and Turgenev. He was also welcome at the imperial court and counted among his closest friends the Comte de Nieuwerkerke, the superintendent of the arts appointed by Napoleon III. Gérôme was extremely successful in the art market with an international reputation that was virtually unrivaled. His dealer, the powerful Adolphe Goupil, made him rich and famous, selling not only his paintings but reproductive photogravures of his paintings (in 1888 an edition of one hundred prints of Gérôme paintings was disseminated throughout America). In 1863 Gérôme entered Goupil's family, marrying his daughter Marie.

Gérôme's painting style could also be called "professional." He fulfilled commissions from major figures within the French governmental, social, and economic establishment who expected paintings done in the grand manner of the great tradition of French painting, à la David and Ingres. Perfectly drawn and carefully composed, his paintings benefited from endless preparatory drawings. Paint was applied in thin layers with small, invisible strokes, enabling an extreme accuracy of detail and a highly polished finish. Above all, Gérôme's pictures were considered tasteful—products of a well-trained hand and a liberally educated mind.

Gérôme's reputation, however, has not fared well in the century since his death. With the advent of modernist painting toward the end of the nineteenth century, and

with it a new heroic myth of the artist as an impoverished outsider struggling against the status quo for recognition, Gérôme became the antihero. He worsened his case in the new court of art history with his reactionary stance against artists like Manet, Monet, and Auguste Rodin (1840–1917). In 1883 he protested the commemorative exhibition of Manet's work at the Ecole des Beaux-Arts, and in 1897 he opposed the extraordinary Caillebotte bequest of Impressionist paintings to the state. In the late 1880s he complained to a friend that the work of the Impressionists was "insipid and badly executed: badly drawn, badly painted, and stupid beyond expression."[1] That Emile Zola picked on Gérôme so tirelessly in his art journalism is hardly surprising.

Though popular among American collectors in the late nineteenth century, in this century Gérôme's paintings have been largely relegated to museum basements—until recently. The last two decades have seen Gérôme's reputation resuscitated with the slow recognition by scholars that the story of Impressionism had eclipsed all others, marginalizing and effacing several artists of quality. Once again, Gérôme's paintings are featured in the permanent collection galleries of museums.[2] Gérôme's great gifts as a painter, his technical virtuosity, broad range of subjects, and above all, his excellent sense of pictorial drama, are recognized anew.

Working toward the end of the centuries-old tradition of history painting, Gérôme often tweaked classical subjects for a titillating effect, or avoided them altogether in favor of subjects with contemporary relevance. His most successful images were scenes from "the Orient" (defined in the nineteenth century as North Africa and the Middle East). After an extensive trip to Egypt in 1856, he became an avid traveler, journeying to Turkey, Palestine, Greece, Spain, Algiers, and Italy. His pictures of Arab religious sites, harems and bathhouses, exotic animals, landscapes and monuments display considerable erudition and ethnographic skill. Gérôme was the darling of the Orientalist

1. Hering 1892, 259; quoted in Ackerman 1986, 128.
2. In France, where his name had taken a far greater beating than in the United States, his reputation was reinstated with a retrospective exhibition only in 1981. See Musée Garret 1981.
3. Ackerman 1986, 106.

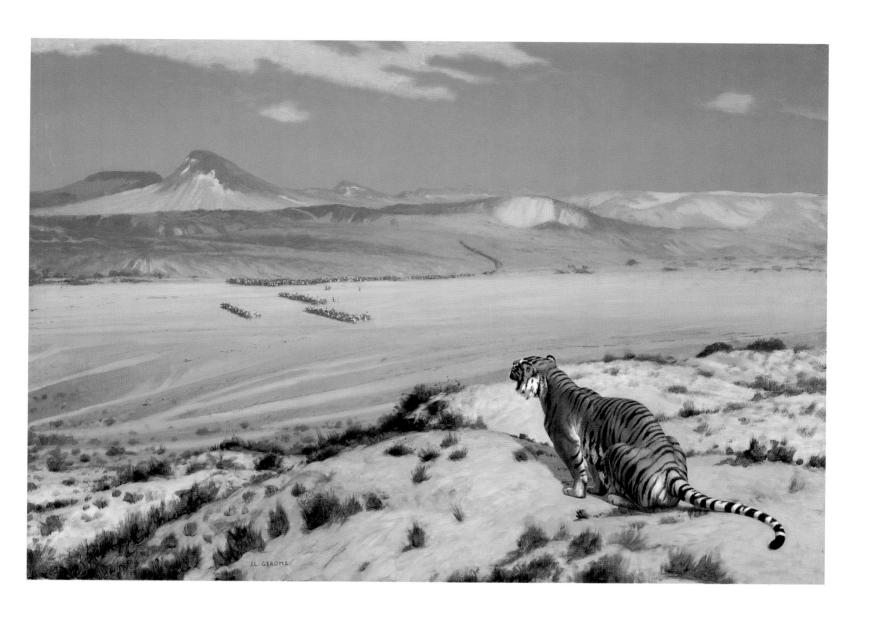

painters, fueling a Western imagination already piqued by the Greek Wars of Independence, French colonialism, the opening of the Suez Canal, and the rise of tourism.

*Tiger on the Watch* incorporates two very popular genres; it is both a scene of the exotic Orient and an animal painting. In the late 1870s sculptures of animals became highly desirable on the art market, and perhaps in part responding to this demand, Gérôme began a series of pictures of lions, tigers, and leopards.[3] He often depicted these lithe, powerful animals in dramatic or anecdotal situations. The museum's *Tiger on the Watch* belongs to the same family of paintings that

includes *The Two Monarchs,* 1883 (Milwaukee Art Center), a highly popular image of a great lion standing alone on a rock above a desert watching the sun set. In the museum's painting, a magnificent crouching tiger silently watches a caravan advance across the desert valley below. Intimations of impending danger emanate from this carefully conceived, seamlessly painted composition, made more dramatic by the spectator's shared vantage point with this beast of prey. We are made to feel, in an almost cinematic way, the presence of this "primitive," decidedly non-Western scene.

# Georges Seurat

French, 1859–1891

## Young Woman Powdering Herself, 1889

Oil on panel, 9 3/4 x 6 5/16 in. (24.8 x 16 cm)
Gift of Audrey Jones Beck
98.301

By the eighth and final Impressionist exhibition in 1886, the cohesiveness of the group of Impressionist painters began to disintegrate. With Pissarro's support, a young band of artists rallying around the so-called scientific theories and techniques of the painter Georges Seurat was invited to participate in the exhibition. Believing themselves to be the artistic descendants of the Impressionists, they called themselves the Neo-Impressionists. Seurat and those he inspired, among them Pissarro and his son Lucien (1863–1944), Paul Signac, and Théo Van Rysselberghe, strove for an art that was more solid, durable, even classic, than the sketchy "impressions" painted by Monet and Renoir.

This conservative attitude was grounded in Seurat's artistic personality. He had been trained in the traditional arts educational system, enrolling in the Ecole des Beaux-Arts and studying in the studio of Henri Lehmann (1814–1882), a student of the arch-academic J. A. D. Ingres. Lehmann taught the classical style of painting, focusing on composition, accurate line drawing, and clear contours. Seurat was attracted to such discipline. Though clearly excited by the bright palette and contemporary subject matter of Impressionist paintings, he craved a similar discipline in his own art.

Like so many ambitious, reform-oriented minds of the nineteenth century, Seurat claimed science as his ideological model, adopting the scientific values of controlled experimentation and systematic rigor. From the writings of optical scientists like Ogden Rood and Eugène Chevreul, Seurat created a theory of color application known as pointillism. According to the theory, which aimed at coloristic purity and intense luminosity, the painter could avoid muddy mixtures of pigment and create a more lively optical effect by carefully placing dots of pure pigment on the canvas and allowing them to mix in the viewer's eye. To the thrill of many young artists and critics, Seurat's paintings—enlisting the Impressionist palette—created images that positively vibrated.

It is perhaps surprising that despite Seurat's predilection for order, and despite his intent replacement of the spontaneous Impressionist dash with the uniform and regular "dot," his paintings are so lively in both content and form. *Young Woman Powdering Herself,* a study for a larger painting now at the Courtauld Institute Gallery of Art in London, is composed of hundreds of tiny dots that, with some distance, evoke a tightly constructed glowing vision of a woman at her toilette. The composition is organized by a series of subtly rhyming curves, in the folds in the woman's skirt, her bent arms, her shoulders and head. At close view the points of color are seen to cluster and follow contours like currents of energy. The woman, frozen in time as she gazes at herself in the mirror, powder puff suspended in the air, appears dignified and serene, almost iconic.

The painting is a portrait of Madeleine Knobloch, an artists' model who became

Georges Seurat, *Young Woman Powdering Herself,* 1889. Oil on canvas, 37 5/8 x 31 1/4 in. (95.5 x 79.5 cm). Courtauld Institute Gallery of Art, London

1. See Sutter 1970, 19–20; Thomson 1985, 193.
2. In general, in addition to Sutter 1970 and Thomson 1985, see the exhibition catalogue for *Seurat,* Grand Palais 1991, and Dorra and Rewald 1959, 246, no. 194.

Seurat's mistress in 1889 (the year the portrait was painted) and bore him a son the following year. Seurat was secretive about their relationship, and the painting may have been intended as a kind of personal ode to their private life together.[1] The image also participates in a genre of painting popularized during the eighteenth century in which women were depicted applying their makeup, a genre that functioned as both a moralizing commentary on vanity and as voyeuristic erotica.

Seurat exhibited the larger version of *Young Woman Powdering Herself* at the Salon des Indépendents in 1890, a descendant of the Impressionist exhibitions showing avant-garde art. One year later Seurat suddenly died from a fatal virus, cutting short his extremely promising career. In his thirty-one years he had finished some 240 paintings, producing more than enough to inspire such artists of the next century as Henri Matisse and Georges Braque.[2]

# Auguste Renoir

French, 1841–1919

## *Girl Reading,* c. 1890

Oil on canvas, 13 1/4 x 16 1/4 in. (33.7 x 41.3 cm)
Gift of Audrey Jones Beck
98.297

1. See Isaacson 1980.
2. Lawrence Gowing, "Renoir's Sentiment and Sense," in Hayward Gallery 1985, 32.

Auguste Renoir painted the museum's *Girl Reading* some twenty years after his *Still Life with Bouquet* (see pp. 154–55) of 1871. Unlike that ode to Manet's realism, which was a fledgling Impressionist work bearing symbolic reference to Renoir's current models, *Girl Reading* is from a fully mature moment in the artist's career. It is a quintessential painting by the master in its depiction of a lovely young girl reading at leisure in a sumptuously colored interior. It is a work of pure and unabashed pleasure—above all the artist's pleasure in the act of painting.

What some scholars have referred to as the crisis in Impressionism of the mid-1880s, in which several artists of the original Impressionist group broke away to explore stylistic tangents, is exemplified most dramatically by Renoir's defection.[1] In 1878 Renoir stopped exhibiting with the Impressionists and returned to the official fold of the annual Salon. He began to challenge the very essence of the Impressionist project, becoming increasingly uncomfortable with its aura of ephemeral informality and with its emphatic empiricism. Around 1884, in an attempt to bring solidity and precision to his work, he adopted a more linear, classical style inspired by Ingres and Raphael. Gradually he returned to Old Master models of the painterly aesthetic: Titian, Velázquez, and Rubens. Traveling in Europe in the late 1880s and early

1890s to see the great museums of Madrid, Dresden, Amsterdam, and London, Renoir considered his place within the trajectory of art history. Far from the militant *avant-gardiste,* Renoir's artistic temperament was more Romantic and traditionalist than aggressively modernist. In some ways, his aesthetic fits more comfortably within the eighteenth century than at the advent of the twentieth.

Renoir's painting has to do primarily with sensual experience, a fact that the artist in his later years came to admit frankly. His work is anti-intellectual and antinarrative, wholly concerned with visual effect. Among Renoir's favorite painters were Fragonard, Boucher, and Watteau, masters of the Rococo who indulged in gorgeous representations of beautiful people enjoying themselves. These artists created a sense of form and space with the paintbrush rather than the draftsman's pencil, an ability to which Renoir aspired. Lawrence Gowing has articulated the intensely physical, almost sexual nature of Renoir's act of painting: "If the brush defines and records, it is for pleasure, and the shapes it makes, quivering in their pearly veil, discover satisfaction and completeness."[2] There is little place for theory or reflection here, just the touch of the brush's tip, wet with pigment, on the surface of the canvas.

*Girl Reading* is a sensual indulgence, inviting the eye to absorb the rich color

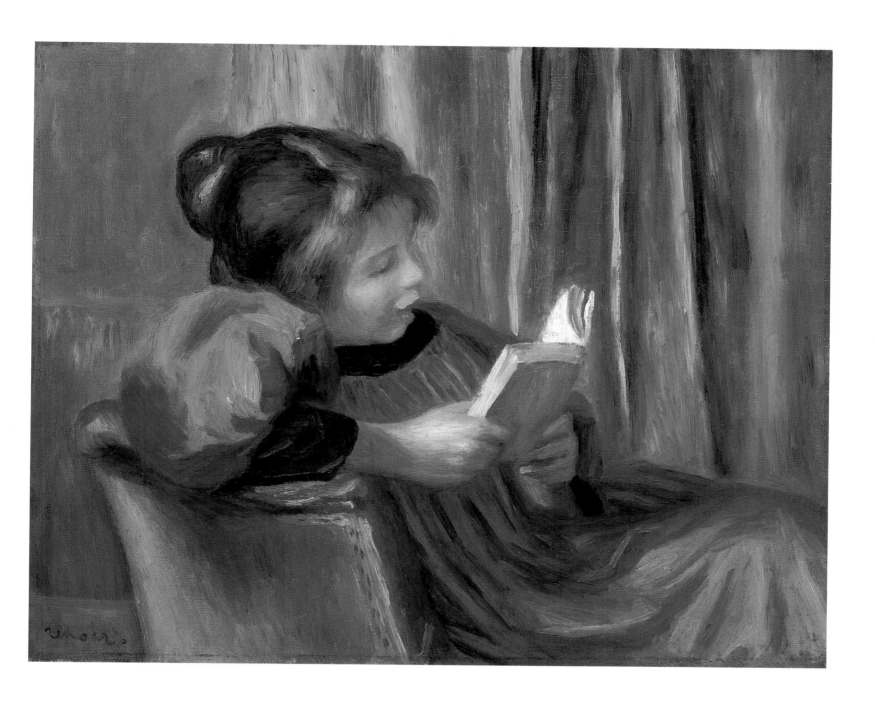

harmonies of warm reds, yellows, golds, and yellow-greens. The background is divided into color panels: the rich warm-gray patch behind the girl's head abuts a section of orange-yellow, which then bleeds into green streaked with vivid yellow vertical lines at the right. Across this varied color field drapes the girl's vivid red dress, trimmed in black, whose folds and light reflections are described in creamy brushstrokes. The girl reads—an in-

tellectual act—but her open mouth (is she reading aloud?) and the book's blank page diminish the sense of cerebral absorption. The space is shallow and the subject is brought close to the viewer, further emphasizing this ravishing painted surface. The painting exudes a warm serenity, one of the key attributes of Renoir's work in general, and one that helped determine his international reputation at the turn of the century.

## Paul Sérusier

French, 1864–1927

*Landscape at Le Pouldu,* 1890

Oil on canvas, 29 1/4 x 36 1/4 in. (74.3 x 92.1 cm)
Gift of Alice C. Simkins in memory of Alice
Nicholson Hanzen
79.255

Paul Sérusier began his career as a devoted disciple of Paul Gauguin. The two painters met in 1888, on the next-to-last day of Sérusier's summer vacation in the Breton village of Pont Aven. With its rustic charm, lovely landscape, and inexpensive living conditions, Pont Aven had become something of an artists' commune, drawing young aspirants from all over Europe and America to paint, discuss art, and carouse together in the warm summer months. Sérusier came from Paris, where he attended the Académie Julian, a privately owned art school where students not enrolled in the Ecole des Beaux-Arts could gather, draw from a live model, and receive informal instruction from Ecole des Beaux-Arts faculty. On the day they met, Gauguin offered Sérusier a painting lesson, taking him out on a riverbank and instructing him in the completion of a small landscape painting. The picture, composed of unmodulated blocks of pure color, was an inspired expression rather than an accurate description of the landscape. The painting, no bigger than a cigar box, became known as *The Talisman.* Sérusier took it back to Paris to show his artist friends, and it became a rallying icon representing the artistic principles to which they would devote themselves. The group, who would call themselves the Nabis (a Hebrew word for "prophets"), included Maurice Denis (1870–1943), Pierre Bonnard, Edouard Vuillard, Félix Vallotton (1865–1925), and Paul Ranson (1864–1909).

Gauguin and Sérusier were attracted to what they felt was the primitivism of Brittany, where the natives lived off the land in harmony with their wild surroundings, and where the culture was profoundly spiritual—

reverently and almost mystically Catholic. In contrast to what they considered the jaded, faithless, artificial culture of urban Paris, Brittany offered a primal paradise, the perfect source of inspiration for a movement that sought to restore spirituality in art. Sérusier, who, in line with current strains of Theosophy,[1] was himself investigating a variety of religions, sought to reconcile his spiritual yearnings with his artistic production, and he believed that Gauguin's art provided the way.

Two years after the debut of *The Talisman,* Sérusier painted *Landscape at Le Pouldu,* about fifteen miles from Pont Aven in the even more rustic fishing village of Le Pouldu on the Atlantic coast. Sérusier spent a couple of weeks there early in the summer of 1890 intently painting alongside his "master," Gauguin.[2] The work depicts a Breton peasant in her native landscape, apparently absorbed in thought. Employing the decorative effects of linear rhythm, expressive color, and repetitive forms, Sérusier aimed to paint a canvas that would impart a sense of harmony, purity, and mystery. The organization of *Landscape at Le Pouldu* is defined by a lively design of tree trunks and branches, shadow shapes and rocks. As if blooming out of the thoughtful head of the female figure, a mysterious form grows at the center of the canvas—the arabesques of roots (or some kind of masonry?) keeping rhythm with the rest of the design. That the painting is not completely decipherable creates a sense of immateriality and the suggestion of an unnamable presence. The work fulfills the Nabis credo of producing art that, while basically naturalistic, also provokes the more abstract effects of visual pleasure and spiritual resonance.

1. Theosophy was a turn of the century quasi-religion associated with Madame Blavatsky and her Theosophical Society, founded in 1875. It was characterized by the belief that the universe was suffused and ordered by the essence of God, and that God was universal, not strictly Christian.
2. Boyle-Turner 1995, 57. See also Boyle-Turner 1983.

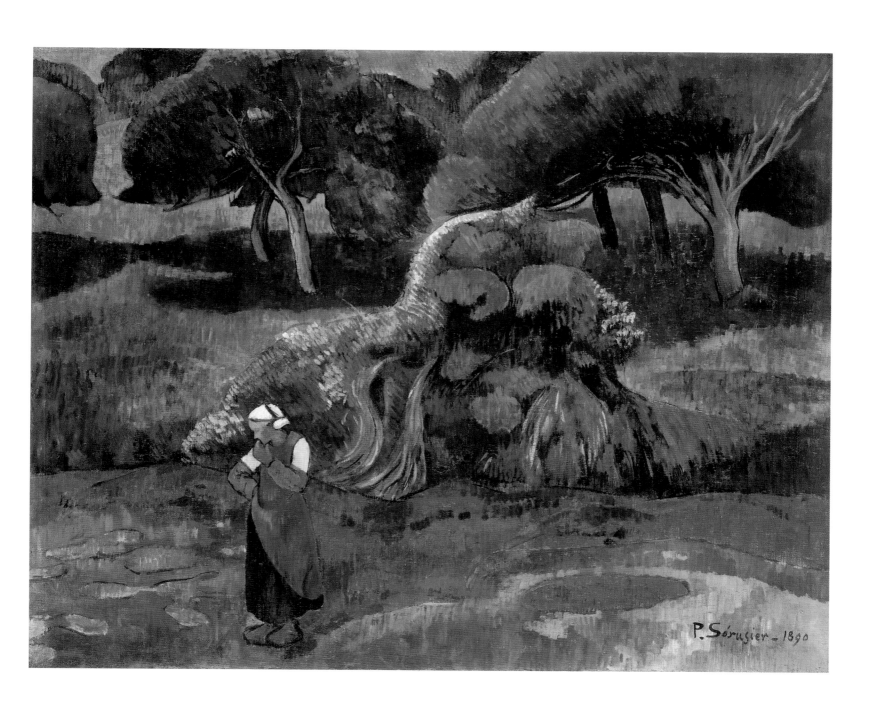

## Paul Gauguin
French, 1848–1903

### *Arearea (Joyfulness) II,* c. 1892

Watercolor on canvas, 11 1/4 x 23 in. (28.6 x 58.4 cm)
Gift of Audrey Jones Beck
77.372

This delicate fan is based on a painting completed during Paul Gauguin's first sojourn in Tahiti. (The original painting, *Arearea I,* now hangs in the Musée d'Orsay, Paris.) Gauguin had spent several years moving between the artistic center of Paris and the rustic villages of Brittany. In 1888 in the Breton village of Pont Aven, he painted his early masterpiece, *Vision after the Sermon (Jacob Wrestling with the Angel)* (National Gallery of Scotland, Edinburgh), which, in its depiction of rural peasants deeply absorbed in spiritual contemplation, and in its strikingly reductive design, so inspired the fledgling group of painters who would later call themselves the Nabis. Gauguin was drawn to what he referred to as the Bretons' "savagery," so different from the hypercivilized modern culture of urban Paris. By the early 1890s, however, he yearned for a culture of even greater difference. Inspired in part by the South Pacific exhibits at the Paris World's Fair of 1889, which showcased not only the latest in technology and industry, but also recent anthropological discoveries, Gauguin began to dream of the "exotic paradise" of Tahiti. Scraping together his meager funds, he embarked for the South Pacific alone, determined to find his true artistic and spiritual self and to live out his remaining years in non-Western exile. As he put it on the eve of his first Tahitian journey, "far from the European struggle for money, there in Tahiti I will be able to listen in the silence of beautiful tropical nights to the soft murmuring music of my heartbeats in loving harmony with the mysterious beings who surround me." [1]

*Arearea,* which means "joyfulness" in Maori, documents Gauguin's fascination with Polynesian rituals and religious mythology. Two young female natives sit on a grassy mound in the foreground, one intently playing the flute, the other lost in musical reverie, or perhaps (as in *Vision after the Sermon*) dreaming the scene depicted in the background. Across the fantastic stream that glows with molten multicolors, three half-naked women enact a ceremony of worship, paying homage to the large stone icon of the Maori goddess Hina. The picture is composed of Gauguin's characteristic flat planes of color, arranged into an engaging decorative pattern. In the simplicity of its design and the brightness of its colors, the painting is intended to convey the intuitive connection with nature that Gauguin found in Tahitian culture. The art critic Achille Delaroche, with whom Gauguin felt a particular sympathy, described *Arearea:* "There stands, in legendary landscapes, the idol, hieratic and formidable; and the vegetation's tribute flows forth in lavas of colors onto its brow, and idyllic children sing on the pastoral flute the infinite happiness of Edens." [2] This kind of utopic yearning can be heard in Gauguin's published account of his life in Tahiti, entitled *Noa Noa,* which defines the perceived moral, physical, and spiritual corruption of Christian Europe in opposition to the pure innocence and truthful nature of Tahiti.

Gauguin's adaptation of *Arearea* into the form of a fan was an extension of his appreciation for and experimentation in the decorative arts. Gauguin felt that art should serve practical life, and the beautiful and the useful should be contiguous, as they were in Tahitian culture. However, he also painted fans because they were, according to his Parisian dealer Durand-Ruel, more saleable. [3] Decorative fans were popular collector's items inspired by the contemporary revival of eighteenth-century minor arts and by the vogue for things Japanese. Several of the Impressionists had painted fans for Durand-Ruel, including Pissarro and Degas. Gauguin painted the museum's fan in Paris during a campaign to raise money for his return to Tahiti. Sadly, Gauguin never completely succeeded in liberating himself from the same money-based Western culture that he so despised. His failure in the art market, despite consistent efforts, and his resulting destitution played a sure role in his tragic end, death by suicide, alone in "paradise."

1. Prather and Stuckey 1988, 210.
2. Ibid., 229. Gauguin carefully kept this review and later called Delaroche the only one who understood his work.
3. Gauguin painted some thirty fans during his career, most of which, like *Arearea II,* were done after larger oil paintings; see ibid., 39. Also see Zingg 1996, 12.

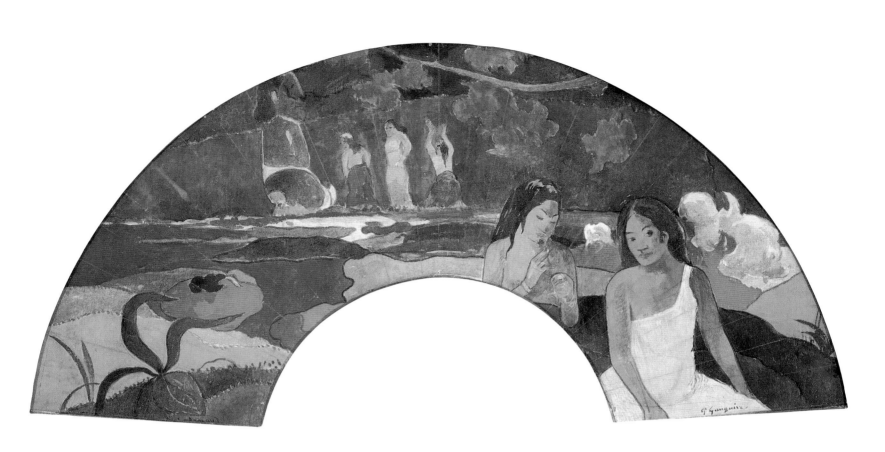

# Paul Signac

French, 1863–1935

## The Bonaventure Pine, 1893

Oil on canvas, 25 7/8 x 31 7/8 in. (65.7 x 81 cm)
Gift of Audrey Jones Beck
74.142

Paul Signac met Georges Seurat at a gathering of the Société des Artistes Indépendents in 1884. Signac was impressed by Seurat's intensity and intelligence and by his ambition to take the art of painting in a new direction. Impressionism, the prevailing avant-garde movement during the 1870s and early 1880s, was thought to have run its course, a belief that was all but confirmed by the final Impressionist exhibition in 1886. Absent of works by the seminal Impressionists Monet and Renoir, that exhibition was dominated by Seurat, Signac, and their cohorts in what they called "Neo-" or "new" Impressionism. While Seurat became the new style's major protagonist, Signac became its most forceful theoretician.

Armed with a classical liberal arts education, Signac articulated what he considered to be the major tenets of Neo-Impressionism in a book titled *D'Eugène Delacroix au néo-impressionnisme* of 1899. This book, which in its careful order reads like a scientific treatise, traces Neo-Impressionism's roots to the great Romantic painter Eugène Delacroix's development of the expressive potential of color and his comprehension of color's laws of contrast and complement. According to Signac, the Impressionists vastly enriched the impact of color by applying only the pure colors of the spectrum to their canvases, avoiding the tempering hues of earth tones (browns, ochers, sienas). The Neo-Impressionists, the product of this evolutionary chain according to Signac's treatise, built on the innovations of both Delacroix and the Impressionists to construct a "scientific" color theory that Signac labeled "divisionism." Applied in uniform separate touches to a white canvas, dots of pure pigment mix on the viewer's retina (with some distance from the picture's surface) instead of having been previously mixed on the palette. The vibrancy of Impressionist canvases would thus be increased and systematized, bringing order and discipline to a style

of painting that, in Seurat's and Signac's eyes, was too spontaneous and superficial. Employing this controlled method, painters could meticulously define form and establish more exact color contrasts and harmonies.

The application of Signac's theory is exemplified perfectly in *The Bonaventure Pine,* one of the great works dating from his stay in the south of France, where he moved from Paris in 1892. Signac's move to the village of St. Tropez on the Mediterranean was akin to van Gogh's move to Arles and to Gauguin's move to Brittany and later to Tahiti; it was in part a symbolic refutation of the decadence of urban life in favor of a utopic, natural environment. The painter Henri Cross (1856–1910), in a letter urging his friend Signac to move south, described the landscape of his new home in the southern region of Cabasson as "rich in magical and decorative scenes."[1] The marvelously luminous image of *The Bonaventure Pine* records Signac's discovery of just these qualities in the southern landscape. Between 1893 and 1896, he was particularly attracted to the lyrical shapes of large trees in the region, above all to the umbrella pines. Signac vividly captures the majesty of this great pine, while also abstracting it into a decorative structure of interlocking arabesques, which in turn harmonize with the similarly abstracted forms of shadows, clouds, hills, and sailboats in the background. At a distance, the viewer shares Signac's evocation of the pure bright light of the south, as it shimmers off the reflective surfaces of pine foliage, grassy plane, and sea. At close range, Signac's divisionist principles are evident—regularly placed, uniformly shaped dots of pigment swirl and stream, defining contours and areas of light refraction. These touches of green, blue, orange, red, pink, yellow, white, and violet are carefully woven together, coalescing to project an image of magical luminosity.

1. Cachin 1971, 55.

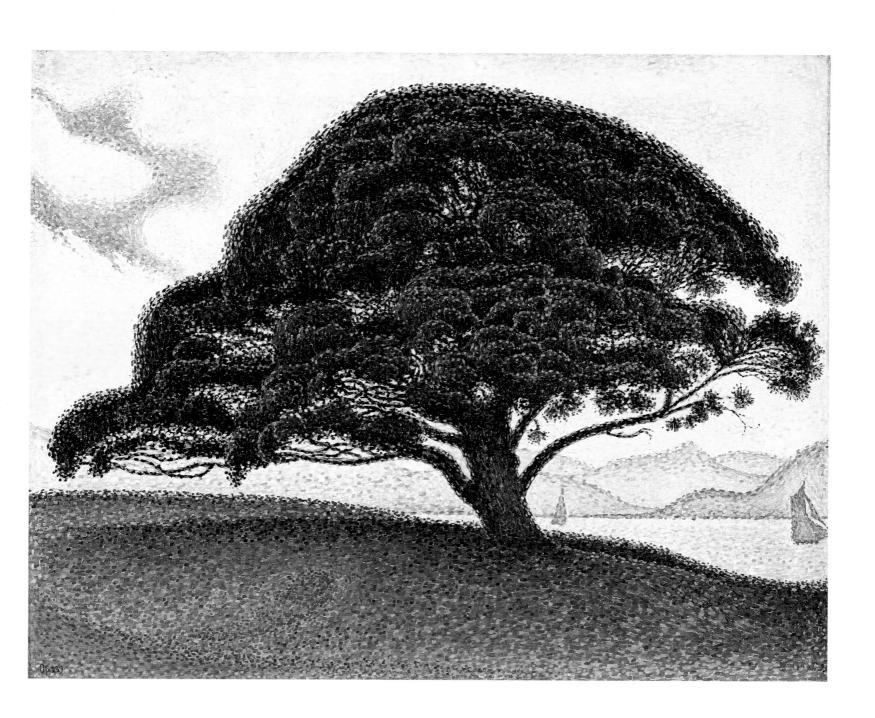

# Edouard Vuillard

French, 1868–1940

## The Promenade, 1894

Distemper on canvas, 84 3/8 x 38 9/16 in.
(214.3 x 97.9 cm)
The Robert Lee Blaffer Memorial Collection,
gift of Mr. and Mrs. Kenneth Dale Owen
53.9

1. Groom 1993, 61.
2. Edouard Vuillard, Journal, MS 5396, carnet 2, 44r:
   16 July 1894; quoted in ibid., 58.
3. For a discussion of the decorative as it relates to
   Vuillard's paintings, see ibid.
4. Ibid., 64. See also Easton 1989, and Thomson 1988.

*The Promenade* is part of a series of paintings completed in 1894 for one of Edouard Vuillard's most successful early decorative projects. It was commissioned by Alexandre and Olga Natanson to decorate the dining room of their new apartment on avenue du Bois de Boulogne in Paris. Along with his brother Thadée, Alexandre Natanson ran *La Revue blanche,* a popular journal among Parisian intellectuals during the 1890s. He was an enormously successful lawyer and investor, and he and his wife frequently hosted members of the cultural and financial elite in their home. Vuillard's decorative paintings debuted at a special soirée in February 1895, for which Henri de Toulouse-Lautrec designed printed invitations and mixed fancy cocktails at an "American bar."[1]

Vuillard's nine painted panels depict casual vignettes of women and children playing and chatting in the lush, sun-filled public gardens of Paris. *The Promenade* portrays three little girls in lace-collared dresses; one holds a toddler, and in the background two fashionably attired women walk with sun hats and parasols. The composition is intentionally flat, free of modeling and organized into colored blocks: the pink, beige, and mauve garden path, green foliage, and powder blue sky. The colors are subdued and highly nuanced, creating sophisticated harmonies. Vuillard employed a unique technique to attain these matte, wallpaperlike finishes, mixing his pigment with warm glue instead of oil. Called *peinture à la colle* (painting with glue), it was a technique he learned from painting backdrops as a set decorator.

Decoration is precisely the realm of art to which Vuillard's painting aspired. "The decorative" in the 1890s was the aesthetic mission of Symbolist and Nabi painters like Bonnard, Denis, and Sérusier. Inspired by the work of Gauguin, these artists turned away from the absolute emphasis on external perception that had dominated avant-garde French painting for two decades, and aspired instead to create an art more expressive of internal orders of meaning and beauty. As Vuillard put it a year before painting *The Promenade,* "the study of exterior perception, filled with painful experiences, is dangerous for my humor and my nerves."[2] The Nabis aimed at decorative effects in painting, privileging the abstract qualities of line and color in place of illusionistic or narrative effects. Instead of the painting-as-window model, in which the represented scene is viewed from a singular fixed point, they offered pictures with cohesive designs and patterns that dispersed visual interest across the entire surface of the canvas.[3]

In addition to wallpaper designs, set decorations, and fresco painting, Vuillard looked to the art of textiles for inspiration in achieving the decorative in painting. He grew up surrounded by textiles in his mother's home, where she conducted her seamstress business (established upon the death of his father when Vuillard was twelve), and his paintings frequently depict highly patterned articles of clothing and upholstered furniture. He also studied the beautiful late medieval tapestries in the Cluny museum in Paris; the influence of these works can be seen in his painted surfaces of regular, overlapping brushstrokes, and in their feltlike, muted palette. Vuillard's decorative panels were not intended to overwhelm the viewer, but rather to provide a pleasant, harmonious background to daily life. Vuillard was supposedly quite delighted to see that, on the evening debut of his panels in the Natanson's dining room, guests busied themselves with conversation and libations, taking little ostensible notice of the décor.[4]

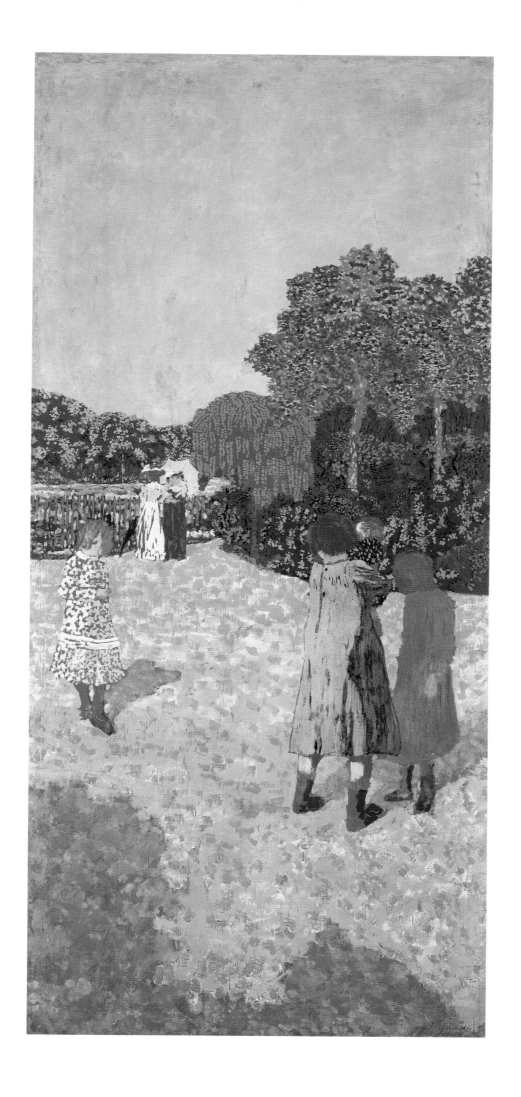

# Théo Van Rysselberghe

Belgian, 1862–1926

## Jeanne Pissarro, 1895

Oil on canvas, 25 3/4 x 21 1/2 in. (65.4 x 54.6 cm)
Gift of Audrey Jones Beck
89.390

Théo Van Rysselberghe painted this portrait during a visit to Camille Pissarro's home in the Norman village of Eragny in 1895. It is one of two portraits by the artist of Pissarro's beloved daughter Jeanne, affectionately referred to in the family as Cocotte. (The other portrait is a more traditional rendering in pastel.) The museum's portrait is in the Neo-Impressionist style developed by Georges Seurat in the mid-1880s, a style passionately embraced by both Van Rysselberghe and Pissarro in the late 1880s. Van Rysselberghe saw the 1886 exhibition of Seurat's masterpiece *A Sunday on La Grande Jatte* (The Art Institute of Chicago), and within a few years he had mastered the "divisionist" technique of juxtaposing individual brushstrokes of pure pigment on the canvas, allowing the colors to mix on the eye as opposed to premixing them on the palette. The vibrancy and luminosity resulting from an effective application of this technique, exemplified by this work as well as the museum's *Young Woman Powdering Herself* by Seurat (pp. 176–77) and *The Bonaventure Pine* by Signac (pp. 184–85), were extremely exciting to many young artists in the last decade of the nineteenth century.

Van Rysselberghe, the principal Neo-Impressionist in Belgium, helped spread the style to the Belgian avant-garde. He was among the founders of Les Vingt, the major avant-garde exhibition group in Brussels, and he served as the group's "talent scout" in Paris. Formed in 1884, Les Vingt was composed of twenty Belgian and Belgian-resident artists who, in addition to sponsoring concerts and lectures, held an annual exhibition in which twenty additional guest artists were invited to participate. In 1887 Van Rysselberghe invited Toulouse-Lautrec to exhibit, having visited the then virtually unknown artist in his studio in Montmartre. Two years later Van Rysselberghe invited Degas, Gauguin, and van Gogh, providing these artists with valuable international exposure.[1] Les Vingt, and the successor exhibition group titled La Libre Esthétique, established Neo-Impressionism and Post-Impressionism as international avant-garde styles.

*Jeanne Pissarro* complements the group of Neo-Impressionist paintings in the museum's Beck Collection, which includes the works mentioned above by Seurat and Signac, as well as works by Henri Cross, Charles Angrand (1854–1926), and Maximilien Luce. This painting is interesting, moreover, in its state of incompletion; it offers a glimpse of the Neo-Impressionist technique in process. Various areas of the canvas reveal the color wash used by the artist to plot out the composition. Van Rysselberghe has built up the image in layers of regular, evenly placed brushstrokes, creating a sense of bright sunlight and shadow through contrasts of pure pigment. Jeanne's hat is painted in large yellow and white strokes, which loosen up considerably in their description of decorative flowers adorning the crown and rim. Beneath the hat is Jeanne's face cast in shadow, where the light is subtler and the face more delicately modeled in smaller, sensitive strokes. Despite the bright colors, the portrait exudes a quiet sense of melancholy. Jeanne wistfully glances over her shoulder, her red lips slightly pouted beneath the arc of her nose. Van Rysselberghe excelled as a portraitist, managing to maintain a personal, human quality in his models despite the systematizing and stylizing tendencies of the divisionist technique.[2] Having mastered Neo-Impressionism in the mid-1890s, Van Rysselberghe would soon move away from the pointillist "dot" to a method more responsive to his capacity for empathy.

1. Sutter 1970, 184–85. See also Herbert 1968.
2. Brooklyn Museum 1980, 145.

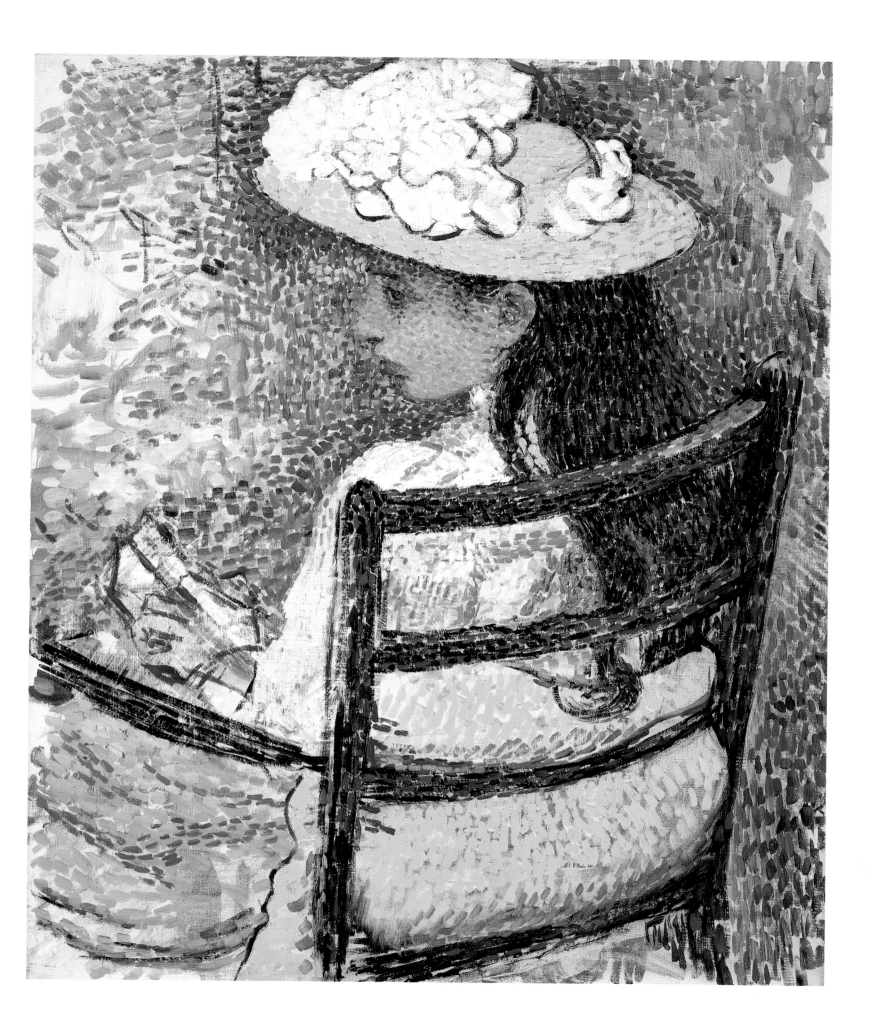

## Edgar Degas

French, 1834–1917

### Russian Dancers, c. 1899

Pastel on tracing paper mounted on cardboard,
24 1/2 x 24 3/4 in. (62.2 x 62.9 cm)
Gift of Audrey Jones Beck
98.278

### The Russian Dancer, 1895

Pastel and charcoal on tracing paper mounted on
cardboard, 25 1/2 x 21 1/2 in. (64.7 x 54.6 cm)
Promised gift of the Sara Lee Corporation

### Woman Drying Herself, c. 1905

Charcoal and pastel on tracing paper mounted by
the artist on wove paper, 31 x 31 in. (78.7 x 78.7 cm)
The Robert Lee Blaffer Memorial Collection,
gift of Sarah Campbell Blaffer
56.21

When Edgar Degas died in 1917 at the age of seventy-three, friends and colleagues in the art world were amazed at the amount of artwork discovered in his studio, particularly the number of works produced during the last decades of his life. It took six separate auctions, in 1918–19, to disperse the accumulated work. Recently scholars have focused on Degas's late career as not only a period of prolific production, but also one of great innovation with portents for twentieth-century modernist painting.[1] Building on an existing oeuvre of artistic achievement, Degas continued his fervent pace of experimentation into the first decade of this century, creating a body of work startling in its linear and coloristic radicalism.

The Beck Collection's *Russian Dancers,* the Sara Lee Corporation's *Russian Dancer,* and the Blaffer Memorial Collection's *Woman Drying Herself* indicate two of Degas's primary obsessions during his late years: depictions of women dancing and bathing, and the artistic medium of pastel. Both dancers and bathers appear in his earlier work, alongside his scenes of cabarets and cafés, brothels and horse races. In the last decades, however, Degas became singularly concerned with the female body, its myriad states of movement and stasis, of nakedness and costume. Degas had always worked in pastel, but after 1895 pastel became his virtually exclusive medium.

Though Degas may have been drawn to pastel later in his life, owing to its practical ease when compared with oil painting and sculpture (it was highly controllable and required minimal preparation and no drying time), he was also attracted to its distinctive physical properties. A committed draftsman, Degas exploited pastel's traditional function as a basic tool of drawing. Pastel is also an enormously flexible medium, allowing corrections and additions with relative ease. In Degas's hands, pastel could achieve coloristic effects of infinite variety and richness. The shimmer and dazzle of his late pastels, brilliantly exemplified by the Beck Collection's *Russian Dancers,* make these works as remarkable as they are irresistible.

In Paris at the turn of the century, Degas was influenced by a vogue for folk art and the exotic, and for Russian culture in particular. He produced a series of pastels and drawings of Russian folk dancers, whom he may have seen performing in the nightclubs of his Montmartre neighborhood.[2] The *Russian Dancers* series is an extension of Degas's lifelong fascination with public entertainment: cabaret singers, orchestra musicians, and, of course, ballerinas. He was clearly attracted to the dancers' vibrant costumes, multicolored skirts and aprons, red boots, flashing beads, and flower-garlanded heads. He also seems to have been mesmerized by their odd yet rhythmically graceful movements, as they kick, bend, and twist, raising bent elbows into the air, all in choreographed unison.

Degas repeated particular dance movements across several pastels and drawings in the series, as can be seen by comparing the Beck with the Sara Lee pastel.[3] He frequently drew on tracing paper in charcoal, transferring posed figures from paper to paper and working them into different groupings and backgrounds. The serial imagery of Degas's late work is a fascinating topic in itself.[4] Degas utilized tracing paper as no artist previously had, pushing the material beyond its preparatory function to serve as the final support for finished work. His serially traced poses became formative motifs from which the artist produced endlessly inventive variations. Degas explained his serial imagery as follows: "It is essential to do the same subject over again, ten times, a hundred times. Nothing in art must seem to be chance, not even movement."[5]

In addition to enabling infinite replication of motifs, tracing paper served Degas as a uniquely potent surface for pastel. Tracing paper is stronger and more durable than other papers, better suited to withstand Degas's exhaustive corrections. The paper's smoothness allowed his crayon to flow freely across the surface. With the help of fixative, Degas superimposed layers of pastel patches and marks, building up a powdery pigmented surface of shimmering translucence.

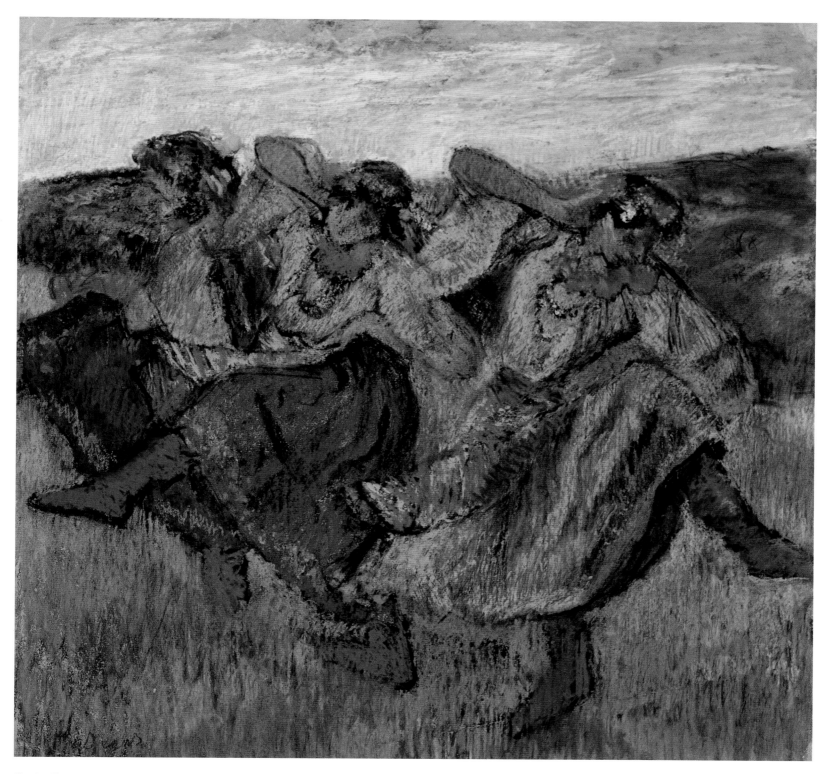

*Russian Dancers,* c. 1899

The flaming reds and oranges, pinks and purples, and blues and greens with which Degas electrified his late pastels are unthinkable in any other medium. Berthe Morisot's daughter Julie Manet recorded in her journal Degas's showing her the Beck Collection's *Russian Dancers* in 1899:

> M. Degas was as solicitous as a lover. He

> *talked about painting, then suddenly said to us: "I am going to show you the orgy of color I am making at the moment," and then he took us up to his studio. . . . He pulled out three pastels of women in Russian costumes . . . in the third [Houston's] the sky is clear, the sun has just disappeared behind the hill, and the dancers stand out in a kind of half-light. The quality of the whites against the*

1. Kendall 1996.
2. Ibid., 278. Pastels most resembling the Houston *Russian Dancers* are in the Metropolitan Museum of Art, New York; the Lewyt Collection, New York; and in private collections.
3. Brettell 1997, 50–51.
4. See, for instance, Richard Kendall's discussion, Kendall 1996, 77.
5. Guerin 1947, 117; quoted in Kendall 1996, 81.

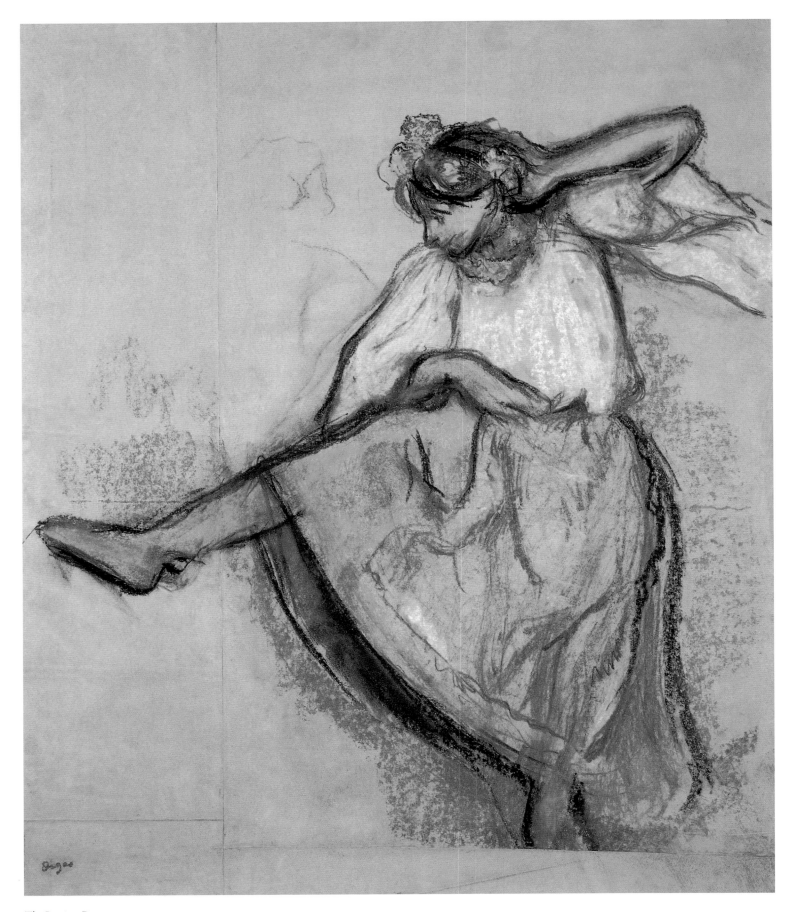

*The Russian Dancer*, 1895

*Woman Drying Herself,* c. 1905

6. Manet 1979, 238 (entry for 1 July 1899); quoted in Boggs 1988, 581. In conversation with the author, Richard Brettell has expressed his opinion that Julie Manet was referring to the Beck Collection *Russian Dancers* as the third pastel shown to her.

7. See, in particular, the more worked, richly colored pastel, *Woman at Her Toilet,* 1903–5 (The Art Institute of Chicago); Shapiro 1982, 15.

*sky is marvelous, the effect so true. This last picture is perhaps the most beautiful of the three, the most engaging, completely over-whelming."*[6]

*Woman Drying Herself* is a more subdued pastel, almost ascetic in comparison to the flamboyant expressiveness of *Russian Dancers.* It also is done on tracing paper and features one of Degas's favorite bather motifs: a woman seen from behind, bending over as she dries her hair. Degas found this routine gesture intriguing, and he produced a large extended family of related compositions in which the pose appears again and again, slightly altered, all alone or with others.[7] Like so many of Degas's nude and seminude bathers, *Woman Drying Herself* is arresting in

8. Quoted in Dunlop 1979, 188.

its unabashed analysis of such a mundane, yet eminently private moment. This woman is utterly unselfconscious and goes about her business with a graceful vigor. The contours of her body, drawn in heavy charcoal lines smeared with signs of reconsideration, compose a vivid form, both convincing and dramatic. The eerily anthropomorphic form of the towel hanging at the left of the composition defines the interior with remarkable economy.

Degas's bathers are highly unconventional within their art-historical context; they participate in a genre of representation dominated by classicized and eroticized depictions of naked females. Salon painting and avant-garde art, as well as popular illustrations, de-

picted the female nude for voyeuristic pleasure, to symbolize an idea, or as an element within a larger formal composition. Degas's bathers are stripped of their "airs and affectations," as Degas put it: "My women are simple, straightforward women, concerned with nothing beyond their physical existence."[8] Like so much of Degas's art, this work penetrates the façade of self-conscious self-presentation (perhaps the primary female preoccupation in late-nineteenth-century bourgeois culture), in order to get at something more "real," more intimate and "truthful." Degas's radical insight, combined with his relentless technical innovation, produced a stream of late works that were nothing short of revolutionary.

## Henri Rousseau

French, 1844–1910

### The Eiffel Tower, c. 1898

Oil on canvas, 20 5/8 x 30 3/8 in. (52.4 x 77.2 cm)
Gift of Audrey Jones Beck
98.299

Henri Rousseau was among the first painters to depict the Eiffel Tower, that icon of modernity and technological progress. One year after its completion and debut at the Paris World's Fair of 1889, Rousseau incorporated an image of the tower into a major painting, a self-portrait and personal artistic statement titled *Myself, Portrait-Landscape* (Národní Galerie, Prague). The tower was hardly a popular motif among those in the artistic and cultural elite, and there were plenty of complaints about the "odious column of bolted ironwork," the "vertiginously ridiculous Tower" that, it was felt, blighted the Gothic grace of the Parisian skyline.[1] Among the general public, however, the modern wonder was wildly popular, and tourists streamed into the French capital to see it and take advantage of the magnificent views afforded by its observation deck.

In the museum's painting, Rousseau places the tower at the center of the composition—at the perspectival point of convergence. A symbol of engineered precision and symmetry, the tower anchors the river and its plunging embankments, the line of trees, cloud

cover, and horizontal bridge. To the right stand three factory chimneys, adding to the painting's résumé of industrial modernity. The work offers a view that does not actually exist (nowhere does the Seine line up with the Eiffel Tower in such a way). As he often did, Rousseau altered reality in this painting to conform to his expressive needs. For in spite of his enthusiasm for the kind of scientific rationalism that the Eiffel Tower represented at the time, Rousseau worked in a deliberately "naive" artistic idiom.

Rousseau is the archetype of the self-taught artist. He received no formal artistic training, painting in his free time from his job with the Paris toll service as a gate operator (hence his nickname, "Le Douanier," the toll collector). He learned by studying the Old Masters in the Louvre, having obtained his permit to make copies of their works in 1884. Early in his painting career he developed a style that was deceptive in its simplicity, conveying a sense of "folksiness." Rousseau consciously maintained "naiveté" in his work as a means of protecting (or creating) its sense of authenticity and innocence.

His work initiated a new category of artistic appreciation, one that implied freedom from the corruption of Western, urban, industrialized civilization. Avoiding the academic conventions upon which serious artists had relied for centuries, Rousseau drew upon intuition and individual perception, which he combined with a formidably disciplined method of execution to create unique images of great charm.[2] Thadée Natanson, co-founder of *La Revue blanche,* described Rousseau's effect in 1897: "Above all mention must be made of Monsieur Henri Rousseau, whose determined naiveté manages to become a style and whose ingenuous and stubborn simplicity, relying solely upon our goodwill, manages to remind us of primitive works."[3]

*The Eiffel Tower* was based on optical observation, but Rousseau imposed upon the subject a carefully constructed composition of horizontals, verticals, and diagonals that,

when combined with the twilight sky and its luminous reflection in the river, offers a dramatic ode to the tower. A whimsical rhythmic relationship is developed throughout the composition as different forms echo one another in threes: the fishermen to the right and the mounds behind them, the factory chimneys, and the boats docked at the left bank. Features of the composition are neatly defined by Rousseau's inconspicuous brushstrokes that, Dora Vallier suggests, "sustain the forms like a kind of internal breathing."[4] His color sense is inimitable; the delicate light blue and pink glazes work in concert to fill the canvas with light. The tight finish; flat, overlapping planes; and chromatic scale are elements of Rousseau's unique style, setting it apart from both official and avant-garde art.

Though his works do not look like anything else being painted in Paris at the time,

1. Thomson 1994, 39.
2. For a definition of naive art, see Cardinal 1996, 439–42.
3. Thadée Natanson, *La Revue blanche,* 15 June, 1897; quoted in Museum of Modern Art 1985, 36.
4. Vallier 1964, 119.

5. For Rousseau's relationship with the Parisian avant-garde, see Roger Shattuck, "Object Lessons for Modern Art," and Michel Hoog, "Rousseau in His Time," in Museum of Modern Art 1985, 11–22, 28–34. For a discussion of Rousseau's modernism, see William Rubin and Carolyn Lanchner, "Henri Rousseau and Modernism," in idem, 35–89.

Rousseau was very much a member of the avant-garde artistic community. He exhibited regularly at the Salon des Indépendents, along with Cézanne, Gauguin, van Gogh, Toulouse-Lautrec, and Seurat. Rousseau shares with these Post-Impressionists a concern for the expression of individual personality in both subject and style and the rejection of official academic artistic conventions. Art critics such as Alfred Jarry and the poet Guillaume Apollinaire championed him early on as a radically modern artist, and he was admired by, among others, Constantin Brancusi (1876–1957), Edgar Degas, Vassily Kandinsky, and Odilon Redon.[5] Pablo Picasso was a good friend and fervent supporter, buying several of Rousseau's paintings and, later in his life, donating some to the Louvre. Rousseau, whose faithful devotion to painting was equaled in intensity by his firm belief in his own artistic excellence, would have expected nothing less.

# Henri de Toulouse-Lautrec

French, 1864–1901

## At the Table of Monsieur and Madame Natanson, 1898

Oil, gouache, and pastel on cardboard, 22 1/2 x 30 3/4 in. (57.2 x 78.1 cm)
Gift of Audrey Jones Beck
98.303

Henri de Toulouse-Lautrec sketched this scene at one of Thadée and Misia Natanson's frequent dinner parties. In Toulouse-Lautrec's composition, Thadée is seated with his back to the viewer. The artist does not exaggerate his host's girth: Thadée was a large man with an enormous appetite, not only for good food, but for art and literature. His expensive tastes, his generosity, and his vitality earned him among friends the nickname "The Magnificent." Thadée was extremely intelligent and knowledgeable, selecting and attracting an extraordinary group of contributors to his journal. Along with Edouard Vuillard and Félix Vallotton, seated in this picture at the left and right, contributors included the poets Stephen Mallarmé and Paul Verlaine, the painter Pierre Bonnard, and, of course, Toulouse-Lautrec himself. At the center of the composition, dominating the table, is Misia, an aristocratic Russian whom Thadée had met and married when she was just fifteen. Misia was fervently admired by the *Revue blanche* coterie. She was beautiful and impetuous, played the piano brilliantly, and ran her famous salons with aplomb.

Toulouse-Lautrec played an active role at Misia's social evenings, occasionally serving as bartender, creating exotic American cocktails. He treasured Misia's company and did many portraits of her in her home and garden at the Natanson vacation house outside Paris. Misia wrote in her diary: "The house at Valvins soon turned into a branch office of *La Revue blanche.* But I was selective and invited only those closest to my own heart. Vuillard and Bonnard had become permanent fixtures; Toulouse-Lautrec used to come every Saturday and stay until Tuesday."[1] Misia and Toulouse-Lautrec spent intimate hours together, reading and chatting in the garden. One biographer suggests that Toulouse-Lautrec was secretly in love with his hostess.[2]

Why, then, would the artist portray Misia so unflatteringly in the museum's picture? In the image, Toulouse-Lautrec has swollen Misia's features so that her physical presence is overbearing. Her expression is sour and shrewish, her heavily painted lips thin and pursed. Her imperious form is capped with an elaborate topknot, the flaming orange-red hair gathered into an absurd construction. Only slightly counterbalanced by the hulking back of her husband who sits across the table, Misia overwhelms the bearded Vuillard to her right and the sullen Vallotton to her left, as they sink down in their chairs, almost blending into the background.

Misia sought to explain this unpleasant portrait in her diary, claiming that Toulouse-Lautrec had portrayed her as a brothel madame out of revenge for her bad behavior while sitting for a earlier portrait.[3] Regardless of the motive in this particular case, within Toulouse-Lautrec's oeuvre this caustic por-

trait, with its subtle references to the demi-monde of prostitution, is hardly out of character. The artist's finely honed skill for social critique is one of the most compelling aspects of his work.

Toulouse-Lautrec's mother and father were notably eccentric, related as first cousins in an aristocratic family. Henri inherited from his parents a cultured, artistic sensibility, a degree of wealth, and a bone disease that left him dwarfed at age sixteen. Perhaps as a result of both his unusual background and his physical condition, Toulouse-Lautrec felt a

certain kinship and comfort among what were considered the marginal members of society—the underclass of prostitutes, beggars, dancers, and artists who inhabited the low-rent area of Montmartre. Though he had received some five years of formal academic training and had mastered the conventions of perspective and volume, in his work he forged an original style more closely related to the so-called low art forms of caricature and commercial graphics. During the height of his career in the 1890s, Toulouse-Lautrec produced unlimited images for magazine and

1. Sert 1952, 47; quoted in Hayward Gallery 1992, 168.
2. Perruchot 1960, 180.
3. Stuckey 1979, 285.

4. Frey 1996, 212–13.
5. Danièle Devynck, "Toulouse-Lautrec: Style and Technique," in Hayward Gallery 1992, 56.
6. Castleman 1985, 11–13.

newspaper illustrations, book illustrations, menus, theater programs, and posters. Much of his imagery was inspired by everyday life in the streets, brothels, and nightclubs of Montmartre. His artistic models included Honoré Daumier, Edgar Degas, and Jean-Louis Forain (1852–1931), whose work he admired for its graphic fluidity and unconventional vision. Like them, Toulouse-Lautrec was something of an iconoclast, stripping away pretensions and capturing hidden emotions with great psychological acuity.[4]

Toulouse-Lautrec's style perfectly served his artistic focus. He was an enormously talented draftsman, and he employed a spontaneous, vivacious line as his primary vehicle of expression. Inspired by the simplified forms; flat, bright colors; and radical compositional principles of Japanese woodblock prints, and by these same Japanese-influenced elements in Degas's work, Toulouse-Lautrec created powerful images of great economy.[5] At the turn of the century, his were among the finest color lithographs produced in Paris.

Like many of his works, *At the Table of Monsieur and Madame Natanson* was painted on cardboard, a porous support that absorbed his thin medium, leaving only the matte pigment on the surface. It is possible that Toulouse-Lautrec's experience with the lithographic process exerted some influence on his paintings. The color of the cardboard is similar to that of a lithographic stone, and the first-time accuracy of drawing required by the stone's surface (revisions are difficult) is evident in this composition on board.[6] Toulouse-Lautrec's posters and prints, as well as paintings like this one, are in many ways responsible for our image of fin-de-siècle Paris. So entrenched was he in the bohemianism and decadence of this culture, that tragically, he did not survive to see much of the new century. In 1901, at the age of thirty-seven, he died of complications from alcoholism.

## André Derain

French, 1880–1954

### The Turning Road, L'Estaque, 1906

Oil on canvas, 51 x 76 3/4 in. (129.5 x 194.9 cm)
Gift of Audrey Jones Beck
74.138

In the summer of 1905, André Derain traveled south to Collioure to paint alongside Matisse, and together the artists developed the essential aspects of a new style. They exhibited their results in the fall, along with their cohort Maurice de Vlaminck (1876–1958), at the Salon d'Automne. The art critic Louis Vauxcelles responded in horror to the utter wildness of their painting, intending derision with his ultimately definitive epithet: "les fauves" or "the wild beasts." Viewers were completely unprepared for their loose, free brushstrokes and high-keyed, saturated colors that often had little relationship to the real visual world. This response was not unwelcomed by Derain, who was by nature a rebellious man. He continued to develop the Fauve style, his hard work culminating in the summer of 1906 with the creation of this monumental landscape.

Though it was productive, the summer of 1906 was a troubled time for Derain. He was plagued by anxiety and confusion over his artistic future and torn by competing ideals. Naturalism, or the direct translation of objective reality, was becoming increasingly constraining, limiting rather than expanding his aesthetic possibilities. He wrote: "All in all, I see no future except in composition, because in work done from nature I am the slave of things so stupid that my feeling recoils from them."[1] Derain's freedom from the expressive constraints of the objective world is celebrated in his masterpiece, *The Turning Road*. Though inspired by a particular motif in the village of L'Estaque, the painting is highly stylized. It is a fantasy in color, in which reality is overrun by the decorative impulse.

Glowing in flat-patterned shapes or exploding into sprays of broken brushstrokes, color is employed toward expressive rather than descriptive ends. Derain plays primary hues—red, yellow, and blue—and their complements against one another to achieve a color effect of extraordinary intensity. He controls this chromatic effusion with a carefully considered, harmonious composition—the curving road and coiling treetops envelope the choreographed forms of villagers moving to their daily tasks, with tree trunks and branches swaying to the rhythm.

Having been inspired by both Impressionism and Neo-Impressionism, Derain reveals in *The Turning Road* the strong influence of both van Gogh, whose 1901 exhibition at the Bernheim-Jeune gallery in Paris had a pro-found impact on young avant-garde painters, and Gauguin, whose Tahitian paintings of the 1890s were equally exciting. Gauguin and van Gogh's liberation of color for expressive means; their ability to achieve compositional stability while maintaining visual liveliness; and their attraction to remote, rural landscapes untouched by what they deemed the perverting influence of urban modernity affected Derain during the feverish months in which he completed this seminal painting. *The Turning Road* serves as a milestone in a crucial art-historical movement that, though brief, explored the central tenet of modernist painting—that the strength of a picture has more to do with colors employed and the kinds of marks made on the surface of the canvas than with serving as an illusory window on the world.[2]

1. Whitfield 1991, 110.
2. Ibid., 8. See also Freeman 1990, Freeman 1995, and Elderfield 1976.

## Claude Monet

French, 1840–1926

*Water Lilies (Nymphéas),* 1907

Oil on canvas, 36 1/4 x 31 15/16 in. (92.1 x 81.2 cm)
Gift of Mrs. Harry C. Hanszen
68.31

*The Japanese Footbridge, Giverny,*
c. 1922

Oil on canvas, 35 x 36 3/4 in. (88.9 x 93.3 cm)
Gift of Audrey Jones Beck
76.198

Claude Monet bought his home in Giverny in 1890 and, over the next twelve years, developed his property into the now famous flower garden. It was an expensive project, involving several acres and a troupe of six gardeners. Monet's garden paradise was funded by his considerable success as a professional artist—well into his fifties, Monet had more than come into his own. This great lover of flowers, and of natural landscape in general, indulged his aesthetic sensibilities in the construction of the perfect landscape. His own private motif, the garden would serve as his chief subject, with the exception of scenes of London and Venice, from 1900 to his death in 1926. Monet completed some 350 views of his garden at Giverny, producing a body of work that, considering its limited subject matter, is extraordinarily varied in effect.

The museum's *Water Lilies* was completed during Monet's first concerted painting campaign in his garden begun in 1903. He had been painting groups of pictures that shared a single motif since his 1876 series on the Gare St. Lazare and had developed the concept of serial paintings through his *Haystacks, Poplars,* and *Rouen Cathedral* compositions of the 1880s and 1890s. For his first water lily series, as for the paintings of the previous series, Monet began each canvas outside in nature, and then returned to his studio to rework them. The studio work served not only to enhance the original effect, making the impression more sophisticated and more durable, but also to integrate each individual painting into the series as a whole. Painted in 1907, the museum's *Water Lilies* falls late in the series. The thinness of the paint and the sureness with which this radical composition was executed reveal that by the end of the series Monet was growing comfortable with his results.

By May 1909 Monet was satisfied enough with his series to release forty-eight paintings to a public exhibition at the gallery of his art dealer, Durand-Ruel. The show, titled *Les Nymphéas: Séries de paysage d'eau (White Water Lilies: A Series of Water Landscapes),* was an enormous financial, critical, and popular success. Monet, now nearly seventy years old, proved to be a painter still very much in his prime, capable of pushing the limits of landscape painting, and of painting as an art, still further.

Over the decades since their first exhibition, there has been considerable discussion as to what these water lily paintings are "about." Monet was quite consistent in his description of their purpose. His explanation, as it had been since the beginning of his career, was that his paintings strove to capture the essence of nature and to relay to the viewer Monet's own immense pleasure in the contemplation of natural beauty. In an interview with the art critic Roger Marx following his 1909 exhibition, Monet stated: "The richness I achieve comes from nature, the source of my inspiration. Perhaps my originality boils down to my capacity as a hypersensitive receptor, and to the expediency of a shorthand by means of which I project onto a canvas, as if onto a screen, impressions registered on my retina."[1] At the same time, Monet sought to heighten viewers' senses through his decorative effects, and it was during this time that he began to plan in earnest the final masterpiece he had long envisioned: the great water lily canvases that eventually would be installed in the circular gallery of the Musée de l'Orangerie des Tuileries, Paris. In the same interview with Marx, Monet described his dream: "nerves overstrained by work would be relaxed there, following the restful example of the still waters, . . . it would offer an asylum of peaceful meditation at the center of a flowery aquarium."[2]

Some critics were not satisfied with Monet's rather humble account of the aims of his work—surely the profound impact of these grand works went beyond mere transcription or decoration, they felt. Some writers, intrigued by the complex level of illusion, projected philosophical intent on the *Water Lilies* series: these paintings were two-dimensional reproductions (paint on canvas) of two-dimensional surfaces (water) that re-

1. Roger Marx, "Les Nymphéas de M. Claude Monet," *Gazette des Beaux-Arts,* ser. 4, 1 (June 1909): 527–28; quoted in Stuckey 1988, 18.
2. Stuckey 1988, 18.

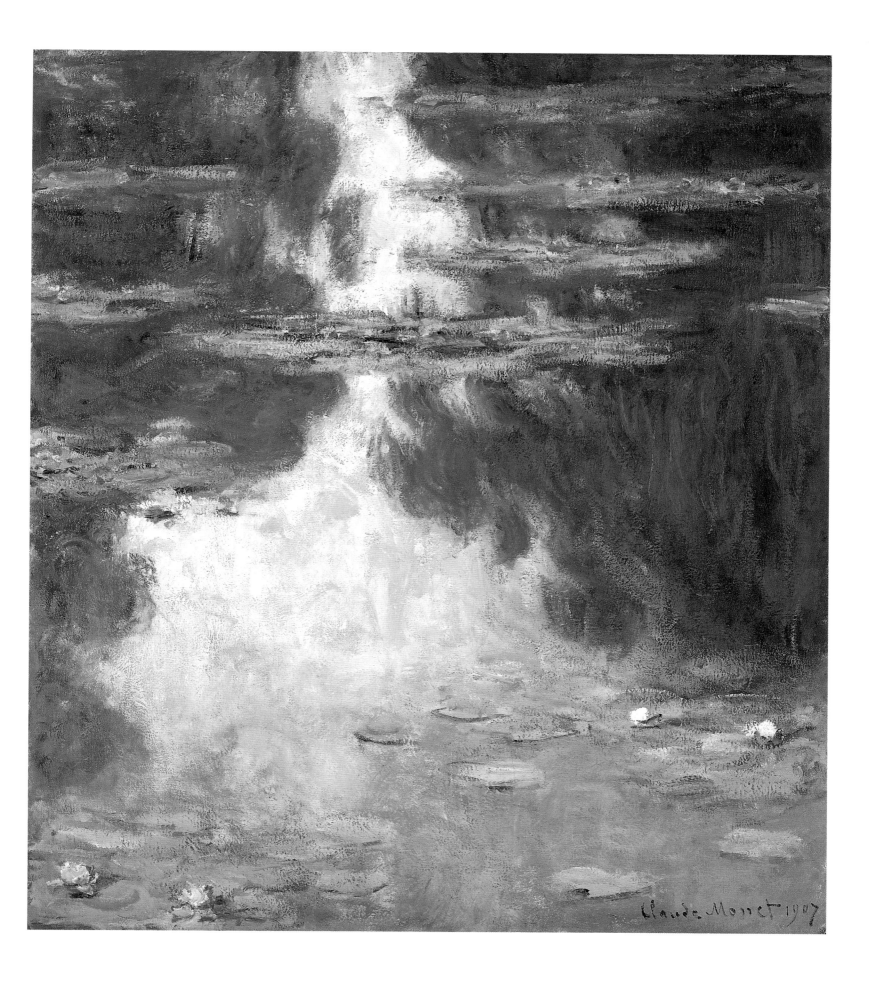

3. Ibid., 17.
4. Ibid., 25.
5. See, for example, Leja 1988, 98–108.

flected the three-dimensional world. Monet's paintings of reflecting water thus suggest Plato's allegory of the cave, which posits the limited capacity of the senses to perceive reality except as illusion.[3]

More recently, critics and art historians have discussed the radical implications of these works within the evolution of painting. Through his *Water Lilies* series, Monet explored the basic tensions of painting—between surface and spatial dimension, flatness and plastic description, brushstrokes and their associations. These works invite at least three forms of contemplation: quick pleasure of the immediate impression; more passive musing, in which the viewer slowly absorbs the subtleties of color harmony and calligraphic stroke; and finally, experiencing the work in relationship with others in the series. In their denial of complete legibility, the water lily paintings are open to a variety of personal responses. They allow the spectator a level of creative participation in the works through a gradual apprehension of the paintings' sophisticated riches.

Clearly, the image of Monet retiring to his gardens at Giverny, spending his days happily among his flowers at pond's edge, leisurely dabbing canvases, is an inaccurate one. The water lily paintings are the result of waves of incessant and obsessive work by an artist who was driven by enormous ambition and whose method was punctuated by violent outbursts of frustration and self-doubt. (Monet periodically burned or slashed paintings that disappointed him.) Though already an officially recognized artist of great accomplishment, Monet refused to live off past glories, and one of the most compelling aspects of his Giverny works is their experimental drive.

Nothing can prepare one, however, for the shocking series of paintings done around 1922 of the garden path from his house, and of the Japanese footbridge. The Beck Collection's *Japanese Footbridge* belongs to this group of some thirty works, painted while Monet was adjusting to cataract surgery. Though the Japanese footbridge is a recycled motif from a series of paintings done in 1900, it is almost unrecognizable in these late works. The paint is heavily and vehemently applied, creating an almost sculptural surface. The tones are simultaneously somber and shrill, striking a nightmarish mood. When Durand-Ruel's son saw the paintings in October 1923, he found them to be "atrocious and violent."[4] Clearly affected by Monet's long suffering vision, and no doubt infused with the anxiety that the artist must have felt at this time, these paintings are nevertheless coherently and confidently orchestrated. Their color chords, though in strident keys at a pitch quite different from Monet's preceding oeuvre, are deeply moving.

Monet refused to exhibit these late works, and they sat in his studio, unsigned and largely ignored by his contemporaries. In the late 1950s, however, during a great revival of interest in Monet's work not only from scholars but from the general public, particular attention was paid to Monet's late works. Stimulated by the radical canvases of the Abstract Expressionist group of painters living in New York immediately after the war (including Jackson Pollock, Clifford Still, Willem de Kooning, Mark Rothko, and Barnett Newman), the art-viewing public was drawn to the "proto-modernism" of paintings like *The Japanese Footbridge*. In the textural richness of their surfaces, the spontaneity of their brushstrokes, and their freedom from descriptive function, Monet's late paintings have proved enormously inspiring to young painters of the twentieth century.[5]

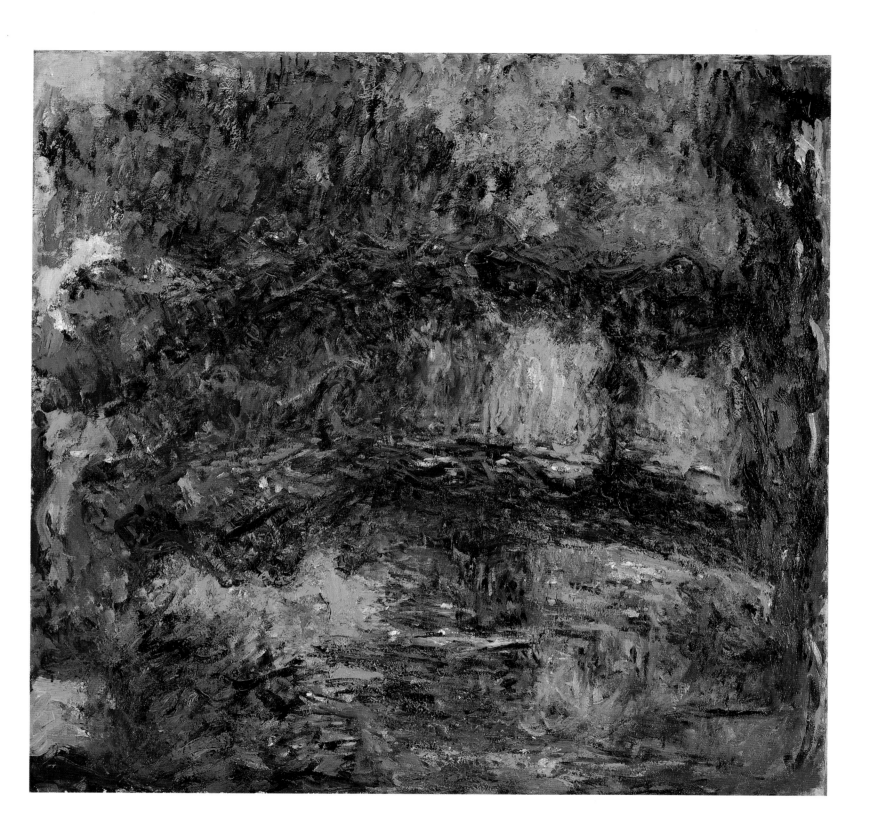

# František Kupka

Czech, 1871–1957

## *The Yellow Scale,* c. 1907

Oil on canvas, 31 x 29 1/4 in. (78.7 x 74.3 cm)
Gift of Audrey Jones Beck
94.247

*The Yellow Scale* is a painted proclamation of František Kupka's belief in the expressive potential of color. It is a highly finished study for Kupka's early masterpiece by the same title, now in the collection of the Musée National d'Art Moderne, Paris. The painting's ostensible function as a portrait seems secondary to the artist's exploration of a wide range of yellows, from pale shades to a deeply saturated orange-tinted hue. Kupka painted this work during a period of intense research in optical science and, in particular, of the principles of color theory. Following on the heels of such "scientific" artists as the Neo-Impressionists Georges Seurat and Paul Signac, Kupka read works like Eugène Chevreul's *De La Loi du contraste simultané des couleurs (On the Law of the Simultaneous Contrast of Colors)* of 1839. The title *The Yellow Scale* (in French, *La Gamme jaune*) may have been directly inspired by the *gammes chromatiques,* the illustrating color scales in Chevreul's treatise. By the turn of the century, the complexity and sheer power of color as an optical effect was a scientifically documented fact to which artists responded with great interest.

Color was the focus in the early-twentieth-century development of abstract painting, a movement in which Kupka was a pioneer. Kupka's anti-naturalism was grounded in metaphysical concerns. Like Vassily Kandinsky (pp. 214–16) and Piet Mondrian (pp. 222–24), he felt that art served a profoundly spiritual, as well as an intellectual and sensual role in life. He grew up in the hilly terrain of Bohemia, in a culture heavily imbued with occult sciences and mysticism. As a young man Kupka explored Eastern religions and Theosophy, and found artistic inspiration in the spiritualist decorative style of the Nazarenes, an early-nineteenth-century German brotherhood of painters inspired by Italian Renaissance art.[1] Studying with the Nazarene artist and Theosophist Karl Diefenbach (1851–1913) in Prague, Kupka forged a conviction in the close relationship between painting and music. In Diefenbach's studio, Kupka and his fellow students were accompanied by a pianist or violinist, a habit Kupka took with him to Paris, replacing the live musician with a phonograph. Kupka saw a correlation between the ability of religious music to provoke spiritual reverie, and the potential of art to project spirituality through form and, above all, through color.

Kupka's early work was narrative, illustrating specific metaphysical and philosophical ideas through figurative images. By 1905 he began to focus on the expressive qualities and decorative value of color, though he maintained a reliance on nature as his foundation, producing portraits and still lifes of great originality. Between 1905 and 1910 he painted a series of self-portraits, challenging himself to simultaneously create a physical likeness while expressing a subjective "resonance."[2] As he wrote a few years later, "the atmosphere of a work is more or less its spiritual factor. Atmosphere in a painting is achieved through bathing the canvas in a single scale of colors. Naturally, this can be a scale of bright yellows, or brilliant reds, as long as there is a chromatic unity. . . . Thus one achieves an 'état d'âme' [state of being] exteriorized in luminous form."[3] *The Yellow Scale,* then, is as much a record of Kupka's physiognomy (his sculpted head and strong nose) as it is of his "state of mind." Indeed, the sense one gets from this portrait is of a man with a powerful intellectual life: the accoutrements of the life of the mind (a state of repose, book in one hand, burning cigarette in the other) underscored by a riveting gaze of intense confidence.

1. For Kupka's early spiritual explorations, see Mladek 1975, 20–26.
2. Kosinski 1997, 67.
3. Quoted in Rowell 1975, 112.

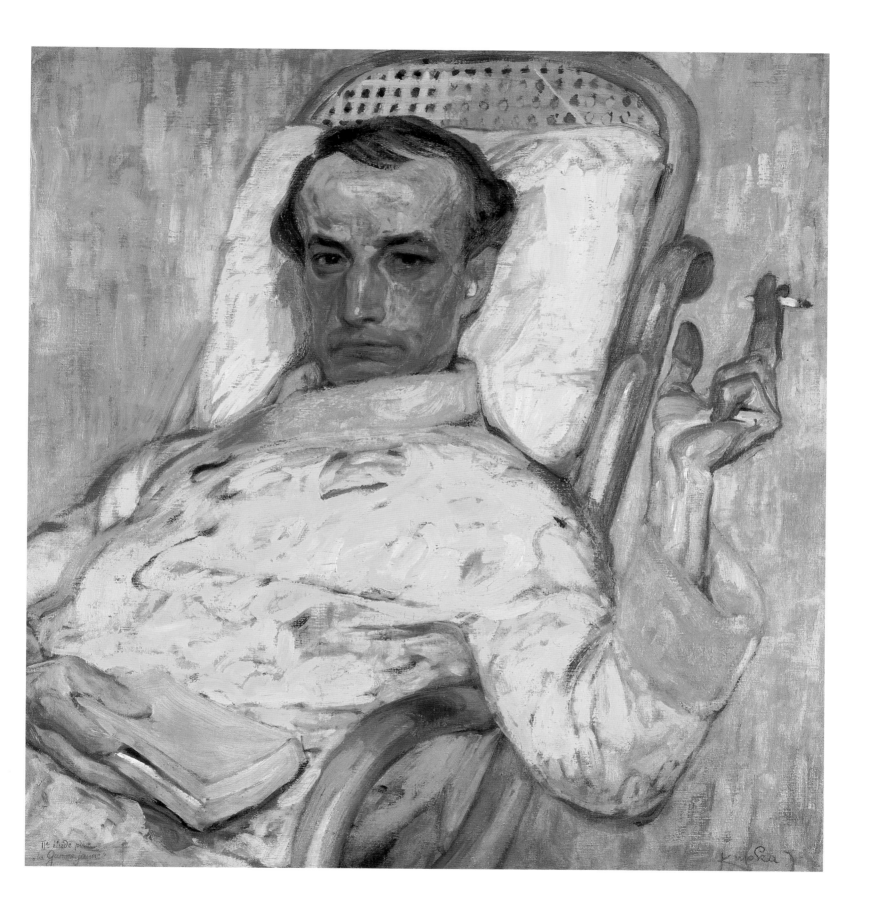

# Georges Braque

French, 1882–1963

## Fishing Boats, 1909

Oil on canvas, 36 1/4 x 28 7/8 in. (92.1 x 73.3 cm)
Gift of Audrey Jones Beck
74.135

Georges Braque, *The Saint Martin Canal,* 1906. Oil on canvas, 19 3/4 x 24 in. (50.2 x 61 cm). The Museum of Fine Arts, Houston, gift of Audrey Jones Beck

1. Quoted in Cooper 1971, 37.
2. Daniel Kahnweiler, recognizing the critical importance of this work, included it in the Third Skupina in 1913 in Prague, one of the most important Cubist exhibitions outside Paris. See Lamac 1988.
3. See, among others, Zurcher 1988, 29–32.

Georges Braque painted *Fishing Boats* during the first years of one of the most famous artistic relationships of our century. Braque met Pablo Picasso in 1907, and over the following seven years, through a profound meeting of minds and artistic will, they forged a revolutionary new way to visualize reality in two dimensions. As Braque put it, the two painters were "roped together like mountain climbers," each individually scaling the face of perceptual possibility, but moving in tandem, tied together at every step.

Writing about Braque's paintings of L'Estaque, which he had seen at Daniel-Henry Kahnweiler's gallery in November 1908, Louis Vauxcelles described Braque's process as reducing "everything, sites, figures and houses to geometric outlines, to cubes."[1] Vauxcelles's repeated references (not entirely complimentary) to the "cubistic" elements of Braque's work evolved into the tag by which this enormously influential movement would be known. However, as with most art-historical labels for movements, "Cubism" does not begin to describe the innovations introduced to Western painting by Picasso and Braque between 1907 and 1914. Cubism emphasized underlying and essential form, and it frequently employed a system of abstracted geometric shapes, but it was equally concerned with surfaces and light. Picasso and Braque liberated the act of painting from the restrictions and limitations of linear perspective that had dominated Western painting since the Renaissance. They experimented with non-naturalistic spatial configurations, which not only acknowledged the two-dimensional nature of the canvas, but involved it in the artistic effect.

*Fishing Boats* was painted in the spring of 1909 and was exhibited at the Salon des Indépendents along with another painting by Braque, a still life that has since been destroyed. Both works drew considerable attention and were among the first truly Cubist paintings.[2] In *Fishing Boats,* Braque denies a conventional sense of spatial recession, eliminating the sky and horizon as well as any single-point perspective. The composition is broken up into a variety of planes that are set at irregular angles but that remain rhythmically interrelated. Simple though unusual shapes, roughly recognizable as boats, masts, walls, and roofs, are faceted and modeled in subdued tones of gray-brown, rust, and white. They flicker in lively tension with the picture plane, alternatively sitting flat on the two-dimensional surface or swelling in descriptive volume. The forms dip and swirl, receding and then lunging out again at the spectator. The sense of wholeness is maintained, however, by the composed cohesion, the simultaneous two-dimensional and three-dimensional integrity, that has little to do with the painting's subject.

In the years preceding his Cubist departure, Braque had worked in the wildly colorful style of the Fauves, led by Henri Matisse and André Derain. Braque's *Saint Martin Canal* of 1906, also in the Beck Collection, is an exemplary Fauvist painting, composed of strong color chords of green and red, purple and orange. Even here, however, one senses the compulsion to adhere to structure that drove Braque beyond Fauvism; the sharply receding *quai* to the left joins the horizontal band of boats and buildings in a solid tectonic joint.

Braque was deeply impressed by the series of exhibitions of Cézanne's paintings that followed his death in 1906. In 1907 and 1908 Braque completed a series of Cézannesque landscapes, painted primarily in L'Estaque (one of Cézanne's painting venues), which show Braque working through Cézanne's radical lessons in the depiction of space and volume on a two-dimensional plane. The artistic lineage of *Fishing Boats* can be clearly traced through these landscapes to Cézanne: the luminous vibration; overlapping, rhythmic planes; and shifting yet solidly constructed space.[3] Later in his life Braque described Cézanne's influence: "The source of everything—contact with Cézanne. It was more than an influence, it was an initiation. Cézanne was the first to break with the eru-

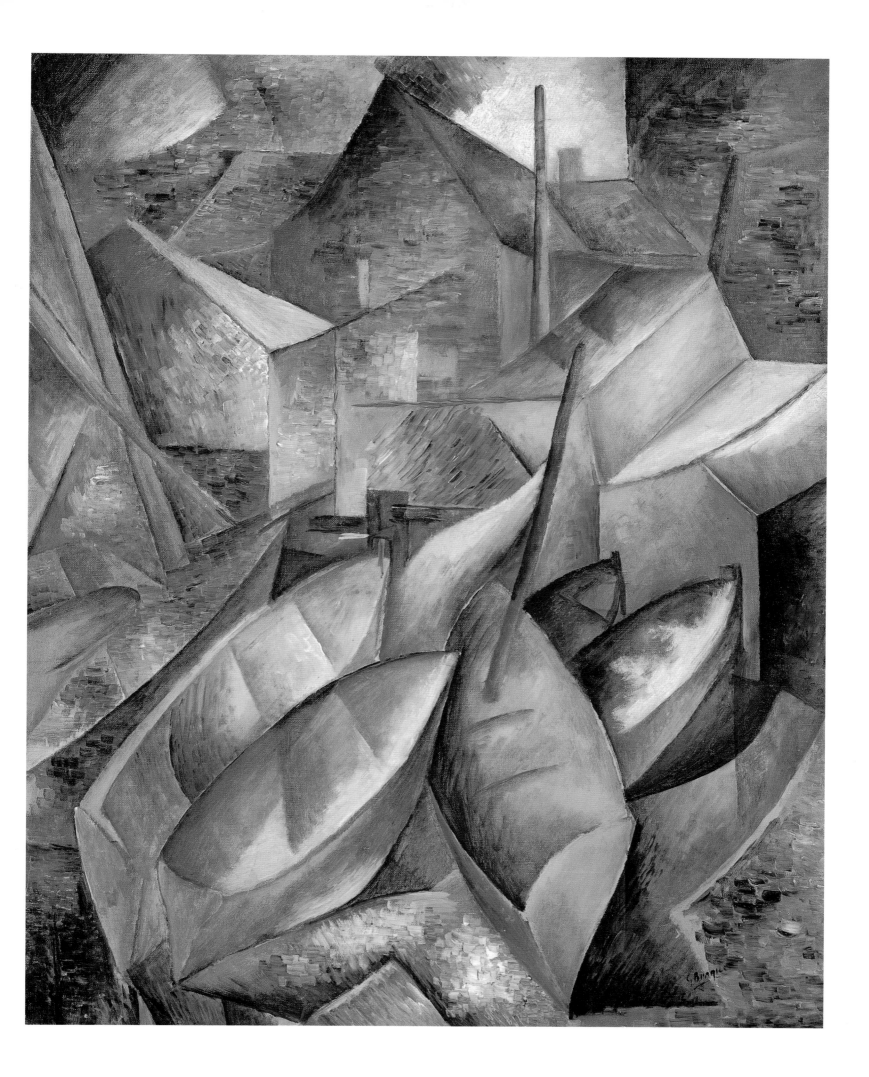

4. Jacques Lassaigne, "Un entretien avec Georges Braque (1961)," *Xxe Siècle* (December 1974): 4; quoted in Wilken 1991, 26.

dite, mechanical perspective that had been practiced by artists for centuries, and that ended up by closing off all possibilities."[4]

Launched by the revolutionary vision of Cézanne, Braque came to the collaboration with Picasso inspired by dreams of a radically new kind of painting. The two met in April 1907 and by the end of the year began seeing each other regularly. *Fishing Boats* is a testament to the high level of practical and conceptual ingenuity that Braque brought to this extraordinary partnership.

## Alexei Jawlensky

Russian (active in Germany), 1864–1941

*Portrait of a Woman,* 1912

Oil on board, 20 7/8 x 19 1/2 in. (53 x 49.5 cm)
Gift of Audrey Jones Beck
98.284

The stylistic lineage of Alexei Jawlensky's vibrant *Portrait of a Woman* can be traced through many of the major innovations in Western painting occurring at the turn of the twentieth century. Jawlensky worked independently as an artist, and though he exhibited with several avant-garde groups, he never officially committed himself to one. He traveled frequently, absorbing and reacting, forging his own artistic agenda. In his best works, *Portrait of a Woman* among them, he employs lessons learned from van Gogh and Gauguin, Matisse and Kandinsky, to create colorfully powerful images expressive of his spiritual life.

Jawlensky was born in Russia and served as a cavalry officer in the army of the czar before moving to Munich in 1896 with his companion from St. Petersburg, the painter Marianne von Werefkin (1860–1938). Munich was known as the Paris of Germany, attracting other ambitious painters like Vassily Kandinsky and hosting important exhibitions of avant-garde art. At the Munich Secession in 1903, Jawlensky was overwhelmed by the work of van Gogh, particularly by the Dutch painter's expressive use of bright color to evoke a spiritual presence. Jawlensky spent the next several years in France, immersing himself in the latest developments in painting. Again, he was drawn to the spiritual resonance of work by artists like Gauguin, Gauguin's follower Sérusier (whom Jawlensky met in 1907), and by the Nabis, who based their practice on Theosophical and mystical concepts. Jawlensky exhibited at the 1905 Salon d'Automne alongside the Fauves and was particularly impressed by the work of Matisse, whose simplified forms and flat areas of color were generating waves of excitement in the art world.

During the summers of 1908 to 1910, Jawlensky painted in the German alpine town of Murnau with Werefkin, Kandinsky, and Kandinsky's companion Gabriele Münter (1877–1962). Werefkin and Kandinsky were well versed in Russian Symbolist literature, and the four painters passionately discussed their idealistic goal of transcending material reality through art.[1] In 1909 they formed the Neue Kunstlervereinigung München (New Artists Association of Munich, or NKVM) as an independent exhibition group apart from both the official art institutions of Munich and from the Munich Secession. The NKVM, with Kandinsky as president and Jawlensky as vice-president, promoted the Symbolist idea of "artistic synthesis." The foreword to their first exhibition catalogue from 1909 reads: "We proceed from the idea that the artist, in addition to the impressions that he receives from the external world, nature, also absorbs experiences from the inner world; and the search for artistic forms which express the mutual interpenetration of these experiences—forms that must be free of nonessentials to emphasize the expression of the essential—in short, the search for an artistic synthesis, appears to us a solution which at present unifies more and more artists."[2]

In 1911 Kandinsky and Münter broke away from the NKVM, contending that it was still too conservative, and along with Paul Klee (1879–1940), August Macke (1887–1914), and Franz Marc (1880–1916), formed the *Blaue Reiter* (Blue Rider) to further promote modernist painting.[3] The following year Jawlensky and Werefkin also split with the NKVM and began contributing to Blue Rider exhibitions, but they did not become official members.

There is much in Jawlensky's evolving aes-

thetic that conforms to the Blue Rider agenda. He shared with Kandinsky and Klee a sensitive palette of luminous tones and rich values indicative of Fauve influence, as well as the conviction that art involved the portrayal of "mystic inner constructions." However, painting was primarily a profoundly private activity for Jawlensky, and he did not share Kandinsky's vision of the social role of the artist. Neither socially nor politically engaged, Jawlensky painted as a means of self-definition and self-revelation. His was a sheltered world of spiritual self-communion, verging occasionally on the ecstatic.

The spring and summer of 1911 brought a turning point for Jawlensky. He abandoned the theatrical, exotic portraits of the previous years in favor of simpler, more intimate, earthbound images. He turned away almost entirely from landscape to the human figure, and the head in particular, as his anchoring motif. As with the Beck Collection's *Portrait of a Woman,* his format became squared, his compositions were simplified, and his palette grew more intense and varied. *Portrait of a Woman* depicts a monumental presence, the woman's head drawn in heavy black lines, her bust filling the entire canvas. The eyes, so

1. Mochon 1991, 15.

2. Ibid., 18. See facsimile page reprinted from the exhibition catalogue at the Galerie Thannhauser, December 1909, in Gullek 1974, 262.

3. See Zweite 1989 for a good overview of the group.

4. Ibid., cat. no. 82.

5. See also Jawlensky 1991, 363, 376, no. 470.

often the dramatic center of Jawlensky's portraits, are drawn in pure velvet black, but they avoid the penetrating gaze of other portraits in the series. There is a sense of vivid introspection to this deeply flushed woman, a sense heightened by the lurid red paint brushed loosely into the background, vibrating around her head. The garish, unreal colors, exceeding even the "wildness" of the Fauves, are held in check only by the solid structure of black lines.[4] In this painting, Jawlensky has gone beyond reproducing a physical likeness of his sitter, and even beyond the formal color experiments of the Fauves. His subject is an internal state of being, or more accurately, his own internal state of feeling. During this dynamic period of work (cut short by the outbreak of World War I), Jawlensky made a significant contribution to what would become known as German Expressionism.[5]

# Pablo Picasso

Spanish (active in France), 1881–1973

## The Rower, 1910

Oil on canvas, 28 3/8 x 23 1/2 in. (72.1 x 59.7 cm)
Gift of Oveta Culp Hobby; Isaac and Agnes Cullen Arnold; Charles E. Marsh; Mrs. W. S. Farish; Robert Lee Blaffer Memorial Collection, Sarah Campbell Blaffer; The Brown Foundation Challenge Grant Endowment Fund; and museum purchase, by exchange

81.29

*The Rower* is among the paintings completed by Pablo Picasso during his momentous 1910 summer stay in the Catalonian fishing village of Cadaqués. He and his then lover, Ferdinande Olivier, were invited by their friends the Pichots, along with André Derain and his wife, Alice, to stay at their seaside villa. Picasso worked with unusual attention that summer, sequestering himself for a good part of each day. He returned to Paris in the fall with an important body of work. His dealer Daniel Kahnweiler recalled in his history of Cubism: "Dissatisfied after weeks of agonizing struggle, Picasso returned to Paris . . . with his works unfinished. But a great step forward had been accomplished. He had shattered the enclosed form."[1]

As early as 1906 Picasso had begun dismantling the conventions of illusionistic space established over centuries of Western painting. Influenced by Iberian and African sculpture, and by the paintings of Cézanne, whose posthumous retrospective of 1907 at the Salon d'Automne had stimulated so many young painters, he produced his first early masterpiece, *Les Desmoiselles d'Avignon,* 1907 (The Museum of Modern Art, New York). Around this time he met Georges Braque, and together they set out on what William Rubin has called "the most passionate adventure in our century's art."[2] During the roughly six years of intense verbal and pictorial dialogue between the two artists, Picasso narrowed his subject matter, excluded narrative from his painting, and suppressed his extraordinary painterly facility, gaining a degree of focus rare in his peripatetic career.[3] Between 1910 and 1912 in particular, Picasso worked with and competed against Braque, exploring an original pictorial language with which to create images on a two-dimensional support. The resultant paintings are revelations of the complexity of consciousness and of the paradoxical character of visual knowledge.

Picasso and Braque spent the summer of 1910 apart, allowing each artist to work through particular problems on his own. Picasso's work of Cadaqués is devoid of the kind of turbulently passionate runoff from his affairs with women that inspired so many of his productive periods. His relationship with Olivier was for the moment peaceful; Picasso retrained his obsessive energy back into his work, and she apparently accepted this new prioritization.[4] Sequestered in his studio, Picasso approached his work with an intense intellectual resolve and produced his most structurally forceful Cubist paintings.

Picasso's Cadaqués paintings are indeed rather hard to read. *The Rower,* in fact, is a later appellation. The painting was earlier known as *Figure* and interpreted both as a portrait and as a person seated at a desk reading a book.[5] In this work, as in Picasso's other great paintings of this summer, *Woman with a Mandolin* (Museum Ludwig, Cologne) and *Guitarist* (Musée National d'Art Moderne, Paris), Picasso refuses to direct the viewer's focus, allowing it instead to slide over the

1. Kahnweiler 1949, 10 (originally published as *Der Weg zum Kubismus,* Munich, 1920); quoted in Richardson 1996, 165. See also Daix 1979, 258, no. 360.

2. Rubin 1989, 15.

3. Ibid., 16. See Rubin's book for a thorough and eloquent account of these artists' collaboration and of Analytic Cubism generally.

4. Richardson 1996, 158–59.

5. See Rubin 1989, 25, and Richardson 1996, 159.

6. See John Richardson's account of the grid in Picasso's painting, which he refers to as "Picasso's champagne-glass figuration" (Richardson 1996, 157).
7. Daix 1979, 83.
8. Rubin 1989, 25.

shimmering, tilting, fragmented planes, in search of something recognizable. The painting feels chaotic at moments, but then Picasso catches the eye on a solidly sculpted joint, and the work's structure falls back into place. He borrowed from Braque the use of an orthogonal grid, which he softened with diagonals and arc shapes.[6] The grid—which would be appropriated by Mondrian the following year and would become a modernist trademark—reiterates the vertical and horizontal axes of the picture's edges, establishing an architectural structure with which to experiment. Having "shattered" the conventional three-dimensional figure-in-space, Picasso fastened the geometrical facets to a new armature, one that melds with the two-dimensional surface on which it is painted. *The Rower* appears simultaneously as a flat pattern of lines and curves, light and dark, and as a volumetric architectural form. The palette has been reduced to monochromatic tones of brown, ocher, and gray to equalize the values of the picture and enhance its effect of unity. From this seemingly abstract image, a solid figure emerges. Pierre Daix describes Picasso's feat: "For [Picasso] objectivity did not consist in the imitation of external reality, but in making a picture into an object that represented reality, a flat object that could be the equivalent of a three-dimensional object (something that no one had previously achieved)."[7] Picasso's goal, then, was not the direct transcription of the figure, but rather the creation of an experience that is like reality, only richer. Indeed, the poetry of these works owes much to the very ambiguity of their forms.[8]

At first, however, the language of this poetry was understood only by its creators, Picasso and Braque. When Picasso showed these works to Kahnweiler on his return from Cadaqués, his dealer bought only one, *Harbor at Cadaqués* (Národní Galerie, Prague). Picasso then took them to Ambroise Vollard, who, though he too barely understood them, bought the lot and exhibited them at a winter show in his gallery. With time, the revolutionary enterprise of Cubism would catch on and, in reverberating waves of influence, excite other artists, collectors, and eventually a broader public.

## Henri Matisse

French, 1869–1954

### *Olga Merson,* 1911

Oil on canvas, 39 1/4 x 31 3/4 in. (99.7 x 80.6 cm)
Museum purchase with funds provided by the Agnes Cullen Arnold Endowment Fund
78.125

Henri Matisse's striking portrait of his student Olga Merson has few of the elements we usually associate with the artist's work: the luxuriating odalisques, the gorgeous interiors and still lifes glowing with pure color, the dynamic design of *Dance,* 1909 (The Museum of Modern Art, New York). Here instead is a woman starkly represented, seated rigidly against two monochromatic bands. The color harmony, though effective, is created by muted tones: pale green and rusty orange-red, pale pink and watered-down blue. The painting has an unfinished look where Matisse has left clear traces of his vigorous working process. The right side of Merson's face has been scraped away and incompletely repainted; her left ear and neck, and her left forearm have been thickly painted over; and the two black arcs slashed over the surface of Merson's torso are ambiguously related to the figure. How can one explain such a strange yet intensely vital painting?

Unfortunately, Matisse's other work of the period reveals little about *Olga Merson.* It seems unrelated to the great still lifes and interiors completed at the same time, works like *The Painter's Family,* 1911 (Hermitage, St. Petersburg), and the *Red Studio,* 1911 (The Museum of Modern Art, New York), which deal with essentially decorative issues. Although it bears some formal similarities to portraits of the period like *Marguerite with a Black Cat,* 1910 (private collection), and *Girl with Tulips: Jeanne Vaberin,* 1910 (Hermitage, St. Petersburg), these works are simpler and more relaxed and their colors are fresh and undiluted. The portrait of Merson was done

1. See Golding 1978 and Elderfield 1992 for formal analyses of Matisse's Cubism.
2. Barr 1951, 131.
3. Flam 1986, 248, 494 n. 5, 498 n. 396.
4. Golding 1978, 6–7.
5. This photograph is illustrated in Elderfield 1992, 184.

in the summer of 1911 in Collioure, where Matisse had painted many of his finest Fauve landscapes and interiors. In this painting he had clearly moved beyond the decorative colorism of Fauvism, the foremost avant-garde movement of the previous decade, and was pushing into unfamiliar artistic terrain.

Matisse's new direction may have had something to do with his prodigious competitor for the lead role in modernist painting, Pablo Picasso. Matisse met Picasso in 1906, initiating a half-century of fruitful artistic rivalry. Matisse was thirty-seven, Picasso twenty-five. John Golding, a historian of Cubism, asserts that Matisse's viewing in 1907 of Picasso's first great masterpiece, *Les Desmoiselles d'Avignon,* profoundly altered his art, setting him off on an experimental alternative to Fauvism that culminated in the overtly Cubist works of 1916–17. According to Golding, Picasso's radical work inspired Matisse to suppress the decorative element in his own painting and to return to a more rigorous, intellectual analysis of form.

Indeed the hedonism that characterizes much of Matisse's oeuvre is absent in the austere *Olga Merson.* Matisse was concentrating on the fundamental problem of portraiture: the placement of the figure within a rectangular two-dimensional format. He leaves signs of his struggle, the scumbling, scratching, and overpainting of the face, neck, and forearm, not to mention the bold black marks that severely reaffirm the figure's disposition within the rectangle.[1] Alfred Barr describes "this slashing curve" as "perhaps the boldest innovation in form—as distinguished from color—that Matisse had made up to this moment."[2]

And what of the painting's subject, Olga Merson? Given the suggestion by several Matisse scholars that the artist was having an affair with the portrait's sitter, it is possible that the oddness of the work has something to do with the circumstances of its creation.[3] (Matisse himself in his articulate 1908 *Notes of a Painter* defined his creative process in personal terms, as the translation of his feelings [*sentiments*] for his subject into lines and compositional arrangements.)[4] Merson was born in Russia in 1878 and entered Matisse's studio as a student in 1908. In 1911 Matisse sculpted *Seated Nude (Olga)* (private collection), a pose similar to his *Small Crouching Nude with Arms* of a few years earlier (Collection Thyssen-Bornemisza, Madrid), but larger and more sensually modeled. A photograph taken in Collioure during the summer of 1911 shows Merson sitting with the Matisse family.[5] Her pose is similar to that in *Olga Merson,* but she sits askew to the camera and looks off to the right. Apparently under pressure from Madame Matisse, the relationship ended between Matisse and Merson sometime in the fall. Reading the work within this context suggests a psychological significance to the work. Merson's presence in the painting is tense and ineluctable. She is locked in a static pose, her posture closed and kempt, her hands folded politely in her lap, knees pressed together, hair and makeup neatly in place. The gaze of her left eye is piercing, emboldened by the black strokes of lid and brow, and supported by the black lines at the left of her neck and arcing down her torso. The signs of frustration in Matisse's composition may have had to do with their dissolving relationship. Merson would eventually move to Berlin, where in 1933, the year the Nazis came to power, she committed suicide.

## Vassily Kandinsky

Russian, 1866–1944

### Sketch 160A, 1912

Oil on canvas, 37 3/8 x 42 1/2 in. (94.9 x 107.9 cm)
Gift of Audrey Jones Beck
74.140

Vassily Kandinsky painted *Sketch 160A* during the roughly three transitional years in which he moved from representational painting to abstraction. The painting belongs to the group of early *Improvisations* and *Compo-* sitions completed between 1910 and 1913, comprising works whose liberation from strict naturalism is intimated in their titles. There is little in these paintings to read, and the viewer determined to make definitive

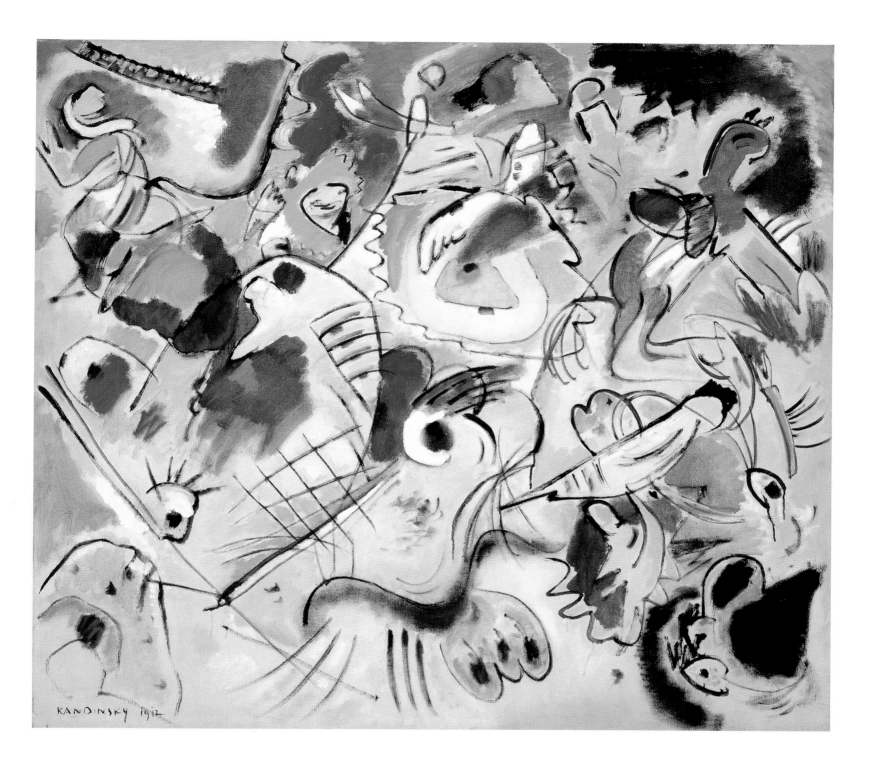

sense of these compositions will be frustrated. The most fruitful approach to *Sketch 160A* is one that is relaxed and open to suggestion. The viewer should allow the eye to move undirected across the squiggles and curves, dipping in and out of color pools while simultaneously taking in the elements as a harmonic whole. The painting offers the game viewer a delightful exercise in imaginative visual play, indulging the eye with rich aesthetic invention.

Kandinsky's artistic intentions, however, were considerably more ambitious. As he stated in his groundbreaking treatise *Concerning the Spiritual in Art* of 1912 (the same year he painted *Sketch 160A*), he wanted the viewer to respond emotionally and spiritually to his work, to allow the carefully nuanced tones and quizzical lines and marks to enact a "vibration" in the viewer's soul, transporting the viewer to a nonrational, nonmaterial realm of experience. *Concerning the Spiritual in Art,* written in clear, engaging prose, is considered one of the first significant theoretical discussions of abstraction in art. An amateur pianist and cellist, Kandinsky asserted

1. Kandinsky [1912] 1947, 24, 33.
2. Washington Long 1980. See also Roethal and Benjamin 1982, 1:no. 442.

music as a model for painting's potential to perform abstractly. With Richard Wagner's operas in the forefront of his mind, Kandinsky celebrated music's freedom from literal, overly rational, conscious expression. Through the purely artistic principles of harmony, polyphony, and counterpoint, claimed Kandinsky, music directly addressed man's "internal element," purifying and sensitizing his soul; painting, by utilizing its own inherent properties (color and line), should follow suit.

Underlying Kandinsky's abstract theories is a negative critique of naturalist art and of the pervasive positivism that so dominated western European intellectual life during the middle decades of the nineteenth century. Building on the Post-Impressionist works of Paul Gauguin and Vincent van Gogh, of the Nabis, Henri Matisse, and the Fauves, and by capitalizing on the turn-of-the-century vogue for the spiritual, exemplified by the influential writings of Henri Bergson and Edouard Schuré and by the popularization of cults and associations like Madame Blavatsky's Theosophical Society, Kandinsky offered abstraction as a means of artistic and social renewal. He felt that art should address society's moral, ethical, and spiritual needs by providing a quality of visual experience that would elevate man beyond his limited, material existence. In *Concerning the Spiritual in Art,* he explained the social role of art with some urgency:

*Only just now awakening after years of materialism, our soul is infected with the despair born of unbelief, of lack of purpose and aim. . . .*

*When religion, science and morality are shaken (the last by the strong hand of Nietzsche) and when outer supports threaten to fall, man withdraws his gaze from externals and turns it inward. Literature, music and art are the most sensitive spheres in which this spiritual revolution makes itself felt.[1]*

There was one potential obstacle, however, to Kandinsky's vaunted vision of the artist as social messiah: would the public make the leap to abstraction? How would the artist reach his audience through the less accessible language of disassociated color and line? In 1912 Kandinsky was unsure of the public's tolerance for abstraction, and his paintings contain small concessions to objective reality in the form of hidden imagery. Indeed, though the primary effect of *Sketch 160A* is produced by chords of harmonic color and inventive linear and spatial composition, the viewer's gradual discovery of the elusive bird, horse, and rider and varied organic forms offers a secondary element of delight. By 1914, however, Kandinsky was practicing what he referred to as "pure abstraction," entirely free of representation, and, his paintings exhibited around Europe and his treatise widely read, he was anointed the harbinger of a brave new style.[2]

## Odilon Redon

French, 1840–1916

### *Two Young Girls among Flowers,* c. 1912

Oil on canvas, 24 1/2 x 20 1/4 in. (62.2 x 51.4 cm)
Gift of Audrey Jones Beck
85.308

1. Groom 1994, 307.
2. Redon [1922] 1961.

*T*wo Young Girls among Flowers belongs to an enchanting group of Odilon Redon's works employing a *fille-fleurs* (girl-flowers) motif. These depictions of young women with fantastic flowers suggest youthful innocence and purity of soul.[1] In his published notes, Redon confessed his love of the *fillette,* the young girl who would, like a flower, blossom into a woman.[2] The girls depicted here are seen in profile, their decorative silhouettes juxtaposed against the exuberant blooms as a

small swarm of pollinating bees takes flight in the upper left. There is a sense of spiritual reverie in these figures, with their eyes closed and heads bent, and the flowers, floating so close to the picture's surface, seem to project the girls' delicate inner vision. The image hangs between reality and fantasy, as Redon draws from both nature and imagination.

Redon's oeuvre participates in a broader reaction, beginning in the 1880s, against the prevailing aesthetic of naturalism. Writers

3. Gustave Kahn, "Réponse des symbolistes," *L'Evénement,* 30 September 1886; quoted in Groom 1994, 198.

4. Kaplan 1996, 168–70.

5. Albert Aurier, "Les Symbolistes," *La Revue encyclopédique,* April 1892, 474–86; quoted in Groom 1994, 199.

6. Groom 1994, 306–7.

7. Hobbs 1996, 71–72.

8. International Exhibition of Modern Art, sponsored by the Association of American Painters and Sculptors, New York, 1913, no. 283. See also Wildenstein 1992, 117, no. 276.

and visual artists were frustrated by the limitations of so-called positivist thought, in which "truth" consisted of only that which could be objectively observed in the external world. For such artists, this narrow empiricism excluded what they considered crucial avenues of knowledge and meaning, such as intuition and fantasy, and subjective irrational experiences like dreams, visions, and hypnotism. This movement, which became known as Symbolism, was initially articulated in literature, in specialized literary journals, and through works like Joris-Karl Huysmans's *A Rebours (Against Nature)* of 1884. In direct response to naturalist theory of the 1870s as it was expounded by critics such as Emile Zola, Gustave Kahn described the Symbolist agenda in 1886: "The essential aim of our art is to objectify the subjective instead of subjectifying the objective."[3]

In the visual arts, Symbolism was a complex aesthetic that stressed feeling and evocation over definition and fact. The suggestive power of color was favored over the decisive power of line. There was an emphasis on texture and surface, and a denial of conventions for creating spatial illusion.[4] Paul Gauguin played a seminal role in developing this aesthetic in painting. Works like *Vision after the Sermon (Jacob Wrestling with the Angel),* 1888 (National Gallery of Scotland, Edinburgh), and the museum's *Arearea II* (pp. 182–83), in which the artist portrays both the dreamer and the invisible dream, set a precedent for Redon's oeuvre. In 1892 the critic Albert Aurier described Redon's Symbolism: "Among those who first spread the word that means so much to the younger generation, we should not forget another artist no less original, ide-

alistic, strange and terrible—one whose love of dreams and spirituality and lofty contempt for soulless imitation have influenced the budding artists of our day as effectively, though less directly than those already mentioned. I refer to Odilon Redon."[5]

The "younger generation" mentioned by Aurier includes the group of Nabi painters, Pierre Bonnard, Maurice Denis, Paul Ranson, Ker-Xavier Roussel (1867–1944), Paul Sérusier, and Edouard Vuillard (see pp. 180–81, 186–87, 218–20). These artists admired Redon's ability to evoke dreams without resorting to allegory.[6] Redon also shared their celebration of the decorative in art, and like Bonnard and Vuillard, he accepted commissions for decorative work. He painted murals and folding screens for private homes, and in 1908 he was commissioned by the French national tapestry manufactory to create a tapestry design. The sumptuous textures and explosive color of Redon's pastels and oil paintings translated with great success into the decorative arts.

Though Redon never officially called himself a Symbolist, nor joined the Nabis nor any of the other groups that formed at the turn of the century, he had a strong influence on avant-garde art. In 1904 Redon submitted a number of works to the Salon d'Automne, contributing to the eruption of Fauvism the following year.[7] And perhaps even more significant was the inclusion of the museum's *Two Young Girls among Flowers* in the 1913 Armory Show in New York, the large-scale exhibition of European modern art that marks the advent of modernism in the United States.[8]

## Pierre Bonnard

French, 1867–1947

## *Dressing Table and Mirror,* c. 1913

Oil on canvas, 48 7/8 x 45 15/16 in. (124.1 x 116.7 cm)
Gift of Audrey Jones Beck
74.134

Pierre Bonnard's *Dressing Table and Mirror* richly rewards the patient viewer who allows the eye a slow acquaintance with the painting's subtle presence. Ostensibly a still life, the painting is an exploration of the mysteries and pleasures of visual perception. The eye is first drawn to the center of the canvas,

to what reads eventually as a mirror reflection, painted in oilier, more thickly applied paint than the rest of the composition. The reflection shows Bonnard's dark brown dachshund in the foreground, curled up on a magenta square, while an oddly beheaded bather sitting on the rear of the long cushion

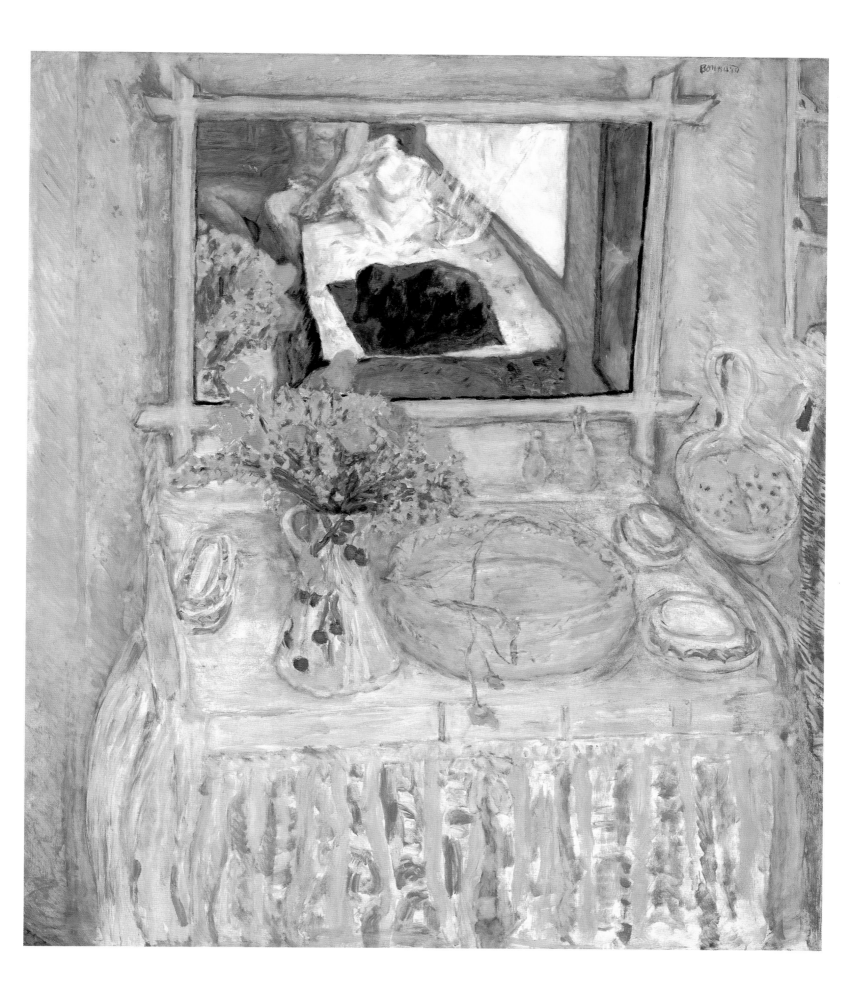

1. Rewald 1948, 40.
2. Ibid., 25.
3. Russell 1984, 10.
4. Elderfield 1998.
5. Whitfield 1998, 15.
6. Bonnard used to say, "the museums are filled with homeless works"; quoted in Rewald 1948, 53.

gestures anonymously. Between these figures, a gauzy curtain billows, fusing with a sculpted mound of bedclothes. This cramped rectangular mirror shares with the nonreflected "real-time" space of the rest of the composition an exuberant vase of orange and yellow flowers—the most telling clue as to the relationship between these two spaces. As the eye spans out from the mirror's chromatic vibrancy, one begins to take in the floating forms of the dressing table and its accoutrements and the wall on which the mirror hangs. These areas are imprecisely defined, and the pigments, aside from the luscious orange and green of the bouquet, are thinly painted over a white canvas that glows through the colored glazes, unifying and lightening the space. These pastel washes in violet, pink, and turquoise create an ethereally abstract landscape, as gorgeous as it is unreal. John Rewald describes the effect of Bonnard's paintings, "covered with colors applied with a delicate voluptuousness that confers to the pigment a life of its own and treats every single stroke like a clear note of a symphony."[1]

Bonnard's early interest in a decorative aesthetic—in the artistic effect of flat, linear patterns and asymmetrical compositions—grew through his contact with Japanese prints and with the mature paintings of Gauguin. Along with his Nabis friends—Denis, Sérusier, Vallotton, and Vuillard—Bonnard was intrigued by the challenge posed by these art forms to Western traditions of picture making. More so than his fellow Nabis, however, Bonnard remained deeply interested in empirical ob-

servation, in capturing "the exquisiteness of banality."[2] In the early years of the century, he returned to the Impressionists for inspiration, attempting to harmonize his decorative instincts with his desire to capture his own lived reality.

*Dressing Table* is early in a series of paintings by Bonnard of his bathroom, a body of work that the art critic John Russell esteems as important to twentieth-century art as Monet's water lily paintings.[3] (Indeed, Bonnard was Monet's neighbor near Giverny in the years preceding World War I and visited him on occasion.) Bonnard's usual point of departure was a moment of visual perception, which during the process of painting he filtered through his memory and his emotions, transforming it through paint into a highly personal form of expression. Though he painted what he was most familiar with—his wife Marthe, their dog, the fixtures of their bathroom—he distanced himself from a direct transcription of this world by painting it from memory.[4] Such mundane subject matter, when translated by Bonnard's rich imagination and technical virtuosity, becomes bewildering and delightful. His paintings make us appreciate not only the formless, inchoate flow of consciousness, but also the expressive potential of the painted surface, governed by its own laws of color and design.[5] Bonnard's art is extremely private, perhaps more appropriately experienced (as he himself once claimed) in the intimacy of one's living room than in the well-traveled galleries of a public museum.[6]

# Amedeo Modigliani

Italian, 1884–1920

## *Léopold Zborowski*, c. 1916

Oil on canvas, 45 3/4 x 28 3/4 in. (116.2 x 73 cm)
Gift of Audrey Jones Beck
98.292

Amedeo Modigliani's portraits depict the painter's friends, lovers, and colleagues, constituting a rogues' gallery of central participants in one of Paris's most vibrant avant-garde communities, that of Montparnasse during the First World War. Among Modigliani's subjects were Diego Rivera (1886–1957), Chaim Soutine (1893–1943), Pablo Picasso, Jean Cocteau (1889–1963),

Juan Gris (1887–1927), and Jacques Lipchitz (1891–1973). Léopold Zborowski, a Polish poet who moved to Paris in 1914, is the patient subject of several Modigliani portraits. Moved by the beauty of the painter's work, Zborowski devoted himself fully to Modigliani's career in 1916, serving as his art dealer and advancing him small loans when his work did not sell.[2]

1. Wilkinson 1996, 786–88. See also Kruszynski 1996, 63–67, and Hall 1990.
2. Schmalenbach 1990, 53.
3. Cocteau 1950, unpag.

The narrative of Modigliani's life is pervaded by the romantic myth of artistic bohemia. He immigrated to Paris from Italy as a young man, poor and in bad health; he was a passionate artist and lover, artistically idealistic and financially unsound; he drank too much and spent whole nights carousing with friends. His first solo show, at the Galerie Berthe Weill in Paris, was censored and five of his nudes were confiscated by the police. Three years later Modigliani died of tuberculosis, the result of a lung condition contracted at the age of ten and aggravated by his life style. He was thirty-six years old.

Despite the chaos and emotional intensity of his life, his art projected an almost classical stability and harmony. His subject was that most ancient motif, the human form, and his style is distinguished by a remarkable consistency. Throughout a wildly inventive decade of art history, from 1910 to 1920, during Fauvism, Cubism, and Futurism, Modigliani continued to produce his carefully measured and balanced compositions.[1]

Modigliani was artistically trained in Florence and Venice and knew well the great Italian masters: Botticelli, Giorgione, Titian, and Raphael. Though he painted his portraits of real people, often intimate friends, he revised his subjects on the canvas into lyrically ideal figures, perhaps the result of his Italian artistic heritage. He began his career as a sculptor, working in the studio of Constantin Brancusi, inspired, as was Brancusi, by the archetypal art forms of Africa, Asia, and an-

cient Egypt.[2] The schematic physiognomy and rigid compositional format of his sculptures and portrait paintings have clear stylistic precursors in these non-European arts. Finally, and perhaps most important, was the influence of Paul Cézanne's late portraits, particularly those of his wife, Hortense Fiquet. Comparing *Léopold Zborowski* with the museum's *Madame Cézanne in Blue* (p. 171) reveals Modigliani's debt: the static, frontal pose; the sense, generated particularly by the impassive eyes, of the sitter's psychological distance; the figure tipping slightly off-axis, gently disconcerting the strong compositional verticals in the background.

Modigliani also typically painted his canvases with heavy accretions of pigment, as did Cézanne. However, Cézanne's surfaces were made dense by an arduous process of working and reworking the image; his paintings document an intense conceptual and physical struggle. In contrast, Modigliani's surfaces are mottled for textural, sensual effect, and his painted forms exude a kind of innocent, unselfconscious grace. The regular perfection of Zborowski's oval face, modeled in warm crimson, tan, and beige-brown, his elongated neck, and the elliptical contours of his body are expressed with seeming effortlessness. As the artist's close friend Cocteau recalled: "Modigliani was our aristocrat. His drawing is supremely elegant; his line is often so attenuated as to be the mere ghost of a line, but it is never blurred."[3]

## Piet Mondrian

Dutch, 1872–1944

### Composition with Gray and Light Brown, 1918

Oil on canvas, 31 9/16 x 19 5/8 in. (80.3 x 49.8 cm)
Gift of Mr. and Mrs. Pierre Schlumberger
63.16

Piet Mondrian painted *Composition with Gray and Light Brown* in 1918 during an intensely experimental moment in his career—one year after completing his first fully non-objective picture, *Composition in Line*, 1917 (Kröller-Müller Museum, Otterlo). He was almost fifty years old and had already produced a large body of work running the gamut from late-nineteenth-

to early-twentieth-century painting styles: Hague School Realism, Neo-Impressionism, Post-Impressionism, Symbolism, and Fauvism. He discovered the Cubism of Picasso and Braque in 1911, which proved to be perhaps his most profound artistic influence. *Composition with Gray and Light Brown* employs the muted gray and ocher palette of early Cubist pictures and is equally con-

1. For Mondrian's relationship with Theosophy and the philosophical underpinnings of his art theory, see Blotkamp 1994.
2. Champa 1985, 61.
3. Bois 1994, 333.

cerned with the relationship between compositional planes and the picture surface. However, Mondrian pushed beyond Cubism to an art utterly devoid of natural references, to a "purely" abstract art. What prepared Mondrian to take such a radical leap, to break firmly and absolutely away from four centuries of basically naturalist Western art?

Mondrian's biography sheds little light on this question. He never married and seems not to have shared his life with a partner. Though he lived in Paris during the heady avant-garde years immediately preceding the First World War and mingled with the expatriate artists who frequented La Coupole and Café du Dôme, he was rather formal and solitary. At his death in 1944, he left few personal effects: no library indicating intellectual interests, no journal or revealing correspondence (in fact he kept no letters at all). The bulk of his legacy consists of a magnificent body of paintings—and of numerous interpretive articles and treatises.

In reading Mondrian's art-theoretical writings, it becomes clear that despite the abstract nature of his mature work, his paintings were intended to convey an urgent and profound message. A member of the Theosophical Society (he joined in 1908 and kept his membership card with him until his death), Mondrian asserted an active spiritual and philosophical role for art, envisioning its mission as nothing less than the gradual representation and revelation of the universal cosmic order, of the divine pulse of life.[1] Like his fellow Theosophist Vassily Kandinsky, he believed that art should provide a transcendental experience free of secular subject matter. Setting forth his theories in Theo van Doesburg's (1883–1931) periodical *De Stijl*, in a series of articles beginning in 1917 and later assembled as *Le Néo-plasticisme* in Paris in 1920, Mondrian described painting as a creative process of ever-evolving intuition, one that would ultimately lead society to a blissful, harmonic paradise.

In the context of Mondrian's writings, the visual effects of *Composition with Gray and Light Brown*—the sense of balance and repose, the perfect symmetry of verticals and horizontals, the nuanced color tones played off one another in an even melody—are connected to the artist's utopian dream of a peaceful egalitarian society. Mondrian's proportional system was based on the golden section, with its even connotations of idealism and harmony. The artist's carefully calibrated squares, drawn on the canvas in charcoal and then covered by dark gray lines in oil paint, were felt to parallel the perfect order of the universe. Mondrian's famous grid, appearing first in paintings like this one from 1918, thus conveys a spiritual aura.[2] Though in his later works the grid became less fixed and more intuitive, it continued to play the central compositional role throughout his mature oeuvre.

Viewing this work today, however, far removed from this turn-of-the-century philosophical and spiritual mind-set, it is difficult to experience the kind of transcendent glimpse of utopia intended by Mondrian. But the work is no less impressive. The pulsing balance between the uniform tone of ocher color planes and the grays shifting in temperature from warm to cool; the stable, frontal force of the grid; and the rectangular shape of the painting itself conspire brilliantly to convey a tensile image of magical, almost musical beauty. As Yves Alain Bois puts it, Mondrian's art is based on "the idea that a painting is the result of a kind of struggle, a precarious equilibrium that must remain suspended so as to sustain its intensity."[3]

# REFERENCES

**Ackerman 1986**
Ackerman, Gerald M. *The Life and Work of Jean-Léon Gérôme.* London and New York: Sotheby's Publications, 1986.

**Ademollo 1888**
Ademollo, Alessandro. *I teatri di Roma nel secolo decimosettimo memorie sincrone, inedite o non conosciute, di fatti ed artisti teatrali, "librettisti," commediografi e musicisti, cronologicamente ordinate per servire alla storia del teatro italiano.* Rome: L. Pasqualucci, 1888.

**Ainsworth and Christiansen 1998**
Ainsworth, Maryan W., and Keith Christiansen, eds. *From Van Eyck to Bruegel: Early Netherlandish Painting in the Metropolitan Museum of Art.* Exh. cat. New York: Metropolitan Museum of Art, 1998.

**Alte Pinakothek 1985**
Alte Pinakothek. *Alte Pinakothek Munich: Explanatory Notes on the Works Exhibited.* Munich: Alte Pinakothek, 1985.

**André 1928**
André, Albert. *Renoir.* Paris: G. Crès, 1928.

**Angulo 1981**
Angulo Iñiguez, Diego. *Murillo: Su vida, su arte, su obra.* 3 vols. Madrid: Espasa-Calpe, 1981.

**Arisi 1986**
Arisi, Ferdinando. *Gian Paolo Panini e I fasti della Roma del '700.* Rome: Ugo Bozzi, 1986.

**Asmus and Grosshans 1998**
Asmus, Gesine, and Rainald Grosshans. *Gemäldegalerie Berlin: Two Hundred Masterpieces.* Berlin: Nicolai for the Staatliche Museen zu Berlin–Preussischer Kulturbesitz, 1998.

**Baetjer and Links 1989**
Baetjer, Katharine, and J. G. Links. *Canaletto.* Exh. cat. New York: Metropolitan Museum of Art, 1989.

**Bailey 1991**
Bailey, Colin B. *The Loves of the Gods: Mythological Painting from Watteau to David.* Exh. cat. New York: Rizzoli for the Réunion des Musées Nationaux, Paris; the Philadelphia Museum of Art; and the Kimbell Art Museum, Fort Worth, 1991.

**Bailly-Herzberg 1980**
Bailly-Herzberg, Janine. *Correspondance de Camille Pissarro.* Vol. 1, *1865–1885.* Paris: Presses Universitaires de France, 1980.

**Bailly-Herzberg and Fidell-Beaufort 1975**
Bailly-Herzberg, Janine, and Madeleine Fidell-Beaufort. *Daubigny: La Vie et l'oeuvre.* Paris: Geoffroy-Deuchaume, 1975.

**Baldassari 1995**
Baldassari, Francesca. *Carlo Dolci.* Turin: Artema, Compagnia di Belle Arti, 1995.

**Baldassari 1998**
Baldassari, Francesca. *Cristoforo Munari.* Milan: Fondazione Cassa di Risparmio di Reggio Emilia "Pietro Manodori," 1998.

**Baldinucci 1845–47**
Baldinucci, Filippo. *Notizie de' professori del disegno da Cimabue in qua, per le quali si dimostra come, e per chi le belle, arti di pittura, scultura e architettura, lasciata la rozzezza delle maniere greca e gotica, si siano in questi secoli ridotte all'antica loro perfezione.* Ed. F. Ranalli. 6 vols. Florence: Per V. Batelli, 1845–47.

**Barr 1951**
Barr, Alfred H. *Matisse: His Art and His Public.* New York: Museum of Modern Art, 1951.

**Barrell 1980**
Barrell, John. *The Dark Side of the Landscape: The Rural Poor in English Painting, 1730–1840.* Cambridge and New York: Cambridge University Press, 1980.

**Baticle 1987**
Baticle, Jeannine. *Zurbarán.* Exh. cat. New York: Metropolitan Museum of Art; Paris: Grand Palais, 1987.

**Baudelaire 1981**
Baudelaire, Charles. *Art in Paris, 1845–1862: Salons and Other Exhibitions.* Trans. and ed. Jonathan Mayne. New York: Phaidon Press, 1981.

**Bauman 1986**
Bauman, Guy. "Early Flemish Portraits, 1425–1525." *Metropolitan Museum of Art Bulletin* 43 (Spring 1986): 4–64.

**Baumgärtel 1998**
Baumgärtel, Bettina. *Angelica Kauffmann.* Exh. cat. Ostfildern-Ruit, Germany: Gerd Hatje for the Kunstmuseum, Düsseldorf; the Haus der Kunst, Munich; and the Kunstmuseum, Chur, 1998.

**Beard 1996**
Beard, Dorothea K. "Théodore Rousseau." In *The Dictionary of Art,* ed. Jane Turner. Vol. 27. London: Macmillan; New York: Grove's Dictionaries, 1996.

**Bergamo 1996**
Galleria d'Arte Moderna e Contemporanea, Bergamo. *Evaristo Baschenis e la natura morta in Europa.* Exh. cat. Milan: Skira, 1996.

**Berhaut 1994**
Berhaut, Marie. *Gustave Caillebotte: Catalogue raisonné des peintures et pastels.* Rev. ed. Paris: Wildenstein Institute, Bibliothèque des Arts, 1994.

**Binaghi Olivari 1996**
Binaghi Olivari, M. T. "Bernardino Luini." In *The Dictionary of Art,* ed. Jane Turner. Vol. 19. London: Macmillan; New York: Grove's Dictionaries, 1996.

**Bissell 1981**
Bissell, R. Ward. *Orazio Gentileschi and the Poetic Tradition in Caravaggesque Painting.* University Park: Pennsylvania State University Press, 1981.

**Blankert 1982**
Blankert, Albert. *Ferdinand Bol (1616–1680): Rembrandt's Pupil.* Doornspijk, Netherlands: Davaco, 1982.

**Blotkamp 1994**
Blotkamp, Carel. *Mondrian: The Art of Destruction.* London: Reardon Books, 1994.

**Bocchi and Cinelli 1677**
Bocchi, Francesco, and Giovanni Cinelli. *Le Bellezze della città di Firenze dove a pieno di pittvra, di scvltvra, di sacri templi, di palazzi, i più notabili artifizj, e più preziosi si contengono.* Florence: G. Gugliantini, 1677.

**Boggs 1988**
Boggs, Jean Sutherland, ed. *Degas.* Exh. cat. Paris: Grand Palais; Ottawa: National Gallery of Canada; New York: Metropolitan Museum of Art, 1988.

**Bois 1994**
Bois, Yves Alain. *Piet Modrian, 1872–1944.* Exh. cat. New York: Museum of Modern Art, 1994.

**Bomford 1990**
Bomford, David, et al. *Art in the Making: Italian Painting before 1400.* Exh. cat. London: National Gallery, 1990.

**Bordes 1985**
Bordes, Philippe. "Montpellier, Bruyas et Courbet." In *Courbet à Montpellier.* Exh. cat. Montpellier: Musée Fabre, 1985.

**Borghi and Company 1991**
Borghi and Company. *William-Adolphe Bouguereau: L'art pompier.* Exh. cat. New York: Borghi and Company, 1991.

**Borsook and Offerhaus 1981**
Borsook, Eve, and Johannes Offerhaus. *Francesco Sassetti and Ghirlandaio at Santa Trinita, Florence: History and Legend in a Renaissance Chapel.* Doornspijk, Netherlands: Davaco, 1981.

**Bowron 1994a**
Bowron, Edgar Peters. "Bernardo Bellotto." In *Art in the Eighteenth Century: The Glory of Venice,* ed. Jane Martineau and Andrew Robinson. Exh. cat. London: Royal Academy of Arts; Washington, D.C.: National Gallery of Art, 1994.

**Bowron 1994b**
Bowron, Edgar Peters. "The Kress Brothers and Their 'Bucolic Pictures': The Creation of an Italian Baroque Collection." In *A Gift to America: Masterpieces of European Painting from the Samuel H. Kress Collection.* Exh. cat. New York: Harry N. Abrams, 1994.

**Bowron 1999**
Bowron, Edgar Peters. "A Brief History of European Oil Paintings on Copper, 1560–1775." In *Copper as Canvas: Two Centuries of Masterpiece Paintings on Copper, 1525–1775.* Exh. cat. New York and Oxford: Oxford University Press for the Phoenix Art Museum, 1999.

**Boyle-Turner 1983**
Boyle-Turner, Caroline. *Paul Sérusier.* Ann Arbor: VMI Research Press, 1983.

**Boyle-Turner 1995**
Boyle-Turner, Caroline. *Sérusier et la Bretagne.* Douarnenez, France: Chasse-Marée, 1995.

**Bredius 1969**
Bredius, Abraham. *Rembrandt: The Complete Edition of the Paintings.* 3rd ed. Revised by Horst Gerson. London: Phaidon Press, 1969.

**Breeskin 1970**
Breeskin, Adelyn Dohme. *Mary Cassatt: A Catalogue Raisonné of the Oils, Pastels, Watercolors and Drawings.* Washington, D.C.: Smithsonian Institution Press, 1970.

**Brettell 1990**
Brettell, Richard. *Pissarro and Pontoise: A Painter in a Landscape.* New Haven: Yale University Press, 1990.

**Brettell 1997**
Brettell, Richard. *An Impressionist Legacy: The Collection of Sara Lee Corporation.* New York: Abbeville Press, 1997.

**Briganti 1954**
Briganti, Giuliano. "Cristofano Monari." *Paragone* 5 (July 1954): 40–42.

**Brooklyn Museum 1980**
Brooklyn Museum. *Belgian Art, 1880–1914.* New York: Brooklyn Museum, 1980.

**Brown 1978**
Brown, Jonathan. *Images and Ideas in Seventeenth-Century Spanish Painting.* Princeton: Princeton University Press, 1978.

**Brown and Mann 1990**
Brown, Jonathan, and Richard G. Mann. *National Gallery of Art: Spanish Paintings of the Fifteenth through Nineteenth Centuries.* Washington, D.C.: National Gallery of Art; New York: Cambridge University Press, 1990.

**Buzzoni 1985**
Buzzoni, Andrea, ed. *Torquato Tasso tra letteratura, musico, teatro e arti figurative.* Exh. cat. Ferrara: Castello Estense, 1985.

**Cachin 1971**
Cachin, Françoise. *Paul Signac.* Greenwich, Conn.: New York Graphic Society, 1971.

**Cachin 1983**
Cachin, Françoise, et al. *Edouard Manet, 1832–1883.* Exh. cat. New York: Metropolitan Museum of Art; Paris: Grand Palais, 1983.

**Cachin 1996**
Cachin, Françoise, et al. *Cézanne.* Exh. cat. New York: Harry N. Abrams; Philadelphia: Philadelphia Museum of Art, 1996.

**Campbell 1994**
Campbell, Lorne. "Rogier van der Weyden and His Workshop." *Proceedings of the British Academy* 84 (1994): 1–24.

**Campbell 1996**
Campbell, Lorne. "Rogier van der Weyden." In *The Dictionary of Art,* ed. Jane Turner. Vol. 33. London: Macmillan; New York: Grove's Dictionaries, 1996.

**Cardinal 1996**
Cardinal, Roger. "Naïve Art." In *The Dictionary of Art,* ed. Jane Turner. Vol. 22. London: Macmillan; New York: Grove's Dictionaries, 1996.

**Castleman 1985**
Castleman, Riva. *Henri de Toulouse-Lautrec: Images of the 1890s.* New York: Museum of Modern Art, 1985.

**Cennini [c. 1390] 1954**
Cennini, Cennino d'Andrea. *The Craftsman's Handbook: The Italian "Il Libro dell Arte."* c. 1390. Trans. Daniel V. Thompson. New York: Dover Press, 1954.

**Champa 1985**
Champa, Kermit S. *Mondrian Studies.* Chicago: University of Chicago Press, 1985.

**Champa 1991**
Champa, Kermit. *The Rise of Landscape Painting in France: Corot to Monet.* Exh. cat. Manchester, N.H.: Currier Gallery of Art, 1991.

**Chaucer Fine Arts 1988**
Chaucer Fine Arts. *Paintings and Sculpture.* Exh. cat. London: Chaucer Fine Arts, 1988.

**Childs 1989**
Childs, Elizabeth C. *Honoré Daumier and the Exotic Vision: Studies in French Culture and Caricature, 1830–1870.* New York: Columbia University Press, 1989.

**Christiansen 1988**
Christiansen, Keith, Laurence B. Kanter, and Carl Brandon Strehlke. *Painting in Renaissance Siena, 1420–1500.* Exh. cat. New York: Metropolitan Museum of Art, 1988.

**Clark and Bowron 1985**
Clark, Anthony M. *Pompeo Batoni: A Complete Catalogue of His Works with an Introductory Text.* Ed. Edgar Peters Bowron. New York: New York University Press, 1985.

**Clarke 1991**
Clarke, Michael. *Corot and the Art of Landscape.* New York: Cross River Press, 1991.

**Clifton 1997**
Clifton, James. *The Body of Christ in the Art of Europe and New Spain, 1150–1800.* Exh. cat. Munich and New York: Prestel, 1997.

**Cocteau 1950**
Cocteau, Jean. *Modigliani.* Trans. F. A. McFarland. London: Zwemmer; Paris: Fernand Hazan, 1950.

**Conisbee 1991**
Conisbee, Philip, Mary L. Levkoff, and Richard Rand. *The Ahmanson Gifts: European Masterpieces in the Collection of the Los Angeles County Museum of Art.* Los Angeles: Los Angeles County Museum of Art, 1991.

**Conisbee 1996**
Conisbee, Philip. "Jean-Siméon Chardin." In *The Dictionary of Art,* ed. Jane Turner. Vol. 6. London: Macmillan; New York: Grove's Dictionaries, 1996.

**Constable and Links 1989**
Constable, W. G. *Canaletto: Giovanni Antonio Canal, 1697–1768.* 2nd ed. Revised by J. G. Links. 2 vols. Oxford and New York: Clarendon Press, 1989.

**Cooper 1971**
Cooper, Douglas. *The Cubist Epoch.* New York: Phaidon Press, 1971.

**Cormack 1968–70**
Cormack, Malcolm. "The Ledgers of Sir Joshua Reynolds." *Walpole Society* 42 (1968–70): 105–69.

**Crow 1985**
Crow, Thomas. *Painters and Public Life in Eighteenth-Century Paris.* New Haven: Yale University Press, 1985.

**Daix 1979**
Daix, Pierre. *Picasso: The Cubist Years, 1907–1916: A Catalogue Raisonné of the Paintings and Related Works.* Boston: New York Graphic Society, 1979.

**Davies 1972**
Davies, Martin. *Rogier van der Weyden: An Essay, with a Critical Catalogue of Paintings Assigned to Him and to Robert Campin.* London: Phaidon Press, 1972.

**De Vos 1994a**
De Vos, Dirk, ed. *Hans Memling.* Exh. cat. 2 vols. Ghent: Ludion Press, 1994.

**De Vos 1994b**
De Vos, Dirk. *Hans Memling: The Complete Works.* Ghent: Ludion Press; New York: Harry N. Abrams, 1994.

**De Vos 1996**
De Vos, Dirk. "Hans Memling." In *The Dictionary of Art,* ed. Jane Turner. Vol. 21. London: Macmillan; New York: Grove's Dictionaries, 1996.

**Dictionary of Art 1996**
*The Dictionary of Art.* Ed. Jane Turner. 34 vols. London: Macmillan; New York: Grove's Dictionaries, 1996.

**Dorival 1976**
Dorival, Bernard. *Philippe de Champaigne, 1602–1674: La vie, l'oeuvre, et le catalogue raisonné de l'oeuvre.* 2 vols. Paris: L. Laget, 1976.

**Dorra and Rewald 1959**
Dorra, Henri, and John Rewald. *Seurat.* Paris: Les Beaux-Arts, 1959.

**Druick and Hoog 1983**
Druick, Douglas, and Michel Hoog. *Fantin-Latour.* Exh. cat. Ottawa: National Gallery of Canada, 1983.

**Dunkerton 1991**
Dunkerton, Jill, et al. *Giotto to Dürer: Early Renaissance Painting in the National Gallery.* New Haven: Yale University Press; London: National Gallery, 1991.

**Dunlop 1979**
Dunlop, Ian. *Degas.* New York: Galley Press, 1979.

**Easton 1989**
Easton, Ellizabeth. *The Intimate Interiors of Edouard Vuillard.* Exh. cat. Washington, D.C.: Smithsonian Institution Press, 1989.

**Ecole Nationale Supérieure des Beaux-Arts 1985**
Ecole Nationale Supérieure des Beaux-Arts. *Renaissance et maniérisme dans les ecoles du Nords: Dessins des collections de l'Ecole des Beaux-Arts.* Exh. cat. Paris: Ecole Nationale Supérieure des Beaux-Arts; Hamburg: Hamburger Kunsthalle, 1985.

**Eisler 1977**
Eisler, Colin. *Paintings from the Samuel H. Kress Collection: European Schools Excluding Italian.* Oxford: Phaidon Press for the Samuel H. Kress Foundation, 1977.

**Elderfield 1976**
Elderfield, John. *The "Wild Beasts": Fauvism and Its Affinities.* New York: Museum of Modern Art, 1976.

**Elderfield 1992**
Elderfield, John. *Henri Matisse: A Retrospective.* Exh. cat. New York: Museum of Modern Art, 1992.

**Elderfield 1998**
Elderfield, John. *Bonnard.* Exh. cat. New York: Museum of Modern Art, 1998.

**Faille 1970**
Faille, J. B. de la. *The Works of Vincent van Gogh: His Paintings and Drawings.* New York: Reymal in association with Morrow, 1970.

**Farmer 1997**
Farmer, David Hugh. *The Oxford Dictionary of Saints.* 4th ed. Oxford: Oxford University Press, 1997.

**Ferino-Pagden 1996**
Ferino-Pagden, Sylvia. *I cinque sensi nell'arte: Immagini del sentire.* Exh. cat. Cremona, Italy: Santa Maria della Pietà, Leonardo Arte, 1996.

**Fernier 1977**
Fernier, Robert. *La Vie et l'oeuvre de Gustave Courbet.* Vol. 1, *1819–1865 peintures.* Lausanne and Paris: Fondation Wildenstein, 1977.

**Ferrari and Scavizzi 1992**
Ferrari, Orestes, and Giuseppe Scavizzi. *Luca Giordano: L'opera completa.* 2 vols. Naples: Electa, 1992.

**Finaldi and Kirson 1997**
Finaldi, Gabriele, and Michael Kirson. *Discovering the Italian Baroque: The Denis Mahon Collection.* Exh. cat. London: National Gallery, 1997.

**Flam 1986**
Flam, Jack. *Matisse: The Man and His Art, 1869–1918.* Ithaca: Cornell University Press, 1986.

**Fogg Art Museum 1967**
Fogg Art Museum. *Eugène Isabey: Paintings, Watercolors, Drawings, Lithographs.* Exh. cat. Cambridge: Fogg Art Museum, Harvard University, 1967.

**Frangi 1996**
Frangi, Francesco. "Tanzio da Varallo." In *The Dictionary of Art,* ed. Jane Turner. Vol. 30. London:

Macmillan; New York: Grove's Dictionaries, 1996.

**Freeman 1990**
Freeman, Judi. *The Fauve Landscape.* Los Angeles: Los Angeles County Museum of Art; New York: Metropolitan Museum of Art, 1990.

**Freeman 1995**
Freeman, Judi. *Fauves.* Sydney: Art Gallery of New South Wales, 1995.

**Frey 1996**
Frey, Julia Bloch. "Henri de Toulouse Lautrec." In *The Dictionary of Art,* ed. Jane Turner. Vol. 31. London: Macmillan; New York: Grove's Dictionaries, 1996.

**Friedländer 1924–37**
Friedländer, Max J. *Die Altniederländische Malerei.* 14 vols. Berlin: P. Cassirer, 1924–37.

**Friedländer 1967–76**
Friedländer, Max J. *Early Netherlandish Painting.* Trans. Heinz Norden. 16 vols. New York: Praeger, 1967–76.

**Friedlander 1952**
Friedlander, Walter F. *David to Delacroix.* Trans. Robert Goldwater. Cambridge: Harvard University Press, 1952.

**Friedmann 1946**
Friedmann, Herbert. *The Symbolic Goldfinch: Its History and Significance in European Devotional Art.* Washington, D.C.: Pantheon Books, 1946.

**Fucíkova 1985**
Fucíkova, Eliska. "Towards a Reconstruction of Pieter Isaacsz's Early Career." In *Netherlandish Mannerism: Papers Given at a Symposium in Nationalmuseum Stockholm, September 21–22, 1984,* ed. Görel Cavalli-Björkman. Stockholm: Nationalmuseum, 1985.

**Fucíkova 1997**
Fucíkova, Eliska, ed. *Rudolf II and Prague: The Court and the City.* Prague: Prague Castle Administration; London: Thames and Hudson; Milan: Skira, 1997.

**Fulcher 1856**
Fulcher, George Williams. *Life of Thomas Gainsborough, R.A.* 2nd ed. London: Longman, Brown, Green, and Longmans, 1856.

**Galassi 1990**
Galassi, Peter. *Claude to Corot: The Development of Landscape Painting in France.* Ed. Alan Wintermute. New York: Colnaghi; Seattle and London: University of Washington Press, 1990.

**Garrard 1989**
Garrard, Mary D. *Artemisia Gentileschi: The Image of the Female Hero in Italian Baroque Art.* Princeton: Princeton University Press, 1989.

**Geissler 1979**
Geissler, Heinrich. *Zeichnung in Deutschland: Deutsche Zeichner 1540–1640: Ausstellung, 1 Dezember 1979 bis 17 Februar 1980.* Exh. cat. 2 vols. Stuttgart: Staatsgalerie Graphische Sammlung Katalog, 1979.

**Gérard 1867**
Gérard, Henri, ed. *Correspondence de François Gérard, peinture d'histoire avec les artistes et les personnages célèbre de son temps . . . Précédée d'une notice sur la vie et les oeuvres de Gérard, par M. Adolphe Viollet-le-Duc.* Paris, 1867.

**Giordani 1871**
Giordani, Gaetano. *Catalogo de' Quadri di Varie Scuole Pittoriche nella Galleria Costabili in Ferrara (Collezione esposta in vendita).* Bologna, 1871.

**Golding 1978**
Golding, John. *Matisse and Cubism.* Glasgow: University of Glasgow Press, 1978.

**Grand Palais 1991**
Grand Palais. *Seurat.* Exh. cat. Paris: Grand Palais; New York: Metropolitan Museum of Art, 1991.

**Gray 1992**
Gray, Christopher. *Armand Guillaumin, 1841–1927.* Chester, Conn.: Pequot Press, 1972.

**Green and Ragusa 1961**
Green, Rosalie B., and Isa Ragusa, eds. *Meditations on the Life of Christ.* Trans. Isa Ragusa. Princeton: Princeton University Press, 1961.

**Gregg 1980**
Gregg, Robert C. *Athanasius: The Life of Antony and the Letter to Marcellinus.* New York: Paulist Press, 1980.

**Grimm 1990**
Grimm, Claus. *Frans Hals: The Complete Work.* Trans. Jürgen Riehle. New York: Harry N. Abrams, 1990.

**Groom 1993**
Groom, Gloria. *Edouard Vuillard, Painter-Decorator: Patrons and Projects, 1892–1912.* New Haven: Yale University Press, 1993.

**Groom 1994**
Groom, Gloria. "The Late Work—The Emergence of a Decorative Aesthetic." In *Odilon Redon, Prince of Dreams, 1840–1916.* New York: Harry N. Abrams, 1994.

**Guerin 1947**
Guerin, Marcel, ed. *Degas Lettres.* Trans. Marguerite Kay. Oxford: B. Cassirer, 1947.

**Gullek 1974**
Gullek, Rosel. *Der Blaue Reiter im Lenbachhaus München.* Munich: Prestel, 1974.

**Haak 1996**
Haak, Bob. *The Golden Age: Dutch Painters of the Seventeenth Century.* New York: Stewart, Tabori and Chang, 1996.

**Hall 1979**
Hall, James. *Dictionary of Subjects and Symbols in Art.* Rev. ed. New York: Harper and Row, 1979.

**Hall 1990**
Hall, Douglas. *Modigliani.* New York: Watson-Guptill, 1990.

**Haskell and Penny 1981**
Haskell, Francis, and Nicholas Penny. *Taste and the Antique: The Lure of Classical Sculpture, 1500–1900.* New Haven: Yale University Press, 1981.

**Hayes 1973**
Hayes, J[ohn] T. "A Turning Point in Style: Landscape with Woodcutter." *Museum of Fine Arts, Houston, Bulletin* 4 (Summer 1973): 25–29.

**Hayes 1982**
Hayes, John. *The Landscape Paintings of Thomas Gainsborough: A Critical Text and Catalogue Raisonné.* 2 vols. Ithaca: Cornell University Press, 1982.

**Hayes 1992**
Hayes, John. *The Collections of the National Gallery of Art Systematic Catalogue: British Paintings of the Sixteenth through Nineteenth Centuries.* Washington, D.C.: National Gallery of Art; New York: Cambridge University Press, 1992.

**Hayward Gallery 1980**
Hayward Gallery. *Camille Pissarro, 1830–1903.* London: Hayward Gallery; Paris: Grand Palais; Boston: Museum of Fine Arts, 1980.

**Hayward Gallery 1985**
Hayward Gallery. *Renoir.* Exh. cat. London: Hayward Gallery; Paris: Grand Palais; Boston: Museum of Fine Arts, 1985.

**Hayward Gallery 1992**
Hayward Gallery. *Toulouse-Lautrec.* Exh. cat. London: Hayward Gallery; Paris: Grand Palais, 1992.

**Heim Gallery 1971**
Heim Gallery. *Fourteen Important Neapolitan Paintings: Summer Exhibition.* Exh. cat. London: Heim Gallery, 1971.

**Heinz 1960**
Heinz, Günther. "Carlo Dolci: Studien zur religiösen Malerei im 17. Jahrhundert." *Jahrbuch der Kunsthistorischen Sammlungen in Wien* 56 (1960): 197–234.

**Helston 1983**
Helston, Michael. *The National Gallery Schools of Painting: Spanish and Later Italian Paintings.*

London: National Gallery in association with W. Collins, 1983.

**Herbert 1962**
Herbert, Robert. *Barbizon Revisited.* New York: Clarke and Way, 1962.

**Herbert 1968**
Herbert, Robert. *Neo-Impressionism.* Exh. cat. New York: Solomon R. Guggenheim Museum, 1968.

**Hering 1892**
Hering, Fanny Field. *Gérôme: His Life and Works.* New York, 1892.

**Hirst 1981**
Hirst, Michael. *Sebastiano del Piombo.* Oxford: Clarendon Press; New York: Oxford University Press, 1981.

**Hobbs 1996**
Hobbs, Richard. "Odilon Redon." In *The Dictionary of Art,* ed. Jane Turner. Vol. 26. London: Macmillan; New York: Grove's Dictionaries, 1996.

**Hofrichter 1996**
Hofrichter, Frima Fox. "Haarlem." In *The Dictionary of Art,* ed. Jane Turner. Vol. 13. London: Macmillan; New York: Grove's Dictionaries, 1996.

**Hood 1996**
Hood, William. "Fra Angelico." In *The Dictionary of Art,* ed. Jane Turner. Vol. 2. London: Macmillan; New York: Grove's Dictionaries, 1996.

**House 1994**
House, John. *Renoir: Master Impressionist.* Exh. cat. Sydney: Queensland Art Gallery, 1994.

**Hulsker 1996**
Hulsker, Jan. *The New Complete van Gogh: Paintings, Drawings, Sketches.* Amsterdam: J. M. Meulenhoff in association with John Benjamins, 1996.

**Humphry 1802**
Humphry, Ozias. "Biographical Memoir." In *Original Correspondence of Ozias Humphry, R.A.* 2 vols. London: Library of the Royal Academy of Art, 1802.

**Huys Janssen and Sumowski 1992**
Huys Janssen, Paul, and Werner Sumowski. *The Hoogsteder Exhibition of Rembrandt's Academy.* Exh. cat. The Hague: Hoogsteder and Hoogsteder; Zwolle: Waanders, 1992.

**Ingamells 1985–89**
Ingamells, John. *The Wallace Collection Catalogue of Pictures.* 3 vols. London: Trustees of the Wallace Collection, 1985–89.

**Ingamells 1997**
Ingamells, John. *A Dictionary of British and Irish Travellers in Italy, 1701–1800, Compiled from the Brinsley Ford Archive.* New Haven: Yale University Press, 1997.

**Isaacson 1980**
Isaacson, Joel. *The Crisis of Impressionism, 1878–1882.* Exh. cat. Ann Arbor: University of Michigan Museum of Art, 1980.

**Ishikawa 1994**
Ishikawa, Chiyo, et al. *A Gift to America: Masterpieces of European Painting from the Samuel H. Kress Collection.* Exh. cat. Raleigh: North Carolina Museum of Art; Houston: Museum of Fine Arts; Seattle: Seattle Art Museum; San Francisco: Fine Arts Museum of San Francisco; New York: Harry N. Abrams, 1994.

**Jacobus de Voragine [c. 1260] 1993**
Jacobus de Voragine. *The Golden Legend: Readings on the Saints.* c. 1260. Trans. William Granger Ryan. 2 vols. Princeton: Princeton University Press, 1993.

**Jawlensky 1991**
Jawlensky, Maria, et al. *Alexj von Jawlensky: Catalogue Raisonné of the Oil Paintings.* Vol. 1, *1890–1914.* London: Sotheby's Publications, 1991.

**Johnson 1986**
Johnson, Lee. *The Paintings of Eugène Delacroix: A Critical Catalogue.* 5 vols. Oxford: Clarendon Press, 1986.

**Jordan 1985**
Jordan, William B. *Spanish Still Life in the Golden Age, 1600–1650.* Exh. cat. Fort Worth: Kimbell Art Museum, 1985.

**Jordan 1997**
Jordan, William B. *An Eye on Nature: Spanish Still-Life Paintings from Sánchez Cotán to Goya.* Exh. cat. New York: Stair Sainty Matthiesen; London: Matthiesen Fine Art, 1997.

**Jordan and Cherry 1995**
Jordan, William B., and Peter Cherry. *Spanish Still Life from Velázquez to Goya.* Exh. cat. London: National Gallery, 1995.

**Jowell 1989**
Jowell, Francis S. "The Rediscovery of Frans Hals." In *Frans Hals,* ed. Seymour Slive. Exh. cat. Washington, D.C.: National Gallery of Art; London: Royal Academy of Arts; Haarlem: Frans Halsmuseum, 1989.

**J. Paul Getty Museum 1997**
J. Paul Getty Museum. *Masterpieces of Painting in the J. Paul Getty Museum.* 3rd ed. Los Angeles: J. Paul Getty Museum, 1997.

**Judson 1969**
Judson, Richard. "Rembrandt in Canada." *Burlington Magazine* 111 (September 1969): 703–4.

**Jullien 1909**
Jullien, Adolphe. *Fantin-Latour, sa vie et ses amitiés: Lettres inédits et souvenirs personnels.* Paris: L. Laveur, 1909.

**Kahnweiler 1949**
Kahnweiler, Daniel-Henry. *The Rise of Cubism.* Trans. Henry Aronson. New York: Wittenborn, Schultz, 1949.

**Kandinsky [1912] 1947**
Kandinsky, Wassily. *Concerning the Spiritual in Art, and Painting in Particular.* 1912. New York: Wittenborn, 1947.

**Kaplan 1996**
Kaplan, Julius. "Symbolism." In *The Dictionary of Art,* ed. Jane Turner. Vol. 30. London: Macmillan; New York: Grove's Dictionaries, 1996.

**Keaveney 1988**
Keaveney, Raymond. *Views of Rome.* Exh. cat. London: Scala Books in association with Smithsonian Institution Traveling Exhibition Service; Rome: Biblioteca Apostolica Vaticana, 1988.

**Kecks 1995**
Kecks, Ronald G. *Ghirlandaio: Catalogo completo.* Florence: F. Cantini, 1995.

**Kendall 1996**
Kendall, Richard. *Degas: Beyond Impressionism.* Exh. cat. London: National Gallery; Chicago: Art Institute of Chicago, 1996.

**Kitson 1969**
Kitson, Michael. *The Art of Claude Lorrain.* Exh. cat. London: Hayward Gallery, 1969.

**Kitson 1996**
Kitson, Michael. "Claude Lorrain." In *The Dictionary of Art,* ed. Jane Turner. Vol. 7. London: Macmillan; New York: Grove's Dictionaries, 1996.

**Koechlin 1927**
Koechlin, Raymond. "Claude Monet (1840–1926)." *Art et décoration* 51 (February 1927): 47.

**Kosinski 1997**
Kosinski, Dorothy. *Painting the Universe: František Kupka, Pioneer of Abstraction.* Exh. cat. Dallas: Dallas Museum of Art, 1997.

**Kozakiewicz 1972**
Kozakiewicz, Stefan. *Bernardo Bellotto.* Trans. Mary Whittall. 2 vols. Greenwich, Conn.: New York Graphic Society, 1972.

**Kruszynski 1996**
Kruszynski, Anette. *Amedeo Modigliani: Portraits and Nudes.* Munich and New York: Prestel, 1996.

**Laderchi 1838–41**
Laderchi, Carlo. *Descrizione della Quadreria Costabili.* 2 vols. Ferrara: Tipi Negri alla Pace, 1838–41.

**Lagerlöf 1990**
Lagerlöf, Margaretha Rossholm. *Ideal Landscape: Annibale Carracci, Nicolas Poussin, and Claude Lorrain.* New Haven: Yale University Press, 1990.

**Lamac 1988**
Lamac, Miroslav. *Osma a Skupina, 1907–1917.* Prague: Odeon, 1988.

**Lanzi [1792] 1847**
Lanzi, Luigi. *The History of Painting in Italy: From the Period of the Revival of the Fine Arts to the End of the Eighteenth Century.* 1792. Trans. Thomas Roscoe. 3 vols. London: H. G. Bohn, 1847.

**Lee 1970**
Lee, Rennselaer W. *Poetry into Painting: Tasso and Art.* Middlebury, Vt.: Middlebury College, 1970.

**Lee 1974**
Lee, Thomas P. "A Barbizon Masterpiece." *Museum of Fine Arts, Houston, Bulletin* 4 (Winter 1974): 62–67.

**Lee 1981**
Lee, Rennselaer W. "Observations on the First Illustrations of Tasso's *Gerusalemme Liberata.*" *Proceedings of the American Philosophical Society* 125 (October 1981): 329–56.

**Leja 1988**
Leja, Michael. "The Monet Revival and New York School Abstraction." In *Monet in the Twentieth Century.* Boston: Museum of Fine Arts; London: Royal Academy of Art, 1988.

**Levey 1993**
Levey, Michael. *Painting and Sculpture in France, 1700–1789.* New Haven: Yale University Press, 1993.

**Leymarie 1988**
Leymarie, Jean. *Georges Braque.* New York: Solomon R. Guggenheim Museum; Munich: Prestel, 1988.

**Lindsay 1973**
Lindsay, Jack. *Gustave Courbet: His Life and Art.* New York: Harper and Row, 1973.

**Links 1994**
Links, J. G. *Canaletto.* London: Phaidon Press, 1994.

**Lloyd 1981**
Lloyd, Christopher. *Camille Pissarro.* Geneva: Skira; New York: Rizzoli, 1981.

**Longhi 1927**
Longhi, Roberto. "In favore di Antoniazzo Romano." *Vita artistica* 2 (1927): 232–33.

**Longhi 1961**
Longhi, Roberto. *Scritti Giovanili, 1912–1922: Containing 260 illustrazioni in nero e 20 tavole a colori.* 2 vols. Florence: Sansoni, 1961.

**López Rey 1948**
López Rey, José. "Goya's Still-lifes." *Art Quarterly* 11 (1948): 250–61.

**Lowenthal 1990**
Lowenthal, Anne W. *Netherlandish Mannerism in British Collections: A Loan Exhibition, June 7–July 10, 1990.* Exh. cat. London: Entwhistle Gallery, 1990.

**Lucie-Smith 1977**
Lucie-Smith, Edward. *Henri Fantin-Latour.* New York: Rizzoli, 1977.

**Luijten 1993**
Luijten, Ger, et al. *Dawn of the Golden Age: Northern Netherlandish Art, 1580–1620.* Exh. cat. Amsterdam: Rijksmusem; Zwolle: Waanders; New Haven: Yale University Press, 1993.

**Maison 1968**
Maison, K. E. *Honoré Daumier: Catalogue Raisonné of the Paintings, Watercolors, and Drawings.* Vol. 1. London: Thames and Hudson, 1968.

**Malvasia [1678] 1980**
Malvasia, Carlo Cesare. *The Life of Guido Reni.* 1678. Trans. Catherine Enggass and Robert Enggass. University Park: Pennsylvania State University Press, 1980.

**Manet 1979**
Manet, Julie. *Journal (1893–1899).* Paris: Librairie C. Klincksieck, 1979. English edition, *Growing Up with the Impressionists: The Diary of Julie Manet.* Trans. Rosalind de Boland Roberts and Jane Roberts. London: Sotheby's Publications, 1987.

**Mathews 1996**
Mathews, Nancy Mowll, ed. *Cassatt: A Retrospective.* New York: Hugh Lauter Levin Associates, 1996.

**Mena 1996**
Mena, Manuela. "Bartolomé Esteban Murillo." In *The Dictionary of Art,* ed. Jane Turner. Vol. 22. London: Macmillan; New York: Grove's Dictionaries, 1996.

**Mérot 1996**
Mérot, Alain. "Laurent de La Hyre." In *The Dictionary of Art,* ed. Jane Turner. Vol. 18. London: Macmillan; New York: Grove's Dictionaries, 1996.

**Millen 1976**
Millen, Ronald. "Luca Giordano in Palazzo Riccardi, II: The Oil Sketches." In *Kunst des Barock in der Toskana: Studien zur Kunst unter Denletzen Medici.* Munich: Bruckmann, 1976.

**Mitchell and Roberts 1996**
Mitchell, Paul, and Lynn Roberts. *Frameworks: Form, Function and Ornament in European Portrait Frames.* London: P. Mitchell in association with Merrell Holberton, 1996.

**Mladek 1975**
Mladek, Medla. *František Kupka, 1871–1957: A Retrospective.* New York: Solomon R. Guggenheim Museum, 1975.

**Mochon 1991**
Mochon, Anne. *Alexei Jawlensky: From Appearance to Essence.* Long Beach, Calif.: Long Beach Museum of Art, 1991.

**Moffett 1986**
Moffett, Charles S., et al. *The New Painting: Impressionism, 1874–1886.* San Francisco: Fine Arts Museum; Washington, D.C.: National Gallery of Art, 1986.

**Moir 1967**
Moir, Alfred. *The Italian Followers of Caravaggio.* 2 vols. Cambridge: Harvard University Press, 1967.

**Monnier 1996**
Monnier, Geneviève. "Pastel." In *The Dictionary of Art,* ed. Jane Tuner. Vol. 24. London: Macmillan; New York: Grove's Dictionaries, 1996.

**Montebello 1966**
Montebello, Guy-Philippe de. "Four Prophets by Lorenzo Monaco." *Metropolitan Museum of Art Bulletin* 25 (December 1966): 155–69.

**Montebello 1970**
Montebello, Philippe de. "Recent Acquisitions: A Masterpiece for the Cullen Fund." *Museum of Fine Arts, Houston, Bulletin* 1 (1970): 66–70.

**Moroni 1840–61**
Moroni, Gaetano, ed. *Dizionario di erudizione storica ecclesiastica da S. Pietro sino ai nostri giorni. . . .* 103 vols. Venice: Tipografia Emiliana, 1840–61.

**Mortari 1966**
Mortari, Luisa. *Bernardo Strozzi.* Rome: De Luca, 1966.

**Mortari 1995**
Mortari, Luisa. *Bernardo Strozzi.* Rome: De Luca, 1995.

**Musée d'Orsay 1995**
Musée d'Orsay. *Gustave Caillebotte: Urban Impressionist.* Paris: Musée d'Orsay; Chicago: Art Institute of Chicago, 1995.

**Musée Garret 1981**
Musée Garret. *Gérôme 1824–1904, peintre, sculpteur et graveur: Ses Oeuvres conservées dans les collections françaises publiques et privées.* Vesoul, France: Musée Garret, 1981.

**Musée National des Granges de Port-Royal 1995**
Musée National des Granges de Port-Royal. *Philippe de Champaigne et Port-Royal.* Exh. cat. Paris: Musée National des Granges de Port-Royal, 1995.

**Museum of Fine Arts 1976**
Museum of Fine Arts, Houston. *Gustave Caillebotte: A Retrospective Exhibition.* Exh. cat. Houston: Museum of Fine Arts, 1976.

**Museum of Fine Arts 1981**
Museum of Fine Arts, Houston. *A Guide to the Collection.* Introduction by William C. Agee. Houston: Museum of Fine Arts, 1981.

**Museum of Modern Art 1977**
Museum of Modern Art. *Cézanne: The Late Work.* Exh. cat. New York: Museum of Modern Art; Houston: Museum of Fine Arts, 1977.

**Museum of Modern Art 1985**
Museum of Modern Art. *Henri Rousseau.* Exh. cat. New York: Museum of Modern Art, 1985.

**Newcome Schleier 1992**
Newcome Schleier, Mary. "Bernardo Strozzi." In *Kunst in der Republik Genua, 1528–1815.* Exh. cat. Frankfurt: Schirn Kunsthalle, 1992.

**Nicolson 1977**
Nicolson, Benedict. "Stomer Brought Up-to-date." *Burlington Magazine* 119 (April 1977): 230–45.

**Nicolson 1989**
Nicolson, Benedict. *Caravaggism in Europe.* Ed. Luisa Vertova. 2nd ed. 3 vols. Turin: U. Allemandi, 1989.

**Nikolenko 1966**
Nikolenko, Lada. "The Beauties Galleries." *Gazette des Beaux-Arts* 67 (1966): 19–24.

**Nikolenko 1970**
Nikolenko, Lada. "The Source of the Mancini-Mazarin Iconography." *Gazette des Beaux-Arts* 76 (1970): 145–58.

**Nochlin 1996**
Nochlin, Linda. "Cézanne: Studies in Contrast." *Art in America* 84, no. 6 (June 1996): 56–68.

**Nordenfalk 1967**
Nordenfalk, Carl. "Realism and Idealism in the Roman Portraits of Queen Christina of Sweden." In *Studies in Renaissance and Baroque Art Presented to Anthony Blunt on His 60th Birthday.* London and New York: Phaidon Press, 1967.

**Novelli 1964**
Novelli, M. A. *Lo Scarsellino.* Bologna and Milan: Silvana, 1964.

**Offner 1945**
Offner, Richard. "The Straus Collection Goes to Texas." *Art News* 44 (15 May 1945): 16–43.

**Olmi 1996**
Olmi, Giuseppe. "Gabriele Paleotti." In *The Dictionary of Art,* ed. Jane Turner. Vol. 23. London: Macmillan; New York: Grove's Dictionaries, 1996.

**Pagnotta 1997**
Pagnotta, Laura. *Bartolomeo Veneto: L'opera completa.* Florence: Centro Di, 1997.

**Palazzo Madama 1959**
Palazzo Madama. *Tanzio da Varallo.* Ed. Giovanni Testori. Exh. cat. Turin: Palazzo Madama, Mastra di Tanzio da Varallo, 1959.

**Panofsky 1953**
Panofsky, Erwin. *Early Netherlandish Painting: Its Origins and Character.* 2 vols. Cambridge: Harvard University Press, 1953.

**Parmantier-Lallement 1996**
Parmantier-Lallement, Nicole. "Jean-Etienne Liotard." In *The Dictionary of Art,* ed.. Jane Turner. Vol. 19. London: Macmillan; New York: Grove's Dictionaries, 1996.

**Pauchet-Warlop 1996**
Pauchet-Warlop, Laurence. "Charles-François Daubigny." In *The Dictionary of Art,* ed. Jane Turner. Vol. 8. London: Macmillan; New York: Grove's Dictionaries, 1996.

**Penny 1986**
Penny, Nicholas. "An Ambitious Man: The Career and the Achievement of Sir Joshua Reynolds." In *Reynolds,* ed. Nicholas Penny. Exh. cat. London: Royal Academy of Arts in association with Weidenfield and Nicholson, 1986.

**Pepper 1979**
Pepper, D. Stephen. "A New Late Work by Guido Reni for Edinburgh, and His Late Manner Re-evaluated." *Burlington Magazine* 121 (July 1979): 418–25.

**Pepper 1984**
Pepper, D. Stephen. *Guido Reni: A Complete Catalogue of his Works with an Introductory Text.* New York: New York University Press, 1984.

**Perruchot 1960**
Perruchot, Henri. *La Vie de Toulouse-Lautrec.* Trans. Humphrey Hare. London: Perpetura Books, 1960.

**Petit-Palais 1984**
Petit-Palais. *William Bouguereau.* Exh. cat. Paris: Petit-Palais, 1984.

**Petrucci 1995**
Petrucci, Francesco. "Monsù Ferdinando ritrattista: Note su Jacob Ferdinand Voet (1639–1700?)." *Storia dell'arte* 84 (1995): 283–306.

**Pickvance 1984**
Pickvance, Ronald. *Van Gogh in Arles.* Exh. cat.

New York: Metropolitan Museum of Art; Harry N. Abrams, 1984.

**Pinacoteca Nazionale 1988**
Pinacoteca Nazionale. *Guido Reni, 1575–1642.* Exh. cat. Bologna: Pinacoteca Nationale; Nuova Alfa, 1988.

**Pissarro and Venturi 1939**
Pissarro, L. R., and Lionello Venturi. *Camille Pissarro: Son art, son oeuvre.* Paris: P. Rosenberg, 1939.

**Pope-Hennessy 1937**
Pope-Hennessy, John. *Giovanni di Paolo, 1403–1483.* New York: Oxford University Press, 1937.

**Posner 1984**
Posner, Donald. *Antoine Watteau.* Ithaca: Cornell University Press, 1984.

**Pott 1782**
Pott, J. H. *An Essay on Landscape Painting, with Remarks General and Critical, on the Different Schools and Masters, Ancient and Modern.* London: J. Johnson, 1782.

**Pouncey 1977**
Pouncey, Philip. "An Unknown Zaganelli." *Burlington Magazine* 119 (May 1977): 376, 379.

**Prather and Stuckey 1988**
Prather, Marla, and Charles Stuckey. *The Art of Gauguin.* Exh. cat. Chicago: Art Institute of Chicago, 1988.

**Preston 1996**
Preston, Harley. "Eugène Boudin." In *The Dictionary of Art,* ed. Jane Turner. Vol. 4. London: Macmillan; New York: Grove's Dictionaries, 1996.

**Rand 1997**
Rand, Richard. *Intimate Encounters: Love and Domesticity in Eighteenth-Century France.* With Juliette M. Bianco. Exh. cat. Princeton: Princeton University Press, 1997.

**Redford 1996**
Redford, Bruce. *Venice and the Grand Tour.* New Haven: Yale University Press, 1996.

**Redon [1922] 1961**
Redon, Odilon. *A soi-même (1867–1915): Notes sur la vie, l'art et les artistes.* 1922. Paris: H. Floury, 1961.

**Regis 1989**
Regis, Michel. *Le Beau idéal, ou l'art du concepts.* Exh. cat. Paris: Cabinet des Dessins, Musée du Louvre, 1989.

**Rewald 1948**
Rewald, John. *Bonnard.* Exh. cat. New York: Museum of Modern Art, 1948.

**Rewald 1985**
Rewald, John. *Studies in Impressionism.* New York: Harry N. Abrams, 1985.

**Rewald 1996**
Rewald, John. *The Paintings of Paul Cézanne: A Catalogue Raisonné.* 2 vols. New York: Harry N. Abrams, 1996.

**Reynolds [1769–90] 1975**
Reynolds, Joshua. *Discourses on Art.* 1769–90. Ed. Robert R. Wark. New Haven: Yale University Press for Paul Mellon Centre for Studies in British Art, London, 1975.

**Richardson 1996**
Richardson, John. *A Life of Picasso, 1907–1917.* New York: Random House, 1996.

**Ridolfi 1648**
Ridolfi, Carlo. *Le Maraviglie dell'arte ovvero le vite de gl'illvstri pittori veneti e dello stato: Que sono raccolte le opere insigni, i costumi, & i ritratti loro: Con la narratione delle historie, delle fauole, e delle moralità da quelli dipinte.* 2 vols. Venice: G. B. Sgaua, 1648.

**Ripa [1603] 1971**
Ripa, Cesare. *Baroque and Rococo Pictorial Imagery: The 1758–60 Hertel Edition of Ripa's "Iconologia" with 200 Engraved Illustrations.* 1603. Ed. Edward A. Maser. New York: Dover Publications, 1971.

**Robertson 1954**
Robertson, Giles. *Vincenzo Catena.* Edinburgh: University Press, 1954.

**Roding and Stompé 1997**
Roding, Juliette, and Marja Stompé. *Pieter Isaacsz (1569–1625): Een Nederlandse schilder, kunsthandelaar en diplomaat aan het Deense hof.* Hilversum, Netherlands: Verloren, 1997.

**Roethel and Benjamin 1982**
Roethel, Hans K., and Jean K. Benjamin. *Kandinsky: Catalogue Raisonné of the Oil Paintings.* Vol. 1, *1900–1915.* Ithaca: Cornell University Press, 1982.

**Roettgen 1993**
Roettgen, Steffi. *Anton Raphael Mengs, 1728–1779, and His British Patrons.* London: Zwemmer, English Heritage; New York: Rizzoli, 1993.

**Roettgen 1999**
Roettgen, Steffi. *Anton Raphael Mengs, 1728–1779.* Vol. 1. *Das malerische und zeichnerische Werk.* Munich: Hirmer Verlag, 1999. [Vol. 2. *Leben und Werk,* is forthcoming in 2000.]

**Roland Michel 1996a**
Roland Michel, Marianne. *Chardin.* New York: Harry N. Abrams, 1996.

**Roland Michel 1996b**
Roland Michel, Marianne. "Jean-Baptiste Pater." In *The Dictionary of Art,* ed. Jane Turner. Vol. 24. London: Macmillan; New York: Grove's Dictionaries, 1996.

**Rosenberg 1982**
Rosenberg, Pierre. *France in the Golden Age: Seventeenth-Century French Paintings in American Collections.* Exh. cat. Paris: Grand Palais; New York: Metropolitan Museum of Art; Chicago: Art Institute of Chicago, 1982.

**Rosenberg and Thuillier 1989**
Rosenberg, Pierre, and Jacques Thuillier. *Laurent de La Hyre, 1606–1656: L'homme et l'oeuvre.* Exh. cat. Geneva: Skira, 1989.

**Rosenblum 1984**
Rosenblum, Robert. *Nineteenth-Century Art.* New York: Harry N. Abrams, 1984.

**Röthlisberger 1961**
Röthlisberger, Marcel. *Claude Lorrain: The Paintings.* 2 vols. London: Zwemmer, 1961.

**Rouart and Wildenstein 1975**
Rouart, Denis, and Daniel Wildenstein. *Edouard Manet: Catalogue raisonné.* Vol. 1. Lausanne: Bibliothèque des Arts, 1975.

**Rowell 1975**
Rowell, Margit. *František Kupka, 1871–1957: A Retrospective.* Exh. cat. New York: Solomon R. Guggenheim Museum, 1975.

**Rowlands 1996**
Rowlands, Eliot W. *The Collections of the Nelson-Atkins Museum of Art: Italian Paintings, 1300–1800.* Kansas City, Mo.: Nelson-Atkins Museum of Art, 1996.

**Roworth 1992**
Roworth, Wendy Wassyng, ed. *Angelica Kauffman: A Continental Artist in Georgian England.* London: Reaktion Books, 1992.

**Roworth 1997**
Roworth, Wendy Wassyng. "Angelica Kauffman." In *Dictionary of Women Artists,* ed. Delia Gaze. Vol. 2. London and Chicago: Fitzroy Dearborn, 1997.

**Rubin 1989**
Rubin, William. *Picasso and Braque: Pioneering Cubism.* New York: Museum of Modern Art, 1989.

**Russell 1982**
Russell, H. Diane. *Claude Lorrain, 1600–1682.* Exh. cat. Washington, D.C.: National Gallery of Art, 1982.

**Russell 1984**
Russell, John. Introduction to *Bonnard: The Late Paintings.* Exh. cat. Washington, D.C.: Phillips Collection; Dallas: Dallas Museum of Art, 1984.

**Rylands 1996**
Rylands, Philip. "Vincenzo Catena." In *The Dictionary of Art,* ed. Jane Turner. Vol. 6. London: Macmillan; New York: Grove's Dictionaries, 1996.

**Salerno 1984**
Salerno, Luigi. *Still Life Painting in Italy, 1560–1805.* Trans. Robert Erich Wolf. Rome: U. Bozzi, 1984.

**Sandoz 1974**
Sandoz, Mark. *Théodore Chassériau: Catalogue raisonné des peintures et estampes.* Paris: Arts et Métiers Graphiques, 1974.

**Schmalenbach 1990**
Schmalenbach, Werner. *Amedeo Modigliani: Painting, Sculpture, Drawing.* Munich: Prestel, 1990.

**Schrader 1970a**
Schrader, Jack L. "Latest Acquisition." *Museum of Fine Arts, Houston, Bulletin* 1 (March 1970): 2–3.

**Schrader 1970b**
Schrader, Jack L. "Recent Acquisitions: A Seventeenth-Century Grand Sujet Mythologique." *Museum of Fine Arts, Houston, Bulletin* 1 (May 1970): 30–31.

**Schrader 1970c**
Schrader, Jack L. "New Acquisitions: A Caravaggesque Judgment of Solomon." *Museum of Fine Arts, Houston, Bulletin* 1 (September 1970): 54–55.

**Schulman 1997**
Schulman, Michel. *Théodore Rousseau, 1812–1867: Catalogue raisonné de l'oeuvre graphique.* Paris: Editions de l'Amateur, 1997.

**Scott 1973**
Scott, Barbara. "La Live de Jully, Pioneer of Neoclassicism." *Apollo* 97 (January 1973): 72–77.

**Segal 1990**
Segal, Sam. *Flowers and Nature: Netherlandish Flower Painting of Four Centuries.* Exh. cat. The Hague: SDU for Nabio Museum of Art, Osaka; Tokyo Station Gallery; Art Gallery of New South Wales, Sydney, 1990.

**Selz 1982**
Selz, Jean. *E. Boudin.* Trans. Shirley Jennings. Naefels, Switzerland: Benfini Press, 1982.

**Sert 1952**
Sert, Misia. *Misia.* Paris: Gallimard, 1952.

**Sérullaz 1998**
Sérullaz, Arlette, et al. *Delacroix: The Late Work.* Exh. cat. Philadelphia: Philadelphia Museum of Art; Paris: Grand Palais, 1998

**Shackelford 1992**
Shackelford, George T. M. *Masterpieces of Baroque Painting from the Collection of the Sarah Campbell Blaffer Foundation.* Houston: Museum of Fine Arts, 1992.

**Shapiro 1982**
Shapiro, Michael. "Three Late Works by Edgar Degas." *Museum of Fine Arts, Houston, Bulletin* 8 (Spring 1982): 9–22.

**Shapley 1973**
Shapley, Fern Rusk. *Paintings from the Samuel H. Kress Collection: Italian Schools XVI–XVIII Century.* London: Phaidon Press for the Samuel H. Kress Foundation, 1973.

**Sherrill 1976**
Sherrill, Sarah B. "Oriental Carpets in Seventeenth- and Eighteenth-Century America." *Antiques* 109 (January 1976): 142–67.

**Slatkes 1996**
Slatkes, Leonard J. "Matthias Stom." In *The Dictionary of Art,* ed. Jane Turner. Vol. 29. London: Macmillan; New York: Grove's Dictionaries, 1996.

**Slive 1970–74**
Slive, Seymour. *Frans Hals.* 3 vols. London: Phaidon Press, 1970–74.

**Slive 1995**
Slive, Seymour. *Dutch Painting, 1600–1800.* New Haven: Yale University Press, 1995.

**Spear 1971**
Spear, Richard E. *Caravaggio and His Followers.* Exh. cat. Cleveland: Cleveland Museum of Art, 1971.

**Spicer 1997**
Spicer, Joaneath A., with Lynn Federle Orr. *Masters of Light: Dutch Painters in Utrecht during the Golden Age.* Exh. cat. New Haven: Yale University Press for the Walters Art Gallery, Baltimore; Fine Arts Museums of San Francisco; and the National Gallery, London, 1997.

**Spike 1996**
Spike, John T. "Mattia Preti." In *The Dictionary of Art,* ed. Jane Turner. Vol. 25. London: Macmillan; New York: Grove's Dictionaries, 1996.

**Spike 1999**
Spike, John T. *Mattia Preti: Catalogo ragionato dei dipinti (Catalogue Raisonné of the Paintings).* Taverna: Museo Civico di Taverna, 1999.

**Steel 1984**
Steel, David H., Jr. *Baroque Paintings from the Bob Jones University Collection.* Exh. cat. Raleigh: North Carolina Museum of Art, 1984.

**Stein 1992**
Stein, Marcia Kay. "The Orpheus and Eurydice Painting of Camille Corot: Lyrical Reflections of Contemporary Society." M.A. thesis, Rice University, 1992.

**Steinberg 1983**
Steinberg, Leo. "The Sexuality of Christ in Renaissance Art and Modern Oblivion." Cambridge: MIT Press for the Institute for Architecture and Urban Studies, 1983.

**Stuckey 1979**
Stuckey, Charles F. *Toulouse-Lautrec: Paintings.* Chicago: Art Institute of Chicago, 1979.

**Stuckey 1987**
Stuckey, Charles F. *Berthe Morisot, Impressionist.* New York: Hudson Hills Press, 1987.

**Stuckey 1988**
Stuckey, Charles F. *Monet Waterlilies.* New York: Hugh Lauter Levin Associates, 1988.

**Sutter 1970**
Sutter, Jean, ed. *The Neo-Impressionists.* London: Thames and Hudson, 1970.

**Sutton 1986**
Sutton, Peter C. *A Guide to Dutch Art in America.* Grand Rapids, Mich.: Eerdmans, 1986.

**Sutton 1991**
Sutton, Peter. *Boudin: Impressionist Marine Paintings.* Exh. cat. Salem, Mass. Peabody Museum, 1991.

**Tabarant 1947**
Tabarant, Adolphe. *Manet et ses oeuvres.* Paris: Gallimard, 1947.

**Tatlock 1923**
Tatlock, Ralph R. "The Robinson Pictures at Christie's." *Burlington Magazine* 43 (July 1923): 34, 39.

**Taylor 1995**
Taylor, Paul. *Dutch Flower Painting, 1600–1720.* New Haven and London: Yale University Press, 1995.

**Taylor 1996**
Taylor, Paul. *Dutch Flower Painting, 1600–1750.* Exh. cat. Dulwich: Dulwich Picture Gallery, 1996.

**Temperini 1996**
Temperini, Ronald. *French Painting of the Ancien Régime from the Collection of the Sarah Campbell Blaffer Foundation.* Houston: Sarah Campbell Blaffer Foundation, 1996.

**Testori 1995**
Testori, Edoardo. "New Drawings by Tanzio da Varallo." *Master Drawings* 33 (Summer 1995): 115–31.

**Thiel-Stroman 1993**
Thiel-Stroman, Irene van. "Pieter Fransz de Grebber." In *Judith Leyster: A Dutch Master and Her World.* Exh. cat. Haarlem: Frans Halsmuseum; Worcester, Mass.: Worcester Art Museum, 1993.

**Thomson 1985**
Thomson, Richard. *Seurat.* Exh. cat. Salem, N.H.: Salem House; Oxford: Phaidon Press, 1985.

**Thomson 1988**
Thomson, Belinda. *Edouard Vuillard.* New York: Abbeville Press, 1988.

**Thomson 1994**
Thomson, Richard. *Monet to Matisse: Landscape Painting in France, 1874–1914.* Exh. cat. Edinburgh: National Gallery of Scotland, 1994.

**Tinterow 1996**
Tinterow, Gary. *Corot.* Exh. cat. New York: Metropolitan Museum of Art, 1996.

**Tylicki 1996**
Tylicki, Jacek. "Three Paintings Reattributed to Pieter Isaacsz." *Oud Holland* 110 (1996): 135–41.

**Vallier 1964**
Vallier, Dora. *Henri Rousseau.* New York: Harry N. Abrams, 1964.

**van Mander [1603–4] 1994**
van Mander, Carel. *The Lives of the Illustrious Netherlandish and German Painters, from the First Edition of Schilder-Boeck (1603–1604): Preceded by the Lineage, Circumstances and Place of Birth, Life and Works of Karel van Mander, Painter and Poet and Likewise His Death and Burial, from the Second Edition of the Schilder-Boeck (1616–1618).* 1603–4. Trans. and ed. Hessel Miedema. 3 vols. Doornspijk, Netherlands: Davaco, 1994.

**Varchi 1888**
Varchi, Benedetto. *Storia fiorentina.* Ed. Gaetano Milanesi. 3 vols. Florence: Società ed. Delle storie del Nardi e del Varchi, 1888.

**Varnedoe 1987**
Varnedoe, Kirk. *Gustave Caillebotte.* New Haven: Yale University Press, 1987.

**Vasari [1568] 1996**
Vasari, Giorgio. *Lives of the Painters, Sculptors, and Architects.* 1568. Trans. Gaston du C. de Vere with an introduction and notes by Daid Ekserdjian. 2 vols. New York: Alfred A. Knopf, 1996.

**Vroom 1980**
Vroom, N. R. A. "William Claesz Heda." In *A Modest Message as Intimated by the Painters of the "Monochrome Banketje."* 2 vols. Schiedam, Netherlands: Interbook International, 1980.

**Walch 1968**
Walch, Peter Sanborn. "Angelica Kauffmann." Ph.D. diss., Princeton University, 1968.

**Walpole [1777–97] 1965**
Walpole, Horace. *Horace Walpole's Correspondence.* Ed. W. S. Lewis. Vol. 1, *Horace Walpole's Correspondence with the Countess of Upper Ossory.* New Haven: Yale University Press, 1965.

**Walsh and Schneider 1982**
Walsh, John, Jr., and Cynthia P. Schneider. *A Mirror of Nature: Dutch Paintings from the Collection of Mr. and Mrs. Edward William Carter.* Exh. cat. Los Angeles: Los Angeles County Museum of Art; Boston: Museum of Fine Arts; New York: Metropolitan Museum of Art, 1982.

**Walther 1992**
Walther, Angelo, ed. *Gemäldegalerie Dresden: Alte Meister, Katalog der Ausgestellten Werke.* Leipzig: E. A. Seemann, 1992.

**Warner 1985**
Warner, Marina. *Monuments and Maidens: The Allegory of the Female Form.* New York: Atheneum, 1985.

**Washington Long 1980**
Washington Long, Rose-Carol. *Kandinsky: The Development of an Abstract Style.* Oxford: Clarendon Press, 1980.

**Waterhouse 1967**
Waterhouse, Ellis. "A Note on Giovanni Maria Morandi." In *Studies in Renaissance and Baroque Art Presented to Anthony Blunt on His 60th Birthday.* London and New York: Phaidon Press, 1967.

**Waterhouse 1978**
Waterhouse, Ellis. *Painting in Britain 1530 to 1790.* 4th ed. Harmondsworth and New York: Penguin Books, 1978.

**Wheelock 1995**
Wheelock, Arthur K., Jr. *The Collections of the National Gallery of Art Systematic Catalogue: Dutch Paintings of the Seventeenth Century.* Washington, D.C.: National Gallery of Art, 1995.

**Whitfield 1991**
Whitfield, Sarah. *Fauvism.* New York: Thames and Hudson, 1991.

**Whitfield 1998**
Whitfield, Sarah. *Bonnard.* London: Tate Gallery, 1998.

**Whitfield and Martineau 1983**
Whitfield, Clovis, and Jane Martineau, eds. *Painting in Naples, 1606–1705, from Caravaggio to Giordano.* Exh. cat. Washington, D.C.: National Gallery of Art, 1983.

**Wildenstein 1992**
Wildenstein, Alec. *Odilon Redon: Catalogue raisonné de l'oeuvre peint et dessiné.* Vol. 1. Paris: Wildenstein Institute, 1992.

**Wildenstein 1996**
Wildenstein, Daniel. *Monet: Catalogue raisonné.* 4 vols. Cologne: Taschen; Wildenstein Institute, 1996.

**Wilken 1991**
Wilken, Karen. *Georges Braque.* New York: Abbeville Press, 1991.

**Wilkinson 1996**
Wilkinson, Alan G. "Amedeo Modigliani." In *The Dictionary of Art,* ed. Jane Turner. Vol. 21. London: Macmillan; New York: Grove's Dictionaries, 1996.

**Wilson 1983**
Wilson, Carolyn C. *Renaissance Small Bronze Sculpture and Associated Decorative Arts at the National Gallery of Art.* Washington, D.C.: National Gallery of Art, 1983.

**Wilson 1993**
Wilson, Carolyn C. "Domenico Tintoretto's *Tancred Baptizing Clorinda:* A Closer Look." *Venezia Cinquecento* 3 (July–December 1993): 121–38.

**Wilson 1995a**
Wilson, Carolyn C. "Focus on Luini's Houston Pietà." *Arte Lombarda* 112 (1995): 39–42.

**Wilson 1995b**
Wilson, Carolyn C. "Fra Angelico: New Light on a Lost Work." *Burlington Magazine* 137 (November 1995): 737–40.

**Wilson 1996**
Wilson, Carolyn C. *Italian Paintings XIV–XVI Centuries in the Museum of Fine Arts, Houston.* Houston: Museum of Fine Arts in association with Rice University Press and Merrell Holberton, 1996.

**Wilton and Bignamini 1996**
Wilton, Andrew, and Ilaria Bignamini, eds. *Grand Tour: The Lure of Italy in the Eighteenth Century.* Exh. cat. London: Tate Gallery; Rome: Palazzo delle Esposizioni, 1996.

**Wintermute 1990**
Wintermute, Alan. *Claude to Corot: The Development of Landscape Painting in France.* New York: Colnaghi, 1990.

**Wissman 1996**
Wissman, Fronia E. *Bouguereau.* San Francisco: Pomegranate Artbooks, 1996.

**Wittmer 1991**
Wittmer, Pierre. *Gustave Caillebotte and His Garden at Yerres.* New York: Harry N. Abrams, 1991.

**Woodall 1963**
Woodall, Mary, ed. *The Letters of Thomas Gainsborough.* 2nd ed. Greenwich, Conn.: New York Graphic Society, 1963.

**Yale University Art Gallery 1987**
Yale University Art Gallery. *A Taste for Angels: Neapolitan Painting in North America, 1650–1750.* Exh. cat. New Haven: Yale University Press, 1987.

**Zingg 1996**
Zingg, Jean-Pierre. *Les Eventails de Paul Gauguin.* Paris: Editions Avant et Après, 1996.

**Zurcher 1988**
Zurcher, B. *Georges Braque: Life and Work.* Trans. Simon Nye. New York: Rizzoli, 1988.

**Zweite 1989**
Zweite, Armin. *The Blue Rider in the Lenbachhaus, Munich.* Munich: Prestel, 1989.

# INDEX OF MASTERWORKS ARTISTS

*Page numbers in italics refer to primary discussions of an artist's work*

*Designed by Bruce Campbell*
*Composed in Adobe Garamond with*
*Univers Condensed display by dix!, Syracuse, New York*
*Color separations and printing by*
*South China Printing,*
*Hong Kong*